DRAWING DIMENSIONS

A Comprehensive Introduction

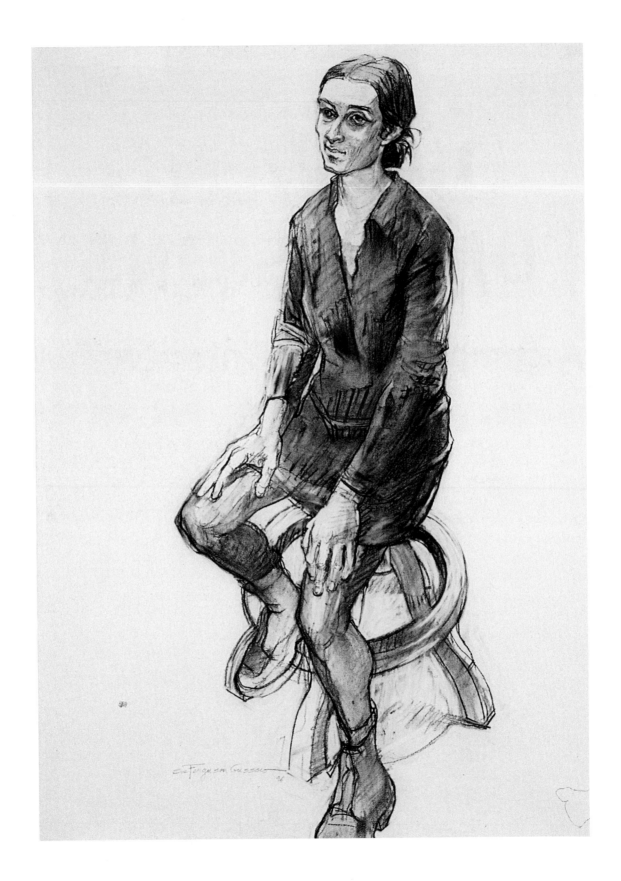

DRAWING DIMENSIONS

A Comprehensive Introduction

CYNTHIA MARIS DANTZIC

Professor of Art
Long Island University

Prentice Hall, Upper Saddle River, N.J. 07458

"Art does not reproduce what we see; it makes us see"

—Paul Klee

Upper Saddle River, N.J. 07458

ISBN 0–13–220153–4

This book was designed and produced by
CALMANN & KING LTD, LONDON
Designed by John Round and Andrew Shoolbred
Edited by Ursula Payne
Picture research by Callie Kendall
Printed in the United States of America

FRONTISPIECE: Sue Ferguson Gussow *Elisa Garcia* 1997 Charcoal on paper
42 × 31¹/₂" (106.7 × 80 cm) Collection of the artist
FRONT COVER: (TOP) Ellsworth Kelly *Grape Leaves II* 1973–4
Transfer lithograph on Arches paper, edition of 50
47¹/₄ × 31¹/₂" (120 × 80 cm) Photo: GEMINI G.E.L., Los Angeles, California
(BOTTOM LEFT) Piet Mondrian *Chrysanthemum*, detail 1908–9
Graphite and watercolor on canvas
Full image 10³/₈ × 6¹/₄" (26.4 × 15.9 cm)
Sidney Janis Family Collection. ©Mondrian/Holtzman Trust,
ᶜ/ₒ Beeldrecht, Amsterdam, Holland/DACS, London 1999
(BOTTOM RIGHT) Piet Mondrian *Composition in Line (Black and White)* 1916–17
Oil on canvas 3'6⁹/₁₆" × 3'6⁹/₁₆" (1.08 × 1.08 m)
Stichting Kröller-Müller, Otterlo, The Netherlands.
Photo: Tom Haartsen. ©Mondrian/Holtzman Trust,
ᶜ/ₒ Beeldrecht, Amsterdam, Holland/DACS, London 1999
BACK COVER: Anna Pinto *Calligraphy with moonshell* 1997
Watercolor on paper 4 × 3¾" (10.2 × 9.5 cm) Collection of the author

Contents

Acknowledgments .. 14

About the Author .. 15

Preface .. 16

INTRODUCTION: Aims and Uses of this Book 19

Making and Seeing Drawings: A Uniquely Human Activity 19

Meanings and Purposes of Drawing: Making One's Mark 19

Why We Draw: The Satisfactions of Observation 19

Other Satisfactions of Drawing 20

Aims of this Book 20

Types of Visual Response: Many Choices 21

Extended Definitions of Drawing: Other Works on Paper 22

Choices and Options 23

Subject or Theme? 24

What Can Make a Work a Drawing? 26

Importance of Perceptual Drawing to Artists 26

Providing the Basics 26

Why Not Only Artists Study Drawing 27

Josef Albers and Perceptual Drawing 28

Section Units or Modules 28

Not from Books Alone 29

SECTION 1
PERCEPTUAL DRAWING: Line and Edge 31

PRELIMINARIES: Before You Begin 31

Looking and Seeing 31

Steps Taken Before Drawing 31

The Figure/Ground Interaction 35

The Framing L 35

Visualizing in Two Dimensions: A Perspective View 36

Viewpoints 37

Supplies: To Start 37

UNIT A: DRAW WHAT YOU SEE: A Matter of Choices 39

A First Study: "Draw What You See" 39

Composing a Composition: The Double L Framing Matt 40

Cropping from the Outside In, or the Inside Out 40

Repeating the Study: Will It Be a Repetition? 41

UNIT B: MANY KINDS OF LINES: Definitions and Perceptions 43

Drawing a Line 43

Lines that Have Two Edges: Applied Line 43

Calligraphic Line 45

Using Both Edges of Applied Line: Linear Woodcuts as Drawings 46

Shaping Space with Line 47

Seeking the Visual Horizon: Connecting Physical Edges 48

Different Kinds of Lines 52

Searching for Lines of All Types 53

Lines Drawn by the Eye 54

Drawing Out a Line 55

Technical Tips: Avoiding Smudges 56

The Back-Stitched, Overlapped Line 56

Mono-Tonal and Multi-Tonal Line 57

The Melted Edge: Alternate Shading 57

A Note on Flattening the Picture Plane 58

Edgeless Drawings: Tonality 59

Many Kinds of Lines 60

The Question of Personal Style 60

Concluding Exercises 61

UNIT C: CONTOUR, THE EDGE THAT ISN'T THERE: A Sequential Development 63

Where Are the Lines We Draw? 63

Contour and Outline 64

Sequential Linear Contour Studies, After Albers 66

Paper Loops and Curls 66

Moebius Loops 66

Ribbons and Belts 68

Cylinders 69

Flowerpots and Cores 69

The Guitar Case 70

The Cookie Cutter 71

Tools 71

The Open Umbrella 72

The Closed Umbrella 72

The Flag 73

The Corduroy Cap 73

Spirals: A Repetitive Linearity 74

Introducing Linear Tonality: The Three-Way Pine Cone 76

Continuous Tone 77

The Paper Bag: A Three-Way Sequence 77

Re-Viewing Your Sequential Studies 78

Additional Sequential Study Drawings: Origami 79

Multi-Page Plant 80

Questions to Consider: Can "Realistic" Drawings be "Creative"? 81

UNIT D: THE ALBERS LINEAR STUDIES: For Control and Facility 83

Drawing a Straight Line Without a Ruler 83

First Lines 83

Linear Tonality: Bands of Tone 84

Variants and Uses 84

Freehand Circle in a Square and Variants 86

Related Exercises: Automatic Two-Handed Symmetry 88

Uses of the Series of Studies 89

SECTION 2
LINEAR ORCHESTRATION: Surface, Form, and Expression

93

UNIT A: CALLIGRAPHIC RIBBON: The Double-Edged, Shaped Line

93

Linear Calligraphy: A Pressure-Sensitive Ribbon 93

Creating Calligraphic Line: Experiments with Materials 93

Using Specific Brushes—Pointed and Chisel-Edged 95

Using Calligraphic Line 97

Linearity in Printmaking 97

Pen and Ink 98

Using Variations in Tone, but Barely 99

Single-Thickness Ribbon-Line: Mono-Line 99

UNIT B: CLUSTERING LINE: Tone and Texture 102
 The Cumulative Effect of Lines 102
 Texture 105

UNIT C: LINEAR SURFACE: Defining Form 109
 Lining Up Form, Conceptually 109
 Forming with Line, Perceptually 110
 Hatching and Crosshatching 113
 Uses in Printmaking 114
 Identifying the Linear Surface 117

UNIT D: EXPRESSIVE LINE: Delineating Emotion 119
 Drawing on Emotions 119
 Drawing as Reflection 119
 Responding with Feeling 120
 Using Materials Responsively 121

SECTION 3
SEEING THE LIGHT: Clarity and Shadow 125

UNIT A: CONTINUOUS TONE: Line as the Edge of Shape 125
 Where We Draw the Line 125
 From the Inside Out 127

UNIT B: EDGELESS TONALITY: Scaling Light and Dark 130
 Growing Darker and Lighter 130
 Mutual Contrast: The Gray Scale 132

UNIT C: LIGHTING FORM AND SPACE: Modeling and Shadowing 138
 Turning on the Light 138
 The Source 139
 A Little Light on Shadows 140
 Chiaroscuro 142
 Seeing in Black and White 143
 Special Effects 144
 Lighting Space Itself 145
 Conception and Perception in Drawing 147

SECTION 4
READING THE SURFACE: Composition and Spatial Concepts

SECTION 4 ... 149

UNIT A: ON THE PICTURE PLANE: Structuring the Rectangle 149
Reading the Surface 149
The Empty Page: Making Choices 151
Raising Your Sights 153
The Drawing Frame 154

UNIT B: PICTURING SPACE: Perspective in Perspective 157
Perspective as a Point of View 157
One-Point Perspective 157
Two-Point Perspective 160
Three-Point Perspective 163
Multiple Perspectives 165
Isometric Perspective 165
Optical Illusion 166
Foreshortening 168
Reverse Perspective 169
Size and Placement 169
Aerial Perspective 171

UNIT C: ABSTRACTING FORM: Progressive Reduction 172
Making Choices 172
Biomorphic Abstraction and Perception 174
Cubist Abstraction 175
Geometric Abstraction 178

SECTION 5
THE HUMAN FIGURE: Structure and Movement

SECTION 5 ... 181

UNIT A: SKELETAL FRAMEWORK: The Support System 181
Drawing the Human Figure 181
Drawing the Skeletal Framework: Preliminaries 182
The Skull 186
The Torso 189

The Shoulder Girdle 189
The Arms 190
The Wrist and Hand 191
The Legs 194
The Feet 195

UNIT B: ANATOMICAL BASICS: Building Bodily Form 197
Approaching Anatomy 197
Getting It All Together 200
Muscles 201
Cartilage 202
Tendons 202
Ligaments 202
Blood Vessels 202
Terms Defined 202
Briefly, From Head to Toe 205
Head, Neck, and Shoulder Activators 206
Armpit, Arm, and Hand Movers 206
The Torso 208
The Legs and Feet 209
Facing the Head 211
The Eye 211
The Nose 212
The Lips 212
Facial Expression 213
The Ear 214

UNIT C: IMPARTING MOVEMENT: Activating the Figure 216
Imaging the Figure 216
The Double Goal: Where to Begin? 216
Posing: A Question of Movement 217

SECTION 6
EXPANDING SPACE AND TIME:
Stretching the Space, Extending the Moment 233

UNIT A: ENLARGING THE FIELD: Multi-Unit Formats 233
Shaping Flat Space 233
Making It Fit 234
Doubles and Triples 234
Overflowing Compositions 236
The Filmic Flow 237
Grid Games 238
Non-Rectangular Formats 240
The Moebius Strip Drawing 241

UNIT B: ENLARGING THE SCOPE: Multiple Viewpoints 242
Drawing Out Time 242
The Continuous Scroll 242
Animating the Surface 243
"The Moving Finger Writes . . ." 245
Seeing Every Side of Things 245
Fracturing Time on the Picture Plane: Cubism 246

UNIT C: BEYOND THE HORIZON: Fantasy and Illusion 250
Picture This . . . 250
What If . . . 250
Fitting Two Things into the Same Space: The Optical Illusion 250
Transformation Over Time 254
Summary: Aspects of Activation and Transformation 254
The Illusion of Place 255

SECTION 7
SEEING WITH THE INWARD EYE: The Conceptual Vision 259

UNIT A: THE MIND'S EYE: Sur-Reality and Dreams 259
Varieties of Conceptual Imagery 259
The Worlds of Surrealism 260
Creating Creatures in the Mind 265

Deities and Superheroes 266

Surreal or Symbolic? 267

Leaving Perception Behind 268

UNIT B: DEPICTING THE UNSEEABLE: Conceptual Drawing 270

Ideas about Perception and Conception in Art 270

Words and Symbols 270

The Nature of Perception 271

Non-Perceptual Subject Matter 273

A Working Terminology 274

Sol LeWitt 276

Kenneth Snelson 277

Dorothea Rockburne 277

François Morellet 281

Julian Stanczak 282

The Big Idea: Albers Has the Last Word 282

UNIT C: CONTROL AND CONTEXT: Criteria for Choice 284

Ideas Affecting the Way We See 284

Control: Self-Directed Drawings 285

Evaluating Self-Directed Drawings: The Importance of Criteria 286

Looking Ahead: Future Study Directions 289

Showing Attitudes or Feelings on Paper 290

Intuitive, Self-Taught, and Tribal Forms 290

"Know Thyself" 291

SECTION 8
APPENDIX: Materials and Supplies, Presentation and Direction 295

UNIT A: USING DRY MATERIALS 296

Pencil 296

Silverpoint 298

Conté 298

Pastel 298

Charcoal 299

Crayons 299

Associated Equipment 300

Sharpeners 300

Erasers 300

Papers 301

The Silent Panel's Individual Requirements: Papers and Pencils 301

Other General Supplies for Drawing in Dry Mediums 305

Making Your Own List 307

UNIT B: USING LIQUID MATERIALS 308

Options 308

Tools for Applying Wet Materials 308

Pen and Ink 308

Markers 312

The Bamboo or Reed Pen 312

Pre-Mixed Inks 312

Brushes 312

The Bamboo Brush 313

Paper for Use with Sumi or Other Bamboo Brush Work 314

Other Materials that may be Used Wet 314

Working Wet 314

Special Recommendations of the Silent Panel 316

Making Your Own List 317

UNIT C: BASIC STUDIO NEEDS AND PRESENTATION OF YOUR WORK 319

Surroundings 319

Your Working Environment 319

Why You Should Stand 319

Turning the Tables 320

Lighting Your Way 320

The Silent Panel Speaks 320

Showing Your Work to Advantage 324

Window Matts 324

Presentation Binders 327

Glossary 328

Bibliography 332

Index 338

Acknowledgments

It is a pleasure to acknowledge with thanks my indebtedness to the many people whose generous assistance and enthusiasm have helped to enrich this book during its actual preparation and in earlier years of study, teaching, and immersion in the worlds of art and education.

At the start, let me express my continuing high regard for the Research/Released Time Committee of Long Island University (L.I.U.) and its Board of Trustees, without whose annual grant of assistance this work would not have been possible. I thank specifically my fellow members of the Committee, recipients of L.I.U.'s Trustees Award for Scholarly Achievement: Professors Bertram Bandman, Kenneth Bernard, John Ehrenberg, Stuart Fishelson, Walter Glickman, Carol Magai, Eric Posmentier, Donald Rogers, Peter Stratigos, and Andreas Zavitsas.

Thanks go to my instructors, starting with my father, Howard A. Gross, and then from early days at the Brooklyn Museum Art School with Isaac Soyer, to Josef Albers, Bernard Chaet, Robert G. Scott, Will Barnet, and José de Rivera at Yale, and calligraphers Sheila Waters, Myrna Rosen, and Jia-Xuan Zhang, to note those of my many teachers most concerned with drawing-related understandings.

Fellow artists, colleagues, and friends whose unselfish contribution of works, ideas, time, and encouragement merit resounding applause include the prodigious, versatile Virginia Cantarella, and Naomi Bossom, Harvey Dinnerstein, Simon Dinnerstein, Shunji Sakuyama, Hélène K. Manzo, Julia Noonan, Anita Dantzic Rehbock, Richard Anuszkiewicz, Diane Miller, Vivian Tsao, Evelyn S. Yee, Lois Dinnerstein, Andrew Reiss, Arthur Coppedge, Leonard Everett Fisher, Posoon Park Sung, Martin Ries, Leendert van der Pool, Alix Rehbock, Eleanor Winters, Lois Swirnoff, Irwin Rubin, Miriam Beerman, Louise Odes Neaderland, Tom Connor, Drs. Tom and Marika Herskovic, Sue Ferguson Gussow, and Nancy Gleason, *semper fidelis*.

At Prentice Hall, devoted attention to this work in early days by Lee Mamunes, later by Gianna Caradonna and, more recently, by Mary Amoon, has earned my sincere appreciation. And in London, at Calmann & King, the unstinting meticulous efforts of Robert Shore, Ursula Payne, and Callie Kendall to turn trans-Atlantic communication into an art must be duly acknowledged with appropriate fanfare. A special word of appreciation goes to my patient and supportive publisher, Bud Therien.

To Jeannie Butler, typist but more than a typist—processor of words and general language consultant—a heartfelt *ave*!

At the Josef and Anni Albers Foundation, I am indebted to Brenda Danilowitz for providing access to the treasury of student drawings done at Yale in Albers' classes years ago. Thanks also to photographer Dennis Barna for difficult prints of these often fragile and pale pencil drawings, and others.

I am particularly thankful to instructors of drawing at The Cooper Union, who have provided a rich resource of works by their students—sometimes inadvertently, seen in frequently changing hallway displays. These excellent drawings, mostly by students of Larry Brown, Scott Richter, Lee Ann Miller, Pat Colville, Sue Ferguson Gussow, and Deborah Priestley, were not always able to be included, or identified individually here from my vast, haphazard photo-documentation. Any acknowledgments due are herewith offered, and any oversights brought to my attention will be corrected in a future edition.

My own current and former students at Long Island University, whose works appear in these pages, are duly noted with much appreciation, as well as my students in 2-D Design at Cooper.

The group of artists and colleagues who agreed to serve as a Silent Panel of advisors is hereby thanked, behind sealed lips. You have provided valuable help and experience beyond measure. In addition, I express my gratitude to the publisher's team of reviewers: Donald Cowan of El Paso Community College, Texas; Paul H. Davis of the University of Utah, Salt Lake City; Maurice Flecker of Suffolk Community College, Selden, New York State; Sylvia R. Greenfield of Southern Illinois University, Carbondale; Robert L. Jones of Northeast Missouri State University, Kirksville; Heather Ryan Kelley of McNeese State University, Lake Charles, Louisiana; Laura Libson of Ohio State University, Columbus; and James Mitchell Clark of Blackburn College, Carlinville, Illinois.

On a personal note, I want to recognize the enormous support and behind-the-scenes activity of family and friends that have made this work possible, from the confidence and love of my husband, Jerry, and son, Gray, to the ceaseless efforts of Jerry's health-care team, Irma Robertson, Marie Pascal, and Huguette Laroche.

* * *

The book is dedicated, with love, to my first, truest champion, and life-long defender of the English language: my mother, Sylvia W. Gross.

Cynthia Maris Dantzic

About the Author

Cynthia Maris Dantzic has been teaching drawing and other studio arts for over thirty-five years at the college level with a varied range of students, from serious art majors to those required to include a course in studio art as part of a general Humanities Core. A student of such diverse instructors as Josef Albers, Stefan Hirsch, José de Rivera, and Isaac Soyer, she has exhibited widely and has works included in major collections such as those of the Brooklyn Museum of Art and the Rose Art Museum in Waltham, Massachusetts. Her previous text, *Design Dimensions: An Introduction to the Visual Surface*, was awarded Long Island University's prestigious Trustees Award for Scholarly Achievement. She is continuing her study of Chinese calligraphy.

Preface

Drawing holds a special place in college and university art departments as the one study providing a common basis for Foundation programs in all the visual arts.

A comparison of available texts has led to the book you are holding, written in response to a number of perceived, yet unmet, needs of art students and their instructors. This single volume provides the basics necessary to pursue the study of drawing in a fresh, accessible, and comprehensive way, suited to experienced and beginning students alike. Its modular, rearrangeable format permits presentation of the eight component Sections in any desired sequence (even omitting one or more), according to individual philosophies or course requirements. Extensive exercises have been designed to develop students' practical skills, and challenging questions for individual or group reflection back this up in thought-provoking ways. Always, there is an emphasis on the search for meaning, understanding, and the harmonious interrelationship of visual elements to be found in the worlds of nature, of geometry, of the imagination.

The illustrations, drawn from many historical periods (color plate 1), comprise an impressive array of varied works, creating a small treasury of world drawings. Works by students and lesser known artists complement the more familiar gallery of classic images (color plate 2), and generous cross-referencing draws multiple meanings and points of interest from each.

Of particular interest are drawings by students of Josef Albers, several by now distinguished exhibiting artists. These were made in the 1950s at Yale, where he developed a unique sequence of perceptual studies and conceptual exercises—presented here for the first time to a broader audience. (You will discover a way to draw straight lines without a ruler, or a perfect circle in a perfect square, freehand!)

At the start, basic but elusive concepts, such as differences between one-dimensional geometric line and two-dimensional applied line, are considered. Other perceptual aspects of drawing—for instance, shaping space, suggesting form, and revealing surface, texture, and light—are often presented from a fresh perspective. For example, shadows are described not as something added to a drawing, but as areas of darkness remaining when an object is illuminated by a source of light.

Ways of reading the visual surface, either to emphasize the structure of the flat, rectangular picture plane or to create the illusion of space, depth, or movement, are studied, as is the progressive reduction of abstraction. The equivalent importance of shape on either side of an edge is stressed.

Section 5 provides a three-unit treatment of skeletal and muscular structure, as well as techniques for imparting a sense of life, movement, and expression

to the human form; the student of figure drawing will not need a separate anatomy text.

Conceptual vision—directly presenting a response to ideas, systems, or imaginative interpretations of the perceivable world—is introduced. Ways of communicating the idea of the extension of space or the passage of time on the pictorial surface are studied, as well as multiple-unit formats and the realms of fantasy, optical illusion, surrealism, symbolism, and chance.

In Section 8 there are detailed overviews of traditional tools and materials as well as suggestions for innovative techniques and alternative mark-making equipment. (Subtle calligraphic niceties of Asian bamboo brush-drawing enrich our Western palette, and help to explain why some art departments require a course in calligraphy.)

Proportion, balance, rhythm, symmetry, perspective, and other compositional elements are explained not only in the Glossary, but appropriately within the text with visual and written description.

A special feature of this book is the Silent Panel, a group of artists and teachers whose supplementary comments, pointers, and suggestions broaden its scope. This valuable enrichment provides the student with a wide range of instructors and suggests the advantage of a varied approach to the learning experience.

This volume is appropriate as a text for such courses as "Introduction to Drawing," "Drawing I and II," "Foundation Drawing," "Basic Drawing," and "Figure Drawing," as well as the studio component of many Humanities Core requirements. It may be used as a self-teaching supplement to classroom instruction, or as a text for individual independent study.

Rather than emphasizing current trends and concerns, this book gives such issues a historical perspective, choosing rather to focus upon the timeless fundamentals of perception and conception in drawing; it should not become dated. It has been written in the firm belief that the study of drawing and its related concerns—the relativity of perceptual truths, for example—can be a spur to ideas and considerations seemingly unrelated to art, while enhancing sensibilities, building skills, and developing a personal style.

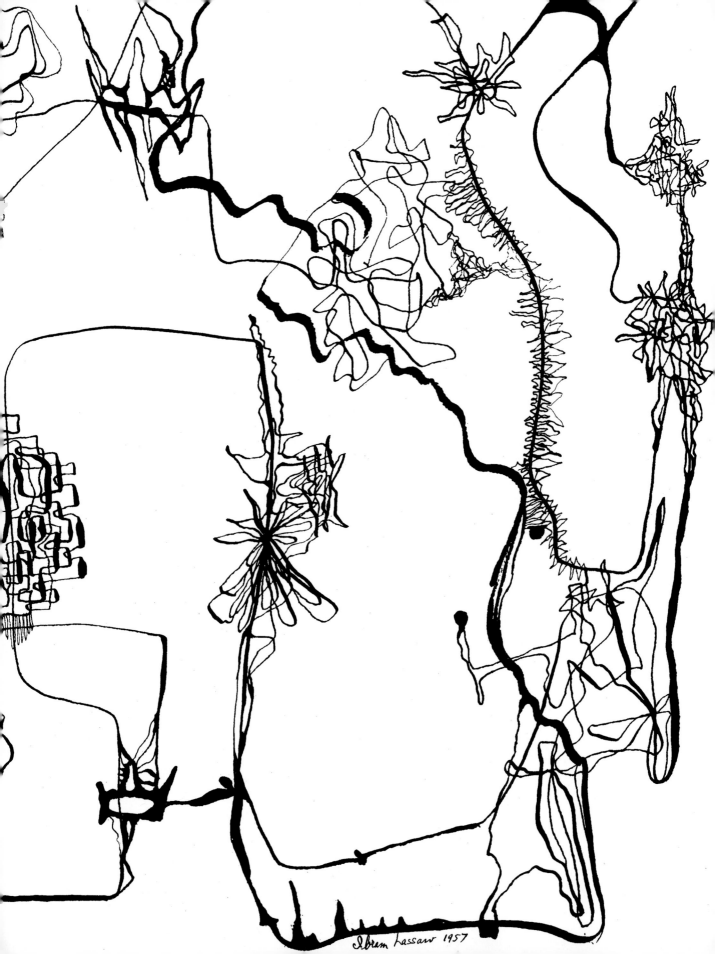

Ibram Lassaw 1957

Introduction:

Aims and Uses
of this Book

MAKING AND SEEING DRAWINGS: A UNIQUELY HUMAN ACTIVITY

Everyone draws; it is one of the earliest activities we all enjoy. We assert our identity through control of the environment by adding something we have created (fig. 0.1). To recapture that early excitement of grasping a crayon or pencil, scraping it across a surface, and discovering the path it has left, permanently recorded and visible, we make our mark again and again. Delight is found in the making of markings at least as much as in the look of the markings themselves (figs. 0.2 and 0.3). This distinction, between the experience of making a drawing and responses to a work by oneself or others, concerned John Dewey in his classic study *Art as Experience*, the title reflecting his point of view.

MEANINGS AND PURPOSES OF DRAWING: MAKING ONE'S MARK

The satisfying experience of making one's mark may be seen on paper left near a telephone and on walls of many cities in the form of graffiti. But these have little to do with traditional or classic drawing as the studied effort to put down on paper a picturing of or a visual response to particular objects or their arrangement, under observation or from the memory of perception.

WHY WE DRAW: THE SATISFACTIONS OF OBSERVATION

If we often draw things in order to see them, or to verify and confirm what we are seeing, the most satisfying kinds of drawing may result from an effort to celebrate and identify with a subject under observation. Enjoying the beauty of natural or created subjects, understanding the interaction of their parts and relationships in almost geometric, musical, or choreographic ways, may be

0.1

Gray Dantzic

First Mark on Paper, One Year Old

1968

Marker on paper bag

5 × 2¾" (12.7 × 7 cm)

Collection of the author

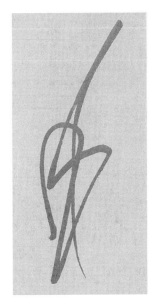

0.2 RIGHT
Ibram Lassaw
Untitled linear study (detail
on p. 18)
1957
Ink on paper
22 × 30" (55.9 × 76.2 cm)
Lent by the artist

0.3 FAR RIGHT
Michael Dinnerstein
A Goat for Grandfather
1972
Pencil on paper
9 × 12" (22.9 × 30.5 cm)
Collection of Lois and Harvey
Dinnerstein

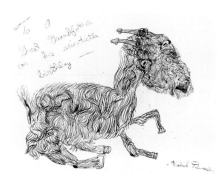

expressed as appreciating them. Any study of Art Appreciation should reinforce this idea that enjoyment of art is requisite, as well as understanding and knowledge.

OTHER SATISFACTIONS OF DRAWING

The enjoyment of drawing may spring from sources other than faithful depiction of a subject seen. Drawing can provide the opportunity to show feelings—to express human response to any subject, whether directly perceived or derived from memory or imagination (fig. 0.4). Drawing may also satisfy purely intellectual goals, if constructed or produced through systems or procedures unrelated to external subject matter. We may draw to show what we see, to show who we are, how we feel, how we think, or how we see (fig. 0.5).

Are these separate purposes truly separable? In what ways may they work together? One of the purposes of this book is to provide you with experiences and insights that will help you address such questions.

AIMS OF THIS BOOK

A main aim of this text is to help you identify and investigate many choices you can make as you build skills and pursue ideas in drawing, so that, when you wish to call upon these resources, they will be available. An ability to

0.4 RIGHT
Käthe Kollwitz
Self Portrait
1923
Woodcut
5⅞ × 6⅛" (15 × 15.5 cm)
Private collection. ©DACS 1999

0.5 FAR RIGHT
Man Ray
Self Portrait
1936
Pen and ink on paper
14⅞ × 10" (37.8 × 25.4 cm)
Photo: courtesy André Emmerich
Gallery, New York. ©Man Ray
Trust/ADAGP, Paris and DACS,
London 1999

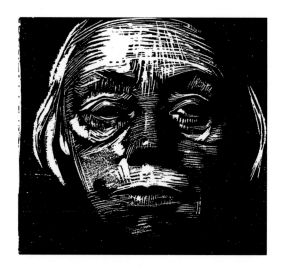

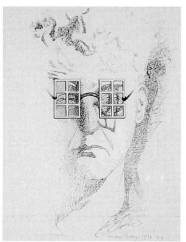

recognize styles and choices made in the works of others will help in the development of your own drawings. But more useful than any study of the works of others will be your own exploration of specific ideas and techniques.

This will be achieved by an introduction to a number of ways to put down, on a flat two-dimensional sheet of paper, lines and other marks that will recall to you later, and suggest to viewers at any time, the visual experience you enjoyed while perceiving a subject directly (fig. 0.6). At the start, let me confess to the strong conviction that a rigorous pursuit of this perceptual approach to drawing will provide you with the most rewarding basis for further development or study.

TYPES OF VISUAL RESPONSE: MANY CHOICES

As your visual experience is enhanced and your perceptive capacity pushed to the very brink, so your discovery of relationships among the parts comprising your perceivable world will increase and the greater will be your enjoyment of drawing.

In addition to drawing the unchanging appearance of a motionless subject, or perhaps suggesting the sense of movement as it is seen changing speed or velocity, you may intend to show feelings about it. Or you may mean to reveal a subject indirectly recalled, imagined, or adapted from another source. You may be concerned with communicating perceptions of emotional states to others, or simply to express them in the sense of getting them out of yourself; that is, almost ridding yourself of the experience. This may verge on the area of *art therapy* or art as therapy (fig. 0.7).

The theme, or subject, of a drawing need not be related to an object at all; to some, any arrangement of lines or other markings produced with materials that leave a visible trace of their movement may be called a drawing. The process may be accomplished by removing as well as depositing material, for example, in works on scratchboard (fig. 0.8). But all these ideas will be available only through wide personal experience, and broad access to historical exemplars, amassed over the centuries from every part of the world.

A Universal Approach

For this reason, and because fashion, style, and current events are in flux and variable, this text emphasizes for the most part the more universal, timeless concerns and aspects of drawing, leaving the changing focus of taste and specific concerns to other treatments of the subject or to the personal pursuit of the reader.

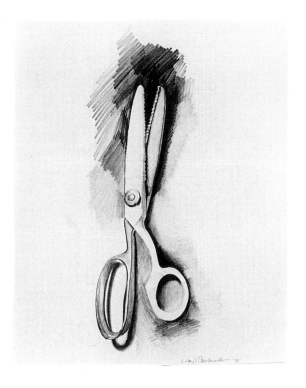

0.6

Virginia Cantarella

Scissors

1978

Pencil on paper

18 × 12" (45.7 × 30.5 cm)

Collection of the author

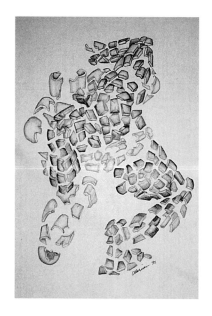

0.7 ABOVE
Charlotte Kasian
Eclipse
1991
Chalk on vellum
24 × 16" (61 × 40.6 cm)
Courtesy of the artist

0.8 TOP RIGHT
L.I.U. student: Stuart E. Alleyne
"House on the Prairie," after Hale Woodruff
1997
Scratchboard
4 × 7" (10.2 × 17.8 cm)

EXTENDED DEFINITIONS OF DRAWING: OTHER WORKS ON PAPER

Certain questions persist: Is it the medium itself or its use by an artist that defines the nature of a particular work? If drawing means *any recording of the movement of a human-directed tool over a receptive surface,* may it not include certain works in printmaking, such as etching, engraving, lithography, woodcut, and linoleum block, and even some works made with paint on canvas (fig. 0.9 and color plate 3; see also fig. 2.8)? In recent years in particular, the combining of traditional materials and methods with one another and with new, experimental procedures and materials has made problematic the business of categorizing and identifying works as definitely *drawings* or definitely *not drawings* (fig. 0.10). Today, it is generally accepted that traditional definitions separating drawing from painting, collage, even sculpture, need not always apply. Artists often combine and orchestrate elements formerly reserved for separate areas of artistic creation and expression; this approach frees the visual artist to achieve a richer, more personal statement than was possible before.

Along with this new freedom of means has come a new freedom related to subject matter, to what may be expressed or presented, and the way themes or subjects are approached (fig. 0.11). Every possible way of seeing, every viewing-point, can be found in galleries, museums, and artists' studios around the world. These may range from actual or apparent photographic representation of subjects under observation by camera, videocam, or eye through freer, but clearly recognizable, interpretations of subjects and their passage through time and space. From the barest reference to a perceivable subject or its significance, to no reference at all, to conceptual content beyond any visible elements, drawings can show a sequential reduction in factual referents or observable details (color plate 4).

Among the delights of the study of drawing can be analytical discussion about particular works or generalizations about the definition of drawing; but eventually, to be meaningful, the final arbiter of your own thought must be yourself.

The general term *works on paper* often serves today as an inclusive category for exhibitions, as it may embrace, in addition to more traditional drawings, works in collage, montage, frottage (rubbings), assemblage, or any materials attachable to a relatively flat piece of paper or other surface (figs. 0.12 and 0.13). For these, exercises starting with detailed perceptual studies, then moving in specific technical or experimental directions, may be devised or selected from those described (see fig. 3.1a and p. 126).

CHOICES AND OPTIONS

If any combination of previously separable forms may be chosen by the artist, then the critical point is a basis for choice. Only when you have developed the various skills, techniques, and understandings available can you enjoy the freedom to select, adapt, or reject them.

You would not choose to make an etching, for instance, without access to an etching press. But you might decide to draw a figure in the absence of a model if you have, stored in memory, experiences gleaned from having drawn directly from the figure in the past, having made a study of human

0.10 BELOW
Tom Wesselmann
Monica Lying on a Blanket
1988
Enamel on laser-cut steel
21 × 40" (53.3 × 101.6 cm)
Photo: courtesy Sidney Janis
Gallery, New York. ©Tom
Wesselmann/DACS,
London/VAGA, New York 1999

0.9 ABOVE
Henri Matisse
"...fraichie sur des lits de violettes..." (plate, p. 27)
Pasiphaë: Chant de Minos (Les Cretois) by Henry de Montherlant
Published Paris, Martin Fabiani, 1944
Linoleum cut, printed in black
Page: 12⅞ × 9¾"
(32.7 × 24.8 cm); composition:
9⅝ × 7 1/16" (24.5 × 18 cm)
The Museum of Modern Art, New York. The Louis E. Stern Collection. Photograph ©1999 The Museum of Modern Art, New York. ©Succession H. Matisse/DACS 1999

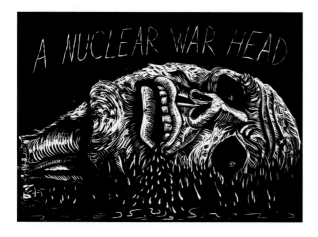

0.11 ABOVE
Robert Arneson
A Nuclear War Head
1984
Woodcut, edition of 5
3'6" × 4'9" (1.07 × 1.45 m)
Photo: courtesy George Adams
Gallery, New York. ©Estate of
Robert Arneson/DACS,
London/VAGA, New York 1999

0.13 BOTTOM RIGHT
Kurt Schwitters
Mz. 88. Red Stroke
(*Mz. 88. Rotstrich*)
1920
Collage of cut-and-pasted
colored papers, tickets,
labels, stamps
11½ × 8¾" (29.1 × 22 cm),
including mount
The Museum of Modern Art, New
York. The Sidney and Harriet
Janis Collection. Photograph
©1999 The Museum of Modern
Art, New York. ©DACS 1999

0.12 RIGHT
Robert Rauschenberg
*"Canto XX: Circle Eight,
Bolgia 4, The Fortune
Tellers and Diviners":
Illustration for "Dante's
Inferno"*
1959–60
Transfer drawing, wash,
and pencil on paper
14½ × 11½" (36.9 × 29.2 cm)
The Museum of Modern Art, New
York. Given anonymously.
Photograph ©1999 The Museum
of Modern Art, New York.
©Robert Rauschenberg/DACS,
London/VAGA, New York 1999

anatomy, or having become familiar with the works of artists who have chosen this subject.

SUBJECT OR THEME?

Can you find a difference between the ideas of *subject* and *theme*? If you draw an eye, is the eye the subject or theme of the work? Study how, in his powerful *Guernica*, Picasso includes subjects such as an eye, light bulb, broken sword, bull, horse, and human figure to emphasize political and humanitarian themes (fig. 0.14; see also fig. 7.6).

It may not be your intention to create works closely depicting the look of your subject; you may prefer to show the subject's movement, action, elegance, strength, permanence, humor, or pain. You may choose particular elements or qualities by omitting, stressing, combining, suggesting, rearranging, or playing with selected aspects, even bringing together unrelated subjects in a single work.

Try not to limit your investigations to ideas or methods you have already encountered, those with which you may feel most comfortable. The broadest foundation will yield the strongest support for your own future direction. Give special attention to new ideas and unfamiliar materials and procedures to build the best possible launching pad for your own flights of achievement.

In the early Sections of this text in particular you may be tempted to pass over seemingly obvious

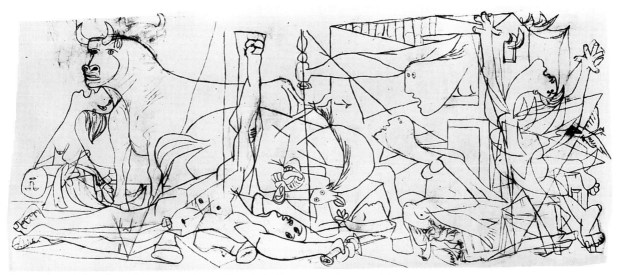

discussion (who doesn't know what a line is?), but attention to this apparent *minutia* can reveal new levels of meaning and potential adaptation for your work.

The distinction between objects and their surroundings may blur as edges become the focus of interest. A drawing may be about more than its ostensible subject (fig. 0.15). Thus the subject of a drawing (e.g. fig. 0.16) may be:

- Movement/gesture
- Acceleration/speed
- Texture/surface
- Light and dark/chiaroscuro
- Line quality
- Arrangement of forms in space
- Visualization of an idea or viewpoint (political, social, economic, or cultural)
- Mood/feeling/a specific emotion
- Sensuality
- Design/pattern

as well as
- Storytelling
- Challenging the viewer's belief
- Illusion of three-dimensional space.

A drawing may be non-descriptive, non-pictorial, non-representational; its subject may be drawing itself (see fig. 0.2). Are all the above distinctions subjects in the sense of *subject matter*, or do some of them suggest the broader category of *theme*? Are these choices always quite clear or open to individual interpretation? Which are clear?

WHAT CAN MAKE A WORK A DRAWING?
What distinguishes a drawing from other works? With which of the following ideas do you agree?

0.14

Pablo Picasso

Drawing for "Guernica"

May 11, 1937

State 1: oil on canvas

11'5½" × 25'5¾" (3.5 × 7.77 m)

Photographie Dora Maar, cliché

Cahiers d'Art, Paris. ©Succession

Picasso/DACS 1999

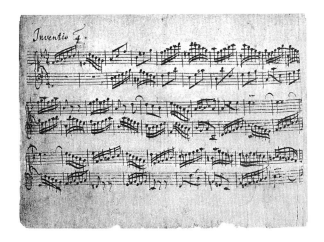

0.15 ABOVE
J. S. Bach
Manuscript of Two-Part
Invention No. 4 in D minor,
BWV 775
1723
Ink on paper
6¾ × 9" (17.1 × 22.9 cm)
Staatsbibliothek zu Berlin

0.16 TOP RIGHT
Georges Braque
Still Life Bach
1912
Charcoal and *faux bois*
paper on paper
18½ × 24 ⁷⁄₁₆" (47 × 62 cm)
Private collection. Photo:
courtesy Galerie Rosengart,
Lucerne, Switzerland. ©ADAGP,
Paris and DACS, London 1999

- *Drawing* is mainly derived from a linear impulse, the movement of the hand along a particular path.
- *Drawing* is generally done on a relatively flat surface such as paper.
- *Drawing* is (generally) concerned with line and edge.
- *Drawing* is (traditionally) concerned with description of things seen, recalled, or imagined.
- *Drawing* generally includes linear description or tonal surface effects of light.
- *Drawing* may include tonality and color in addition to or instead of line (color plate 4).
- Visualizing on paper is a main concern of *drawing*.

IMPORTANCE OF PERCEPTUAL DRAWING TO ARTISTS

To some, drawing always retains the connotation of a visual response to what is seen, by the use of traditional tools and materials. But even those whose work has moved far from a representation of the visible world generally recommend the study of drawing from observation, or perceptual drawing, as a valuable basis for any later developments in style or concept. In 1991, visitors to the Sidney Janis Gallery in New York were astonished to see that the most outspoken proponent of "pure plastic" non-objective, geometric art, Piet Mondrian, far from ceasing to produce works that bore any resemblance to the natural world after the attainment of his mature style, continued to draw and paint flowers in the most detailed and poetically descriptive fashion. Was he a "closet realist" (fig. 0.17)? (See also figs. 2.32 and 4.33a and b.)

PROVIDING THE BASICS

As we have said, this book will provide you with a wide variety of choices for creating your own work in drawing. But at every step it will be your perceptions, your sensibilities, your response to technical suggestions and conceptual guidelines that determine your progress. The first consideration will be to help you attain a high degree of proficiency in the areas generally considered the basics.

Structuring the Basics in this Book

The basics in this study include: different kinds of line in Sections 1 and 2; dark-and-light tonality and the illusion of light and shadow to define volume in Section 3; the relationship between filled (figure) and unfilled (ground) areas, and the relative size and placement of parts in relation to the whole—proportion and composition—in Section 4. These are often emphases rather than truly separable components of drawing (figs. 0.18 and 0.19). Section 5 is devoted to a survey of the most familiar subject of all the visual arts, the human figure, looking at its skeletal and muscular structure and methods of bringing these components to life on the page. Ways of communicating the expansion of *time* and *space*, and of revealing unseeable concepts and subtle emotional meanings, are studied in Sections 6 and 7. A full range of traditional and experimental tools and material is presented in Section 8 as an Appendix; however, you may wish to spend at least one semester developing the rich potential of pencil on paper before moving to pen, brush, and ink, and other wet materials.

Investigation of color and computer-assisted drawing is not undertaken in this introductory level study. This author believes they are more appropriate to those who have already achieved a certain level of basic skill and understanding, but some instructors may include either or both in a beginning drawing study, providing up-to-the-minute material for individual or class investigation.

WHY NOT ONLY ARTISTS STUDY DRAWING

The study of drawing, both direct participation in its creation and an understanding of its history, is not necessarily reserved for artists and art students. It can be shared by everyone, as a truly humanizing experience. For this reason, many universities and colleges include the study of at least one hands-on studio course, along with Art Appreciation or the History of Art, as a core requirement in the humanities. Values that go beyond words—the other-than-verbal meanings and expressions of the human condition, a significant part of our common cultural heritage—should be available to everyone. Not long ago, every educated individual was expected to study music and perhaps even to play a musical instrument, as well as to have a basic knowledge of the visual arts and drawing; perhaps we are witnessing a return to this understanding.

JOSEF ALBERS AND PERCEPTUAL DRAWING

Much of the philosophy and many of the methods included in this text were developed from the teachings of one of the most celebrated educators and artists of the twentieth century, Josef Albers. This approach to the study of drawing is based on observation, analytical perception, and control; the relationship between the eye, the mind, and the hand. No matter how far

0.17

Piet Mondrian

Chrysanthemum

1906

Charcoal on paper

$14\frac{1}{4} \times 9\frac{5}{8}$" (36.2 × 24.5 cm)

The Museum of Modern Art, New York. Gift of Mr. and Mrs. Armand P. Bartos. Photograph ©1999 The Museum of Modern Art, New York. ©Mondrian/Holtzman Trust, ᶜ/₀ Beeldrecht, Amsterdam, Holland/DACS, London 1999

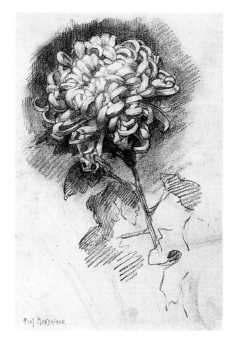

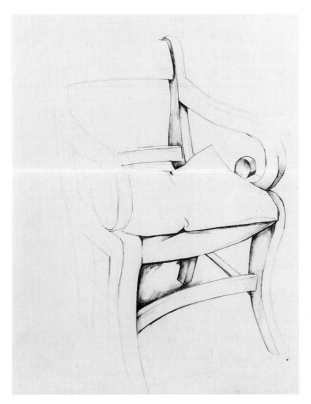

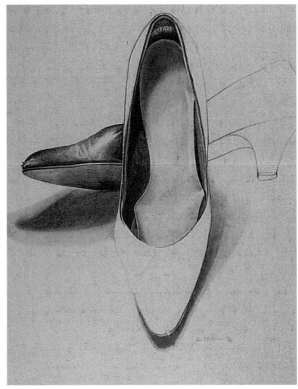

0.18 ABOVE
Stefan Hirsch
Chair with Cushion
1920
Pencil on paper
10 × 7⅝" (25.4 × 19.4 cm)
Photo: courtesy Conner •
Rosenkrantz LLC, New York

0.19 TOP RIGHT
Virginia Cantarella
She's Disappearing
1994
Pencil and colored pencil
on paper
20 × 17½" (50.8 × 44.5 cm)
Collection of the artist

afield you may travel artistically, or how far behind you may think you are leaving the realm of drawing-based-on-perception, it can always be there as an invisible support for your work and continue to provide you with a foundation that will never fail to be of service. Two Albers-based series of studies are presented in Units C and D of Section 1 (see pp. 66–91), including a selection of studies made by his students at Yale. (Although works by Albers' students at the Bauhaus or at Black Mountain would surely have been an enrichment, it was enough to be granted the privilege of using the accompanying student drawings from the archives of the Josef and Anni Albers Foundation.) The first shows drawn-from-life perceptual works and the second a selection of the conceptual sequence of linear freehand exercises Albers devised for the development of skill, coordination, and … yes, elegance!

SECTION UNITS OR MODULES

Exercises and questions for thought and discussion are included in each Section, each of which comprises several Units. To make this book useful in a variety of situations, these Units may be studied in any order or given for home reading or self-directed study.

All Exercises throughout the text may be used as presented, modified to suit individual needs, or simply noted in passing as a spur to invention. The illustrations have been chosen to provide a varied balance of well-known master works from many civilizations and generations (color plate 1), plus a

selection of contemporary professional and student drawings (fig. 0.20). These will permit considerable cross-referencing to stress technical, formal, and expressive qualities. Some of these references will be indicated; others await your own delighted discovery.

NOT FROM BOOKS ALONE

Any textbook is only a silent partner in learning. In a studio participational study such as drawing, special attributes are brought to the experience by each instructor and student. Starting with this understanding, it is the author's hope that you will actively investigate all the book's ideas, exercises, and technical suggestions. Then what you choose to take and make your own will truly belong to you.

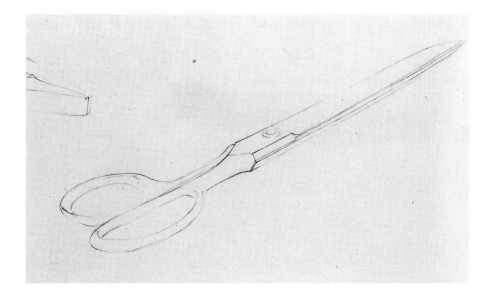

0.20

Albers student: Neil Welliver

Study of pliers and scissors, detail of scissors

c. 1952

Pencil on newsprint

Full image 11¾ × 17¾" (29.8 × 45 cm)

Josef and Anni Albers Foundation, Orange, Conn.

Photo: Helga Photo Studio, Upper Montclair, N.J.

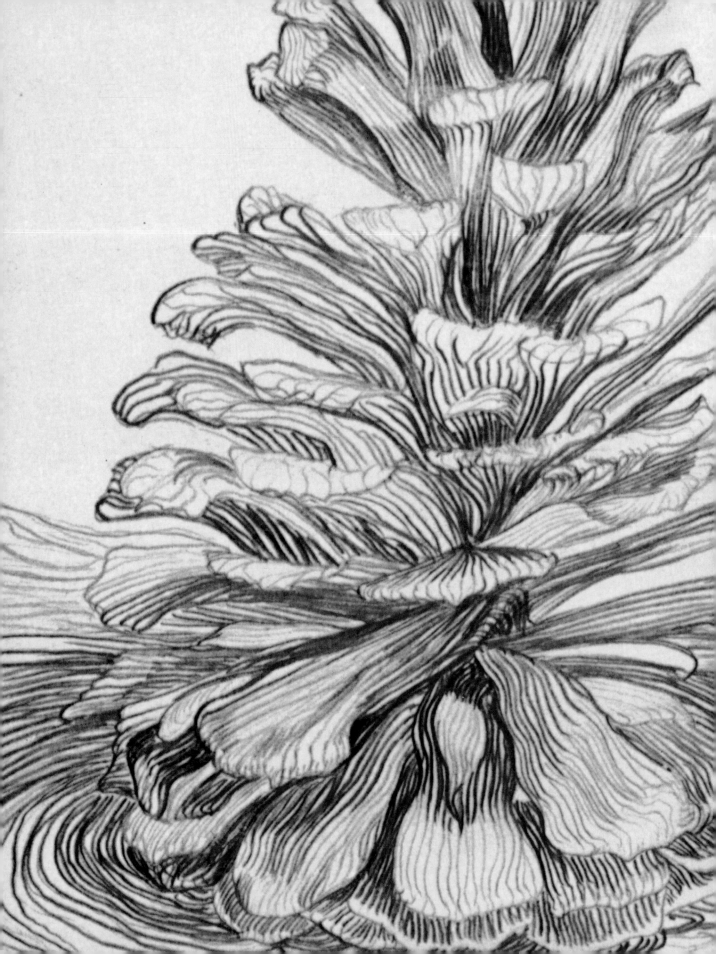

Perceptual Drawing:

Line and Edge

Preliminaries:
Before You Begin

LOOKING AND SEEING

In this descriptive approach, drawing shows your response to direct perception of a subject. Therefore looking precedes drawing. This is very personal; nobody will draw the way you do. In any class, after a few days one can identify students by their individual calligraphy—a kind of wordless handwriting, no two alike!

Yet each person may be making the same kind of effort—to put down on paper a record of direct visual experience, the thing seen as it is seen. Let us try to put into words the steps usually followed in drawing what we are looking at.

STEPS TAKEN BEFORE DRAWING

First, you might entertain the notion, perhaps the itch: I think I'll make ... a drawing! You may glance around in a general way, within an environment: indoors or out, well-lighted or dim, spacious or confined, quiet or busy, inviting or uncomfortable, relaxed or tense. Then, you may limit your field of visual interest until some object or arrangement catches your eye, your attention. (In a school or studio setting your attention may be directed for you—to a still-life arrangement, a figure, or an object placed under carefully controlled lighting to cast specific shadows.) Next, you select a specific vantage point from which to observe the subject. If you have the opportunity to move

1.1

Leonardo da Vinci
Study for "Adoration of the Magi"
c. 1481
Red chalk on white paper
6 × 5½" (15.3 × 14.2 cm)
The Royal Collection ©Her Majesty Queen Elizabeth II

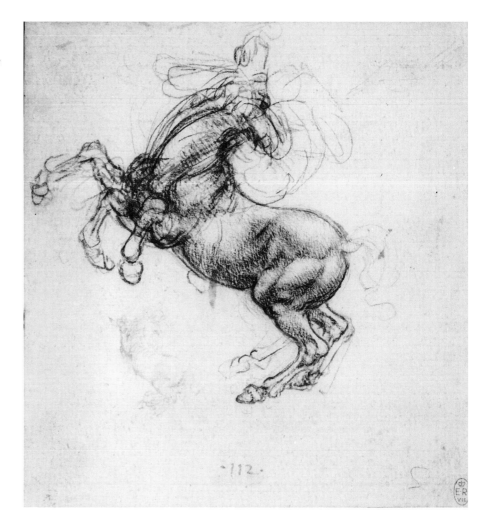

around the subject and watch it change in aspect, revealing new details and contours, concealing others as it turns, you realize that a drawing can show only a single face or view of its subject. Many separable views may be orchestrated, for differing purposes, such as those developed by Braque and Picasso as Cubism, or even by the pioneers of Animation (fig. 1.1; see also figs. 5.55 and 5.56 and pp. 175 and 246).

As you move around a three-dimensional subject, you stop the action, *freeze the frame*, and hold the moment, in order to draw what is seen for an extended period. This is surely an artificial situation; in life we rarely hold ourselves still at the same moment as the surrounding scene is held motionless. Things move or we move around them. As we will see later in detail, the entire concept of Renaissance vanishing-point perspective depends on the willingness of the artist and viewer to imagine that a stationary subject is seen in space by a stationary viewer. Any change in the relationship between subject and observer causes a change in the apparent perspective (see fig. 5.57a and p. 157).

Taking Your Position

Having selected your subject and viewing point, there are other choices to be made before you start to draw. Will you stand at an easel, freeing your arm for long sweeping movements, placing your paper perpendicular to the eye, to eliminate the distortion that can occur when the page is seen flat on a table? Will you rest your paper on a sturdy support such as a drawing board, and balance it at an angle to reduce this distortion? Or will you simply place your pad or sheet of paper flat, and risk foreshortening the subject (fig. 1.2; see also fig. 4.21)? A table easel might be a good compromise; if so, try to raise the top of your page in some way. If you sit, permit your elbow to remain slightly higher than the drawing surface, allowing your hand to fall comfortably as you work.

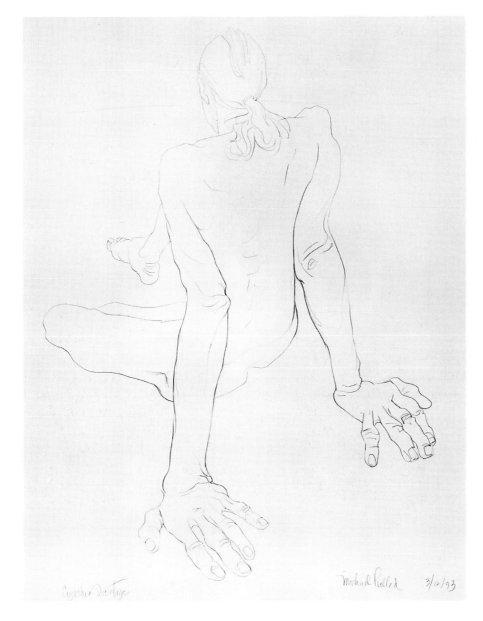

1.2
Cynthia Dantzic
Michael, Pulled
1993
Pencil on paper
24 × 18" (60.1 × 45.7 cm)
Collection of the artist

The Visual Field

Now you must decide just how much of your visual field will be included in the drawing. To experience a sense of your entire visual field, with your head held still, raise your eyes as high as possible until your eye socket provides a border at the top, then lower your gaze until your lower lids create a base line.

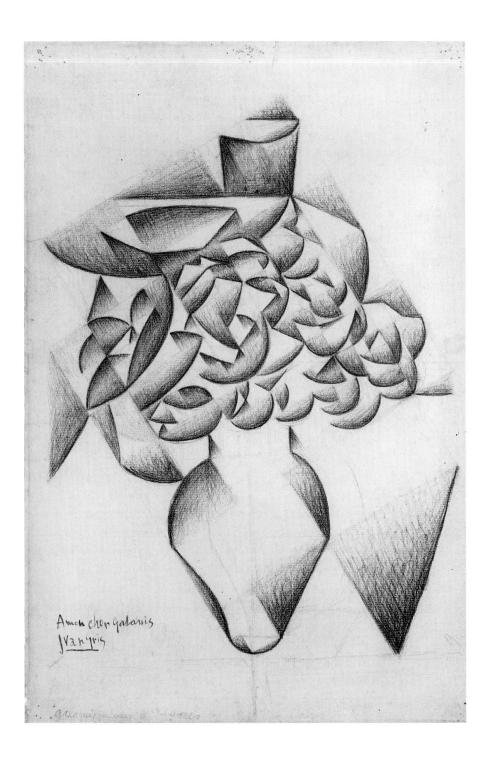

1.3
Juan Gris
Flowers in a Vase
1911–12
Charcoal on paper
18⅛ × 12½" (46 × 31.8 cm)
Indiana University Art Museum,
Bloomington, Ind.

Move both eyes to the right, briefly shutting the right eye to see how much of your binocular (two-eyed) vision is actually monocular at the right horizontal extremity; then do the same to the left, and you will discover how narrow the static binocular field is. Fortunately, we can move left, right, or up and down freely, constantly enlarging our visual field to a very wide panorama, except when we concentrate on a single stopped image, a frozen moment, for study and for direct perceptual drawing.

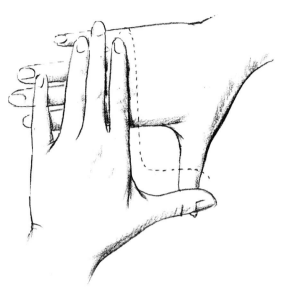

THE FIGURE/GROUND INTERACTION

Notice that however small the area of your attention, it will always fill a *shape*, perhaps a rectangle, vertical or horizontal, perhaps a vaguely ovoid or elliptical area, or one without a clear boundary. But you always see, in addition to objects, the space or spaces around them. You observe the shape of these surrounding spaces as well as the shapes and forms of the objects themselves. You perceive an interaction between the object and its containing space, the figure and its ground. It may be easier to understand this idea when you are drawing abstract shapes, and you are no less interested in the outside, external unfilled shapes than in the inner, filled subject shapes themselves.

1.4

Virginia Cantarella

Sketch of hands making framing L

1998

Pencil on paper

Sheet: 3 × 4" (7.6 × 10.2 cm)

Collection of the author

Many beginners start to draw anywhere on the paper, heedless of the size of the image they are creating in relation to the entire page. They may not yet recognize that they are determining the shape of the spaces around the subject as well as of the subject itself. From the first, try to get a feeling for the entire page, the full rectangle of space you are determining (fig. 1.3).

THE FRAMING L

To help establish the rectangle of space that will be filled by the subject-and-its-ground, you may try several methods. For the simplest, though not very exact rectangle, make an L of each hand (fingers flat and together, thumb out at right angles) and overlap them to make a more or less perpendicular frame (fig. 1.4). Closing one eye, place this frame over the subject, moving it slowly closer to your eye to make a larger field or farther away to reduce the image. The closed eye will aid in the illusion of flatness, as it removes the perception of depth—a binocularly received phenomenon. We are so accustomed to seeing three-dimensionally, we may not recognize this loss of depth perception unless a special effort is made to visualize it.

A composing frame may also be made of two small cardboard right-angle Ls placed to make a rectangular window which can be opened or made smaller to frame your subject, moving closer to or farther from the eye. This can be

hinged for easy movement. It may be useful to draw a rectangle of similar proportions on your paper in which to contain the composed area of your visual field (see also p. 40).

VISUALIZING IN TWO DIMENSIONS: A PERSPECTIVE VIEW

If you hold your head still as you study your composition within its containing frame, you may be able to imagine you are looking at a drawing of the subject rather than at real objects in time and space. Try to achieve a sense of the all-important translation from three to two dimensions, the elusive effect known as flattening the picture plane. Close one eye to remove the perception of the third dimension. Elimination of color from this experiment, using a white on white arrangement (say eggs and white pottery pieces with a white drapery or cloth on a large white matt-board surface), can give a dramatic illusion of visual flatness.

Notice that you cannot see the entirety of any object in view; parts of some objects disappear behind others closer to the eye, while some parts are always hidden, as is the dark side of the moon. Overlapping is one way to suggest depth or space (see p. 170).

Smaller objects nearer than larger more distant ones look much bigger, just as your hand held before your eye blocks the immense sun. This illusion (that objects moving away from the viewer appear smaller until they vanish entirely at a point on the horizon) is called vanishing-point perspective (see p. 157). The horizon, that horizontal edge in our field of vision beyond which we cannot see, is always at eye level (figs. 1.5a and b).

Lines that you know to be parallel, such as the edges of a book, which stay physically the same distance apart, appear to converge or come together as they move away. If these lines were continued in space beyond the objects they described, the point at which they would be seen to vanish is called the *vanishing point.*

Edges that continue beyond the point where they move out of sight, such as the bottom curve of a flowerpot or the opening of a collar or sleeve, may be

1.5a BELOW and
b BOTTOM RIGHT
Hélène K. Manzo
*Two-way landscape:
"Shore with Watersplash"
and "Beach with Weeds"*
1998
Rubber cement and ink on board
10 × 12" (25.4 × 30.5 cm)
Collection of the artist

seen to disappear behind other lines or edges, and then to reappear from behind them, sometimes in unexpected places (fig. 1.6; see also fig. 1.33).

VIEWPOINTS

When we draw what we see, are we drawing what is really *there*? Lines are often seen where they cannot be found to exist on closer inspection. Standing on the beach, we perceive the horizon at the edge of the ocean as a horizontal line; yet if we were to move toward that edge we know it would keep moving away.

If we are not drawing edges that physically exist, what is the nature of the edges we do see and draw? This question is discussed in detail in Units B and C of this Section. If drawing is not a way to show the reality of things in space, it may often suggest the look of the actual world. What you know is not necessarily what you see.

Viewpoint determines perception in that it changes the very shape of what is seen. Is this related to the statement by scientists that the observer affects the event or thing observed?

If perception is shaped by our viewpoint, can this refer to our attitude—as an idea as well as a physical position? If this is so, is thinking an important aspect of drawing? Do we simply respond to the visual world in some automatic way, or do we derive meaning as we consciously study, analyze, evaluate, and add something of ourselves to the picture (see fig. 5.43)? This book is intended to help you find new ways to approach these questions.

SUPPLIES: TO START

A full range of supplies and materials will be discussed in detail in Section 8, as Units A and B. But the basic ideas and techniques related to perceptual drawing, the subject of Sections 1, 2, and 3, whether linear or tonal, can be developed with simple, familiar pencil and paper, supplemented by a good sharpener and, perhaps, an eraser. If you use a drawing board, select a lightweight, hollow wooden model, although a rigid piece of cardboard, foam core, or masonite will do as well, and attach paper by means of tape.

Choose white paper of medium weight, opaque and smooth (preferably not in a spiral-bound pad), at least 18×24". It is impossible to remove a page neatly from a spiral binding, whether for display, class critiques, or multiple-sheet drawings. Glass pushpins may be used to attach works to studio wallboard (supporting, not piercing, the paper, if you plan to matt or display it later).

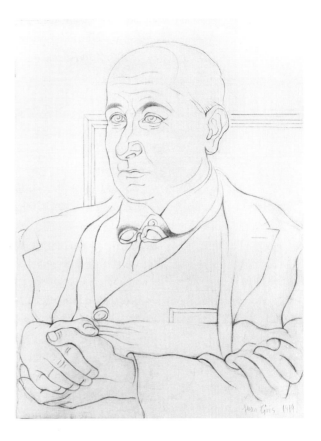

1.6

Juan Gris (José Victoriano González)

Portrait of Max Jacob

1919

Pencil on paper

Sheet: $14^{3}/_{8} \times 10^{1}/_{2}$"

(36.5×26.7 cm)

The Museum of Modern Art, New York. Gift of James Thrall Soby. Photograph ©1999 The Museum of Modern Art, New York

A sharply pointed pencil will give you the greatest freedom and control for the carefully studied sequences of drawings in Section 1. Try several, from a crisp and smudgeless 2H or F (the higher the number, the harder, paler, and crisper the mark) to a medium HB or slightly softer, blacker 2B or 3B. You can do very nicely at the start with a regular #1 or #2 writing pencil. A cased pencil sharpener will allow you to work with a sharp point at any time and place, but these are often badly constructed; be sure to try one before you pay for it. The sharpener should produce a perfect point with a few short twists, without chewing up a great amount of wood.

Some instructors discourage erasing; some won't permit it at all. If you don't overdo and erase more than you draw, adjustments and corrections can heighten your perception. Later, you will see how some erasers may be used as drawing tools, to produce tonal and textural effects. If you do choose to use one, a kneadable gray plastic eraser will be sufficient to start with (see fig. 8.6).

Many of these preliminary ideas will appear, expanded and in detail, where appropriate, throughout the text. When you next encounter one, in context, perhaps it will have the added values of experience and confirmation (fig. 1.7).

1.7
Peter Schwarzburg
Landscape
c. 1984
Ink wash on paper
18 × 24" (45.7 × 61 cm)
Collection of the artist

Unit A
Draw What You See:
A Matter of Choices

A FIRST STUDY: "DRAW WHAT YOU SEE"

A great deal of understanding may result from the simple experiment described here in detail, plus the discussion to follow. Place a subject (such as a large-leaf potted plant) on a sheet of paper covering a drawing board atop a stool in the center of a studio or drawing space. A split-leaf philodendron with its wide open spaces works well, but any large plant will do so long as it sits in a simple clay flowerpot. Placement of the subject on a large sheet of white drawing paper assures a clear view of the plant as well as its full shadow and a rectangular shape against which it may be seen.

Walk around the plant several times to select a spot from which to draw. Sit or stand at an easel or table, then draw what you see, using opaque white paper, $18 \times 24"$, and a sharply pointed pencil. You may have questions: "Should I draw only the plant?" "Can I use shading?" "Do I have to add the flowerpot?" and so forth. However, the freedom of the original idea, "Draw what you see," is retained, as any qualifying of freedom involves a diminution and, in essence, a denial of the very concept. Later, discussions may move from the subject of drawing and art to seemingly unrelated, even political, areas. (In this sense, every class is a class in philosophy, which is perhaps the reason a Ph.D. remains a doctorate in philosophy, no matter what particular subject area is studied.)

Study of First Drawings: Choices Available, Choices Made

After the drawing is finished, it is pinned to the wall and studied. A surprising amount of specific, perceptive, and useful commentary can be elicited to reveal the large number of choices made, consciously or not. Does your drawing:

• Show the page held vertically (horizontally)?
• Use the full amount of space on the page?
• Show the plant in the center of the page?
• Use only line, with no "shading"?
• Show only the plant? The plant and the pot? The drawing board? The stool? Other objects in the studio?
• Use a light or heavy touch?
• Show the opening of the flowerpot as an ellipse?
• Show the opening or bottom of the pot as a straight, flat line?
• Show the leaves as flat, frontal shapes?
• Show each leaf as a separate, curved form?
• Show overlapping?
• Show the stems and branches as lines? As cylindrical forms?
• Show ... (add your own questions ...)?

Other choices might relate to composition and full use of the rectangular picture plane, the illusion of space, or a concern with poster-like flatness. Are you surprised at the number and variety of decisions to be made each time you draw (figs. 1.8 and 1.9)? As this experiment serves to introduce many of the areas to be investigated later, it can lead into a brief overview of the entire study.

COMPOSING A COMPOSITION: THE DOUBLE L FRAMING MATT

A device recommended for this discussion and many other uses is the adjustable or expandable double L frame described earlier. Many a weak drawing will turn from a sketch or floating vignette to a well-placed, balanced composition by using the L frame, cropping from the inside out (see fig. 1.4).

CROPPING FROM THE OUTSIDE IN, OR THE INSIDE OUT

Holding a yardstick at any outer edge of the drawing, move it slowly closer to the opposite side until the amount of background (or unfilled space) seems

1.8
L.I.U. student: Errol Coombs
Plant—"draw what you see"
1997
Pencil on paper
18 × 24" (45.7 × 61 cm)

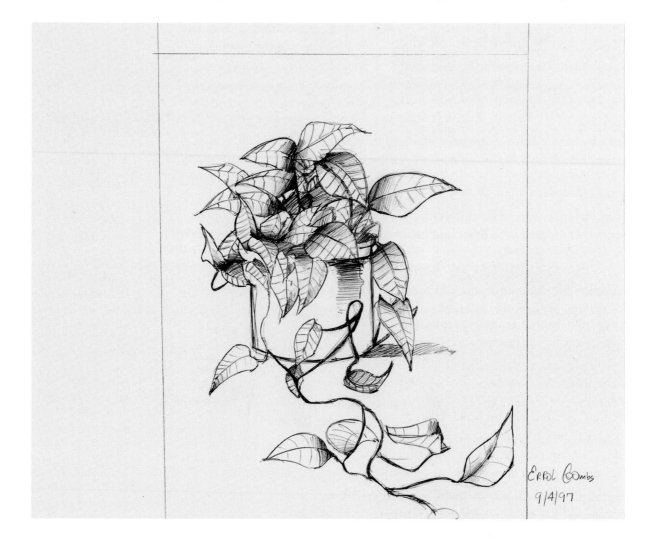

correct. Then draw a pencil edge to stop the space. Do this for all four sides, and your drawing should fit comfortably within its framing.

Or you can work from the inside out by placing the yardstick in the middle of the subject, parallel with one edge of the paper, and slowly pulling the drawing out toward that edge, until it wants to be stopped by a pencil line. Do this on all four sides. Which method gives you a better opportunity to find the most appropriate boundary?

Sequence of Choices Made

When all your drawings have been framed or cropped, try to recall exactly how each was started, then developed. Different choices were made although it may be difficult to retrieve them from memory. Once a vantage point was selected, did you:

- Make an overall light sketch?
- Perceive an intersection?
- Find a physical edge (see p. 52)?
- Draw in the air?
- Use a tracing box (see p. 322)?
- Study the structure of the subject first?
- Flatten the three-dimensionality in your mind's eye?
- Start at the top, unrolling the drawing (as a scroll) toward your eye?
- Start at the bottom and work upward away from your eye?
- Scribble general lines of movement, then draw over them, perhaps on tracing paper, in line?
- Fully draw one element of the subject, then proceed to an adjacent area and continue?
- Follow one contour until it disappeared behind another, draw the overlapping form, and continue?
- Lightly show general compositional elements in relation to one another?
- Or ….

REPEATING THE STUDY: WILL IT BE A REPETITION?

If you repeat this assignment, the results may be quite surprisingly different. Freedom, with a knowledge of possible choices, will be seen as far different from the blissful innocence of a first experience.

1.9
L.I.U. student: Evelyn Chirinos
Plant—"draw what you see"
1993
Pencil on paper
24 × 18" (61 × 45.7 cm)

1.10

Ellsworth Kelly

Avocado

1967

Pencil on paper

29 × 23" (73.7 × 58.4 cm)

Photo: courtesy Matthew Marks

Gallery, New York

However, a possible over-reaction to the very large new menu may be the attempt to put too many ingredients into the mix, or frustration at the limitations on achievement imposed by undeveloped skills. Patience and continued study are advised, one drawing at a time (fig. 1.10).

Unit B
Many Kinds of Lines: Definitions and Perceptions

DRAWING A LINE

Draw a line. A group of people following this simple directive will provide quite a varied collection of lines (figs. 1.11 and 1.12). And yet there may be none at all! What is meant by a *line*? There's a fine line between perception and description. When we say "This is a line," what do we actually mean? Is *line* as defined by the mathematician the same as that defined by the artist?

LINES THAT HAVE TWO EDGES: APPLIED LINE

Look at any drawn line (you may use a magnifying lens) and you will discover that it has a certain amount of thickness. The pencil has deposited some gray or black material on your paper, giving a tone to this width. If you know the geometric definition of a line, whether it is *the distance between two points*, *the extension of a point in space*, or *a one-dimensional idea having length but no width*, it is clear that this kind of line cannot be drawn with a pencil. What have we been drawing all these years? Of course they are lines, but not geometric lines; they are drawn lines, or lines applied to a surface. These applied lines can have all the width they need, and they will always have two edges. Can you draw a line without two edges? Later, in an interesting way, we will start with an applied line to show that this can be accomplished (see p. 129). However, there is always a discrepancy between theoretical, factual (one-dimensional) line and actual or applied (two-dimensional) line.

1.11 BOTTOM LEFT
Paul Klee
Growth is Stirring
1938
Colored paste on
newspaper, mounted on
cardboard
12⁷/₈ × 19¹/₈" (33 × 48.7 cm)
Kunstmuseum, Bern,
Switzerland. Paul Klee Collection.
©DACS 1999

1.12 BELOW
André Masson
Furious Suns
1925
Pen and ink on paper
16⁵/₈ × 12¹/₂" (42.2 × 31.7 cm)
The Museum of Modern Art, New
York. Puchase. Photograph
©1999 The Museum of Modern
Art, New York. ©ADAGP, Paris
and DACS, London 1999

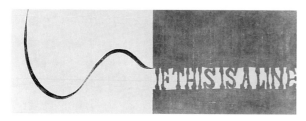

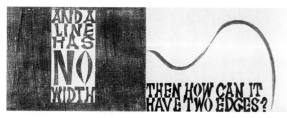

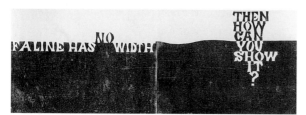

1.13a–c LEFT
Cynthia Dantzic
Pages from "What Can You See?"
1963
Woodcuts
Each 10 × 30" (25.4 × 76.2 cm)
Collection of the artist

1.14 BELOW
Georgia O'Keeffe
Evening Star, III
1917
Watercolor on paper
8⁷⁄₈ × 11⁷⁄₈" (22.7 × 30.4 cm)
The Museum of Modern Art, New York. Mr. and Mrs. Donald B. Straus Fund. Photograph ©1999 The Museum of Modern Art, New York. ©ARS, New York and DACS, London 1999

1.15 RIGHT
Henri Matisse
Composition, Black and Red
1947
Paper collage
20¹⁄₁₆ × 25 " (51 × 63.5 cm)
Davis Museum and Cultural Center, Wellesley College, Wellesley, Mass. Gift of Professor and Mrs. John McAndrew, 1958.11. ©Succession H. Matisse/DACS 1999

Ideas about Line

- Once you've drawn a line, it's no longer a line because …
- Line as edge can be seen but not drawn because …

If a line has no width, then how can you show it? Are the two edges that border every drawn line examples of true linearity? Is line the edge between two shapes? Is line the edge of any shape? Do shapes create edges, or do edges create shapes? Show your response to each of these ideas (figs. 1.13a–c and 1.14). If line is the edge of shape, can one shape outline another? Can you always tell the difference between line and shape? Can you see why Matisse once said he could only draw with scissors (fig. 1.15)?

Exercise A:

Draw a simple still-life arrangement in one-dimensional line with scissors. Use a dark sheet of paper, and paste or glue your drawing to a sheet of white paper the same size.

Exercise B:

Use the left-over (background) shapes to achieve an identical work with colors reversed.

Is the *drawing* the same in both studies?

1.16
L.I.U. student: Chris Cai
Horse
1997
Chinese ink on rice paper
Sheet: 17 × 14" (43.2 × 35.6 cm)

CALLIGRAPHIC LINE

Once the width of drawn line is understood as an ever-present consideration, a greater sensitivity to touch, weight, and consistency of flow will result. In the series of drawings in Unit C of this Section, it will become increasingly apparent. This understanding, that any drawn line is in a sense a shape, opens a number of interesting possibilities, some of which will be left to later investigation (see p. 93). The thickness or width of a drawn line may be varied, in effect moving its two edges nearer or farther from one another. This flexibly weighted line is often called *calligraphic*, as it resembles written markings, particularly Asian brushwork (see figs. 2.1 and 4.30). From paleolithic

1.17

Al Held

BWXX

1969

Acrylic on canvas

8 × 8" (20 × 20 cm)

Photo: courtesy André Emmerich

Gallery, New York. ©Al

Held/DACS, London/VAGA, New

York 1999

art to the works of Picasso and today's artists, such lines are often seen (fig. 1.16; see also figs. 2.12 and 2.18). This idea is developed in Section 2, Unit A.

On the other hand, lines may also be carefully controlled by keeping their two edges virtually parallel, as stripes or heavy bands, or thin and as light as possible. Study these alternatives in works by Mondrian, Al Held, and Sol LeWitt (fig. 1.17; see also p. 99).

As you experiment with applied, shaped lines, you will become aware of choices not consciously available before. The weight of each line and the amount of pressure applied as you draw will matter in a new way. Lines will be seen to have a life and strength of their own, their visual interest adding to any merely descriptive achievement.

USING BOTH EDGES OF APPLIED LINE: LINEAR WOODCUTS AS DRAWINGS

As a development of Asian thick–thin brush drawing, linear woodcuts can show two-edged shaped line very clearly (fig. 1.18).

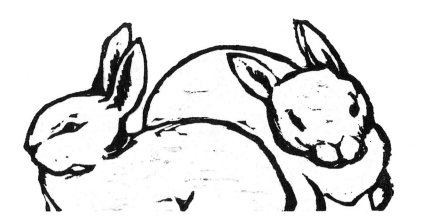

1.18
Naomi Bossom
Rabbits
1998
Woodblock print
4 × 6" (10.2 × 15.2 cm)
Collection of the artist

Optional Exercise:

Draw an image in line on a block of soft white pine with Chinese ink and an Asian bamboo brush. If necessary, enhance the thickness of your line before cutting away the surrounding ground with a set of woodcut knives and gouges. Or simply incise around the line deeply with a #11 X-acto pencil knife, and chip up to that edge with a flat chisel blade. Then gouge away the additional background with a broad U-shaped chisel. Use a rubber brayer or roller to apply ink to the surface of the wood, press a sheet of rice paper to the inked block, and rub with a flat wooden spoon to make each print. Include or omit textural areas by deciding where to roll the brayer on the gouged background. A stencil may be used to eliminate much of this.

The same effect in reverse may be achieved more easily, by cutting away only the calligraphic line and inking the background, the remainder of the block. Use the #11 X-acto knife, held almost vertically, along each edge of the applied line, angling it slightly toward an imagined center line, creating a long V-shaped groove. Or simply use a V-shaped gouge. This will produce a white, un-inked line if you print black ink on white paper.

You may, however, prefer the first-described method; it is more painstaking and tedious but gives an inked, stronger, more positive line, like those often used to separate color areas in traditional Japanese woodcuts.

Once you have carved a linear woodcut (or linoleum block), you have physically experienced the idea that every applied line is enhanced by a sensitivity to its two-dimensionality (see p. 97).

SHAPING SPACE WITH LINE

Inside its edge, any shape, no matter how thin or linear, also defines the shape of the space around it. This is another way to see the figure/ground idea, the yin/yang, filled/unfilled, container/contained, equivalence-of-opposites concept. Space is shaped on both sides of every edge as you draw (see pp. 125 and 247).

Stressing Shapes Around the Subject

Since in linear drawing there is a tendency to focus on inner shape—the forms and details of the subject—without equal consideration given to the shapes, forms, and details surrounding it, emphasizing these outer spaces will help achieve greater balance among all the shapes in your drawing.

1.19

Albers student: John Houk

Drawing of spaces around wooden stools

1950s

Pencil on newsprint

17¼ × 11¾" (43.8 × 29.8 cm)

Josef and Anni Albers Foundation, Orange, Conn.

Exercise:

Center your main subject on the page, giving it breathing room and a comfortable sense of fitting into its environment. Focus your greatest attention on the shapes created by the outer edges of the subject. (Think of these as unfilled spaces, equal to and opposite from those spaces filled with the material of the subject itself.)

Select subjects having irregular borders or large unfilled areas within their silhouette, such as bicycles, market baskets, chairs, studio stools, ladders, rockers, or plants. Draw the shapes around the material only; the spaces left undrawn will define the subject. Be sure to leave correctly proportioned spaces between the shapes drawn; after all, it will be only these (ground) shapes that describe the actual subject (figure) of your drawing (figs. 1.19–1.21).

SEEKING THE VISUAL HORIZON: CONNECTING PHYSICAL EDGES

In addition to differences between (theoretical) geometric and (applied) drawn lines, another critical distinction may be seen in the relationship between lines that describe physical edges and those that describe visual edges seen but not actually present (see p. 63). (For those studying this text to identify specific teachings of Josef Albers, and because this was the first eye-opening, never-before-seen, *magic* effect demonstrated on the first day of his celebrated course in drawing, special note is made at this point.)

Observe a flat sheet of paper tacked to the wallboard with a single pin. Would you say it has four edges, two

Plate 1

Anonymous prehistoric artist

Second "Chinese Horse," Lascaux, France

c. 30,000 B.C.

Pigment on limestone rock

Length of horse 4'8" (1.42 m)

Photo: Claudio Emmer

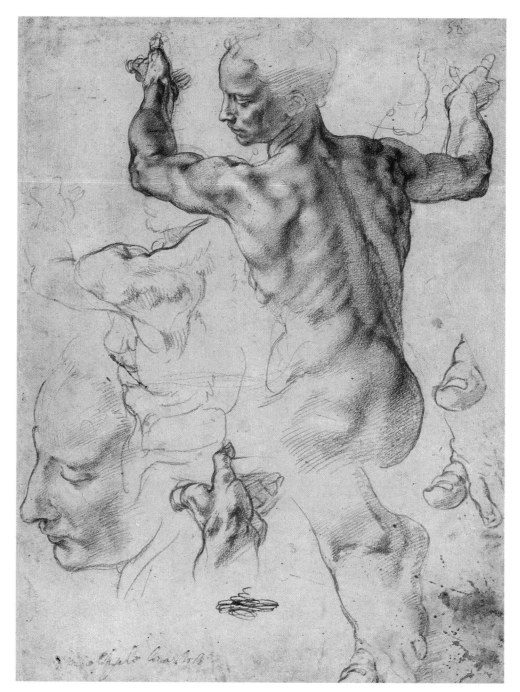

Plate 2

Michelangelo Buonarroti

Studies for "The Libyan Sibyl" in the Sistine Chapel

1510–11

Red chalk on paper

11³/₈ × 8⁷/₁₆" (28.9 × 21.4 cm)

The Metropolitan Museum of Art, New York. Purchase, Joseph Pulitzer Bequest, 1924

(24.197.2). Photograph ©1995 The Metropolitan Museum of Art

pairs of parallel edges, or one continuous edge with four right-angle bends? What differences would exist if we chose different descriptions? How many surfaces can you see? How many are *there*, but hidden? How can you show the sheet's face or front surface? What is there to draw? The only visible aspect of this rectangle that can be drawn in line is its outline, its edge, its border.

Move the tack lower on the page, allowing the top to fall forward in a curve. Can you still see each of the four edges? The top and bottom lines are much the same—virtually straight lines. One side is now curved, but still entirely visible. The fourth edge is seen to disappear behind the new flap of paper, then to reappear and continue its curve to its end point. Draw it as though it were transparent, visualizing its continuation where it is actually hidden, or show the unseen portion as a dotted line (fig. 1.22a).

At this point, you have drawn the four physical edges of the original sheet of paper, but you have not drawn every edge you see. You have indeed shown the cut physical edges, but not the apparent edge of the surface of the paper as it is seen to move toward and disappear behind a visual horizon at the top of the sheet. This apparent horizon moves farther from the eye as it is approached. Although it must be drawn in order to show the surface of the sheet, this edge does not actually exist; it has visual but not physical existence (fig. 1.22b). If you are drawing what you see, then visual reality is as important and as real as the physical kind. Your awareness of the difference between these kinds of reality will affect the quality of your description.

Particularly if you have been drawing for years with little concern for these seemingly minute distinctions, such analysis can reveal new levels of significance. The subject may not be quite so elementary after all, as words we

1.20 TOP LEFT
Virginia Cantarella
Crook tool, detail
1975
Pencil on paper
24 × 10" (61 × 25.4 cm)
Collection of the author

1.21 TOP RIGHT
Naomi Bossom
Figures in a Landscape
1995
Brushed ink on paper
18 × 24" (45.7 × 61 cm)
Collection of the artist

1.22a ABOVE and b TOP RIGHT

L.I.U. student

A sheet of paper:

(a) physical edges only,

and (b) with transitional

contour line added

1997

Pencil on paper

Each 4 × 5" (10.2 × 12.7 cm)

use to name things or ideas actually alter our perception of their identity and meanings (see p. 64).

Physical and Visual Edges

What shall we call visible but physically non-existent line: *visual, transitional,* or *apparent edge*? *horizon* or *contour line*? Regardless of the name, the important thing is to understand the idea and show this in your work.

In figure 1.22b, a single horizon or visual line is seen. There is also a single hidden portion of one of the physical edges. This may be shown by a lighter or dotted line. As subjects become increasingly complex, the eye must travel a longer path behind the scene to follow each type of line. You can draw what you know as well as what you see.

DIFFERENT KINDS OF LINES

As we have seen, there are several kinds of lines and edges to be considered:

- *Geometric line*: one-dimensional, an idea extending from point to point in space.
- *Applied line*: the path made by a moving implement on a surface depositing (or removing) a swath of material, having two physical edges. This is the appropriate category for linear drawing of all types.
- *Physical edge*: seen at the actual termination of a plane, volume, or other existing shape or form. These are observed to change according to our point of viewing them and may move out of sight, sometimes to reappear at a distance. The laws of vanishing-point perspective are seen to apply to their relationship when translated from the real three-dimensional world to the flat two-dimensional drawing surface (see p. 157).
- *Visual edge*: seen at the apparent boundary between the visible and hidden

parts of form, also called contour and horizon. Not physically present, these edges change as the subject turns in relation to the eye. At times, they may coincide with the outer line (outline) or silhouette at the periphery; at times they move to the inside or across the entire form.

- *Contour line*: may be drawn where either actual (physical) or apparent (visual) edges are seen to turn and move from view (see fig. 1.33).

Although it is useful to think about these ideas and terms and to analyze each subject for the kinds of lines and edges you see, such study must be done with discretion. Otherwise the investigation may become an intellectual, not a perceptual, study. When a drawing is "correct," no analysis seems necessary. It is said to work. It is convincing. It is a pleasure to look at (figs. 1.23 and 1.24).

SEARCHING FOR LINES OF ALL TYPES

To some, drawing always implies linearity, whether the applied line-with-thickness or the widthless edge separates any two areas or shapes. Indeed, some painters rely on linear drawing as a structural basis for their composition. Artists, such as Robert

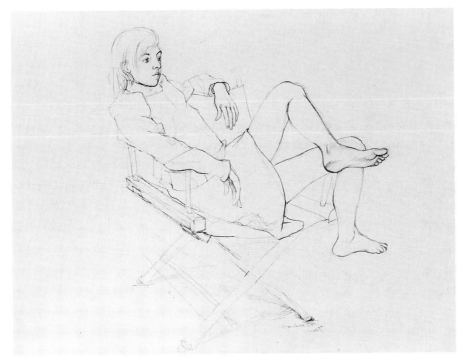

1.23 ABOVE
Juan Gris
Still Life
May 1918
Pencil on paper
18⅛ × 11⅝" (46 × 29.5 cm)
Stichting Kröller-Müller, Otterlo, The Netherlands

1.24 LEFT
Bernard Chaet
Study for Spring Light
1968
Pencil on paper
18 × 23½" (45.7 × 59.7 cm)
Collection of the artist. Courtesy M B Modern, New York

Gwathmey, may even return to earlier works as a source of inspiration for later drawing studies (fig. 1.25). "Drawing is the very crux of my work," said Will Barnet in a conversation with the author when asked about its importance to him in painting (see fig. 4.5).

Study paintings of different periods and styles to see which are truly dependent on line or edge (fig. 1.26) and which seem not to be (color plates 1, 3, 5, and 8; see also fig. 7.9). Some subjects, such as the egg, having no physical edge, require a contour edge when drawn in line. But many objects combine actual with apparent edges and require considerable patience, analysis, and sensitivity before they yield their structural secrets.

Exercise:

Study drawings of drapery, plants, and ribbons to distinguish physical from visual edge-lines. Try to follow lines that disappear behind other edges to see if they reappear as expected (fig. 1.27; see also fig. 1.6).

Using tracing paper, continue such lines where they disappear and bring them into view again at just the right spot. Light lines or even softly dotted lines may be used, fading away at the most distant point, then re-emerging with greater strength.

1.28 FAR LEFT
Pablo Picasso
Page illustration for "Le Chef d'Oeuvre Inconnu" by Honoré de Balzac
Paris, Ambroise Vollard, Editeur, 1931
Wood engraving by Aubert after a drawing by Picasso
Page: 12¹⁵/₁₆ × 9¹⁵/₁₆"
(33 × 25.2 cm)
The Museum of Modern Art, New York. The Louis E. Stern Collection. Photograph ©1999 The Museum of Modern Art, New York. ©Succession Picasso/DACS 1999

LINES DRAWN BY THE EYE

Lines need not be drawn to be seen; the eye easily connects a sequence of spots, marks, or other clues, even across a considerable distance (fig. 1.28). They may melt and fade, to reappear and continue along a path, following the natural tendency of the mind to what is called closure or the gestalt effect (fig. 1.29). These terms describe the eye's wish for completeness, simplicity, and the most direct visual route (fig. 1.30).

DRAWING OUT A LINE

To draw out a line, that is, to pull it along in a steady, continuous movement, follow every bend and turn of the edges you see, curving in and out of view as necessary, making sure that reappearing lines emerge at just the right spot.

1.29 TOP RIGHT
Richard Mayhew
Spring Thaw
1989
Pen and ink on paper
16 × 21" (40.6 × 53.3 cm)
Photo: courtesy of the artist

1.30 LEFT
Neil Welliver
Trout and Reflected Tree
1985
Etching, edition of 80
Sheet: 25³/₄ × 28"
(65.4 × 71.1 cm);
image: 18¹/₈ × 20³/₄"
(46 × 52.7 cm)

Avoid sketchy, hesitant strokes that obscure the clear edge you see. Maintain a light but sure touch, avoiding the deep engraving of excessive pressure or the indecision of many small, approximate strokes.

TECHNICAL TIPS: AVOIDING SMUDGES

As you work, rest your outer palm on a small piece of tracing paper that moves along with you. This will prevent smudges yet permit you to see the entire drawing as you proceed. When working quickly, or in scroll style (moving from top to bottom with little reworking, building of tonal areas, or shading), this is not needed, but if you plan to return to previously drawn areas or develop light and dark tones, it can keep your work clean. Use a feather or tissue, not the side of your hand, to remove small particles of eraser; this also prevents smudges and streaking, particularly when using a soap eraser.

Erasing to Clear Smudges: Add Light

To clear small areas of smudging, lighten a line or tone, or pick out a highlight (the highest spot of light), first twist an end of the kneaded gray eraser to remove it from the larger piece. Press it to the smudge and wiggle, which often works better than scrubbing. Use this bit of eraser to soften a too-sharp edge, also with a press-and-wiggle technique. Try *tap, tap, tap* or other short repetitive movements to see what works best for you (see fig. 8.6 and the discussion on p. 300).

THE BACK-STITCHED, OVERLAPPED LINE

To give the appearance of a continuous, fluid line where it is difficult to draw that way, pull a seamless flow of shorter telescoped segments by lifting, backtracking, and picking up the line just before its ending, in a single groove. As you lift your pencil, slow down, reverse direction, and in the same track pull

1.31 BOTTOM LEFT
Ellsworth Kelly
Catalpa Leaf
1965–6
Transfer lithograph on
Rives BFK paper
35⅛ × 24⅝" (89.9 × 62.5 cm)
Photo: courtesy the artist's
studio

1.32 BOTTOM RIGHT
Henri Matisse
Branche de Roncier
1941
Pen and ink on paper
8 × 10" (20.3 × 25.4 cm)
Photo: courtesy John Berggruen
Gallery, San Francisco.
©Succession H. Matisse/DACS
1999

the line out of itself, continuing it until another elongation seems called for. In a complex, detailed work requiring many turnings and re-studyings, this telescopic pulled line can give an elegance and flow, without showing pauses or disturbances in continuity. The effect is akin to the backstitch in sewing, created of many short, overlapping units but visually continuous, as opposed to the feather stitch in which each unit retains its own identity, softening and blurring linear movement in a kind of textural wash of strokes (figs. 1.31 and 1.32).

MONO-TONAL AND MULTI-TONAL LINE

An evenness of tonal surface is achieved by applying the same pressure throughout a drawing, avoiding too heavy a clustering of lines in any one area. Or, to enhance three-dimensionality, to emphasize forward-reaching forms, and to separate parts of a subject spatially from one another, pressure on the pencil (or pen or brush) may be increased, creating a heavier, darker line, or released, achieving a thinner, lighter stroke. The implement can even be lifted entirely, allowing the eye alone to complete the edge of form, the visual path. Such undrawn, implied contours are best reserved for fast-changing horizon-lines, apparent edges, or other lines that aren't there, leaving exact pinning down of a periphery to the eye or imagination of the viewer. Physically existing edges generally benefit from a more continuous description (fig. 1.33).

THE MELTED EDGE: ALTERNATE SHADING
Achieving Line Through Tone

Can you make a pencil drawing that has no double-edged linear thickness, no applied line, visible?

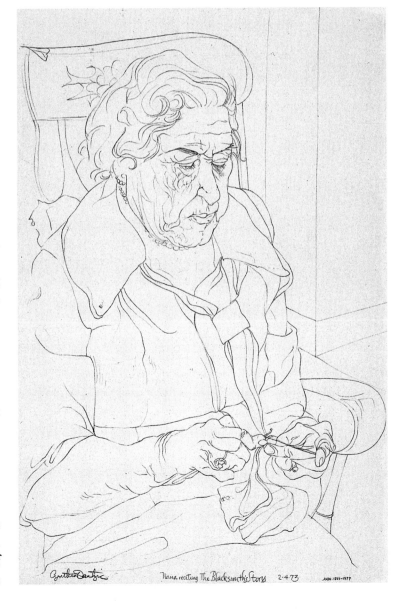

1.33
Cynthia Dantzic
Nana Reciting "The Blacksmith's Story"
1973
Pencil on paper
24 × 18" (61 × 45.7 cm)
Collection of the artist

Exercise:

Begin with a simple, light line drawing of an egg, cup, or cylinder. Look at the line at the bottom of the object as though it were the

beginning of the shadow beneath it, and begin to eliminate the outer edge of the line itself by extending its width while reducing its darkness or weight (fig. 1.34). The sense of a larger area of shadow can be created by continuing the newly begun shape for a considerable distance, or simply by softening one edge of the original applied line, almost immediately melting it into the white paper. Treat the upper line of the egg in the same way, but melt its tonality inside the form (on the egg) by softening its lower, inner edge.

This tonal treatment results in a single, widthless linear edge, the tone appearing either outside or inside the form. The resulting appearance of shading has nothing to do with the illusion of light falling on the object, creating the appearance of cast shadows (see p. 138). By arbitrarily melting the edges of an applied line partly inside and partly outside an object, alternate shading gives a clean, truly one-dimensional outer line to a form (see fig. 3.4 and p. 129).

The relative strength (sharpness or softness) of its two edges will determine whether the line itself is read as belonging to an object, to its surrounding background, or to neither, simply existing as a separation between them. If both edges of a line are kept relatively soft, this decision may be determined later by sharpening or melting either edge.

A NOTE ON FLATTENING THE PICTURE PLANE

Alternate shading was often used by Juan Gris and other early twentieth-century Cubists to achieve a general flattening of the picture plane while suggesting the roundness of individual forms and their surrounding units of space (fig. 1.35; see also p. 34).

Why might it be considered an achievement to flatten the picture plane, when so many students (and artists) seek a convincing representation of three-dimensional space? Although physically the two-dimensional surface remains flat, many visual clues can suggest the illusion of depth or space (the picture plane as a window), of elements protruding forward from the surface, or of seeming to reflect objects in front of the surface (the picture plane as a mirror). So the ability to maintain the look of the honest, flat, two-dimensional surface while also suggesting objects existing in a three-dimensional space may indeed be considered an achievement.

A study of Asian isometric perspective and the ambiguous spaces created by flip-flop optical illusions, as well as the philosophy of the Cubists, can provide a context for this point (color plate 10; see also p. 251).

1.34

Cynthia Dantzic

Sketch showing alternate
shading

1990

Blue crayon

1½ × 2" (4.1 × 5.2 cm)

Melted contour can be used to show edges of form flattening to become areas of surface in complex three-dimensional subjects such as drapery and the human form or skeletal structure. Paper bags and napkins, crumpled and dropped, may show accidental peaks and valleys of form with unpredictable contours and edges.

EDGELESS DRAWINGS: TONALITY

We have shown the double-edged line reduced to a single cutting edge, but can a drawing exist with no lines at all? Look again at the egg to find an area of shadow at a distance from its lower edge inside its apparent border. With a pencil, how could you show such an area of edgeless tone?

Exercise:
Using an egg or other rounded subject, start with a soft smudge (use the side of the pencil) to create an area of light gray in the vicinity of this tone on your linear drawing. Now, referring to a *gray scale* (see fig. 3.6), determine how much darker the deepest tone in this shadow needs to be, and darken your pencil work accordingly. Slowly reduce the level of grayness and melt the tone into the surrounding whiteness of the paper so that any sense of an edge disappears. You have drawn an edgeless field or expanse of tone (see also p. 130).

It is not necessary to show a complete outer line or outline surrounding every object drawn. A melted, softened contour which disappears into the merest hint of edge, is gone, and then reappears may build a sense of object-merging-with-its-space to heighten the sense of volume and help weave the subject into its surrounding space, unifying the surface of the drawing (fig. 1.36).

Exercise:
From imagination, create an entire drawing of line-less tonality. Would this be possible with an actual subject? Try a cluster of cotton balls on a white surface, clouds … or ….

Later, we will build areas of tonality with or without the appearance of a clear edge by additive linear processes called hatching and crosshatching (see p. 113).

1.35
Juan Gris
Head of a Woman
1911–12
Charcoal on paper
10⅝ × 10⅝" (27 × 27 cm);
page: 19 × 12⅜" (48.1 × 31.5 cm)
Öffentliche Kunstsammlung
Basel, Kupferstichkabinett,
Inv. 1965.21

1.36
Giorgio Morandi
Still Life
1954
Pencil on paper
6¼ × 9¼" (16.3 × 23.5 cm)
©DACS 1999

MANY KINDS OF LINES

You have seen line act as an undrawable idea, a double-edged shape, a physical boundary, a visual horizon, a separator of areas, a path, direction, flow, and even an invisible continuation of a periphery, existing only in the eye of the mind. How can you know when to call upon the particular lines you need and be sure of your choices?

THE QUESTION OF PERSONAL STYLE

Any effort to put down on paper an image of your visual perception will of necessity bear the marks of your individuality. You don't have to search for a style; you can't avoid it. You can try to draw just like an instructor or someone else whose work you admire (and even succeed) but, if you are true to yourself, your work will always reflect its source. Shakespeare said this better: "To thine own self be true"

The knowledge that your unique individuality will surely mark your own mature style, eventually, does not minimize the great value that many find in a period of self-imposed apprenticeship to a "master," or an admired instructor. This is a personal decision. The renowned sculptor Giacometti made studies, in ballpoint pen, of many well-known works of art (see fig. 8.12 for his analysis of a lithograph by Henri de Toulouse-Lautrec).

Emergence of Style

One of the advantages of drawing with a group of fellow artists or classmates is the opportunity to study individual choices made in working out the same problem. Sometimes it may seem that you have shown an accurate

representation of what you were studying, but your drawing hasn't much personality. It isn't anything special; you drew what you saw, but without any style or flair. Only when you have seen the great variety of choices and calligraphies, the different handwritings of a number of individuals, can you more fully appreciate your own distinctive manner of seeing and drawing. You may come to recognize qualities that distinguish your works from those of others. Without trying for a style, you will develop one.

In a way, then, the larger the group, the more you are able to learn about yourself. If it is not possible to include as many critiques or discussions as you might wish, use rest periods or breaks to study the works of others, observing the subject from each person's vantage point to see how the individual has translated perception into drawing.

Returning to your own spot, look at your work in this same way, as though for the first time. Perhaps there is a noticeable style developing after all!

No amount or quality of individual instruction can provide you with the special benefits of a good-sized group of peers or fellow students; after all, uniqueness has little significance unless contrasted with others. If yours are the only choices you see, you may not recognize them as choices but think they were inevitable necessity. A respect for individual differences is one of the most important lessons in any studio experience. In a study as direct and personal as drawing, the human quality particularly remains a primary criterion of esthetic value. This realization lifts drawing above its often subordinated traditional role as a preliminary stage of a more finished work in another medium and places it at the forefront of an artist's means for achieving an immediately accessible, inimitable, and complete visual statement (see fig. 5.44).

Realism Personalized

Even among those artists with whom we most strongly associate the idea of realism, of accuracy of representation—the Old Masters, if you like—each readily displays individuality. You would never confuse a drawing by Dürer with one by Michelangelo, or a Leonardo with a Rembrandt. Of course, you will not want to limit your research to the few examples that can be included in this or any text. Visits to museums and galleries will provide direct enjoyment and understanding of works in their true size, tonality, surface texture, and environment. Well-printed books devoted to the works of an individual artist, period, technique, or medium should be consulted frequently (color plate 2 and fig. 1.37).

CONCLUDING EXERCISES

For this overview of your study of lines, you can formulate individual exercises whose purpose is skill development and comparison of styles and techniques. Add to this list, select those that most strongly appeal to you, and give yourself an assignment!

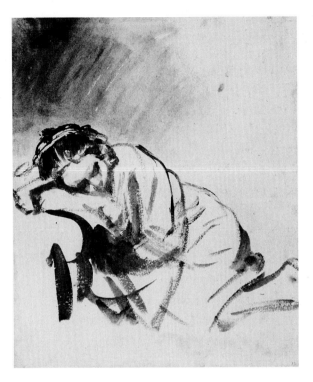

1.37
Rembrandt Harmensz van
Rijn
*Young woman sleeping
(Hendrickje Stoffels),
her head resting on her
right arm*
c. 1654
Brush and brown wash
with some white bodycolor
on paper
9³⁄₄ × 8" (24.6 × 20.3 cm)
British Museum, London

Exercises:

Divide a sheet of drawing paper into a grid of 8 (4, 12, 16) boxes, and draw the same subject in each space with a different kind of line.

• Divide a sheet of paper as above and draw the same subject with a different tool or material.

• Find a drawing by Juan Gris which shows alternate shading, set up a similar still life, and draw it in that style (see figs. 1.3 and 1.23).

• Draw an egg in light pencil line, then complete the work in as many ways as you can devise.

• Draw a transparent, linear cube, then complete the work in as many ways as you can devise.

• Draw

Unit C
Contour, the Edge that Isn't There: A Sequential Development

WHERE ARE THE LINES WE DRAW?

No matter what it is, a drawing is never a copy of things in the real world. Things in the three-dimensional world do not come with lines around them; there is no place on most objects for such lines! As you turn your hand slowly in front of your eyes, the edge-lines that appear at the seeming periphery of each finger, knuckle, and crease of flesh disappear as other lines come into view and replace them. Only if you stop moving your hand and hold it steadily in one position can you see any edge-lines at all (fig. 1.38). Look at an egg. Where is its edge? Does the fact that things may not possess edges keep you from being able to draw them? Does this suggest that every drawing, selected from all that could be shown, is indeed an abstraction (see p. 272)?

It is worth mentioning one of the many useful verbal images to be found in

1.38

L.I.U. student: Betty Ko

Hand

1993

Pencil on paper

Sheet: 9 × 12" (22.9 × 30.5 cm)

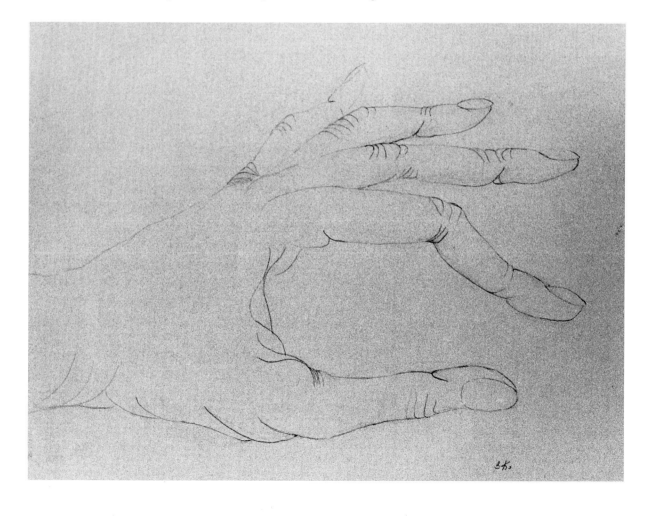

writings on General Semantics, the idea of "non-allness": The map is not equivalent to the full territory, of which it represents a selected portion, or an abstraction (see the Bibliography).

CONTOUR AND OUTLINE

In an almost seismographic way, we can leave a shifting, searching linear trace of our visual journey over the apparent periphery of forms and surfaces seen from a stopped position at a single moment. This is often called contour drawing (see p. 53), although the term can be misleading; to some, it seems to suggest a sort of outlining or silhouetting, which is far from the case. In true contour drawing, the smallest modulations, turnings, deflections, and protuberances of form are followed by similar movements of the tool, as an extension of the fingertips, probing across ever-changing horizons of form and light (see fig. 1.33).

The Turning Edge of Contour Line

As you develop confidence, your line will show greater elegance, flow, and the curvilinear fullness known as *turgor*, an inflated fluidity often seen as beautiful. A balloon sufficiently filled with air shows this condition, which readily disappears as air is permitted to escape and the fullness collapses.

You may rely less on many hesitant strokes of the tool that produce sketchiness in favor of the single, precisely felt turning edge (fig. 1.39). Now it

1.39
Albers student: Richard
Claude Ziemann
Study of tools
1950s
Brown pencil on newsprint
17³⁄₄ × 11³⁄₄" (45 × 29.8 cm);
drawn vertically
Josef and Anni Albers
Foundation, Orange, Conn.

is seen as the periphery of perceptible form—the outer line of outline—now swinging directly into the interior of the surface, now riding over the fluid contours of its many substructures. Contour line may disappear behind and around a form, to reappear at just the right spot at a distance, softly melt away, perhaps to return, strongly asserting itself, and stop abruptly where it is overlapped by a more advancing prominence.

By the artful application of contour drawing, through the use of line alone, nuance of form, surface, light, proportion, the suggestion of three-dimensional space, and the apparent diminution of objects along certain paths as they move away from the eye (linear perspective) can all be shown with a sense of tonal variation (fig. 1.40; see also figs. 1.24 and 1.49).

Why Start with Pencil?

Broad strokes of crayon, charcoal, conté, and brush can obscure the telling contour edge, while a sharply pointed medium-soft or medium-hard pencil will allow considerable freedom in describing the most minutely perceived detail. A relatively light touch, combined with a readiness to change the direction and weight of line on the spot, will help avoid the rigidity or tightness that can destroy the art in any drawing. Using a responsive touch to define the very edge of perceived form and the joining of adjacent forms, their emergence and disappearance, you will begin to develop a sense of structure, the essence of the visual experience. As drawing responds to observation, it provides the best available means of showing ourselves and others how clearly

1.40
Evelyn S. Yee
St. Martin's Nature Reserve, detail
1997
Pen and ink on paper
Full image 5 × 11"
(12.7 × 27.9 cm)
Collection of the artist

we have seen what we are looking at. When we say, "I see," in the sense of "I understand," we acknowledge the kind of seeing that drawing alone can reinforce. When we study the drawings of others, we enrich our own experience in seeing the things of the real world as well as in the world of art, because we are experiencing this world through eyes and sensibilities other than our own (see fig. 8.16).

SEQUENTIAL LINEAR CONTOUR STUDIES, AFTER ALBERS

This series of contour studies was developed to build perception and skill through a linear analysis of increasingly complex but related subjects. Many were included in the basic drawing course taught by Josef Albers at Yale. Although I continue to include them in my own classes, surely over the years many modifications have appeared and the sequencing has altered. Those illustrated by works of Albers' students are of particular interest.

The studies move into a consideration of tonality through several three-way drawings of the same subject seen in contour line, linear tonality, and then continuous tonal gradation. Although these last two ideas will be developed more thoroughly in a later Section (see p. 125), they are noted here for comparison and for individual enrichment. Several special projects will be presented at the close of this Unit for class or individual study. These supplementary studies should give you sufficient material and ideas for a long time after the conclusion of any course.

Try each exercise yourself. Only through personal investigation will you be able to understand first-hand the differences between reading about a visual idea, seeing a picture of the results of another person's experience, and actually participating in the process.

PAPER LOOPS AND CURLS

First study the demonstration of the difference between physical and visual edge (see figs. 1.22a and b), then arrange a long strip of brown paper on the wallboard so that a number of simple bends and turns appear. In trying to draw only edges perceived, it will be necessary to visualize (and in a sense see as with X-ray vision) their continuation where partially obscured. First draw the physical edges between the curves, as a kind of tangent. Increasing complexities of looping will require greater analysis and descriptive finesse. An elegance of line and a sweeping curvilinear flow seem to grow naturally from this study (figs. 1.41 and 1.42).

MOEBIUS LOOPS

The Moebius loop, a simple loop with a twist, shows that seeing is believing, as you try to follow its edges and surfaces. Use adding machine tape or a strip of heavier paper about 2" wide and a foot in length. Tape its narrow ends together neatly, twisting it once so that one surface is placed adjacent to the reverse surface, the top of one side flat up against the bottom of the other.

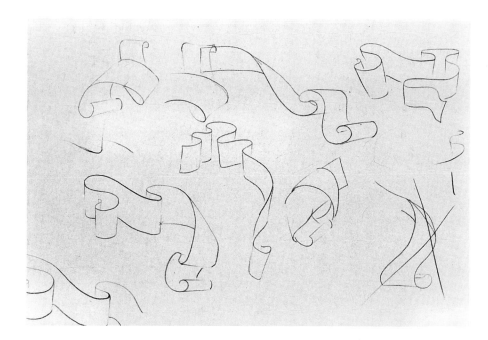

1.41 LEFT
Albers student
Paper loops and curls
1950S
Blue pencil on newsprint
11³/₄ × 17³/₄" (29.8 × 45 cm)
Josef and Anni Albers
Foundation, Orange, Conn.

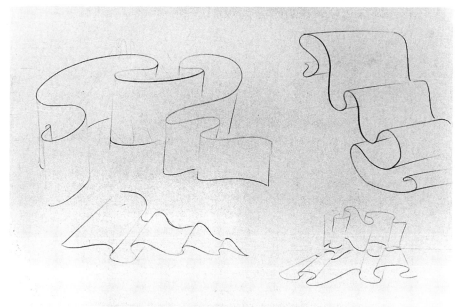

1.42 LEFT
Albers student
Paper loops and curls
1950S
Blue pencil on newsprint
11³/₄ × 17³/₄" (29.8 × 45 cm)
Josef and Anni Albers
Foundation, Orange, Conn.

If you had simply taped the loop together, you could paint the outer surface red, for example, and the inner surface blue; they would remain completely separate as two distinct areas. Now, place a dot of red on the outer surface and another of blue directly behind it (on the inner surface); observe the result of drawing a single line down the middle of the loop from, and back again to, the red dot. Do you expect to pass the blue dot (on the "other side") along the way? How many separate *surfaces* does the Moebius loop have?

Count the edges of this intriguing object. Put a red dot at one edge of the loop and, on the same surface, a blue dot across on its "other" edge. Follow the

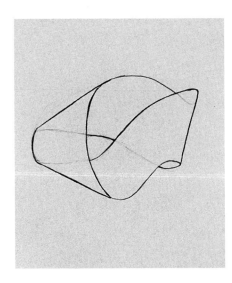

1.43 ABOVE
L.I.U. student
Moebius Loop, detail
1997
Pencil on paper
Sheet: 12 × 9" (30.5 × 22.9 cm)

edge from the red dot all the way around the loop until you reach it again. Do you expect to pass the blue dot along the way? How many separate *edges* does the Moebius loop have? At any one place, how many surfaces and edges do you see? If the loop had no twist, how many visual edges (horizon-lines) would you expect it to show? With the extra twist, how many can you see? Since each of its curves presents a disappearing/reappearing physical edge, how many such edges can you find? An interesting optical illusion can be achieved by drawing each of the hidden edges as though the loop is transparent; that is, completely visible. You can make the loop do visual flip-flops or draw it inside out by selectively erasing and redrawing the hidden lines. Or you might redraw the loop in different ways on a sheet of tracing paper. The finished drawing should give the impression that the strip remains the same width throughout (fig. 1.43).

In these drawings, a fully inflated, turgid, elegant, curving line is essential to convey the fluid continuity of the contained and containing spaces.

RIBBONS AND BELTS

In drawing a ribbon (figs. 1.44a and b) curved with added Moebius-like loops, or a leather belt, you may add the extra lines that describe the leather's thickness. Use a less rigid line to show the softness and pliability of the material (leather isn't stainless steel); your line should show a distinction. If you add a buckle, let your line quality distinguish its material from the leather.

1.44a RIGHT and b BELOW
Albers students
Ribbon drawings, details
1950s
Pencil on newsprint
Each sheet: 17³⁄₄ × 11³⁄₄"
(45 × 29.8 cm)
Josef and Anni Albers
Foundation, Orange, Conn.

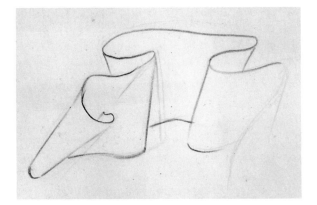

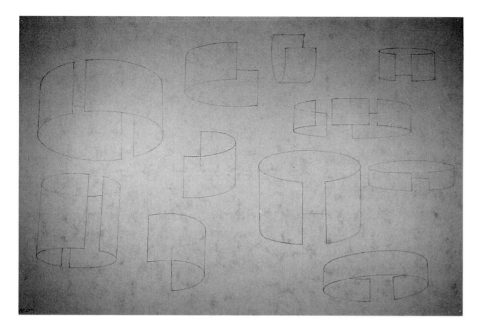

1.45
Albers student: Rita V.
Forest
Cylinders
1950s
Pencil on newsprint
11¾ × 17¼" (29.8 × 43.8 cm)
Josef and Anni Albers Foundation,
Orange, Conn.

CYLINDERS

Perception of angle is the key to drawing cylinders. Observe the angle at which you see the top opening, which remains physically a circle though it appears as a particular ellipse or oval from differing viewing points (fig. 1.45). The lower edge is also a circle, although remaining partly hidden by the material of the cylinder unless it is transparent.

Does the oval ever come to a point, almond-like, at its apparent corners? Why do many beginners see it (or at least draw it) that way? Are the top and bottom ellipses exactly the same? Always?

The long edges of the cylinder, which do not actually exist in any fixed place, may be seen as visual horizons, although they may in fact be vertical. To see this, first place the cylinder on its side so that the horizon-lines *are* horizontal.

Be sure these visual edges are placed at a tangent to the two ellipses, apparently touching them perpendicularly at their outermost points. Note that the tangent visual edges do not actually touch the ellipses at their outermost points; they touch at the *geometric*, not the *perspectival*, center. (See the Bibliography for sources of geometric enrichment.) Of course, if an object—a flowerpot, for example—has tapering, non-parallel sides, these lines will connect their ellipses but will not be parallel.

FLOWERPOTS AND CORES

A flowerpot carries an additional ellipse, marking the bottom of its upper band. To show the thickness of material, draw a second ellipse, reducing the distance between the two as they move away from the eye, suggesting the illusion of perspective (fig. 1.46).

If you draw a simple cardboard cylinder, such as a toilet paper or paper

1.46 RIGHT
Albers student: Eugene
Nowak
Study of flowerpots
1950s
Blue and sepia pencil on
newsprint
11¾ × 17¼" (29.8 × 43.8 cm)
Josef and Anni Albers
Foundation, Orange, Conn.

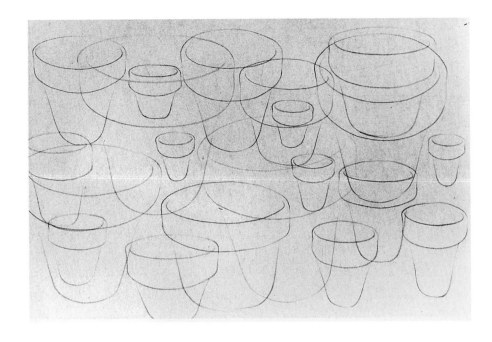

towel core, this thickness need not be shown. Add the spiral line marking the physical edge of the cardboard strip that has been curved into the cylinder. Keep that curve fully rounded and inflated to show the form of this circular object.

The related but more complex subjects to follow, such as the open guitar case, guitar, spools, bottles, and cookie cutters are all essentially parallel top and bottom curves with vertical connecting lines.

A tracing paper overlay is useful in drawing cylinders and related forms, particularly in verifying the similarity of the ellipses or other parallel curves, one partially hidden.

1.47 BELOW
L.I.U. student: Martin
Mateo
Violin
1989
Pencil on paper
18 × 24" (45.7 × 61 cm)

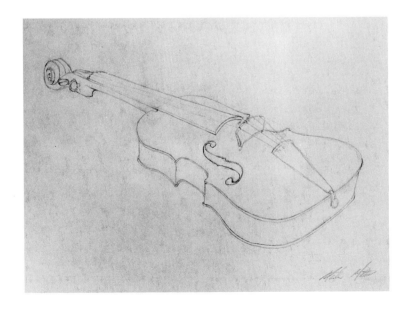

THE GUITAR CASE

The guitar case, open, also presents parallel curvilinear top and bottom edges. The wall created between these edges may be seen, half on its inner and half on its outer surface. Verticals are seen wherever the ribbon of the wall curves the material away from the eye.

The opening itself may be seen as two rounded forms connected by a narrower waist. With the added factor of perspective's slight reduction in size as the case moves away from the eye, this subject offers

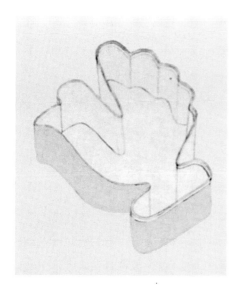

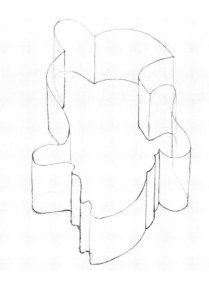

1.48a FAR LEFT
L.I.U. student: Rahil Rahim
Cookie cutters, detail
1993
Pencil on paper
Sheet: 24 × 18" (61 × 45.7 cm)

1.48b LEFT
L.I.U. student: E.J.C.
Cookie cutters, detail
Undated
Pencil on paper
Sheet: 24 × 18" (61 × 45.7 cm)

subtle opportunities for proportional discrepancy.

After the case, the guitar itself may be drawn, the opaque material of the instrument obscuring the inner surface of its side wall. Show the visible portion of the lower curve parallel to the top edge, the verticals appearing at every bend in the wall's curvature.

A violin may be used, but it is not as simple in form or as flat of surface (fig. 1.47). A ukelele, though small, is a good choice.

THE COOKIE CUTTER

Open, metal-strip cookie cutters, an ideal subject, reveal parallel edges connected by a ribbon wall. The complex convolutions that may be seen clearly along the upper edge are repeated precisely below, though much of the lower edge is obscured by turns in the opaque metal. Some of the vertical contours, tangent to each pair of curves they connect, appear along the outer surface, others along the inner surface of the cutter; some are almost completely hidden. Be sure your verticals are parallel and upright. Show the ribbon of material the same width throughout by drawing the upper and lower edges with a slight convergence as they move away from the eye (figs. 1.48a and b).

1.49 BELOW
Albers student: Neil Welliver
Study of pliers and scissors, detail of pliers
c. 1952
Pencil on newsprint
Full image 11¾ × 17¾"
(29.8 × 45 cm)
Josef and Anni Albers
Foundation, Orange, Conn.
Photo: Helga Photo Studio,
Upper Montclair, N.J.

TOOLS

Hammers, pliers, scissors, and other hand tools provide a similar visual challenge, side "walls," and interesting curvilinear connectives (fig. 1.49).

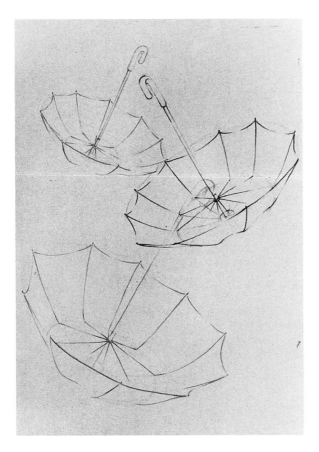

1.50

Albers student: Bernard
Voichysonk

Open umbrellas

1955

Black (center) and red (top
and bottom) pencil on
newsprint

17³/₄ × 11³/₄" (45 × 29.8 cm)

Josef and Anni Albers
Foundation, Orange, Conn.

THE OPEN UMBRELLA

Select a long-handled, preferably seven-section black standard model and study it, open, from several positions. Seen from below or above, it shows basically a geometric figure with lines (spokes) radiating in toward the center. Although these spokes are curved, as is the skin of fabric stretched over them, the single shape described by the outer edge is the only periphery to be seen. Notice that each of the component lines is a taut, tightly pulled, concave curve.

In addition to this outer edge-line, you see curved contours of stretched fabric when the umbrella is viewed from an angle. Place it so that a portion of both the inner and outer surfaces can be seen at the same time, showing taut, crisp curves of physical and visual edges in distinct ways (fig. 1.50). Indicate the lines of the individual spokes in other ways, perhaps softer or lighter in feeling.

Be careful not to let the structure of elaborate skeletal framework overwhelm the description of the fabric shell. Make the shaft of the handle neither too long nor too short, and perpendicular to the general half-sphere of fabric.

Should you draw the fabric first and then add the handle, or the shaft of the handle first and curve the fabric around it? Experiment.

THE CLOSED UMBRELLA

Stand the partly closed umbrella on its point, leaning it lightly against a chair or easel, so that a portion of the interior is visible. Collect discarded, storm-tossed, even inverted umbrellas for this project; no example is too rearranged by the elements. Study the newly shaped form before starting to draw. Although the original physical structure is basically unchanged, it may be difficult to perceive almost any relationship between the clean curves of the opened umbrella and this collapsed, wrinkled drapery hanging from its framework.

Follow the original seven-sided physical edge as it loops and curls from spoke tip to spoke tip, disappearing at times and reappearing briefly. Show the difference between the freely suspended loops and the sharper, angular directional shifts that occur at every spoke tip.

From each tip, follow the straight length of the spoke, even if largely in your mind's eye, directly to the central point on which the umbrella is standing. All spoke lines will lead to this same hub. Even though you cannot see most of their length, the small protruding portions must be shown aimed at this spot, to give credibility to your drawing.

Show the loosely suspended material falling in folds from this now relaxed framework. Try a variety of techniques to show the subdivisions and softenings of form. Be selective; you need not show every fold and crease to give a clear impression of the structure (fig. 1.51).

Aim the handle shaft directly at the hub of the form, even though much of its length is not visible. Details of the handle should be left to a late stage of this drawing, as you may need to modify its angle and size after completing the drapery.

An umbrella drawing may show a surprising resemblance to a windswept group of floating or falling autumn leaves. Study these works to see which best create such an illusion. Then either by changing your position, or by rearranging or selecting a new example of the subject, draw the umbrella again a little more loosely, this time emphasizing the draped-leaf effect, omitting the handle and any mechanical details.

Compare the two drawings; note whether the second work displays a greater unity or integrity. Does it seem to convey a more comfortable interaction of elements?

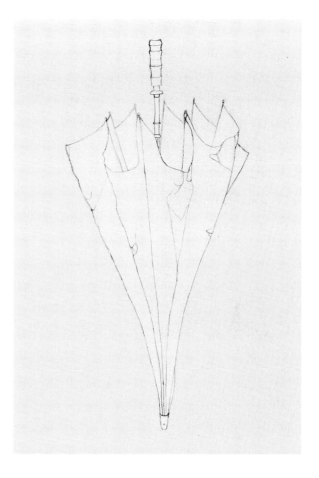

1.51
L.I.U. student: Shelton Smith
Closed umbrella
1997
Pencil on paper
Sheet: 24 × 18" (61 × 45.7 cm)

THE FLAG

The American flag may be seen as a continuous field of ribbon shapes with shared edge-lines at the meeting of its red and white stripes. If possible, suspend it from a pole or drape it over a stool so that only the stripes are visible. Start at the outer edge along one stripe, and draw it as a single ribbon as much as possible. Then, using the inner edge of that stripe as the outer edge of the next, continue to build the field of fabric. If this drawing follows the partly closed umbrella study, you will be prepared for the soft and abrupt contours that mark the draping of fabric.

The stripes should help you keep your place as you read the convoluted surface of the flag; even where they are only partly visible, keep their apparent width consistent. Any striped, draped fabric may be used for this study (fig. 1.52).

THE CORDUROY CAP

What may at first appear a single continuous edge is composed of individual turns, where each cord (or strand) of the corduroy moves up, over, and out of sight.

Describe the path of a single cord, then the next, and draw it more or less

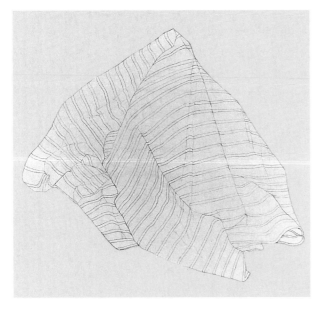

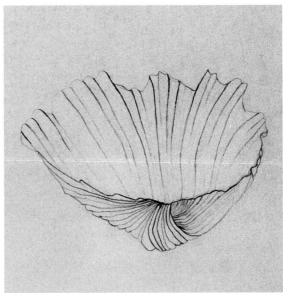

1.52 ABOVE
L.I.U. student: Rahil Rahim
Draped striped fabric
1993
Pencil on paper
Sheet: 18 × 22" (45.7 × 55.9 cm)

1.53 TOP RIGHT
L.I.U student
Sea shell
Undated
Pen and ink
Sheet: 7 × 5" (17.8 × 12.7 cm)

1.54 CENTER
L.I.U. student: Martin
Mateo
Screw
1989
Pencil on paper
12 × 6" (30.5 × 15.2 cm); drawn
vertically

parallel to the first, making any necessary modifications. Continue in this structural way, never achieving the final silhouette until the drawing has been completed. This is the opposite of making a light general sketch of the overall form first. It is an additive, constructed, touch-contour study, working from the inside out rather than from the outside in.

There should be no straight lines in this drawing; even the flat peak will show some roundness and curvature. Avoid mechanical repetition of parallels, and give each strand its own distinctive contours. Rigidity is the bane of this study; it can be overcome by careful attention to subtleties of form and lightness of touch.

SPIRALS: A REPETITIVE LINEARITY

Spiraling contour studies show the physically continuous but visually elusive swirl of linearity that can enfold an object. Lines disappear as they move out of sight in a continuous curve behind the subject, then reappear as a flowing

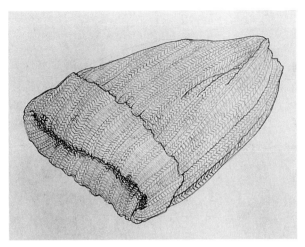

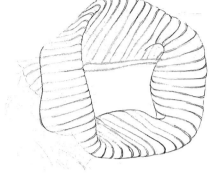

1.55 ABOVE
L.I.U. student: Robert
Candella
Knitted hat
1989
Pencil on paper
5 × 7" (12.7 × 17.8 cm)

1.57 CENTER RIGHT
L.I.U. student: Goduwa
Abdullah
Ball of yarn
1989
Pencil on paper
Sheet: 9 × 12" (22.9 × 30.5 cm)

1.56 TOP RIGHT
L.I.U. student: E.J.C.
Knitted collar
Undated
Pencil on paper
Sheet: 24 × 18" (61 × 45.7 cm)

1.58 BOTTOM RIGHT
Leendert van der Pool
Ship's rope
1992
Conté/sanguine on paper
39½ × 27½" (100.3 × 69.9 cm)
Collection of the artist

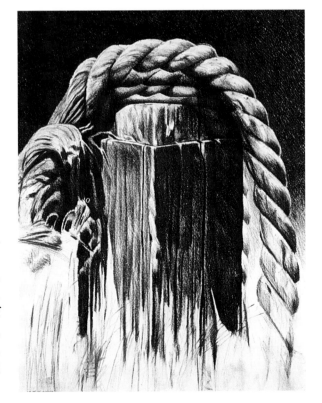

extension of their curvilinearity. Sea shells, screws, paper curls, wood shavings, rope, knitted hats, collars and cuffs, hanks and balls of string and yarn are excellent subjects (figs. 1.53–1.56). Particularly descriptive work can be developed from spiraling yarn or string, whose additional dimension of thickness, like the lines or bands of corduroy, provides considerable information and linear detail encircling a central form (fig. 1.57). Later tonal studies depend on early skillful observation (fig. 1.58).

A Note on Sequencing

The following presentation of *linear tonality* and *continuous tone* may be reserved for later study with Sections 2 and 3 (see pp. 109 and 125). However, you may prefer to pursue the sequential development of the three techniques here, using a common subject, to show the transitional relationships connecting line, texture, and tone.

INTRODUCING LINEAR TONALITY: THE THREE-WAY PINE CONE

This sequence may be developed directly after several of the previous contour drawings, particularly the corduroy cap, yarn or wool, sea shell or rope. But the pine cone's naturally striated forms and deeply shadowed interior may guide you most directly to a clear application of the idea of building tone through more or less parallel linear elements (fig. 1.59). (If you are using this text in a modular, non-linear way, that is, moving through the Units to seek out desired technical or conceptual material in your own order, then this is a good time to refer to the series of linear exercises developed by Albers, described in Unit D of this Section.)

1.59
L.I.U. student: C. Mabry
Linear pine cone
Undated
Pencil on paper
12 × 9" (30.5 × 22.9 cm)

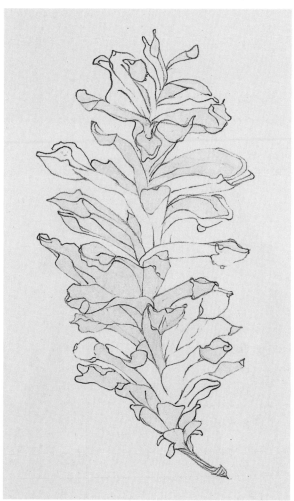

In the first pine cone drawing, concentrating on structure in a linear way, you may find the concentration and clustering of lines beginning to give a sense of dark and light tonality without conscious attention.

For the second of these three-way drawings, begin again with a single leaflet, perhaps starting with the topmost central shape. When you have placed several forms together as they appear to the eye, begin to increase the number of lines parallel to the long axis of each. Build the necessary tonality to show light and dark areas as you see them; be selective and use the fewest lines possible. Even in the deepest central core area, maintain the individual integrity of each line; avoid blurring or smudging them into a solid tonal field. You may find that only the small edge-surfaces will remain completely light; this depends on lighting conditions and your placement of the cone. Parallel-line tonality, showing the shadow on which the cone is sitting, should give a strong three-dimensional feeling to the drawing. Be sure the base shadow extends right up to (and includes) the lines defining the lowest leaflets.

In working with linear tonality you may choose to let the additive concentration of lines build your areas of dark and light with no additional

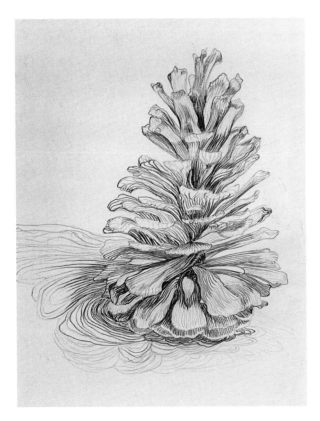

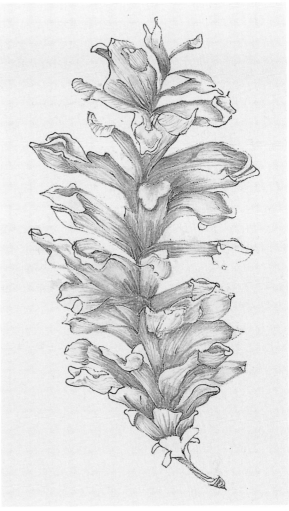

emphasis, such as extra pressure or weight of line on your pencil. Or you may enhance the illusion of three-dimensionality by applying touches of darker darks or blending linear elements into tonal areas or pencil washes. Retaining discrete linear elements may provide greater clarity; the choices are always yours (figs. 1.60 and 1.61).

CONTINUOUS TONE

This study may be achieved in two distinct ways. If you are following the three-part sequence, begin with a simple linear contour, making no line darker than the tone on either side of it. Refer to your gray scale (see fig. 3.6), and slowly create a smooth tone at the perceived degree of darkness for every area. Lines will disappear as they blend into tonal areas. For every line, decide into which of its two adjacent areas it will be blended; will the line remain as the beginning of a shadowed area on the form itself, or will it mark the very start of the shadow area behind that form? In either case, the line as such will disappear (see also p. 58).

THE PAPER BAG: A THREE-WAY SEQUENCE

This study should be done after you have completed gray scales in linear and continuous tonality. Concentrating on the contours of its often geometric

1.60 TOP LEFT
L.I.U. student: Michael Neuhaus
Linear tone pine cone (detail on p. 30)
1977
Pencil on paper
11 × 8½" (28 × 21.6 cm)

1.61 TOP RIGHT
L.I.U. student: C. Mabry
Tonal pine cone
Undated
Photocopied line with pencil on paper
11 × 8½" (28 × 21.6 cm)

facets, first make a purely linear description of a simple brown paper square-bottomed bag, plus a second, lighter drawing, to be developed in a different way. Be sure you can see some portion of the interior space. In the first drawing, the line work may be incorporated into tones of dark or light gray, built up as a surface of parallel strokes, almost merging edgelessly where possible (fig. 1.62).

The third study (which may be reserved for a later date) is drawn directly in tonal areas with little or no additional linear work. Exploring alternative directions from the start, you will be more aware of what you choose to include and exclude, and realize choices are always made; no one drawing can show all you know (see p. 151).

RE-VIEWING YOUR SEQUENTIAL STUDIES

In each series, study the three drawings side by side. Which one seems most real to you, most descriptive, most detailed, most rounded or three-dimensional, most comfortable, most convincing, most well-drawn?

1.62
L.I.U. student: Robert Candella
Paper bag
1989
Pencil on paper
Sheet: 18 × 24" (45.7 × 61 cm)

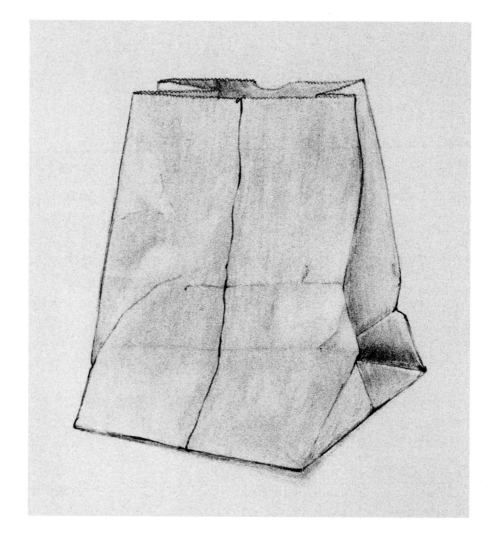

At the end of this analysis of the three-way drawings (pine cone, shell, or any other), set up the subject once again, and this time just draw. You may be surprised to see yourself combining the three techniques or developing a new approach. The difference is that this time you have a variety of experiences on which to draw! (Pun intended.)

ADDITIONAL SEQUENTIAL STUDY DRAWINGS: ORIGAMI

Here, the first drawing is the same as that for showing the difference between physical and visual edges (see p. 52); this is a simple rectangle or, in the case of origami, a square. A single crease is added and drawn to show the first new edge. Although the additional edge-lines describe actual edges, the problem of showing parts of lines hidden from view remains. Indeed, it is the increasingly complex subdivision, restructuring, and obscuring of details that add to the challenge and fascination of this series. If possible, try not to see the final form of the origami figure until it has been completed.

As each step is demonstrated, fold an example and place it on a white sheet of paper adjacent to your drawing pad. Draw each preliminary stage in a continuing series of small studies on a single large sheet. (If told in advance how many steps are to follow, you can plan ahead to compose your page.) Other folded paper structures may be studied as well (fig. 1.63). Create, then draw, forms seen in figure 1.63, from differing angles.

1.63

U.C.L.A. student of Lois Swirnoff

Folded papers

1980s

Pencil on paper

18 × 24" (45.7 × 61 cm)

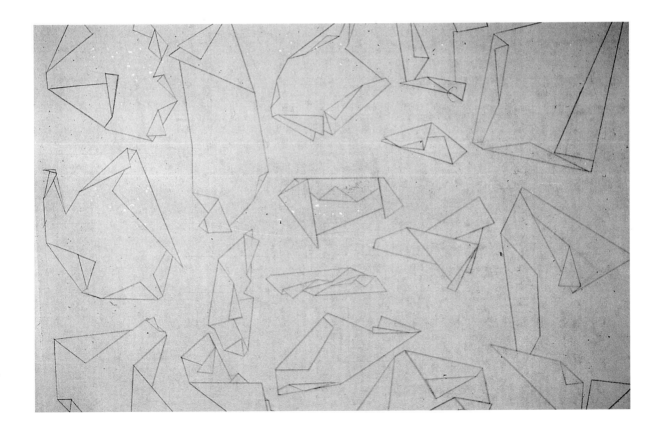

MULTI-PAGE PLANT

This exercise-study (see also Section 6, Unit A) addresses several questions you may encounter in your own work, yet never resolve in studio assignments:

- How can I approach the overwhelming challenge of a mural-size drawing?
- Must I always work within a predetermined page size?
- Where do I start when drawing a very complex subject?
- How can I maintain interest when doing a very large or lengthy project?
- How do I manipulate a very large expanse of paper?
- How can I work on a single project over an extended period of time?
- Must I have a preliminary sketch for a very large work?
- Must every drawing be contained within a rectangular format?
- Must I have an idea of the finished composition before I start every work?
- (Add your own question.)

For this exercise-study you will need:

- A non-spiral-bound pad of heavy white drawing paper, 18 × 24" (to attach individual sheets).
- A medium soft, non-smudgy pencil (HB, IBM, electrographic, 2B, 3B— your choice).
- A kneaded gray eraser and a heavy white plastic eraser (for small or major changes).
- A lightweight but firm drawing surface (to use as a lapboard or floorboard) 18 × 24" or larger.
- A roll of micropore paper surgical tape ³/₄ –1" wide (to attach sheets).
- A small pair of scissors (to trim the tape).
- A small sheet of tracing paper (to keep beneath your hand to prevent smudging).

If possible, select a large potted plant in a semi-public area where you can position yourself at some distance to see the entire subject clearly. A library, office building, lobby, gallery, school entrance area, or public garden may be appropriate. Select a spot where you can work uninterrupted and return as often as you wish. A large pandanus screw-pine with freestanding roots set up off the floor on a small high table works very well, but any large-leafed decorative potted plant will do.

Sit near enough to see each leaf clearly but far enough away to see the entire plant. To start, simply draw one leaf in a clean linear descriptive way, life-size. Only draw what you can see; stop where one form is overlapped by another. Use a confident, continuous, firm line. Draw the inner details of the leaf's structure where you see them, including the central stem and veining. As the leaf needs to extend beyond one page, follow this procedure:

- Remove the page from your pad carefully, plus a second sheet.
- Butt the two sheets together edge to edge, exactly, on your drawing board.
- Carefully tape the two together, placing the tape equally on both sheets, and trim the tape exactly at the edge of each sheet.
- Continue the drawing of the single leaf until it is completed.

- Fold back the original sheet when it is no longer needed.
- Open the double sheet to the original page, to draw a second leaf in relation to the first in the same way.
- Touch each new leaf to a previous one in some way.
- Continue adding sheets as needed, always working on only one or two at most.
- Fold the extra sheets away as you would fold a road map.
- Do not count the number of sheets you are adding; let the drawing grow.
- Continue in every direction until you have drawn every leaf and the pot.
- Stop at any time, fold up the work, and return later.
- When it is finished, tack the multi-page drawing to the wallboard and study it as a whole from a distance.

Would the drawing be enhanced by the addition of one or more blank sheets to complete a rectangular or other format? If so, add these sheets in the same way, and place the newly completed work on the wall. Does it still need additions? Removals? Do any areas want to be restudied? (Individual panels may be removed with a matt knife or X-acto knife, replaced by a blank sheet and retaped before the drawing continues.) Note that you can easily draw on micropore tape, unlike other kinds.

As you study your completed drawing, you may begin to find answers to several of your earlier questions. Note that a work considered very large by the person who drew it may look surprisingly small beside another individual's drawing. Look for unexpected compositional lines and rhythms which could not have been planned consciously ahead. Given a single sheet of paper the size of your final work, would you have been able to produce this drawing? Why? Why not?

QUESTIONS TO CONSIDER: CAN "REALISTIC" DRAWINGS BE "CREATIVE"?

In this Unit, all your drawings have been perceptual; that is, a direct response to perceived visual experience. In other words, you have been drawing in a realistic manner, trying to show on paper what you have observed in the real three-dimensional world. Do you have questions about this?

Some writers claim that realistic or representational drawing is not creative, but merely a copying or duplication of reality. Do you agree? Consider the following statements:

- In reality, most edges we see don't physically exist.
- Our developing understanding of structure determines how we perceive and draw.
- The more we look, the more we see.
- Everyone looks and sees in a unique way.
- Everyone has an individual style to be developed.
- A flat, two-dimensional drawing can never contain all the attributes of three-dimensional reality.

- As an object turns, it shows differing faces from which we select one, stopped, for each drawing. (The Cubists often combined several such views; see p. 246.)
- A drawing may include applied line, one-dimensional edge-line, edgeless tonality, or any combination of these.
- If drawing from real objects was mere copying, then all drawings of the same subject would look alike.
- Drawing involves selection, from the totality of our visual experience, of those elements we wish to show in a particular way.
- Drawing, a unique human response to the objects of perception, will always show a personal interpretation of its subject (see figs. 5.43, 5.45a and b, and 7.25).

Why Talk about Drawings?

Do you agree with any of these statements? Do several seem to be saying the same thing, but from differing points of view? Do you find value in so much consideration of ideas about drawing? Would it be better to eliminate discussion and dialogue, and simply draw? Can't an instructor simply tell you what you need to know, cover all the material, and correct your mistakes as necessary? Of course not; no-one can convey ideas that are unspoken, non-verbal things-that-must-be-seen. And no amount of showing what others have done will develop your own abilities, will assure your *dis*covery, your *un*covering, of these truths. Where you might have seen more clearly, an instructor can point the way, can help you use what you have seen as a basis for what you will see. Albers often said something could be "wrong, but in the right direction," giving suggestions for improvement in perception which would lead to improvement in drawing. This kind of encouragement is quite different from "pointing out mistakes" or from a blanket acceptance of whatever is done: "That's nice; keep going." The idea is, as he put it, "to open eyes."

Unit D
The Albers Linear Studies: For Control and Facility

DRAWING A STRAIGHT LINE WITHOUT A RULER

This series of linear studies is a selection of those designed by Josef Albers to develop the ability to control direction and fluidity of freehand lines through coordinated interaction of the eye, the mind, and the hand. Akin to practicing scales on the piano, they can build confidence, fluency, and technique but, alone, they are not necessarily music. An understanding of the way this sequence of studies provides control and confidence will not, by itself, produce results. Spend some time each day, if possible, to develop the habit and the repetitive reinforcement needed to ensure that your pencil follows the paths you have chosen.

The first study will enable you to control the pencil point as an extension of your fingertips, so that you consistently draw a straight line without a ruler. The pencil will be guided to produce lines with easy confidence, giving an instantaneous unity between the eye's perception and the hand's response.

FIRST LINES

This first study may be done at the start of each drawing session as a warm-up exercise, or any time you have pencil, paper, and a few spare minutes.

Near the upper left-hand corner of a drawing sheet (preferably 18 × 24", held horizontally) place a barely perceptible dot to serve as a target at which you are going to take visual aim. Then, eyes still on that point, lift and bring your pencil about 1$\frac{1}{2}$" closer to yourself, place it decisively but lightly on the page, pause briefly to take aim at the original point, and move the pencil in a slow but definite straight line toward that target. Then stop. See if you've kept the line straight, without curving in order to meet the target point. If it missed, it missed. Start again, making the second target point a short distance to the right of the original. Your aim will improve remarkably; soon you will hit the mark every time. Then place dots at other points on your page and fire lines in all directions, always straight at the target. When you can readily aim and fire a short line straight at a desired point, at your own pace, continue the sequence (fig. 1.64).

1.64
Student
Ready, Aim, Fire
1998
Pencil on paper
Sheet: 7 × 8⅞" (17.8 × 22.4 cm)

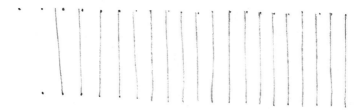

LINEAR TONALITY: BANDS OF TONE

Align a growing row of target points to create a field of parallel lines. Maintain an even band of lines, keeping starting and stopping points equidistant as you go. Don't measure, except by eye. From a distance, after you've achieved a certain amount of control, you will see a band of an even tone of gray. Keep each line the same weight and quality, and maintain the same distance between them. Then try a row that aims at tonal variety by spacing alone. As the lines move closer together, a deeper gray tone is seen and, where they move apart, a lighter gray. Control the shading by careful sequential placement of these otherwise identical lines (fig. 1.65).

On a new page, draw a continuous band of 1½" lines, slowly growing closer and darker, then farther apart and lighter, in a regular way across the entire sheet of paper. Below that, draw a second row of lines, alternating the darks and lights with those above. Leave no space between rows; use the implied line created by the bottom points of the upper band of lines as the top of those beneath. A third row, with darks and lights corresponding to the first band, should produce a marked illusion of push–pull bulging and receding dimensionality.

Continue, alternating darks and lights for several additional rows. The effect of the completed page should be quite three-dimensional and optical, particularly if you achieve a strong illusion of dark and light in each unit of the pattern.

VARIANTS AND USES

Variations on this theme (such as swelling the bands so they appear to press forward in space, and narrowing the darker portions so they appear to recede) will give a heightened appearance of three-dimensionality and interrupted surface (figs. 1.66–1.68).

1.65
U.C.L.A. student of Lois Swirnoff
Gradient drawing
1980s
Pencil on paper
18 × 24" (45.7 × 61 cm)

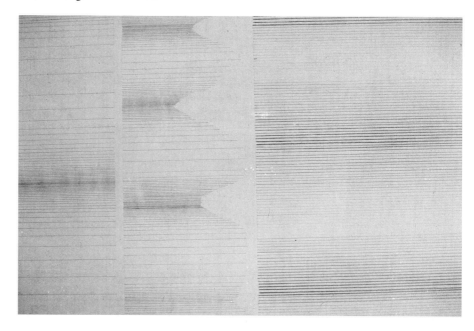

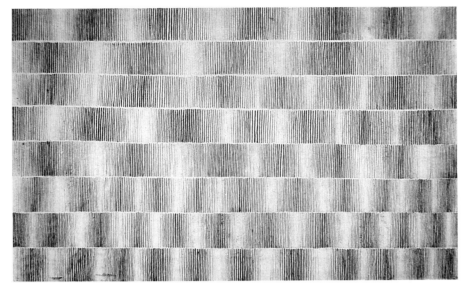

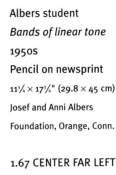

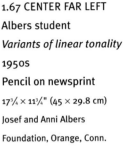

1.66 LEFT

Albers student

Bands of linear tone

1950s

Pencil on newsprint

11¾ × 17¾" (29.8 × 45 cm)

Josef and Anni Albers

Foundation, Orange, Conn.

1.67 CENTER FAR LEFT

Albers student

Variants of linear tonality

1950s

Pencil on newsprint

17¾ × 11¾" (45 × 29.8 cm)

Josef and Anni Albers

Foundation, Orange, Conn.

1.68 LEFT

Cooper Union student of

Irwin Rubin

Variants of linear tonality
with swelling

1980s

Pencil on paper

24 × 18" (61 × 45.7 cm)

Invent your own variations, aiming at increasing the illusion of depth and space. The one constant should be the precision of each linear unit of the total configuration.

This sequence leads to a facility in creating linear tonality or parallel shading, in which a series of linear elements moves around a three-dimensional form, swelling and contracting to build dark and light tones, or chiaroscuro (from the Italian *chiaro*, meaning light or clear, and *oscuro*, meaning dark or obscure; see p. 142).

Parallel linear tonality can be used as a basis for many types of other-than-representational drawings, particularly those more closely related to conceptual than perceptual concerns (figs. 1.69a–c). Among the many schools or styles that might be included here, you will find such names as *abstract, geometric,*

1.69a–c
Richard Anuszkiewicz
Working drawings
1998
Pencil on various papers
Each 14 × 8½" (35.6 × 21.6 cm)
Collection of the artist. ©Richard
Anuszkiewicz/DACS,
London/VAGA, New York 1999

non-objective, constructivist, minimalist, and even *pattern* drawing and painting (fig. 1.70). Research and investigation will bring valuable insights (see p. 274).

FREEHAND CIRCLE IN A SQUARE AND VARIANTS

The original study can be developed to produce a seemingly virtuoso performance: the perfect circle in a perfect square, completely freehand! The few minutes needed each day to build a pattern of ever more satisfying trial and success will be rewarded by a sense of real control, real achievement.

After you gain skill through the starting sequence of "Ready, Aim, Fire," to each line you draw, add a line of equal length, pulled out to the right, so the sequence becomes, "Ready, Aim, Fire, Right Angle." This time, after drawing each straight line, stop briefly, visualize a perfect right angle extending from your line, then draw it as long as the original. After a time, your idea of a right angle will come into focus, and you will achieve perpendicularity without a second thought.

When you have the right angle in your fingers, pull a quarter circle, or *spandrel,* within the corner from point to point. Now you are drawing "Ready, Aim, Fire, Right Angle, Spandrel." The perfect quarter circle of the spandrel will improve as a result of imaging or imagining the spandrel as a path of points. Eventually your pencil will ride neatly along this invisible track as you fit the spandrel in place.

Pulling a perfect quarter circle may be difficult, even if the first exercises were relatively easy. The goal may be more valuable than your actual achievement; the very effort to control a smooth curve within a right angle will give you a sense of that fullness or inflation known as turgor (see figs. 4.23 and 7.17), which can make all the difference in a drawing between sagging, collapsed volume and an elegant, evenly swelled form.

After you are satisfied with the spandrel curve, try a double spandrel, following this sequence: "Ready, Aim, Fire, Right Angle, Spandrel" (then bring

1.70 LEFT
Richard Anuszkiewicz
Green, Blue, and Gray Knot
1986
Acrylic on canvas
5 × 6' (1.52 × 1.83 m)
Photo: courtesy ACA Galleries,
New York. ©Richard
Anuszkiewicz/DACS,
London/VAGA, New York 1999

the pencil toward you, continuing in the direction of the spandrel); "Ready, Aim, Fire, Right Angle, Spandrel" (continue the first spandrel curve so that it becomes a continuous half-circle).

Eventually (and this may well be months after the first exercise) a second half-circle double-spandrel sequence should, in theory, give you a perfect circle in a perfect square, drawn completely freehand! By changing the rectangle you can vary the ellipse (fig. 1.71).

1.71 BELOW
Albers student: John
Coutsis
Spandrel studies
1950s
Pencil on newsprint
Sheet: 11¾ × 17¾"
(29.8 × 45 cm)
Josef and Anni Albers
Foundation, Orange, Conn.

Variations on this sequence include reversing the direction of the double spandrel to produce an S pattern. This can precede freehand drawings of several letters of the Roman alphabet, drawn within rectangular frameworks.

A Few Pointers
- Avoid resting your hand on the page; move your arm along with the pencil.
- If you miss the target, don't correct your aim; try again.
- Draw slowly and deliberately with little pressure on the pencil.
- Focus on the target spot, not your moving pencil point; with practice, your aim will improve.
- With practice, the quality of your line will improve; it will show more confidence, less hesitation, greater control.

RELATED EXERCISES: AUTOMATIC TWO-HANDED SYMMETRY

The inkblot, whose halves are mirrored around a central line or axis, shows bilateral (two-sided) symmetry. A natural tendency we all possess, this left–right balance of elements may be relied on without conscious effort. Several exercises can show just how strong this quality is for each individual.

Stand in front of a large sheet of paper tacked to the wallboard, holding two crayons (or a chalkboard, holding two pieces of chalk), one in each hand. Touch both together to a central point on the board above eye level and close your eyes. Slowly, letting your dominant hand lead at first, begin to draw a free scribble with both hands. Moving apart, then together, circling, sweeping, shifting direction, let both hands participate in this activity. After a while, look at your work; you should see a bilaterally symmetrical design. If not, perhaps you held one hand immobile while the other drew freely. Perhaps the second hand trailed along the path directed by the dominant partner.

Try the exercise a second time, eyes open, aware of the symmetrical possibilities. As if conducting an imaginary orchestra, your hands should move in a rhythmic flow, a linear pattern, more fluid and comfortable as you permit the symmetrical movement to carry you along.

This exercise is most satisfying if done as large as possible. Brown wrapping paper may be stretched along an entire wall for a group activity. If you prefer very small work, it can also be developed in this way, with sharply pointed pencils or pens, incorporating intricate, detailed refinements.

All these symmetry exercises may be developed

1.72
Cooper Union student:
Ashley Brown
Two-handed self portrait
1998
Two pencils on paper
11 × 8½" (28 × 21.6 cm)

1.73

Albers student: Eugene Nowak

Automatic two-handed symmetry: writing studies, detail

1950s

Pencil on newsprint

Sheet: 17¾ × 11¾"

(45 × 29.8 cm)

Josef and Anni Albers Foundation, Orange, Conn.

into more finished works with colors (paints, inks, collage, crayons) as you wish. Often, figurative forms seem to emerge, such as mask-like faces, animals, plants, or grotesque imagery. Try a two-handed self portrait (fig. 1.72)!

A variation, enjoyed by Albers' students, calls for writing with two pencils, starting at a central point and proceeding outward. The left hand will write in reverse or backward. If you are left-handed, this will be easier, but still reversed. Next, try writing with both hands, starting apart and approaching a common meeting point. Now, the right hand will write backwards.

Try both these studies again, this time upside-down. It may require quite a bit of concentration to make your hands go where you direct them but, with practice, the results can be useful in reinforcing the relationships between mind, eye, and hand. You may discover that your "other" hand has quite a bit of potential after all—or even that you are ambidextrous. Individuals with natural left-handedness who have been encouraged to write with the right hand often find a new facility and satisfaction in permitting the left hand to blossom (fig. 1.73).

USES OF THE SERIES OF STUDIES

These exercises can provide the technique to make your lines do what you direct them to do and go where you want them to go. You will have gained freedom; even if you eventually reject straight lines and perfect circles, your decision will be from choice and not because of a lack of ability to "draw a straight line"!

This selection of studies is by no means the complete series presented in Albers' drawing classes. Those of more specific use to students of graphic design and architecture, for example, have not been included. Some of the

1.74 ABOVE

Albers student: C. Spofford

Simulated newsprint

drawing

1950s

Pencil on paper

16¾ × 11¾" (42.5 × 29.8 cm)

Josef and Anni Albers

Foundation, Orange, Conn.

1.75 TOP RIGHT

Arnold Bittleman

From the Feather to the

Mountain, detail

1970

Ink on paper

Full image 26 × 25"

(66 × 63.5 cm)

Collection of Dolores Dembus

Bittleman

others emphasize variants on the visualization of patterns and letter forms from several oblique viewpoints. The newspaper page illusion was a special favorite of many of his students (fig. 1.74).

The mature works of a number of Albers' former students show a direct application of these studies, while at first glance others seem not to be related. You will readily identify the parallel linear concerns of Anuszkiewicz, Swirnoff, and Stanczak, for instance, but can they be discerned in the drawings of Bailey (see fig. 8.1) and Bittleman (fig. 1.75)? Perhaps the confident linear elegance and control seen in Bailey's works and the freely released fluidity of Bittleman's line reveal as much individual indebtedness to these early studies as more directly geometric applications appear to show. Is there an implicit respect for precision, a sensitivity to tonality and line in their works, no matter how distinct each artist's style (fig. 1.76)?

What will your drawings show in the years ahead? Remember that skills as well as artistry require time and patience to develop. From the start, try to draw with confidence, knowing that your work will show steady development. Act as though you can control your line, even before you feel you possess the ability to do so and, as you build skills and use them, you will enjoy a spiral of achievement and satisfaction.

1.76
Albers student: Neil
Welliver
Coat, hanging on a nail
1950s
Blue pencil on
newsprint (with rubber
cement on reverse
showing through at
edges)
Sheet: 17³/₄ × 11³/₄"
(45 × 29.8 cm)
Josef and Anni Albers
Foundation, Orange, Conn.

Linear Orchestration:

<div style="background:gray">2</div>

Surface, Form, and Expression

Unit A

Calligraphic Ribbon:
The Double-Edged, Shaped Line

LINEAR CALLIGRAPHY: A PRESSURE-SENSITIVE RIBBON

Calligraphic line, most often associated with brush-drawn Asian writing, is produced with any hand-directed tool responsive to varying pressure and direction. Each individually applied two-edged line may be considered a separable, though related, element in a calligraphic drawing. Whether you are concerned with description of perceived contours of form, proposing conceptual possibilities, or giving visible form to any linear idea, this quality of pressure-responsive shift in the width and flow of line is the essence of its calligraphic identity. The uses of such line do not define it; indeed, in Asian languages the terms for what we might call brush-writing and brush-drawing are often one and the same. Certainly both would be considered on the same high plane of achievement (fig. 2.1).

CREATING CALLIGRAPHIC LINE: EXPERIMENTS WITH MATERIALS

To experience the rich range of calligraphic line and its uses, experiment with a variety of tools and materials: soft and hard pencils, several brushes, including at least one Asian bamboo writing brush, a chisel-edge lettering brush, a soft round watercolor brush, and a number of pens. A single wooden nib-holder will do, plus a few penpoints or nibs, preferably a number of chisel-

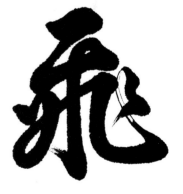

2.1
Jia-Xuan Zhang
"To Fly," Chinese character
1998
Bamboo brush and Chinese ink on rice paper
3 × 3" (7.6 × 7.6 cm)
Collection of the author

edged calligrapher's nibs (Speedball C-2 and 3 are good, and a split-tip pointed nib used for copperplate script or for bookkeeping). Use any black India or calligrapher's ink.

Later we will suggest traditional Asian stick ink, moistened and scrubbed onto a prepared inkstone with a water-holding depression or well for diluting the ink into tones of gray (see fig. 3.7).

Exercise:
On a large sheet of opaque white drawing paper, use your implements, in turn, to find each tool's full range of calligraphic capability. Use the following guidelines or devise any comfortable method of organizing these lines; be consistent and orchestrate a clearly structured page.

Guidelines
Using your hardest pencil, draw a series of lines, increasing the pressure applied, from the merest wisp of a line as the pencil barely touches the page, to a deeply gouged groove as excessive weight is added. Do you see much variation in width or thickness of these lines? What is the range of their tonal value or dark-and-light quality? Does the sharpness of the pencil point make much difference?

Try the same sequence with each softer pencil, to discover the full range of calligraphic results. If you have a wide-edged carpenter's pencil, or an extra-dark ebony, IBM, or electrographic pencil, try these in the same way. Which pencils seem to offer the greatest calligraphic range? Which can you control most readily? Which are the most difficult to direct exactly as you wish?

Other materials to try are charcoal, litho crayon, and brush and ink. These are discussed in detail in Section 8, but should be tested and used for varying calligraphic lines here.

With the bamboo brush, press and allow the brush to make a simple "footprint" on your page (fig. 2.2). (It may resemble a tadpole or raindrop.) Then try to make the least mark possible—the finest, almost single-hair "brush-print"—and, pulling the brush along the surface, draw as thin a calligraphic line as you can. It will still have some width, some space between its two edges, even if that thickness is barely perceptible. With the same brush, make a series of lines of increasing thickness by subtle application of additional pressure. At some point, you may begin to lose control of the line quality, relinquishing any sense of the brush's point, almost grinding the hairs into the paper with the bamboo itself. Perhaps before you reach that point you will want to begin again with a larger brush.

2.2

L.I.U. student:

Kwang-Min La

Footprints of bamboo brush

1998

India ink on paper

8½ × 11" (21.6 × 28 cm)

With chisel-edged brushes, a different approach is required in order to create lines of varying thickness. Can you discover this through experimentation before reading the following description, or do you prefer to know in advance what to expect before you proceed? (Know thyself!) Particularly in the visual arts, it is important to be aware of your own likes, dislikes, comfortable and uncomfortable working environments, and other personal factors. Art is personal; no one else can draw your lines. Would LeWitt agree? (See p. 276.)

USING SPECIFIC BRUSHES—POINTED AND CHISEL-EDGED

(To those who prefer to seek and find without a map, proceed to experiment with the pointed bamboo and chisel-edged brushes on your own, before reading the following guidelines.)

Holding the pointed, cylindrical bamboo brush with the handle more or less vertical—that is, perpendicular to the page—you can move the brush in almost any direction and create a similar kind of line (see fig. 2.13). Think of the brush-point as the center of a circle and any line drawn from that point as a kind of radius from the center, regardless of its weight or thickness.

With a chisel-edged brush, you can vary an additional factor—the angle at which the tool is held to the paper. To test the great difference this can make, select a brush about $^1/_4$" wide and, with minimal pressure, make a straight, even, ribbon-line, vertical or horizontal, as thick as the brush itself. Try this again, with additional pressure. Do you see much difference?

Holding the brush in the same position, draw a line perpendicular to these (at right angles to them). This line will be considerably thinner—only as wide as the thickness of the brush. In fact, if the brush is fairly large and thick, you may be able to draw along the edge between the width and the thickness and achieve a very thin line indeed. Now add pressure. Does this make a difference? You can see that varying the angle at which the chisel brush is held greatly alters the thickness of the line drawn (fig. 2.3). Try the following exercises to discover a range of possibilities.

2.3

Dan Christensen

Untitled (#003–78)

1978

Synthetic polymer paint on handmade gray-green paper

31$^1/_2$ × 22$^7/_8$" (80 × 58.1 cm)

The Museum of Modern Art, New York. Gift of Mrs. Frank Y. Larkin. Photograph ©1999 The Museum of Modern Art, New York

Exercise:

Work on graph or quadrille paper, or use a horizontal line near the top of your page as a guide.

- Make a series of vertical ribbon-lines, decreasing the thickness of each by increasing the angle at which the brush is held to the page, until it is at

right angles to its starting position, that is, aligned along a vertical line on the grid rather than the original horizontal.

- Draw a series of horizontals, starting with the full width of the brush in its new position. Sequentially reduce the thickness of these horizontals by slowly bringing the brush up to its original horizontal placement.
- Create a number of (basically) straight lines, running the full length of your page, varying in width as they go, merely by subtly turning the angle of the brush. As this page develops, allow the brush greater freedom, moving up and down, following the impetus of the turning angles until you are almost dancing the brush along the surface.

This is an exercise that can benefit from musical accompaniment. The kinds of markings produced will be seen to change, often dramatically, as the music is changed in tempo, style, and rhythm. Try works by Prokofiev, Khachaturian, Saint-Saëns, or Joplin. Since it is a study of calligraphic line, focus on the two edges moving together or apart.

Other exercises to familiarize you with the range of calligraphic lines that can flow from a chisel-edged tool (we will be repeating this sequence with chisel-edged calligraphy pens) are derived directly from those you would encounter in learning freehand lettering (fig. 2.4; see also fig. 8.13).

2.4

Eleanor Winters

Gothic calligraphy, detail

1998

Pen and ink on paper

Full image 11 × 8½"

(28 × 21.6 cm)

Collection of the artist

It is good to be
 merry & wise,
It is good to be
 honest & true,
It is best to be off
 with the old love,
Before you are on
 with the new.

Exercise:

On graph paper, place your chisel-edged tool at a 45° angle to the page, so that a vertical line would be about half the maximum thickness of the brush's width. Draw a short vertical toward yourself and, without altering the angle at which the brush is held, move it to the right the same distance, creating an L of relatively consistent thickness. Repeat this L several times and slowly begin to curve the sharp right angle. Continue this movement, adding more spirit to your curves, until you are actually carrying the curve up and over, returning to your starting place having drawn a fully rounded oval or circle. These may be drawn as a continuing series of loops, spiraling along your base line. For control and discipline, make several lines of these loops with as little variation as possible among the individual units.

Notice the apparently planned placement of thicks and thins that have appeared without any actual planning. The elegant sweep of line, swelling and tapering in rhythmic repetition, is an automatic result of holding the tool at a single consistent angle. This is one of the secrets of successful calligraphic writing: It's all in the angle.

USING CALLIGRAPHIC LINE

There are two ways to make use of calligraphic line: the intentional and the automatic. In the first, consciously vary pressure on your tool, whether pencil, brush, pen, or gouge, to create variation in thickness of your line. As you can see in the drawing by Alfred van Loen (fig. 2.5), the thick and thin edges of calligraphic line may be subtly, or even dramatically, moved by simple pressure applied to the ribbon-line, that is, by moving the two edges of the tool closer or farther apart.

2.5 LEFT
Alfred van Loen
Tiger
1972
Linoleum cut, incised line, printed in reverse
8 × 6" (20.3 × 15.2 cm)
From *An ABC Bestiary* (Merrick, N.Y.: Cross-Cultural Communications, 1990). Photo: courtesy Helen van Loen

In traditional Asian calligraphic drawing and writing, reworking of one's first spontaneous brushwork is unacceptable. The original movement of the hand and brush, as one, constitutes the calligrapher's visual choreography (fig. 2.6). While calligraphic line is capable of wide extremes in thickness, weight, and curvilinearity, works with very subtle, small variance and delicacy are often prized (fig. 2.7).

LINEARITY IN PRINTMAKING

In relief printmaking, such as linoleum blocks and woodcuts, you will find many examples of carved calligraphic line. Study the very heavy positive linearity of Antonio Frasconi (fig. 2.8) and Naomi Bossom (see fig. 1.18), who have carved away all the material around their lines, leaving them heavily inked for printing. Then observe the more delicate, continuous negative or unfilled line of Henri Matisse, who has more directly cut away the line itself with varied thickness and inked the surrounding background areas, leaving as the calligraphic line the white of the paper (see fig. 0.9).

Are these works actually drawings? Haven't we just identified them as examples of printmaking? Is it possible that a work in any medium that incorporates the concept or shows the particular effect being studied or

2.7 ABOVE
Takeuchi Seihō
Sketch of a Rabbit
c. 1920
Ink and slight color on paper
15³/₄ × 21⁵/₈" (40 × 54.9 cm)
Philadelphia Museum of Art. Gift of Henry B. Keep

2.6 LEFT
Hsu Wei
Twelve Flowers and Poems, detail
16th century
Handscroll: ink on paper
Whole handscroll 12³/₄"
× 17'6⁷/₈" (32.5 cm × 5.36 m)
Freer Gallery of Art, Smithsonian Institution, Washington, D.C.

discussed qualifies as an exemplar within that context?

Turn ahead to the etching by Rembrandt (see fig. 2.30) to see another form of printmaking which we will include as an incomparable demonstration of clustering line, creating texture and tone.

Questions

Do you feel it is more useful to seek and discover inseparable interrelationships between areas of the visual arts often said to belong to different categories, or to try to pigeonhole and separate art into as many distinct classifications as possible? Do you think that the way a question is posed may affect the way it is received or answered? (See the Bibliography.)

PEN AND INK

After your experimentation with pencil and brush, repeat these exercises as closely as possible with pen and ink. First, use the split-point nib to see the effect of pressure alone on width variation in line. Then work with the chisel-edged calligrapher's nibs to see how pen angle can be critical in creating thicks and thins. Can you see why the study of freehand calligraphy is often a requirement in the foundation program of many art schools and departments of art?

Chisel-edged works can provide you with a second way to use calligraphic line in your drawings, the more automatic or non-directed method, in which the angle of the tool creates a flow of varied thickness. This needn't be exaggerated, even obvious, in a specific drawing; pressure and angle both play a part, whether boldly or whispered, in many exquisite drawings in the East as well as the West (fig. 2.9). The two edges of such lines, in pen or brush, need not be parallel—an important subtlety!

2.8 ABOVE

Antonio Frasconi

A Vision of Thoreau with His 1849 Essay: Civil Disobedience

1965

Woodcut

7^1/$_2$ × 5^1/$_2$" (19.1 × 14 cm)

Private collection. ©Antonio Frasconi/DACS, London/VAGA, New York 1999

2.9 RIGHT

Arthur Baker

Calligraphic alphabet

1981

Pen and ink on paper

11 × 17" (28 × 43.2 cm)

Collection of the author. Gift of the artist, 1996

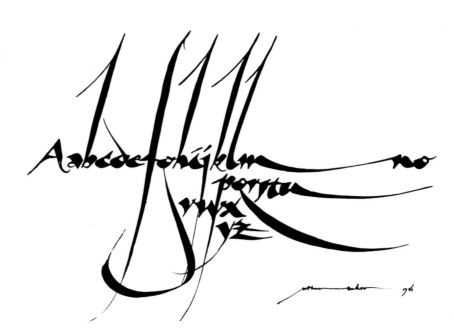

USING VARIATIONS IN TONE, BUT BARELY

Tonal variation and texture may appear in calligraphic line drawings, particularly when a partially dry brush is used or the ink is diluted with water, but these variants are not necessary. Some of the purest, most fluid examples of this kind of linearity show no variation in tone, just a solid black or gray line. For very controlled yet subtle calligraphic line, study the leaf and plant drawings of Ellsworth Kelly (see figs. 1.10 and 1.31)—bare bones, almost too little to see, yet just enough. At first, you may find these spare drawings flat, even, and without much sensitivity. Look again for slight pressure-sensitive modulations, for the balance of width variation that suggests roundness, depth, space, the third dimension, without apparent effort or intent. In this, as well as in their seeming stinginess of detail, these drawings reveal more to the patient eye. They may epitomize the frequently repeated, often misunderstood, axiom: Less is more. Fewer elements, greater focus on those presented; less fuss, more strength.

A Note on Reproducing Drawings

Reproduced here, screened in ink and considerably smaller than the size of the originals, many of these printed illustrations bear only a slight resemblance to the actual drawings. This is true of any art works seen in books. At best, such reproduced illustrations serve as suggestions of what you would find in the works themselves. Whenever possible, visit the museum, gallery, or other location of any work you wish to see. The actuality of size, surface, texture, space, and presence of a work, plus other qualities that cannot be conveyed through words alone, will add immeasurably to your appreciation.

In the next Units, understanding of this idea will assume even greater importance. As the complexity of the linear surface grows, so will our need to look with imagination and an inner vision, as well as our optical powers of perception.

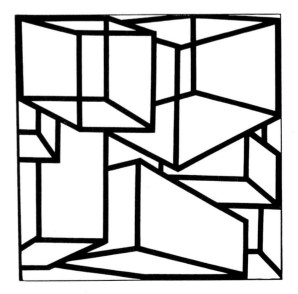

2.10
Al Held
Phoenicia II
1969
Acrylic on canvas
4'1/2" × 4'1/2" (1.23 × 1.23 m)
©Al Held/DACS, London/VAGA,
New York 1999

SINGLE-THICKNESS RIBBON-LINE: MONO-LINE

In the previous discussion, variable-width calligraphic line owed its differing thickness to changes in pressure applied to an implement or to changes in the angle at which that tool was held. Lines produced by a chisel-edged or wide-based brush or pen with unchanging equal weight, steady pressure, and a constant angle, maintain an even, single thickness frequently enjoyed by contemporary artists seeking a cool, flat, all-over surface. They may give an almost decorative, graphic feeling to the picture plane and, when the parallel edges of such lines are sufficiently spaced, it may be difficult to say at what point a line becomes a shape (fig. 2.10). Study the works of Mondrian to see this development, as early drawn lines later become black-barred linear shapes (figs. 2.11a–c).

2.11a RIGHT

Piet Mondrian

Tree #2 (detail on p. 92)

1912

Black crayon on paper

22^1/$_4$ × 33^1/$_4$" (56.5 × 84.5 cm)

Haags Gemeentemuseum, The Hague, The Netherlands.

©Mondrian/Holtzman Trust, c/$_o$ Beeldrecht, Amsterdam, Holland/DACS, London 1999

2.11b RIGHT

Piet Mondrian

The Sea

1914

Charcoal on paper

37^7/$_{16}$ × 50^7/$_{16}$" (95.1 × 128.1 cm)

©Mondrian/Holtzman Trust, c/$_o$ Beeldrecht, Amsterdam, Holland/DACS, London 1999

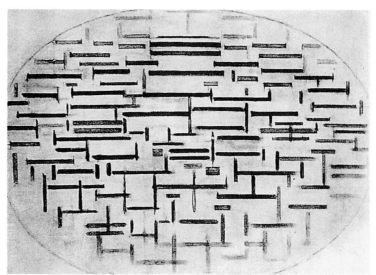

2.11c RIGHT

Piet Mondrian

Composition, Black, White, Yellow

1936

Oil on canvas

28^3/$_8$ × 26^3/$_8$" (72 × 67 cm)

Philadelphia Museum of Art. Louise and Walter Arensberg Collection. ©Mondrian/Holtzman Trust, c/$_o$ Beeldrecht, Amsterdam, Holland/DACS, London 1999

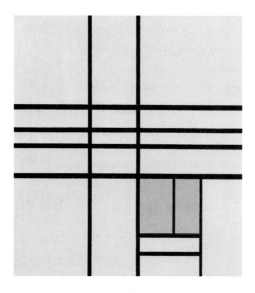

Exercise:

Re-create (not quite the same as *copy*) the basic strokes of Chinese calligraphy (fig. 2.12), holding the brush upright, perpendicular to the page (fig. 2.13). Watch the direction in which the very tip of the brush points (follow the guide given) and very slowly apply the amount of weight called for, no more. Follow the path of the moving brush as indicated, and press down or release the brush at the end of the stroke. The sequence of strokes in a word (or character) is important (see fig. 4.30). If the results of this exercise inspire you, investigate the subject further.

2.12 LEFT
Jia-Xuan Zhang
Basic strokes of Chinese calligraphy
1998
Bamboo brush and Chinese ink on rice paper
Sheet: 11 × 17" (28 × 43.2 cm)
Collection of the artist

2.13 BELOW
Jia-Xuan Zhang showing how to hold the brush correctly
Photo: C. Dantzic

Unit B
Clustering Line:
Tone and Texture

THE CUMULATIVE EFFECT OF LINES

The additive result of placing line against line, building a surface of texture and tone, is derived from the necessary two-dimensionality of applied lines; that is, their width. The ink, graphite, or carbon deposited on the page by a single line occupies space and, when repeated or combined with other markings, can become an inseparable unity, a new entity seen as a cluster, field, shape, or form.

In Section 1, Unit D, where linear exercises developed by Josef Albers were presented, the first of these showed the development of control between eye, hand, and brain to create a series of parallel straight lines without a ruler, freehand. At that point, the focus was on cumulative repetition to build skill and facility (see fig. 1.64). This same sequence of exercises may be followed to create varying effects of tone, surface, form, and space.

Assuming a certain proficiency in achieving the elusive straight-line-without-a-ruler, we will proceed directly to several specific uses.

Exercise:

At the upper left-hand part of a page, draw a single vertical straight line, perhaps 1$\frac{1}{2}$" in height. Continue adding parallel lines across the page, exactly the same height, but slowly moving farther apart until the distance between them seems too far to maintain any visual relationship. Then begin to place the lines gradually closer until they almost appear to merge. Leave a clear separation between lines, even if the intervening space is no wider than the pencil line itself. Maintain an even pressure so that lines remain constant in weight and tonality, any effects achieved resulting from clustering or spacing alone.

Once you have a sense of the limits of separate linear elements to work together modifying the visual surface, draw a continuous band of lines growing steadily apart, then together, in a regular rhythm. Show several full transitions of spacing along a single band (see figs. 1.66–1.68).

Study this linear flow to read clear differences in light value (levels of grayness or dark-and-light quality). If you have prepared a gray scale (see fig. 3.6), compare its slow, continually intensifying tonal movement (from almost-white to almost-black) with the more subtle shifts you see here.

For a rich visual workout, develop a full gray scale by means of this exercise. Later, you might add the elements of enhanced dark and light, using a number of different pencils (from 7H to 4B), but at this point use a single pencil to develop your ability to control tone by spacing alone.

Optional Exercise:

Create a smoothly flowing, almost pulsating band of straight lines that moves from dark to light to dark to light with a constant rhythm across the page. This is the kind of study some find entrancing and challenging, and they almost compulsively rework it until they are satisfied. Works of breathtaking precision, glowing with bursts of lights and deep hollows of darks, may be produced (fig. 2.14).

When you have a satisfactory band of undulating linear tonality, place a second band of identical tones beneath the first, alternating the areas of dark and light; where the first band showed lines closest together, the second will place them at their greatest distance. The page begins to assume a three-dimensionality with the push and pull of darks and lights.

Additional alternating bands of evenly placed lines will produce a remarkably pulsating, never-flat effect. This is one of the means used to create the eye-dazzling visual illusions known in the 1960s and beyond as Optical or Op Art (fig. 2.15; see also p. 85).

2.14 ABOVE
Albers student: Ruthe
Seifert
Alternating tonal bands
1950s
Pencil on newsprint
11¾ × 17½" (29.8 × 44.5 cm)
Josef and Anni Albers
Foundation, Orange, Conn.

2.15 RIGHT
Bridget Riley
Current
1964
Synthetic polymer on
composition board
4'10¾" × 4'10⅞" (1.49 × 1.5 m)
The Museum of Modern Art, New
York. Philip Johnson Fund.
Photograph ©1999 The Museum
of Modern Art, New York

Optional Exercise:

You may choose to carry this study to a full page of bands alternating and shimmering with a push–pull space and tonality. Variants include swelling and compressing the bands—wider to show the expansion of lighter bulges, and narrower in receding darker depths. Compare these studies with continuous tone exercises of a similar nature in Section 3, Unit B.

Some questions may arise: Are these simply exercises, useful in building skill and control in freehand drawing? Certainly they are not perceptual; they do not represent objects perceived. Or are they conceptual drawings, even *art*, pursuing an idea and giving it visual form? Do they possess that quality we sometimes call beauty? In which beholder's eye? We may often agree on the beautiful in nature; would we be as likely to agree to the nature of beauty in drawing (see pp. 182 and 184)?

Exercise:

Devise additional variants of this study to produce a full page or a specific shape (e.g. 5 × 7") filled with smaller, modular units such as squares, repeated identically, reversed, or turned in a sequential way. Create three of these works, thinking of each, from the start, in a different way. Let one be a linear exercise, one a modular pattern, the third an experimental drawing.

Questions

Does the definition affect the work itself or the way in which you see or approach the drawing of the work? This may well be a reason for opposition to the use of newsprint. If you know the drawing won't last, that it is on an impermanent surface, will you make your best effort? Will you devote time and energy to a work destined to disappear, or to one that you think of as *only a sketch*? (Are these questions appropriate? Should they be reserved for a discussion of art appreciation, esthetics, or philosophy? Would your time be put to better use just drawing, leaving the thinking and talking to an instructor? See fig. 1.76.)

2.16
Vincent van Gogh
Tree with Ivy in the Asylum Garden
1889
Pencil, chalk, reed pen, and brown ink on Ingres paper
24 × 18¼" (61 × 46.4 cm)
Van Gogh Museum, Amsterdam

To this point, our investigation of the cumulative effect of line has stressed parallel straight lines. From such studies it will be possible to make the transition to softer, more curvilinear applications of linear tonality. The form-describing, contour-seeking line shown in Section 1, Unit C, provides a perceptual introduction to this development. (Of the three-way drawings suggested on p. 76, this is the second.) Study the student drawing of the linear tone pine cone (see fig. 1.60) for a fairly free interpretation of the idea, with lines drawn as descriptive contours flowing directly into these, revealing form and light value. Do you think this student had spent much time working with the more formal parallel linear straight-line exercises?

Modifying physically parallel linearity, introduce lines that follow a visually parallel path, following the contours of forms, seen on surfaces as well as at perceived edges. Such lines actually converge and diverge to produce their light and dark effects. But this use of light as light value need not relate to light as it is perceived. A conceptual kind of linear tonality used to describe dimensionality, it may not show the reflection of light on a particular surface.

2.17
Paul Cézanne
"Milo of Crotona," after
Pierre Puget
c. 1882–5
Pencil on paper
8½ × 5³⁄₁₆" (21.8 × 13.2 cm)
Kupferstichkabinett, Kunsthalle,
Bremen, Germany

Multiple Uses of Illustrations

While this book and any text may, for the purposes of investigation and emphasis, focus on a particular aspect of a work, there is always more to be said about any illustration, more to be discovered through study than the immediate subject. Indeed, every drawing in this volume has been selected with an eye to its multiplicity of uses, its ability to show several of the ideas momentarily extricated from the whole fabric yet, in actuality, inseparable from the unity that gives it visual integrity (fig. 2.16).

Linear tonality can become a heavy overlay giving texture, as well as a feeling of surface form, to a subject. But used with subtlety it may indicate such qualities in a restrained, quiet way (fig. 2.17); surely there is room in our visual lexicon for both.

TEXTURE

When we indicate texture in a drawing, is it the feeling of material, the furriness, glassiness, leafiness, silkiness, that we are somehow able to sense with the "fingertips" of our eyes? Or does the term refer as well to the visual feel of the material with which the work has been made, the tactile essence of the drawing itself? Can a drawing somehow contain and present both at once through the use of line alone (figs. 2.18 and 2.19)?

2.18 RIGHT
Pablo Picasso
"The Pigeon," from
"Histoire Naturelle" by
Buffon
Paris: Martin Fabriani, 1942
Lift-ground aquatint
16¹/₄ × 12³/₈" (41.5 × 31.5 cm)
Musée Picasso, Paris. Photo:
©R.M.N.—Coursaget, Paris.
©Succession Picasso/DACS 1999

2.19 RIGHT
Lee Mamunes
Sensuous Trunks
1988
Pen and ink on paper
18 × 21" (45.7 × 53.3 cm)
Collection of the artist

When you think of *text*ure, associated words may come to mind: *text*iles, a book's *text*, the con*text* determining whether threads, words, or individual letters are the units being woven together. But always there is a sense of bringing individual elements into a single unity; there is a modularity about the idea of repeated elements seen at a distance or on a scale at which they appear to merge inseparably (fig. 2.20; see also fig. 2.29).

Exercise:

Make a crayon rubbing of any strongly textured surface, such as the bark of a tree, a brick wall, woven basket, grainy piece of wood, or kitchen grater. With pencil markings of a linear nature (dots, dabs, broken strokes of any kind), try to re-create the sense of the actual surface captured by the rubbing process (fig. 2.21). Then subdivide the surface into component elements by enlarging or reducing a portion of the texture. Continue, enlarging or reducing again, to reach the essential unit from which the visible surface texture was composed. Certainly some of this will involve imagination, experimentation, and a willingness to play with the idea. If pencil does not seem to produce the results you need, repeat the sequence with brush or pen and ink, or crayon, charcoal, or ….

2.20 ABOVE
Elizabeth Catlett
Sharecropper
1968
Color lithograph
17 × 16¹/₂" (43.2 × 41.9 cm)
National Museum of American Art, Smithsonian Institution, Washington, D.C. Photo: VAGA, New York. ©Elizabeth Catlett/DACS, London/VAGA, New York 1999

2.21 LEFT
Albers student: Paul Boatwright
Linear study of wood
1950s
Pencil (top) and marker (bottom) on newsprint
11 × 16" (28 × 40.6 cm)
Josef and Anni Albers Foundation, Orange, Conn.

2.22

Cooper Union student: Ken E. Okiishi

Self Portrait

1998

Xerographic reduction

11 × 8¹/₂" (27.9 × 21.6 cm)

Exercise continued:

To reveal hidden insights into the very core of texture, use a photocopier to develop a crayon rubbing of a particular surface. Place the rubbing on the glass and enlarge the image as much as possible, perhaps by 150 per cent. Try the same magnification at varying levels of contrast until you are satisfied; then enlarge a portion of the enlargement, and continue in this way until you reach a surprising stopping place.

A sharply focused photograph may be used in place of the crayon rubbing. Select a surface that does not appear to contain much texture at all—perhaps a fabric book jacket, tablecloth, sea shell, or wall. The xerographic enlargements of this subject may surprise you even more that those of the rubbing.

Use these studies as the inspiration for a set of drawings, reducing each to its simplest linear form (fig. 2.22).

Some questions to consider: Are these studies more perceptual (related to what you are seeing) or more conceptual (related to an idea you wish to show) (see p. 270)? At what point does the nature of the drawings seem to move from one of these categories to the other? It has been said that if you seek, you shall find; perhaps you will find more to be seeking!

Optional Exercises:

Develop a modular, conceptual, repeat-pattern work, perhaps within a grid format. Maintain the look of each unit for the most successful textural result.

Repeat the modular drawing with greater or lesser line density in each unit, changing the overall tonality to affect the textural surface. As the final step in this sequence, study the original surface and draw it anew as though you had never seen it before.

Perhaps you will not have to pretend; surely you will see something that "wasn't there" before. (Does *there* refer to:

- *There* in the texture itself,
- *There* on the paper, or
- *There* in your mind's eye?)

Unit C
Linear Surface:
Defining Form

LINING UP FORM, CONCEPTUALLY

Although a surface defined by line may maintain its flatness, imposing a planar frontality upon the page, a remarkable degree of roundness and depth can also be suggested through line alone. Factors affecting these differences include straightness or curvilinearity of lines, and similarity or variety in their length, weight, shape, spacing, and placement.

In the previous Units you saw the flat *integrity of the picture plane* respected by an even placement of similar lines, then interrupted in a regular pattern of push and pull through controlled spacing adjustments (see figs. 1.66 and 1.68). The lines, though drawn freehand, were straight. A number of contemporary artists, such as Sol LeWitt (color plate 4), have developed a virtual catalogue or sampler of surface-covering linear meshes, latticeworks, and screenings, as well as freer but controlled linear webbings and gridlike intersectings of imposing invention. Some of these have been realized on a very large scale, often by the artist's assistants following verbal or written directives, directly on the walls of galleries and museums. Overlapping sets of parallel lines are often used to achieve LeWitt's varied effects. In some instances, the finished work cannot be seen until it has been installed *in situ*.

Exercise:
Draw a series of parallel lines within a defined square or rectangular space. Repeat this sequence in several identical spaces, and overlap each with a different set of parallels to create as great a variety of surfaces as possible.

Exercise continued:
Try a similar page of square or rectangular studies. This time, allow the sets of lines to move away from the parallel in both directions. Start with a slight digression, then move farther away until you find the most comfortable relationship between the two linear groupings. In the last few drawings the two opposing sets of lines may weave together so that their orchestration is stronger than the identity of any particular line.

Invent a variation of this study, but develop it in a regular additive way.

Exercise:
When curves are introduced, the picture changes remarkably. Flatness

gives way to rounded form and spatial separation of elements occurs. Before we begin to work with the linear surface from a pictorial or perceptual perspective, a few simple exercises should show you how dramatic this difference can be. Draw a vertical straight line about 2" high. In the air (in imagination) draw a slightly curved line attached to this one at top and bottom. This can resemble a long and stylized capital letter C. When this arc seems smooth, draw it on your paper. Add a second, wider arc in the same way, then several others, each equally farther at the center from the straight starting edge. Stop when you have drawn a nicely rounded half-sphere; then add the other half on the other side of the mid-line. Repeat this several times until you have drawn an evenly rounded, shaded ball.

Exercise continued:

Draw a similar ball shape, but without the originating vertical. Work out how far from that central axis you can begin, maintaining the roundness and spherical quality of your globe. In how few lines can this be achieved?

Exercise continued:

Repeat the entire sequence, starting with a horizontal at the center. Does this kind of roundness look somehow different? What happens when you begin with a diagonal?

In these studies, you will notice the same cumulative effect (lines creating a darker field as they move closer, and a lighter one as they separate) that we have seen in Section 2, Unit C. However, when lines do not approach in a parallel sequence but converge, the effect can be stronger, smoother, and yet more subtly applied. In the same way, as they diverge, the opposite result is enhanced.

FORMING WITH LINE, PERCEPTUALLY

All these points have been made without the observation of an actual subject. When they are applied to objects of perception, a new dimension can be added.

Study the curved-line bits and pieces that make up the broken contour of the hands in figure 2.23. Each small linear element describes the turning of a particular place on the form, where the visual edge curves away and moves out of sight. As the full three-dimensionality of the hand is a complex aggregation of muscle, fat, skin, and their bony support, this is a highly irregular, idiosyncratic structure. (See Section 5, Units A and B, introducing the basics of human anatomy, for greater understanding of the specifics noted here, but try to work from an actual subject where indicated; see fig. 1.38.) The hand is quite appropriate for this focus: It is an instance of the right hand knowing what the left hand is doing; one posing, the other drawing!

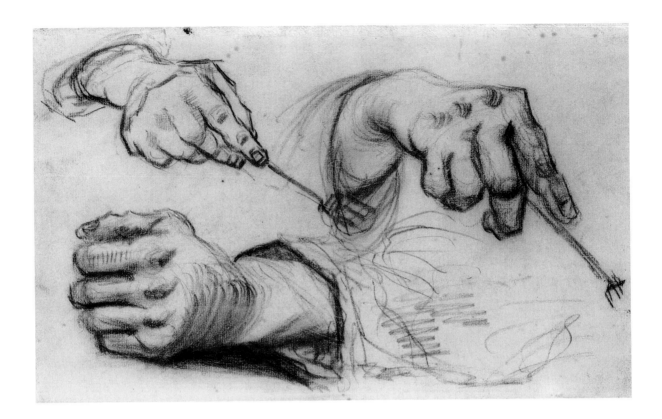

In the following broken contour study, the length and curvature of each line will vary with the needs of the subject. In some places, few lines are called for, the form almost melting away from view. In other places, much detailed information can be conveyed by careful use of many small visual clues and their exact interrelationship.

But we can add lines that describe more than the physical contours of form at their perceived edges. Very much like those in the Exercise on page 109, lines generally parallel with or converging with contour lines may be used to show greater volume, roundness, surface texture, or even light and dark tonality. Before attempting the complex hand, try these effects as seen in a simpler, yet organic, subject. See how van Gogh animated entire landscapes through selective linear orchestration (fig. 2.24). Select a regular, perhaps symmetrical object as a good starting place.

2.23
Vincent van Gogh
Three Hands, Two with a Fork
1885
Black chalk on paper
7⁷/₈ × 13" (20 × 33 cm)
Van Gogh Museum, Amsterdam

Exercise:
Place an egg or small rubber ball on a sheet of paper and visualize (in imagination) a series of bands ringing the form, as lines of latitude on a globe do. Imagine a great many such bands, perhaps subdivided into a greater number. Then draw the very turning edge of each band as it moves around and behind the form, disappearing where the next band overlaps it. Do this as lightly and as simply as possible. Or try the human figure (fig. 2.25).

2.24 RIGHT
Vincent van Gogh
Olive Trees with the Alpilles
in the Background
1889
Pencil, pen, reed pen, and
ink on paper
18¹/₂ × 24¹/₂" (47.2 × 62.5 cm)
Staatliche Museen zu Berlin—
Preussischer Kulturbesitz
Kupferstichkabinett. Photo:
B.P.K., Berlin/Jörg P. Anders

2.25 BELOW
Albers student: Warren
Scadron
Figure study
1950s
Pencil on newsprint
17¹/₄ × 11³/₄" (43.8 × 29.8 cm)
Josef and Anni Albers
Foundation, Orange, Conn.

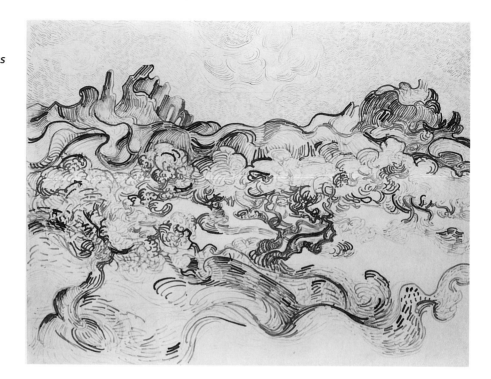

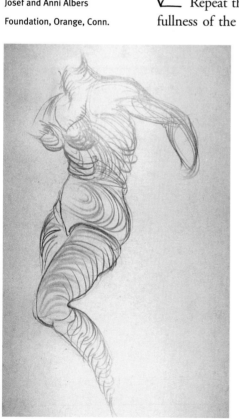

Exercise continued:

Repeat this idea with a piece of fruit, e.g. an orange or pear, allowing the fullness of the object's form to push its way out from the center in a kind of inflated turgor (see p. 86). With this growing organic form, small divergences from the parallel will develop. A lopsided green pepper or cauliflower could provide the next subject. Now you can play more freely with the broken contour as well as with adjacent linear enrichments; eventually they will be seen as inseparable.

Exercise continued:

Draw a hand, using your own non-drawing specimen if you wish (see fig. 1.38). It may be preferable to ask a friend to pose so your full attention can be directed to the task instead of dividing yourself, half into the artist, half into the model trying to keep still.

Work slowly and (at least the first time) be painstaking and meticulous. This does not mean be fussy or put in too much detail, too many lines. It suggests that you look with great precision, study the origin and destination of each curved contour, and put down exactly what you wish to show about the specific part of the form you are seeing. You risk inaccuracies in proportion or in perspective or in the

relationship of the various component parts of the form but, at this point, don't worry. This is an exercise in perception of form and contour, of linear orchestration and surface.

As an interesting variant, try a hand wearing a woolen or soft leather glove. The glove may be drawn over the first study on a sheet of translucent vellum or heavy tracing paper. All these studies may be repeated as overlays on top of studies of the skeletal structure of the hand, which will be introduced in Section 5 (fig. 2.26; see also figs. 5.16a and b).

A Note on Proportion

A sense of proportion, of the correct relationship of parts to the whole, will develop almost automatically as you continue to study and draw from observation. Certain measurements and traditionally respected guides to beautiful proportions, such as the Golden Mean and the Equiangular Spiral, can be of immeasurable value (see the Bibliography and also p. 192).

HATCHING AND CROSSHATCHING

The term *hatching* may describe the more or less parallel, form-following, multi-linear, surface-covering drawing we have been exploring in this Section. The term seems to relate best, however, to a more formal use of the technique as seen in engravings, etchings, wood engravings, and illustrations from the Renaissance to the present day (fig. 2.27).

Crosshatching, a more complex development of the idea, involves the addition of a second clustering of more or less parallel lines drawn at an angle to the first set of hatchings—across them, as the name implies. Handled expertly by masters such as Leonardo and Michelangelo, and many others, including Picasso, this technique can bring great richness, texture, tonality, and expression to drawings (fig. 2.28). Particularly in studies of the human figure and of drapery, crosshatching can provide a means of enhancing volume and form without losing the individual sense of each

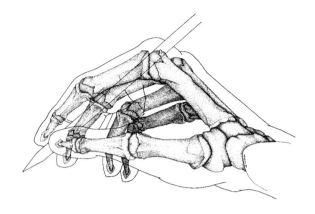

2.26 ABOVE
L.I.U. student: Alix Rehbock
Drawing of hand with
skeleton
1980
Pen and ink on paper
4¹/₂ × 7" (11.4 × 17.8 cm)

2.27 BELOW
Albrecht Dürer
Six Pillows
1493
Pen and ink on paper
10⁷/₈ × 8" (27.6 × 20.2 cm)
The Metropolitan Museum of Art,
New York. Robert Lehman
Collection, 1975 (1975.1.862)

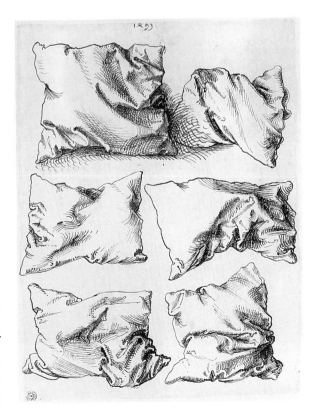

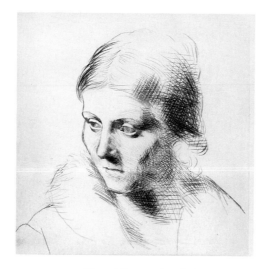

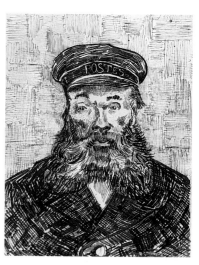

2.28 RIGHT
Pablo Picasso
Portrait of Madame Picasso, II (Olga)
1923
Drypoint on zinc
19$\frac{1}{2}$ × 19$\frac{3}{8}$" (49.5 × 49.2 cm)
Musée Picasso, Paris. Photo: ©R.M.N., Paris. ©Succession Picasso/DACS 1999

2.29 FAR RIGHT
Vincent van Gogh
Portrait of Joseph Roulin
1888
Reed quill pens, brown ink, and black chalk on paper
12$\frac{5}{8}$ × 9$\frac{5}{8}$" (32 × 24.4 cm)
The J. Paul Getty Museum, Los Angeles

2.30 BELOW
Rembrandt Harmensz van Rijn
The Shell (Conus marmoreus)
1650
State 1: etching reworked in drypoint and burin
3 states: 3$\frac{3}{4}$ × 5$\frac{1}{4}$" (9.7 × 13.2 cm)
Rijksmuseum, Amsterdam

component line. The path of the artist's hand over the surface of the page is completely retained (fig. 2.29).

USES IN PRINTMAKING

In *etching*, separate lines may be drawn through a waxy, resisting surface covering a metal plate before being permanently bitten into the metal during an acid bath, then inked and heavily impressed into thick, damp paper. These elaborate technical procedures may tend to obscure the basic linear drawing that defines such works. Hatching is often employed in etching, as are crosshatching and other cumulative linear techniques. When would you call these prints *drawings*? When would you call these drawings *prints*?

Rembrandt's etching *The Shell* (fig. 2.30), which we will study later for its rounded form, light and dark structure, and use of tonal contrast, shows layered hatchings and crosshatchings, flat and form-hugging curved lines, almost woven into a tight fabric of surface-covering linearity. On careful study, you can always distinguish its separable component lines and retrace the hand of the artist at work (use a magnifying lens to be sure).

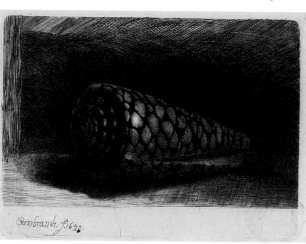

Engravings are made by gouging lines deeply into the surface of copper, other metal, or even hard acrylic plates, then inking the grooves and printing, in much the same way as with etchings. It is possible to produce extremely minute details in engravings, to cover the surface completely in webs and meshes of overlapping hatchings and textures. Generally, engravings can appear more rigid and less spontaneous than etchings, but freely drawn, fluid, and elegant engravings can certainly take their place among those works we call master drawings.

Plate 3 RIGHT
Vincent van Gogh
Red Cabbages and Onions
1887
Oil on canvas
19³/₄ × 25³/₈" (50 × 64.5 cm)
Van Gogh Museum, Amsterdam.
Vincent van Gogh Foundation

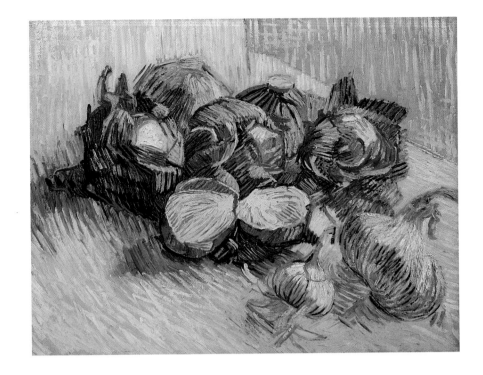

Plate 4 RIGHT
Sol LeWitt
*Three-Part Combinations of
Four Directions (Horizontal,
Vertical, Diagonal Right, and
Diagonal Left) in Three Colors
(Yellow, Red, and Blue)*, detail
1975
Pen and colored ink on tracing
paper
Full image 18¹/₈ × 24" (45.9 × 61 cm)
©ARS, New York and DACS, London
1999

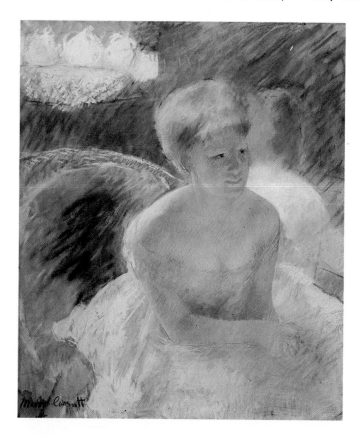

Plate 5 LEFT
Mary Cassatt
At the Theater (Woman in a Loge)
c. 1879
Pastel on paper
$21^{13}/_{16} \times 18^{1}/_{8}$" (55.4 × 46.1 cm)
The Nelson-Atkins Museum of Art, Kansas City,
Miss. Purchase: acquired through the generosity
of an anonymous donor. ©The Nelson Gallery
Foundation. All Reproduction Rights Reserved

Plate 6 BELOW
Bill Traylor
Blue Goat
1940s (undated)
Pencil and gouache on cardboard
12 x 18" (30.5 x 45.7 cm)
Photo: ©1998, Sotheby's, Inc., New York

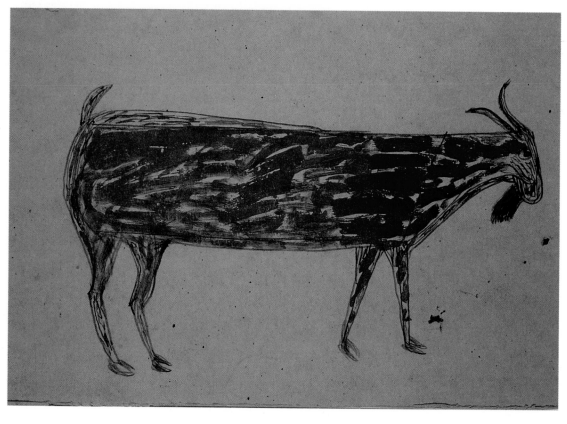

IDENTIFYING THE LINEAR SURFACE

Linear surface can refer to all or part of a drawing. The space within an object's visual boundary may be treated as a unified linear field, or the entire picture plane may be filled with markings defining its spaces between, as well as within, objects or subject matter (fig. 2.31). In such works, the entire drawing is the subject that matters!

Study the chrysanthemum drawing by Mondrian to see a focal form defined by contours, parallel linear tonality, hatching, and other markings (fig. 2.32). Mondrian made many drawings of these and other flowers, each using line and tone in a different way. In at least one, he has flattened the space behind the flower by using a series of straight-line parallels and hatches, adjacent to a remarkably rounded blossom whose individual petals seem almost carved by their form—following parallel-line description (see figs. 0.17 and 4.33a and b and color plate 9).

As a kind of transition between linear and tonal drawing, some artists use a broad stroke in an up-and-down or side-to-side rhythm, sometimes overlapping and blending, losing and finding traces of their basic linear impulse. Kollwitz's *Self Portrait, Drawing* (see fig. 2.33) epitomizes this idea, suggesting the actual experience of drawing.

2.31 ABOVE
Jacques Villon
Interior
1950
Pen and ink on paper
9¹/₈ × 6³/₄" (23.1 × 16.9 cm)
The Museum of Modern Art, New York. Gift of John S. Newberry. Photograph ©1999 The Museum of Modern Art, New York. ©ADAGP, Paris and DACS, London 1999

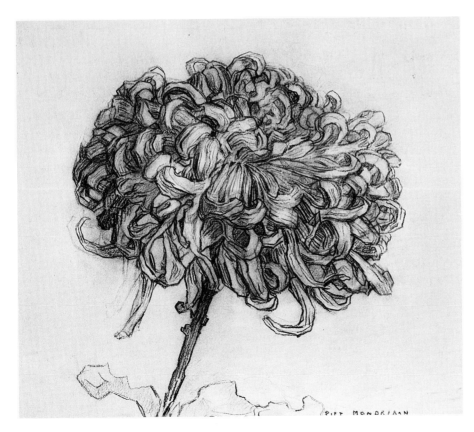

2.32 LEFT
Piet Mondrian
Chrysanthemum
1908–9
Charcoal on paper
10 × 11¹/₄" (25.4 × 28.7 cm)
Solomon R. Guggenheim Museum, New York. Photo: Robert E. Mates, ©The Solomon R. Guggenheim Foundation, New York (FN 61.1589). ©Mondrian/Holtzman Trust, ᶜ/₀ Beeldrecht, Amsterdam, Holland/DACS, London 1999

Exercise:

Select one of your contour line drawings from Section 1, Unit D—perhaps the pine cone, sea shell, rope, knitted garment, or flower. Choose a fairly small, clearly defined study, and draw a rectangle around it. Make several exact or very similar copies of this drawing, either by hand or using a photocopier. Complete each new work in a different way, choosing from among these ideas:

- Following the form of the original contours, add supplementary parallel lines to develop the three-dimensionality of the object, without adding tone or shading.
- Following the form of the original contours, add converging and diverging lines to add three-dimensionality as well as dark and light tonal value.
- Around the drawing of the object, add straight-line parallels to flatten the background or field. Then develop the drawing of the object in one of the ways described above.
- Add linear markings on both sides of the original contour drawing until you have merged the object into its surrounding space, filling the entire rectangle.

Develop each drawing differently, using lines in a variety of new ways. If you need more copies, produce them. Can a *copy* be a kind of *original*? How? If you use a copier, finish the drawings with a dark ebony or IBM pencil or with a pen and India ink so that your new lines become an indistinguishable part of the whole. Can a computer printer be used for this purpose?

As a final investigation for this Unit, study several paintings of Vincent van Gogh in which he used a brush and paint to develop the surface in a linear, field-covering way, much as we have been discussing with monochromatic, single-color drawings. See these as *painted drawings* or perhaps *drawn paintings*—if you would like to coin a new term.

Are all of van Gogh's works developed in this way? Did he tend to use this method more, or less, as his work matured? Have other painters developed this or a similar idea? Do you consider van Gogh's drawings and paintings more a reflection of his visual perceptions or more an expression of his feelings about a subject (color plate 3)?

This brings us to a consideration of the role of emotion, and a new Unit of study.

Unit D
Expressive Line: Delineating Emotion

DRAWING ON EMOTIONS

Some drawings are criticized as lacking emotion or feeling. Works in mechanical drawing, for example, may look accurate in proportion, with correct perspective, and be well-drawn in every particular, but are just not right, just not *art*.

What is found wanting in these works? Whose emotion has been overlooked—that of the person who made the drawing or the person looking at it? Several questions may be asked:

- What is the relationship in drawing between perception of and feelings about a subject?
- Can emotion be depicted, or can it only be suggested, evoked, recalled?
- How can the artist show differences between responding with emotion, calling forth a response in the viewer, and describing feelings experienced by the subject of a drawing?
- Is it better to discuss these ideas in a general, philosophical way, or with specific drawings in view? (See fig. 0.11, and any others you may choose.)

Do you believe emotions have no place in drawing so long as the artist honestly depicts what is seen? Perhaps you believe that visual accuracy is not important in drawing, so long as you honestly express your feelings about what you see or imagine. Or do you believe that all drawing involves a response of some kind, whether to a perceived, remembered, or imagined subject or to a conceived, constructed, or proposed idea?

If you would prefer to consider this a little longer before casting a vote, let us look at various options.

DRAWING AS REFLECTION

In purely perceptual drawing, you may aim at creating a reflection, as in a mirror, of what you see. Philosophers have long debated the exact nature of this activity, posing various queries relating to the thing being seen, and the mind, eye, or optical equipment doing the seeing. One problem is that an object, existing in the round in space, can never be seen in its three-dimensional entirety at a stopped moment from an unmoving place or viewing point (see p. 163). Parts of the object, turned from the eye, are out of sight at any given time, so the whole can never be shown at one time. (The Cubists addressed this, among other concerns.) Before you start to draw, therefore, you must choose one spot from which to let the subject present itself to your eye and to represent what you see on your paper. Will you place the object at eye level (looking at it square in the eye); will you place yourself above the object (looking down on it) or below it (looking up to it)? Read the attitudes built

into each of these viewpoints! Can you eliminate them? Do you want to?

Will you show the object small, surrounded by much space (from afar, alone, vulnerable); or large, with little, if any, surrounding area (in your face, up front, aggressive)? Do you agree that simply selecting your physical position in relation to a subject necessarily involves some kind of attitudinal or emotional choice (see fig. 1.2)?

Upon reflection, do you think you *can* act as a mirror without somehow reflecting yourself?

Exercise:

Select a simple object toward which you have a strong response, positive or negative. Choose a slice of pie, a stuffed animal, a favorite hat, a dead bird, a cigar stub, a banana peel, or ….

Place the object on a large sheet of paper on a freestanding surface (a drawing board on a low stool, for instance) and walk slowly around it, bending down, then standing directly above it, until you see the subject in its most attractive position. Make a contour line drawing, describing what you see. Then, approaching the work from each side of the page with a straight edge, draw a rectangle around it, giving just the amount of space (air, breathing room) to enhance its appearance.

Put this drawing aside and circle the subject again, seeking a viewing point which brings out an ungainly, unappealing, off-balance, or other unattractive quality. Repeat the other steps, aiming at showing your negative feelings about the object, even in your cropping of the finished work.

Tack both drawings on the board, side by side. Can you see your feelings expressed in each work? Ask others which drawing is which. What seemed so obvious to you may be seen quite differently by others. How do you read the pairs of studies made by others? How might you modify these drawings to make your feelings more clearly seen?

RESPONDING WITH FEELING

True or false? When you study certain drawings, you can almost feel what the artist must have felt while doing the drawing (fig. 2.33).

Certainly you can experience a strong feeling while looking at drawings, but how can you know what the artist felt? Just as an actor may show and express powerful emotions called for by a role, regardless of personal involvement, an artist may call upon a number of means to elicit a response from the viewer. Do the artist's own feelings about the subject necessarily show? What can be done to enhance, ensure, or eliminate evidence of one's feelings? Can spontaneity be induced? Can the appearance of spontaneity be achieved?

Remember that questions often determine the responses possible. Can every question be answered True or False? Is this two-valued choice a useful model of our world? (Remember to answer this one True or False!)

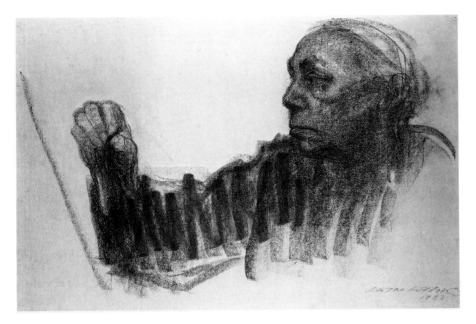

2.33 LEFT
Käthe Kollwitz
Self Portrait, Drawing
1933
Charcoal on brown laid
Ingres paper
$18^3/_4 \times 25$" (47.7 × 63.5 cm)
National Gallery of Art,
Washington, D.C. Rosenwald
Collection. ©DACS 1999

Here are suggestions of some of the emotions we respond to in drawings:

- Awe, sanctity, holiness, reverence (in icons and religious imagery).
- Fear, terror, anxiety, and revulsion (in images of war, hunger, poverty, death). Yet the etchings of Goya and the lithographic drawings of Kollwitz may elicit feelings of empathy, compassion, sorrow, and ... (see fig. 0.11).
- Pleasure, comfort, erotic attraction (in drawings of familiar objects or scenes, and of the human figure, at times; see figs. 0.9 and 0.18).

Facial expression and body language can evoke a great variety of responses (see figs. 5.48 and 5.30); also gesture and pose in animals and human subjects. Emotions such as hope, striving, despair, confusion, and oppression have all been conveyed through drawings of a politically or socially conscious inclination, sometimes in an exaggerated and excessive way, producing an effect other than that intended (fig. 2.34; see also figs. 5.22a and b).

2.34 BELOW
Honoré Daumier
Men of Justice ("He is a lawyer evidently full of such deeply rooted conviction . . . that his client will pay him very well")
1845
Soft black chalk on
yellowish slate
$6^1/_4 \times 8^3/_4$" (15.9 × 22.2 cm)

While we will investigate means of evoking specific responses from the viewer later, in Section 7, Unit C, dealing with the forming of feelings conceptually with the inner eye, here we will identify and try to use specific methods involving perceptual linear orchestration.

USING MATERIALS RESPONSIVELY

Dramatic variation in the use of drawing materials can suggest similarly fluid or changeable emotional responses to a subject. Drawing with the side of your pencil to produce a wide swath of tone

2.35
Rembrandt Harmensz van
Rijn
Lion Resting
After 1660
Pen in brown ink on paper
4¾ × 8⅜" (12.2 × 21.2 cm)
Rijksmuseum, Amsterdam

(growing stronger and darker with pressure, or softer and lighter as it is released) can convey a sense of quickly changing sensitivity to a subject in motion or about to move. It may be the mood or pose of the subject that is transient, or your fleeting perception of imminent change (see fig. 5.52).

With brush or pen, modification of pressure can be intensified by continuing to draw after the ink has begun to dry. This dry-brush line can be almost edgeless and pale, or heavily calligraphic and broad, all in a single sweeping stroke (see fig. 1.37). Simulating dry brushwork with the side of a soft pencil may be more successful if attempted after trying the actual brush technique. Rembrandt's drawing of a lion (fig. 2.35) shows a wide range of wet and dry brushwork. The resulting palette of tones and textures defines the animal's tense, unpredictable pose and produces strong feelings: of lightly checked motion, of potential danger in the animal's presence, of enviable elegance and poise, of confidence and strength. Are these feelings experienced by Rembrandt, the lion, or this author? Do you share any of them? How much emotion resides in the drawing and how much in the viewer?

Can you tell whether Rembrandt made this drawing in the actual presence of a lion, from memory, from a description, from the work of another artist? The only thing you can be quite sure of is that it cannot have been drawn, in the seventeenth century, from a photograph! Does the knowledge that this drawing is in various tones of brown ink, while you are seeing it in black and white, affect your response?

Exercise:

Taking the same subject as in the previous exercise, use a bamboo brush and ink to draw it three different ways. First, with a wet brush, keep the tip firmly pointed and make a thin contour-line descriptive drawing, varying pressure as little as possible.

Then, adding water to the mix to permit varied tonality, increase the pressure from time to time as you draw to give a greater range of richness and strength to the line.

For the third study, use a soft paper towel to absorb much of the ink and scrape the semi-dry brush along in a linear way to produce *scumbled*, textured, unpredictable markings, varying the pressure and adding a little ink as needed.

In the final drawing of this series, forget (or at least put out of your consciousness for the moment) what you have been trying to accomplish, set out pencil, brush, paper towel, and ink … and draw—with feeling!

Questions

What is the relationship between the emotion we believe to be felt by the subject of a drawing, that experienced by the artist, and that felt by the viewer?

Must they all be the same? How can we tell? One way would be to have the same drawing read by a group of viewers. Even if its message seemed clear, its emotional content self-evident, would everyone agree? Would it help to study the history of the work in advance; should the group know when and where it was drawn and by whom? Should they investigate possible literary allusions or historic references? What must a viewer bring to the experience of evaluating the emotional content of any drawing (see fig. 7.24)?

What questions do you need to ask before you can respond with appropriate feelings to the messages of the two drawings in figures 2.34 and 2.35? What emotions do you find yourself feeling without asking any questions? Does your reaction prompt you to investigate the history of these works after you have seen them? Is your interest stronger after having responded to them directly, without knowing their story? Would it have been better to know what response was expected of you before you invested any emotional energy in them? Are these the only choices?

Exercise:

Taking the same subject as in the previous two exercises, use a fairly hard pencil (perhaps a 2H) to make a drawing that shows absolutely no feeling toward the object. Try to make a consistent, unvarying line of even thickness and weight. Can you describe your feelings while making this study? Do you think your feelings can ever be completely left out of the picture? How do you feel about that?

The next Section will shed a little light on the subjects of our study, but from a different point of view.

Seeing the Light:

Clarity and Shadow

Unit A
Continuous Tone:
Line as the Edge of Shape

WHERE WE DRAW THE LINE

The edge between two shapes or spaces is seen as a line. On a flat surface, this periphery or border, when it encloses a completed shape, is assumed to belong to that shape or to the object it depicts. The place all around it may be called the background, continuing unseen behind the object and containing or supporting it. Is it possible to assign the edge-line to the unfilled surrounding space, so that the outer line of the object is also the inner line of the shape left over by the object? To think of outline (and perhaps inline) in this way, moving around the periphery between a two-dimensional shape-and-its-background, as a kind of moving point, with no thickness at all, makes it possible to see it as true one-dimensional line.

When Matisse cut shapes-and-their-surrounding-shapes together with scissors for his late cut-paper works, he felt that at last he was truly drawing in line (see fig. 1.15). His philosophy affected his actions, for the lines he sliced through each sheet of color produced shapes of equal vigor, interest, and elegance on both sides of the cut. For a finished work it was necessary to change some aspect of the surface on each side, or the line, having no substance, could not be seen. This was accomplished by a change in color.

In order to emphasize our concern with line, the exercises suggested may be completed in black and white or their mixture, grays.

Exercises:

Select two sheets of paper of different light value, from white to black, including any tones of gray. Lightly attach these with rubber cement. (Use ventilation; this cement should not be inhaled. It may be easily removed from a surface, unlike glue stick or acrylic glues. If removable spray adhesive is used, avoid inhaling this as well.) Use as a model a broad-leafed plant—preferably Matisse's favorite, the split-leaf philodendron—to complete Exercises A, B, and C.

Exercise A:

Using pencil, slowly draw several of the plant's most clearly defined leaves, with separate contour lines enclosing each shape you create, whether it is a part of a leaf or an entire leaf-form. Work freely, allowing the pencil to swim around the shapes in an interesting way, not necessarily copying what you see. Fill as much of your drawing area as possible.

With a pair of sharp scissors, slowly cut along each of your lines until you have created a group of shapes inside and outside the various leaf-forms. Do not use a knife or a heavy or blunt pair of scissors; you want flexibility and freedom of movement. Try holding the scissors in one spot, turning the paper as you cut.

Carefully separate the two layers of paper comprising each shape, and reposition the pieces so that you have two identical works, alternately toned, jigsaw-puzzle style. Glue each of these new wholes to two sheets of lightweight paper for support, placing them one on top of the other. Draw a single sinuous line through the entire top work, dividing it more or less in two, never allowing this new line to ride on an existing edge. Then separate, alternate, and glue as one work each new half-and-half study (figs. 3.1a and b; see also the Cubist idea of the split plane on p. 246).

Have you been drawing? Have you created leaf shapes and their backgrounds? Have you created shapes on either side of the edges of leaves? Does your attitude change the way you have been working?

Exercise B:

Repeat Exercise A, with one difference: Draw immediately with scissors, bypassing the pencil step entirely. Both these works are different from *collage*, since they have used *intarsia*, an inlaid technique, and not a freely torn, cut, or overlaid method. In the next study, consider adding elements of collage, retaining the linear edge as your major concern.

Consider these Exercises from esthetic, philosophical, botanical, art historical, and other possible viewpoints; then try this summarizing exercise.

Exercise C:

With a variety of differently toned papers (perhaps an assortment of Color Aid grays) plus black-and-white and newspapers, cutting directly with your scissors, make a full-page study of the plant and its environment. Try these formats: 5 × 7", 8 × 10", and 12 × 14". Pairs of papers may be tacked with rubber cement as you work and separated after cutting.

The finished studies may be used to inspire works in other mediums, such as woodcut, painting, and collage in color. You may wish to refer to a wider assortment of Matisse's collages than can be included here. What other artists come to mind, besides the Cubists?

FROM THE INSIDE OUT

In the previous exercises, line was seen as an edge, separating shapes on either side equally, regardless of their identity as filled or unfilled spaces, as figures, or as grounds. This is more readily seen when working with cut paper than when drawing on one side only with a material such as pencil or ink.

Still, the idea holds as true when you work inside a drawn line, even a sensitively responsive contour. There is a tendency to pay more attention to the shapes created inside the edge by the graphite or ink than to the shapes "left over" outside that edge.

Can the extra attention paid to these ill-named negative spaces give an additional strength and graphic quality to drawings (see figs. 1.19–1.21)? See the background-space drawing exercises on page 48 (which may indeed be re-examined here). These linear studies provide different understandings from those now being sought, in which we are concerned with determining edges

3.1a BOTTOM LEFT

L.I.U. student:

Kwang-Min La

Butterfly

1997

Cut paper

Sheet: 3 × 2" (7.6 × 5.1 cm)

3.1b BELOW

Henri Matisse

"The Lagoon," plate 18 of "Jazz"

1947

Painted and cut paper

16$^{1}/_{8}$ × 24$^{1}/_{8}$" (41 × 61.3 cm)

The Museum of Modern Art, New York. Photograph ©1999 The Museum of Modern Art, New York. ©Succession H. Matisse/DACS 1999

from the inside out, so to speak, but they supplement our present search as they emphasize the all-important figure/ground relationship. It is the terms figure (suggesting a solid, actual object) and ground (suggesting an empty, surrounding space) that confer an unequal, off-balance verbal sense to the idea. Consider alternative terms: containing, unfilled, or surrounding space, shape, or area. This kind of differentiation does make a difference; words do more than simply describe, as they actually determine the nature of our thoughts, and therefore our actions—in drawing as well as in other aspects of life. Turn to the Bibliography to find sources of additional material relating to General Semantics (see especially the entries under "Hayakawa").

Exercise D:

Using the philodendron as a model, select a single leaf, and find a place in the middle of its shape to begin working. With the side of your broad-edged or soft pencil, describe its dark, smooth surface, building a wide area of tone from inside the shape toward its edge. Stop only when you reach the border as you move the pencil around the form. Don't bother with small details or tonal modulations; it is the general shape of the subject you are seeking and delineating, from the inside out. Maintain a constant tone in this and the next exercise.

Exercise E:

To reverse the study just completed, draw the same leaf, using pencil to find the edge of the form from the outside. Start to build tone at a distance from the leaf, and let the pencil stop exactly where the philodendron starts. The leaf itself remains empty paper. These studies may also be done with a bamboo brush and India ink.

Exercise F:

Begin to melt away one edge of a pencil line drawn at the rim of the same leaf. First, using the broad side of your pencil and aiming the point at that rim (from inside or outside the borderline), draw the shape of the leaf. See that the point has created a fairly crisp, sharp edge, and the back end of the pencil lead has left a softer stopping place. With the side of the tool, continue that softer tonal area, almost immediately releasing some pressure, lightening the shade of gray. Continue releasing pressure and reducing the level of gray, until the pencil marking seems to melt away into the whiteness of your paper. You will then see a single linear edge around the leaf. Is the thin pencil wash of tone on the inside or the outside of the form? Repeat this study with less pencil work until the area of your tonal shading is as minimal as possible.

Exercise G:

The reverse of the study in Exercise F is accomplished by placing your pencil on the other side of the line, that is, aiming the point at the single edge from the outside if you have been working on the inner side, or from inside if you have been drawing outside the edge. Again, reduce the amount of pencil work in several re-drawings until you see barely a trace of tone on one side of the edge. The level of darkness of your original pencil marking will determine the weight of your final edge-line.

3.2 ABOVE

Juan Gris

Fruit Bowl, Glass, and Newspaper (detail on p. 124)

1918

Pencil on paper

14¹/₈ × 21¹/₈" (35.5 × 53.5 cm)

Stichting Kröller-Müller, Otterlo, The Netherlands

3.3 BELOW

Georges Seurat

Seated Boy with Straw Hat

1883–4

Black conté crayon on Michallet paper

9¹/₂ × 12¹/₄" (24.1 × 31.2 cm)

Yale University Art Gallery, New Haven. Everett V. Meeks Fund

Exercise H:

This is the alternate shading study referred to before (see p. 58). Draw the entire plant, or a smaller portion within a rectangular frame. Using the side of your pencil, aim the point at the varying visual edges alternately inside and outside each shape or form arbitrarily (not according to any seen or imagined plan of lighting). Each leaf or form should be drawn partly from the inside out, partly from the outside in. As before, try this several times, reducing the amount of pencil marking with each re-drawing. Eventually try to use the point of the pencil at the very edge, deciding later whether to melt the tone inside or outside the form. A light touch will help. If you begin with a heavily applied line, you will have to fade from black or fade to black, where no black may be called for at all. Diluted inks and watercolor can be used to melt brush-drawn lines in a similar way.

A number of artists have used this concept without necessarily giving it a name. Among those to study are Amédée Ozenfant, Georges Braque, and Juan Gris (fig. 3.2). The Cubists, in particular, found the idea useful in maintaining the flatness of the picture plane by treating objects and the spaces around them equally, giving neither side greater solidity, volume, or importance (see fig. 1.3).

Used with subtlety, and sparingly, alternate shading adds a sense of depth, a touch of light, a hint of volume, a richness you may miss in purely linear contour studies.

From scissor-separated cut-line shapes to barely perceptible wisps of alternately shaded pencil edges, you have seen one-dimensional, widthless line created in numerous dissimilar ways to expand the very definition of drawing (fig. 3.3).

Unit B
Edgeless Tonality:
Scaling Light and Dark

GROWING DARKER AND LIGHTER

Can there be drawing without some kind of line or clear separation of the differing shapes, areas, or places drawn? Our attention has been attracted to the edge of shape in a number of ways, but we have always returned to that borderline.

When you reduced pencil pressure, softening one edge of an applied line in the previous Unit, a first step toward complete elimination of the cutting-edge of line was taken. As you worked, gradually creating a fluid sequence of increasingly lighter tones finally melting into the white paper, you succeeded in removing any trace of an edge on the pencil-worked side of the original drawn line. This tonal wash can be greatly refined and simplified until it covers a very narrow swath along the remaining edge (fig. 3.4). Having achieved the evaporation of one edge, can you now make the other periphery disappear? What would remain after both vanished?

3.4

L.I.U. student: Hina Patel

Sliced Pepper

1996

Pencil on paper

Sheet: 22¹/₂ × 18"

(57.2 × 45.7 cm)

Exercise:

Draw an interesting, many-looped, curved line, not necessarily representing a particular subject. From the starting point, slowly soften one edge for several inches, swelling then reducing the amount of pencil work as you go until you are back to the mere thickness of the original applied line. Moving your pencil to the other side of the line, soften that edge also for several inches. Continue in this way, varying the length of the melt on either side, developing a single curving wash of soft pencil tone, alternating along both sides. At a certain point, perhaps approaching a large swell or bulge, begin to soften both edges at once as you proceed, controlling the width and tonal value of the edgeless swath by working one side first, then moving across to the other. Complete the drawing by adding additional linear, then tonal, pencil work up to the physical edge of the page or within a rectangular shape (see fig. 1.23).

As you study these drawings, can you identify places where line disappears and something else is introduced? Is there any apparent break in the

movement, direction, or visual velocity of the curvilinear sweep established by your original pencil line?

Is the full extent of the originating impulse of motion still apparent? Can you see a slowing of movement where the line has lost its edge? Is the suggestion of form enhanced or blurred? What else results from this treatment of line? Would you have developed the drawing differently if this had been clear at the start?

Exercise:
Using the side of your pencil, softly draw a similar curvilinear path through the space you have determined as the boundary of a new study. This time develop a continuous edgeless sweep of tonality along both sides of the pencil-path at once as you go. Allow the area of tone to grow or shrink freely, becoming darker or lighter as determined by the needs of the drawing.

Is there any remaining sense of line? Would you consider the single-direction flow of movement throughout the work a kind of linearity?

Areas of edgeless tone may sometimes be seen in nature. Where would you expect to find them? A productive experiment involves the use of a camera.

Exercise:
Using black-and-white film, take photographs of subjects that appear to show areas of tone without any clear edge: clouds, areas of sand, beach, and other water-surrounding locations. Watch shadows as they change out-of-doors under differing light conditions—shadows of trees and plants, shadows of people and animals, shadows of unknown origin. Inner portions of edged subjects, such as draped fabric, may be used so long as no sharp edge is seen.

Exercise:
Using the most successful photographs, make several edgeless drawings relating to, but never copying, the inspiring image.

How does reference to an original subject affect your finished drawings? Are they improved by illegibility or a non-referential appearance? (See Section 4, Unit C.)

Edgeless pencil, charcoal, or crayon forms can merge areas of differing light value; they do not need to move from black to white, but can show any intermediate tones of gray (fig. 3.5; see also fig. 1.29).

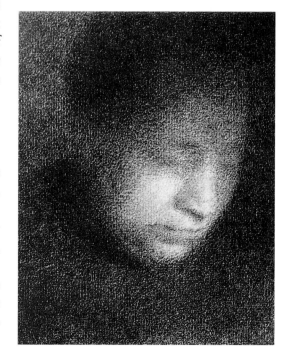

3.5

Georges Seurat

Madame Seurat, Mother

1882–3

Charcoal on paper

12 × 9¹/₄" (30.5 × 23.3 cm)

Private collection

3.6

L.I.U. student: Peter
Maslow

*Gray scale with central
band*

1992

Pencil on paper

Sheet: 11 × 8¹/₂" (28 × 21.6 cm)

MUTUAL CONTRAST: THE GRAY SCALE

The very words "gray scale" have been known to cause wholesale page-turning, although the visual magic you can create by playing this scale may turn you into an enthusiast after a demonstration of its amazing effects. Study figure 3.6 and the examples in figures 2.14 and 3.9, trying to count the number of different shades or tones of gray they include. Are there clear separations among tones, or do they blend into a single seamless flow? Should such a scale be subdivided into steps? Why? Why not?

If you imagine pure white to be the equivalent of #1 (100 per cent light) at the top of a hypothetically complete scale and pure black to be #10 (0 per cent light), what range of grays is seen in the scale shown? Is every tone or shade of gray from 1 to 10 included? Would a complete scale have to be considerably longer than the height of this page to cover the entire tonal range? Could the scale be reduced in size, but still include the full number of tones?

Look at the central band of grays running the length of the scale in the opposite direction, that is, lighter at the dark end of the scale and growing steadily darker toward the light end. Does this central strip appear to contain all the tones of the larger outer gray scale? Let us investigate.

Exercise:

Use two wide strips of white paper (the height of this page and half as wide) to cover the outer gray scale, leaving a white ground on either side of the central band. What has happened to the carefully modulated central band of grays? Where did it go?

Clearly, the physical fact is that the central band does not change at all, but remains one tone of middle-gray throughout. Study it carefully to see that this is so, then remove the masking sheets and try to see the central strip as the single continuous tone you know it to be. Just as clearly, seen against a modulated ground, the central band performs its visual magic and, in an equal and opposite way, assumes all the subtle tonalities of that surrounding field.

At this point, you have demonstrated a major and seemingly irreconcilable condition of visual perception: that there is a discrepancy between physical fact and visual or psychic effect. In his pioneering text *The Interaction of Color*, in his teaching, and in his art, Josef Albers based much of his work on this observation and its applications.

Which is true? Is the strip one tone as you see it physically? Or is it a graduated field of grays, as you see it against the outer gray scale?

Perhaps the discrepancy is semantic, a question of words. Under one set of conditions, the strip is seen one way and under another set of circumstances, another. If this is so, then the apparently irreconcilable situation resolves itself.

The gray you see is determined by the gray that surrounds it. This effect, sometimes called Mutual Contrast in the visual arts, has applications in other areas, particularly the sciences, where it is often noted that "an event is affected by its environment." In order to discover ways in which this idea can be of use, we shall begin with several scales of gray.

Exercise:

On a single full-size sheet of paper, draw a series of gray scales in this way: Near the upper left-hand corner, begin to build grays, in even steps, from white paper to the deepest black your darkest pencil can produce, without edges between them. Each scale should be about ³/₄–1¹/₄" wide.

To maintain a clean edge, use a strip of white artist's tape along each side, a good eraser afterward, or great care as you work within softly drawn guidelines. Leave a few inches, and to the right draw a better, more evenly modulated scale. Leave a few inches, and again try to improve the flow of tones from light to dark. Each scale may be a different length as you work to improve it. You may have space for five or six scales on one sheet, if you have held the paper horizontally.

Placing a sheet of clear tracing paper beneath your drawing-hand's heel as you work (to avoid smudging, but permit you a full view of your drawing), surround the first gray scale with a single dark tone on all sides. Make this tonal ground wider than the gray scale itself. Surround the second scale with a gray about the same light value as your middle tone. Leave the third scale surrounded by white paper. For the fourth scale, slowly build a graduated gray scale behind it, moving in the opposite direction. Behind the fifth scale, place a solid dark along one side and a modulated scale on the other. If you have made additional scales, invent other varied grounds to surround them. Then place the page at a distance, perhaps tacked to the wallboard, and study the various effects achieved.

Do you see the discrepancy between fact and effect? More important, do you see that no tone at any light level is permanently fixed in your drawing until it can be seen in its final relationship to all the tones that surround it? Are there places where tones blend, edge disappears, and spatial relationships seem to reverse? What happens when you squint to reduce subtle detail and increase contrast, or close one eye?

Exercise:

If there is space on the first sheet, place a series of equal-tone gray bands beneath the first set of gray scales. Using a middle gray if possible—about a #5, but not darker—surround the first band with a very dark solid ground on each side, the next with a light band, and leave the third against the white page. Place a graduated scale behind the next band and a graduated scale moving in

the opposite direction behind the next. If you have additional bands, follow the system established above to complete your sheet. If your first sheet did not have room for this second set of studies, use a new page and place them above one another on the wall for study.

In addition to seeing the interaction of tonal values (the action of mutual contrast) on any areas of tone in your studies, you may enjoy the surprising variety of effects achieved by the entire group. Even in such supposedly technical, uncreative works as these, individuality is unmistakable, your work reflecting your own handwriting (or hand-marking) to a surprising degree. In apparently impersonal studies you often begin to recognize qualities distinguishing your work from that of others.

Exercise:

Use a series of rectangles or squares about the size of a sheet of typing paper in several tones of gray plus black and white (at least four, and possibly as many as eight). Put them in order, with the lightest on top. Placing a simple subject (such as a pepper) in the center of the top sheet, make a small tonal drawing of the object and its surrounding ground. Be sure to include any shadow. Position subject and background so that you see a complete field of the ground tone around the object.

Remove the top sheet and repeat the drawing with the subject seen against the next, slightly darker, ground. Continue in this way until you are drawing the object against the black ground. Tack the entire series in a row on the wallboard for study.

Does the pepper appear to have the same tone in each drawing? How does it differ? Do you want to make any modifications to equalize the tonality of the peppers?

Alternate Exercise:

Draw a tonal series of a single pepper (or any small subject) as identically as possible, on a number of sheets of white paper. The subject should be seen against a white ground. Be sure to include the shadow. Then, sequentially, change the grounds beneath the object, and adjust each drawing in turn to accommodate any changes you see. How can you add the lighter tones that become apparent when you study the subject against darker grounds and black? Consider chalk, pastel, and several types of eraser.

In the drawings shown in figures 3.7 and 3.8, study the mutual contrast of tone. Can you tell whether it was developed working both sides of each edge together, or whether certain parts—say the solid objects—were completely drawn before the surrounding backgrounds were added? Would this latter choice have seemed as unlikely before you worked the set of studies in this Unit as now? Will you still be tempted to draw actual things in future

drawings completely, inside their outlines, regardless of your new knowledge? Old habits are hard to overcome; don't be discouraged if you find yourself shading in that teacup, flowerpot, or figure before you ever look at the tonality of the tablecloth, saucer, or drapery surrounding it. But now you have a choice: to look beyond the edge, over the horizon, to see both sides at once—a goal of philosophers, admittedly, but just as important to the visual artist.

In the next Unit, "Lighting Form and Space," we will see how edgeless tonality and mutual contrast can show effects of light on rounded objects in creating the illusion of volume and shadow. Since we will refer frequently to the gray scale, you might prepare a special scale in one of the following ways.

Exercise A:

On a rectangle of white museum board, matt board, or two-ply Bristol board, perhaps $4 \times 8''$ or $5 \times 10''$, place strips of masking or white artist's tape vertically about an inch apart, the full length of the board. Leave a top and bottom margin, then draw your scale as evenly as possible in a continuous flow of tones. Trim the top and bottom edges as necessary. Glue

3.7 ABOVE
Mu Ch'i
The Six Persimmons
1268
Brush and ink on paper
$14^1/_8 \times 11^1/_4$" (35.9 × 28.6 cm)
Collection of Ryoko-in, Daitokuji, Kyoto, Japan

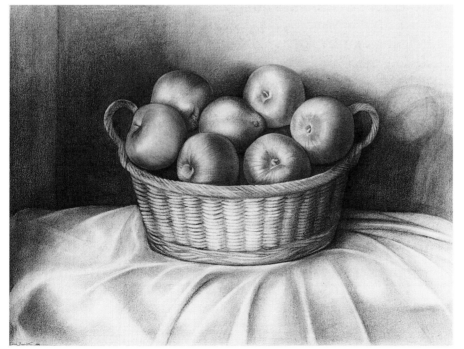

3.8 LEFT
Simon Dinnerstein
Winter Apples
1986
Conté crayon, colored pencil, and pastel on paper
$18^7/_8 \times 28^1/_8$" (48 × 72.4 cm)
Collection of Pamela Stein, New York. Photo: courtesy ACA Galleries, New York

a folded, narrow rectangular strip of board behind this scale, to act as a support. Be sure to remove a slightly angled piece at the bottom so it will stand easily, and remove the masking tape when ready to use it. You may wish to prepare half a dozen of these panels.

Exercise B:

On one panel, equally divide the area for your scale into eight or ten horizontal segments with a pale pencil line. Fill each section with a solid area of one tone of gray. Try for an edgeless sequence of tonality, even within this structure.

3.9
Shunji Sakuyama
Reversed tonal figure
1975
Litho crayon on paper
24 × 18" (61 × 45.7 cm)
Collection of the artist

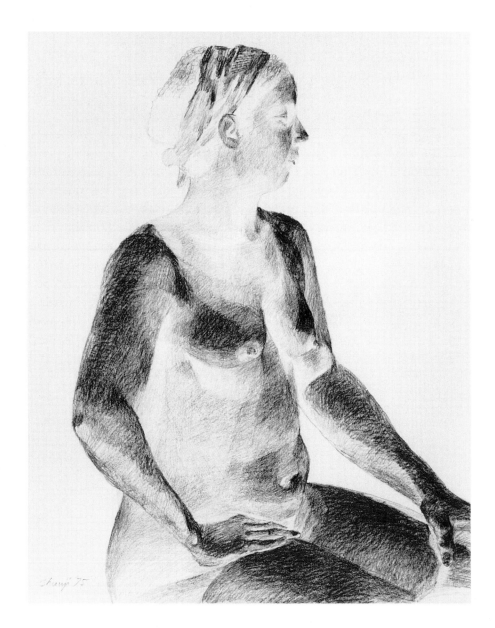

Exercise C:
On another panel, use parallel linear tonality, not continuously toned areas, to create your gray scale as a fluid, sectionless development of grays.

Exercise D:
Divide the scale area of another panel into rectangular segments before completing the scale as a linear tonal development.

Exercise E:
Develop the tones of gray on other panels, by any means, perhaps incorporating scribbles, rubbings, newspapers, xerographic prints, photographs, or ….

Think of other interesting, challenging ways to show these ideas:

- A composition can be altered dramatically by varying its tonal contrasts. Objects may be seen to melt into newly-combined larger shapes, to stand out in bold relief from one another, or to create a variety of apparently differing effects (fig. 3.9).
- To make two shapes of physically differing tones appear to be the same tone, it is necessary to alter the tones against which they are seen.
- It is possible to make a physically lighter shape appear darker than a physically darker shape by careful adjustment of their ground tones.
- An object can be made to appear to advance, recede, or remain on the picture plane by careful attention to mutual contrast of tonality (fig. 3.10).

These studies may be seen as exercises or as sequentially developed drawings. Does the category make a difference? Would you rather include a *drawing*, a *study*, or an *exercise* in an exhibition? Would you rather show your work in a *student exhibition* or an *exhibition of drawings*? As you consider these points, note the attitude revealed by the (silent) *tone* of your voice!

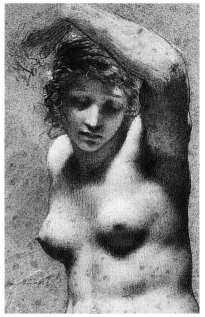

3.10
Pierre-Paul Prud'hon
Bust of a Female Figure
c. 1814
Charcoal and black and white chalks on blue paper
11 × 8³/₄" (28 × 22.2 cm)
Philadelphia Museum of Art. The Henry P. McIlhenny Collection in memory of Frances P. McIlhenny

Unit C
Lighting Form and Space: Modeling and Shadowing

TURNING ON THE LIGHT

All we see is light; without it, we could not see at all. Because we draw with darker tones on white paper, we say we are adding shadow but, in fact, it is light added to the all-surrounding universe of darkness that permits us to see. Objects in space are made visible as rays of light strike their surfaces and bounce or reflect back into our eyes, where our minds interpret the images received on the screen of our retinas as electrically charged impulses. (If this extreme simplification of the nature of visual perception does not satisfy your curiosity, consult the Bibliography.) For the purposes of our study, the important point is that only in the presence of light does seeing exist. If we are going to discover ways to show the action of light on objects seen in lighted space, it will be helpful to think of light, not shadow, as the element being added to the picture.

Exercise:

Start with a field of solid darkness: a rectangle of black scratchboard. This ink-covered, clay-surfaced board can be made to reveal its potential light by using a sharply-pointed tool or a scraper to remove lines and broader areas of its top coating (fig. 3.11). Small pieces of scratchboard will be sufficient—up to 6 × 8", or considerably smaller, as you prefer. Make at least six studies, starting with the first described and several others as you choose.

On the first piece of board, simply experiment to see how you can show a rounded object being bathed in light. You will have to think in reverse, removing dark to reveal areas of light. Imagine an egg, apple, or other simple form—perhaps a geometric solid such as a cube. Create a variety of tones through differing uses of line, including hatching and crosshatching (see p. 113), in lines of light on dark. Cover the scratchboard with interesting possibilities; this is a sampler.

Exercise continued:

Place a green pepper on a sheet of dark green or black paper, shining a single light on the subject. On your scratchboard, create a sense of the areas of light you see, using short curved lines in a kind of parallel linear tonality, creating or melting edges as you see them. Either side of the pepper's edge may appear lighter, even the so-called black ground.

Exercise continued:

Place a white object on a black ground and reveal its light-struck surface on your black scratchboard. Include its shadow. Select an egg, teacup, or other simple form.

Optional Exercises:

Place a dark object on a white ground and do the same. Place a white object on a medium gray ground ... or ... a white object on a white ground ... or ... a medium gray-toned object on a black ground ... or

Create a simple composition including several small objects on a piece of drapery or other non-level space, and draw their light on the black scratchboard. For your first composition, include only all-black objects; or all-white objects; or one white and one black on a gray field ... you decide.

Scratchboard, both black-surfaced and clear white with areas of black added, has been used by many artists and illustrators, who value its ability to hold a great many details and to permit both extremely free and extremely controlled work on a single surface. Textural inventions and powerful descriptions of lighting effects seem to be enhanced by this versatile medium (see fig. 8.9).

THE SOURCE

Since light rays travel in straight lines, enlightening objects in their path, we can see only those parts of an object they strike. The rest remains out of sight, behind the visible portion. At the same time, we can see only those parts of an object defined by the light rays reflected back at the object by our retinal screens. The rest of the object is also out of sight. This is a double limitation. If the source of light came from the eye, light would fall on the front of each object and the shadow would be behind it, away from us. (Imagine cartoon super heroes with light-ray vision, beams of light in triangular cones piercing the darkness before them.)

As it is, the viewpoint of our eyes determines the shape of the edge we see around objects, and the source of the light falling on the objects determines their shadowing and tonality. These ideas may be considered in a different way: Just as multiple sources of light produce greater illumination (and overlapping multiple *penumbras* or secondary shadows), differing verbal viewpoints (wordpoints?) may clarify otherwise opaque-seeming explanations.

Imagine an egg on a table with a single light shining on it from a point directly in front of your eye. (You are holding a small flashlight in front of your face in a darkened room.) Each ray of light shoots from your eye and the light source together at the egg, bathing its surface in light so you can see it. As rays of light approach the visual edge (the contour, or oval outline, of the object) each acts as a point beyond which light cannot reach. The *locus* (or path) of these points makes up the visual edge or contour of its form beyond which we cannot see any egg. Each of these points may be at a different distance from

3.11
L.I.U. student: Slava
Polishchuk
The Man
1997
Scratchboard
8 × 5" (20.3 × 12.7 cm)

3.12 ABOVE

Virginia Cantarella

Drawing of an egg

1988

Pencil on paper

5 × 6" (12.7 × 15.2 cm)

Collection of the artist

the eye; the visual contour may not in fact be a continuous physical edge. To draw this contour as a line is a convention accepted as visual reality.

If each of these rays were to be continued in space, stopping only on the sheet of paper beneath and beyond the egg, they would also describe a locus, the path of these points of light striking the paper, which would become the softly oval shadow shape we see (fig. 3.12). In this hypothetical situation, the visual contour is directly related to the shape of the shadow.

A LITTLE LIGHT ON SHADOWS

This is rarely the case; the sources of light may be in any relation to an object: in front, above, below, behind, high, low, near, far, or any combination of these. Therefore, shadows may appear on and around an object at any angle, in any strength and intensity, and in any number of overlapping combinations, softening or intensifying one another, creating increasingly pale, soft-edged penumbras. These shadows will follow the general contour of the object as seen from the viewpoint of the light source (fig. 3.13). One of the most frequent problems is the puddle-of-India-ink effect, or the too strongly outlined, too intensely black shape placed near an object in the hope that it will pass as a shadow. Subtlety pays. A major consideration is that each source of light physically adds light and thus diminishes the darkness of any combined shadow. Areas of light appear inside multiple shadows, occasionally dissipating the darkness altogether. The darkest part of any shadow is generally directly beneath and touching the object, even if only as a

3.13 RIGHT

Philip Pearlstein

Model in a Horn Chair with Kimono

1990

Pencil on paper

30 × 40" (76.2 × 101.6 cm)

Photo: courtesy Robert Miller Gallery, New York. ©Philip Pearlstein

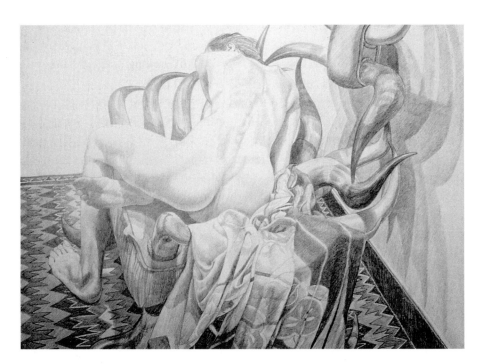

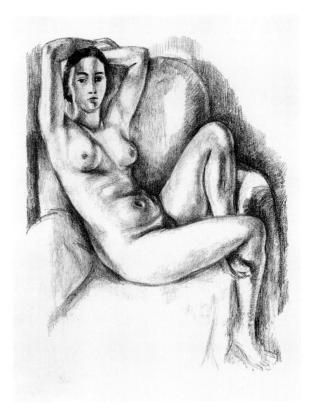

3.14a ABOVE
L.I.U. student: Leon Jansyn
Shadow study
1996
Pencil on paper
9 × 12" (22.9 × 30.5 cm)

3.14b RIGHT
Henri Matisse
*Nue au coussin bleu à côté
d'une cheminée*
1925
Lithograph
25 × 18³/₄" (63.6 × 47.6 cm)
Photo: courtesy Sotheby's, Inc.,
New York. ©Succession H.
Matisse/DACS 1999

very thin wash. This is often the place for sensitive softening of one edge of a thinly applied line, the edge away from the object (figs. 3.14a and b).

Exercise:

Place an egg on a white ground, illuminated by a single source of light—perhaps a window, bathing the subject in softly diffused light, or a flashlight in a darkened room, producing a strong, sharp-edged shadow. Draw the subject and its shadow in continuous tonal shading with no double-edged applied lines visible. Refer frequently to your gray scale, comparing the tones on your scale with those on the subject, making any necessary adjustments. Adding darker tonality is not a problem, but how can you reduce an area of tone that is too dark? Try a piece of kneaded eraser, warmed and softened in your hand, formed into a small rounded ball. Press this eraser form onto the area of tone you wish to lighten, and wiggle it without moving it across the surface of the drawing. Press and wiggle until the gray tone is sufficiently lightened. You can always make it darker if you overdo it (see fig. 8.6).

Exercise continued:

Leaving the subject untouched, add a second source of light and draw what you now see: more complex areas of shadow but, overall, less darkness.

Compare the two drawings. In addition to changes in shadowing on the support surface, what differences are observed on the rounded surface of the egg? Do you see an area of edgeless tone in a soft crescent shape appearing inside the oval of the subject, never touching its visual contour? Does the level of gray in this floating shadow grow darker and lighter in a certain way? Study other similarly rounded forms to identify this feature. Pitchers, bowls, and the human form will usually reveal such rounding crescents if you play with the lighting until they appear (see figs. 3.12 and 3.14b).

CHIAROSCURO

As mentioned on page 85, the relationship between clear, light tones and more obscured, darker levels of light is called chiaroscuro. The studies we have been making of light and dark tonality and the effects of mutually contrasting levels of the gray scale have introduced aspects of this idea.

As long as work is done on a white surface, however, shadow continues to be added in contradiction to the natural way light is added to dispel darkness and permit seeing. In a way, scratchboard drawings provide a means to reverse this learned exchange of light and dark, but they generally tend toward extremes of contrast (see fig. 0.8).

A classical chiaroscuro technique moves from a middle gray toward both the light and dark ends of the scale. These drawings are made on gray paper, with lighter and darker materials defining form and space, distinguishing receding blacks or grays darker than the drawing surface from approaching whites or grays lighter than the paper. A neutral middle distance, from which other parts advance or move back, is held by the paper itself or grays close to it in value.

Study the drawing by Prud'hon (see fig. 3.10) to see how the figure has been modeled in tones of light and dark to show roundness and a sense of space. Where did the artist blend strokes to make areas of tone? Where did he continue to separate individual markings?

Are there places where the tone of the figure and its ground melt at the same level of gray and no edge is to be seen between them? Are certain darks stressed to separate forms and to push or pull an area in space? For the highest tone of light, has a pure touch of white been used? (This is called a highlight.) Such a point or streak of light may be added with white chalk, crayon, or a delicate stroke of paint. It may also be removed by means of a soft or hard eraser or by the touch of an electric eraser.

Select a subject whose overall color is the equivalent of a middle gray in tone. To clarify the relationship between chromatic colors and the gray scale, try the following demonstrations before completing the chiaroscuro exercise to follow.

Exercise:
Place several small objects (such as pieces of fruit, vegetables, tools, pine cones, drapery, or dishes) on a colored board. Take overhead photographs by

standing above the arrangement and shooting directly down. Include your gray scale in the composition. Avoid using flash; perhaps you can do this out-of-doors. If possible, take two photographs, one in color, one in black and white. If you make a color photo, study a xerographic black-and-white version of this print, a third tonal interpretation of the subject.

Pin all three images to your wallboard and compare the various tonal values. Where is the darkest dark, the lightest gray? Is there any spot of white? How do the photographed or photocopied tones compare with your prediction? (Later they will be compared with a pencil drawing of this composition.) Which objects stand out sharply in contrast to the ground; which seem to melt into its particular tone of gray? Study the actual arrangement of objects while observing the black-and-white prints, to develop an ability to override perception of chromatic color and visualize directly in terms of black and white. This is difficult at first, but every good student of photography has made the same effort and developed individual methods of achieving success.

SEEING IN BLACK AND WHITE

Instead of signaling the end of visual art as some had predicted as far back as 1865, photography has enriched our visual vocabulary in numerous ways. Certainly, everyone today is comfortable and familiar with the idea of seeing the world on a flat surface in black and white, whether in photographs, images in newspapers and magazines, or on the ubiquitous television screen. But direct black-and-white interpretation of a particular object or scene appearing before your eyes in full color may require extra effort when you are drawing what you see.

Exercise:
As an additional demonstration of the discrepancy between perception of color hue and value, make a photograph in black and white of red flowers and their foliage. Areas that almost vibrate with opposing colors will lose their color contrast and, having no tonal contrast to substitute, will simply blend with the very similar grays of neighboring shapes. Can this be shown in a drawing? How?

Chiaroscuro Exercise:
Develop areas of linear tonality in modulated tones softly blending in an edgeless way into the gray of the paper, in both the *chiaro* and *oscuro* directions. Let your work show the texture of curved parallel lines building form, light, and shadow. Drapery, the human figure, red and yellow peppers, old shoes and boots are suggested; their forms are imprecise and loose enough to permit exaggeration without losing credibility.

Chiaroscuro Exercise continued:

A second drawing of the subject may be done with the lighting changed in a dramatic way. Are you convinced that light actually defines the visible form of an object? Have you wondered why the name of the photographer is often given with a photograph of a work of sculpture? After all, the sculptor created the work; the photographer just took its picture! Can the photographer actually create the look of a work in ways as inventive as the artistry of the sculptor?

SPECIAL EFFECTS

Lighting a subject carefully before drawing what is seen can make all the difference when trying to re-present a full range of tonal values or the three-dimensionality of forms. A number of special effects can be achieved with lighting; several are identified easily in drawings or other two-dimensional work. The most striking examples can be found in black-and-white photographs.

Back-Lighting

Placement of darks and lights can determine composition and create patterning, as well as reveal the actual play of light on a subject. There are interesting ways to justify or make sense of unusual relationships of tonality—to ring an object in a halo of light instead of a heavy dark outline, for instance, or to obscure central details within the periphery of a light-edged form. This effect is known as *back-lighting*.

Place the source of light behind the subject so that it cannot be seen directly. In this way, an overflow of light at the edges will cause diffused illumination, spilling through any non-opaque materials such as foliage, hair, and fabric, washing the edges of solid forms in a luminous glow (color plate 5).

Dramatic Lighting

Film aficionados will be familiar with what is called spook lighting. Monsters and other creatures are made more fearsome by placing the light source at a low angle, sending harsh angular patches of shadow across their features and catching the whites of their eyes in brilliant glare. Variations of this idea are often used by artists and illustrators for expressive purposes when an intense emotion is called for on the part of the subject or the viewer (fig. 3.15).

Rembrandt Lighting

To achieve the most attractive disposition of lights and darks on the human face or figure, artists have often studied the works of Rembrandt. His lighting effects in drawing and painting seem to bring out not only the structure and roundness of each head, hand, or garment, but also to impart a unity, cohesion, and luminous beauty to the pictorial surface (fig. 3.16).

It will not detract from the magic of this effect to describe the lighting

placement Rembrandt frequently employed to achieve it, but instead of studying a diagram or reading a verbal translation of this visual demonstration, you may find it more useful, and more exciting, to re-create the experience of modeling form directly with light.

Exercise:

Seat a model (large velvet hat not required) against a dark, light-absorbing drape or fabric background. Matt velvet, felt, or other non-shiny material (not satin or plastic) will do. Place a single light, perhaps on an adjustable light-stand, higher than the model's head and at about a 45° angle to the figure, at a point about halfway between out to the side and directly in front. Keep your eye on the model's face and slowly raise and lower the light (also moving it a little to the front and to the side) until you can see a small triangle of light appearing on the inner cheek of the side of the face away from the light. As you move the lamp, almost imperceptibly you will be able to experience control of form through the manipulation of light and fix the small triangle exactly where you wish to place it on the model's face. Draw what you see, using a combination of linear and tonal pencil work to capture the glow and inner light as well as the broader configurations of your subject.

LIGHTING SPACE ITSELF

Although the importance of the space on both sides of every edge in a drawing has frequently been noted, in this Unit thus far we have stressed the effect of

3.15 BOTTOM LEFT
Cooper Union student:
Anca Vasiliu
Self Portrait
1997
Pencil on paper
12 × 9" (30.5 × 22.9 cm)

3.16 BELOW
Rembrandt Harmensz van Rijn
Rembrandt's Father (?)
1635
Etching
6 × 4⁷/₈" (15.2 × 12.4 cm)
Rijksmuseum, Amsterdam

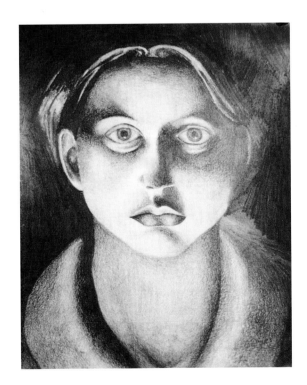

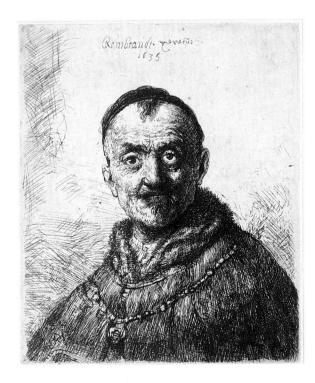

light on objects, not on the spaces between them. In the three-dimensional world, we can experience the emptiness of this air between physical objects. It is a major concern of sculptors to give dimension to and determine such space-forms which, in turn, fit into and give structure to the sculptures they surround.

On the two-dimensional page, however, there is no such distinction. Flat paper surface covers the entire work, regardless of our intention that the viewer read a particular part of the planar surface as solid or empty, as figure or as ground. The two-dimensional shapes on the other side of an object's edge, outside its contours, are equally part of each drawing. This is easier to recognize in drawing than in sculpture, for there is always something to be seen between objects on a page, whether it is a drape, wall, table, sidewalk, mountain, or another object. Even if it is sky or a general airy atmosphere, we sense the presence of a definite filler between the elements that compose our page.

A way to approach the drawing of these in-between spaces is to see them as flattened shapes bounded by the outer edges of the objects around them. This is as true of solid objects that appear next to others as it is of so-called empty space around an object (fig. 3.17).

Once you have determined the shape of these spaces, the next step in creating a sense of connectedness or of separation between objects has to do

3.17
José de Rivera
Working drawings, detail
1960s
Pencil on cardboard
14 × 11" (35.6 × 28 cm), irregular
Private collection

with the strength of edges between them. A soft edge, or almost no edge at all, between shapes will tend to make them appear as a single form occupying a common outline and space, while a sharply defined edge, perhaps linear, perhaps using contrasting tones, will separate objects from each other and from the spaces around them (see fig. 1.29).

Exercise:
Arrange a still life leaving space between the objects. Without changing your viewing point, make two drawings of this arrangement, grouping the objects differently by using variations in lighting and treatment of edge contrast. Try to give substance to any unfilled space by careful attention to the strength and closure of physical contours. Are there any shapes on your page that are truly without substance, that do not show some material object, even if at a distance, in your field of vision?

CONCEPTION AND PERCEPTION IN DRAWING
Keep in mind the difference between the arbitrary invented lights and darks of alternate shading (see p. 129) and the specific observed relationship of tonal values when drawing from life (fig. 3.18). It would be an oversimplification to see these differing approaches as evidence of a clear distinction between conceptual and perceptual drawing, one based on idea, the other on actual sensory experience. (See Section 7 for an investigation of the conceptual approach to drawing.)

Do we see what is really in front of our eyes, or is our view always affected by our philosophy? Is every kind of drawing based on an understanding of certain basic principles or assumptions relating to the arrangement of forms on the flat two-dimensional surface or picture plane?

Let us consider such fundamentals of composition and spatial arrangements in the next Section, "Reading the Surface."

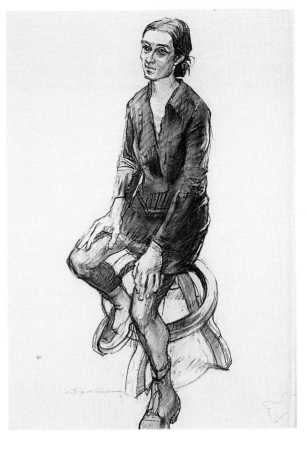

3.18
Sue Ferguson Gussow
Elisa Garcia
1997
Charcoal on paper
42 × 31¹/₂" (106.7 × 80 cm)
Collection of the artist

Reading the Surface:

Composition and Spatial Concepts

Unit A

On the Picture Plane:
Structuring the Rectangle

READING THE SURFACE

Whether looking at a page in a book or a drawing on a rectangle of paper, our eye scans the surface in a learned, sequential way which may be called reading. Your eye entered the flat plane of this written page at the upper left, is moving in parallel sweeps lower and lower, and will exit at the bottom right. Similarly, when studying a drawing we begin at the left and feel space opening toward the right. Is this true when making a drawing as well? Do you consider the left edge the starting line and the field of space as opening toward the right? If any of the Western languages is your primary language, you should feel comfortable with this description.

Just as naturally, if you read primarily an Asian language, you may find your eye entering the flat rectangle of the page at the upper right, moving in long vertical sweeps to the left, and leaving the page at the lower left. In this way, the right edge from top to bottom at a constant distance from the eye is the starting line, opening as a sliding door or screen might, across the page to the left. Empty space seen in this way looks to the left.

Midway between these pathways for the eye, the Middle Eastern languages (Hebrew and Arabic) and art are read from right to left, but in horizontal bands.

4.1 RIGHT
Anonymous Arabic
calligrapher, Istanbul
Arabic prayer
1987
Reverse painting on glass
(*verre, eglomisé*), black
and silver
4 × 10" (10.2 × 25.4 cm)
Collection of the author. Gift of
C. Tauss and B. Spitz

4.2 BELOW
Josef Albers
Schoolgirl VIII
c. 1917
Pen and brown (originally
blue) ink with red
highlights on transparent
wove paper
7 × 5" (17.8 × 12.7 cm)
Josef and Anni Albers
Foundation, Orange, Conn.
©DACS 1999

An interesting question may be derived from this discrepancy in reading the pictorial surface. Could the idea of perspective as seen in the West (with objects reducing in size up to a horizontal edge and its vanishing points, and similarly increasing in size as they appear lower and nearer on the picture plane) be directly related to the way in which the surface itself is read? When we read any surface in Western fashion, do we start at a distance at the upper edge and sweep not only downward but nearer as we approach the bottom of the page, since the constant is the top horizontal band? And in reading Eastern works (fig. 4.1) do we find it easier to see a planar flatness, since the eye starts out by holding the entire right edge at a constant distance? This is a new way of looking at an old question (see fig. 4.30).

The introduction of Japanese woodcuts to the West in the mid-nineteenth century gave a new point of view, a new perspective, to artists such as Degas, Cassatt, and Gauguin (see p. 166, figs. 4.18a and b, and the Bibliography). Could it have been this sense of the flat, scrolled picture plane that they found most innovative and intriguing?

Differing approaches to achieving the look of space on a flat surface through several kinds of perspective will be investigated in Unit B; here we are concerned with the picture plane itself. (Referring to other Units for comparative purposes will reinforce the interrelated, inseparable nature of many topics presented separately for the purposes of study; see pp. 235 and 251.)

From Corner to Corner

For well over a century, Western artists have studied and adapted ways of visualizing space as developed in the arts of Asian and other non-Western people, and the search for different ways to present the appearance of visual reality continues (fig. 4.2). Recently, many books and commercially marketed examples of the auto-stereogram (a means of seeing deep 3-D space without special red/green or polarized glasses) have become available—the very antithesis of flat picture-plane integrity.

What unvarying factors can transcend learned, culturally instilled readings of the surface and ideas about spatial perception or its representation? Looking at the empty, undetermined, neutral picture plane itself, a simple sheet of paper, is the eye

4.3 LEFT
Paul Klee
Letter Ghost
1937
Watercolor, gouache, and
ink on newspaper
13 × 19¹/₄" (33 × 48.9 cm)
The Museum of Modern Art, New
York. Purchase. Photograph
©1999 The Museum of Modern
Art, New York. ©DACS 1999

4.4 BELOW
Diane Miller
Laurie, Posing
1993
Pencil on paper
25 × 19" (63.5 × 48.3 cm)
Collection of the artist

drawn to any special parts of the rectangle? Of course, its four corners pin down the size and shape of the quadrilateral, holding the sheet taut, stretching its pairs of parallel sides. An invisible X pulls across the surface from corner to corner, finding the central hub around which the entire shape is structured (fig. 4.3).

Midpoints can be identified on each of the four sides and connected in the mind's eye to create four smaller rectangles. Additional midpoints may be imagined and joined to form a variety of grids. Soon the entire surface, which at first may have seemed utterly blank and devoid of content, is completely activated by its potential subdivisions.

THE EMPTY PAGE: MAKING CHOICES

In a sense, the page is never completely empty; it always contains the potential of its structural forces, such as the corners, center, midpoints, and their possible connections that we have noted. Other implied divisions of the rectangle are triangular rather than perpendicular, seen when the corners are pulled toward one another through the midpoint. The largest triangle, made by a simple diagonal through the entire picture plane, can create powerful, dramatic compositions (see fig. 4.8). Entire triangulated compositions may be built of carefully subdivided diagonals.

Sometimes compositions may seem to be contrived, made to fit intellectually preconceived patternings. These could be seen to succeed as *illustration* rather than as *art*. What do you think? Does the aim, use, or function of a drawing affect its nature as a work of art? If so, how; if not, why (fig. 4.4)?

Must all the forces acting on the plane of a picture be used, or even acknowledged? Must drawings always be read in accordance with an

identifiable structure? Is it a good idea to be familiar with a number of choices, then decide which, if any, to use? Or should we just draw, knowing that a good instructor will help us see the choices made, even when we are unaware of having made any? Will an instructor always be available? One result of good teaching is said to be the increasing ability of the student to make independent choices.

Composing Your Drawing

If a page holds so much potential structure before you have begun to draw, how can you decide what to include, where to begin? One choice is to accept the given size and shape of a page and plan the drawing to fit precisely within its boundaries—to compose for the existing space. Such a decision assumes the ability to translate three-dimensional objects-in-space to flattened two-dimensional shapes (plus the shapes of the spaces between them) up to a predetermined rectangular stopping place, the rectangle of the drawing paper. This sounds suspiciously like the steps involved in composing a photograph. Would it be helpful to try to see as a camera sees, flattening all the shapes before it onto a single framed surface (see fig. 4.8)?

4.5
Will Barnet
Mother and Child
1938
Etching, edition of 50
4³/₈ × 3" (11 × 7.5 cm)
Photo: courtesy Frederick Baker, Inc., Chicago. ©Will Barnet/DACS, London/VAGA, New York 1999

Exercise:

Using a camera with a clear viewfinder, indoors or out, select as a subject a variety of elements at a distance from one another. Move the camera left and right, nearer to and farther from various groupings of the elements, up and down, even around to the side or behind the subject, until you can identify several compositions or arrangements within the rectangle. Make a number of black-and-white photographs in this way. Or you may prefer to make pencil drawings directly of these camera glimpses.

Optional Exercise:

Instead of a camera use a simple lensless, adjustable framing L (see p. 35) to visualize the shape of spaces surrounding your main subject or areas of interest. These often neglected (unfilled or background) spaces will be seen to fit around the shapes of your main subjects exactly, just like jigsaw puzzle pieces (fig. 4.5). (Use the Index to find other references to this concept, called equal figure-ground or the figure-ground exchange, in other contexts.)

The meshing of object-plus-its-surrounding-space flattens the shapes described by the objects behind or adjacent to the main subject. But their outer boundary, provided by the framing L, gives them a completed periphery, a border. Of course, such borders do not exist physically, any more than the momentary contours of the subject seen from a single stopped viewing point. The discrepancy between physical and visual reality cannot be stressed too often. Composing is an arbitrary, selective activity; any adjustment to even a single element makes a difference to the total visual presence of a work.

RAISING YOUR SIGHTS

Once you see the object and its surrounding space as a unity, you become freer to adjust the shapes that occur on either side of their mutual edge. One way this is accomplished is by altering your position in relation to the subject.

Exercise:

Place a simple subject on a large surface to see the ground completely surrounding it. With a framing L before you, approach the subject until it fills as much of the field as possible; then open the L a little to add some of the surrounding area. You may be standing above the subject at this point, looking almost directly down on it. As you move away, lower the L slowly until the subject is no longer surrounded by the background. What can you now see behind and touching the subject in your frame? Perhaps other students, studying the subject from across the studio, or unrelated objects in the room. Place the subject in various positions within the rectangular format: centered, resting on the lower edge, in one corner, occupying almost the entire frame, very small and to one side, extending beyond the frame but cropped in an interesting way.

Do you have to move around the subject considerably to create some of these compositions? How can you position yourself to show the greatest amount of ground around the figure? Instead of moving, can you arrange the subject to show a larger amount of ground while you maintain a level position? Study the still-life compositions of the Cubists to see dramatic tipping of tables and other surfaces to accomplish this visual goal. Even earlier than Picasso's and Braque's efforts in this direction, Cézanne and other Post-Impressionists tilted surfaces to increase the amount of drapery and other surface-covering components of their still-life compositions (fig. 4.6; see also fig. 6.7 and the discussion on p. 245).

Many techniques and methods can be introduced to assist in the placement of shapes within the rectangle of the page.

4.6
Paul Cézanne
A Corner of the Studio
(verso of *Heads of Madame Cézanne and Cézanne's Father*)
1881
Graphite on cream wove paper
8½ × 4⅞" (21.8 × 12.4 cm)
Courtesy of the Fogg Art Museum, Harvard University Art Museums, Cambridge, Mass.
Bequest of Marian H. Phinney

Eventually you may choose to compose in your mind's eye, let the drawing compose itself, crop (taking a little off the sides), or even add more space to the existing page by attaching additional paper (see fig. 7.12).

The Imaginary Window Shade

Visualize a raised window shade directly above the subject you wish to draw. Imagine that this shade, when rolled down, will exactly cover the area of the drawing. It may help to envisage the drawing made directly on a transparent shade. In imagination, align the top of the non-existent shade with the top of your drawing paper. Let the sides of the shade stop exactly where the sides of your page intersect the top. Then roll the shade down, covering the subject precisely, stopping at the bottom of your page.

Exercise:
After you have done this in imagination, try the actuality, then the reverse—imagining your page as a window shade being lifted up to cover the subject at exactly the right distance.

THE DRAWING FRAME

The gridded drawing frame is a classical device, used by Albrecht Dürer and others to transfer the proportions and placement of elements within a perceived arrangement of forms to the flat picture plane (fig. 4.7). There are several ways to create a drawing frame.

Exercise:
Draw a series of equally spaced vertical and horizontal lines on your paper, perhaps 2" apart or a little less, to create a grid. Then attach a similarly spaced set of strings to an empty frame or to a canvas stretcher. These may be closer together or farther apart, but they must be the same in number and equally square.

Devise a means of standing the stringed frame in front of your subject so that a satisfactory composition is enclosed within it. Use folded strips of matt

4.7

Albrecht Dürer

Device for representing perspective: A network of black threads divides a plate of glass between the eye and the subject

From K. A. Knappe, *Dürer: The Complete Engravings, Etchings and Woodcuts* (London: Thames & Hudson, 1965) and Dan Pedoe, *Geometry and the Visual Arts* (New York: Dover Publications, 1983)

board, wires, or found materials. Draw each section, as seen in the stringed frame, in its corresponding square on the page until you have in effect transferred the image onto the paper.

A refinement of this method calls for placing the gridded page beneath a sheet of translucent vellum or heavy tracing paper so that when completed and lifted from the grid, a gridless continuous drawing is seen. Each of these methods has its supporters. The gridded version is particularly popular among those who emphasize structure and substructure in contemporary drawing and treat each square slightly differently in tonal or other surface-enhancing ways. The grid is also helpful in transferring work to a larger page, canvas, or wall (fig. 4.8).

A Little Left Over

Sometimes through timidity or a desire not to let the drawing spill over its edges, the subject is made a little smaller than seems right, so that when it is finished there is too much empty, undetermined space at the outer portions of the page. This is easily corrected by cropping, placing a straight-edge alongside the main subject and slowly moving it toward the outer edge until the right balance of subject and space around it appears. Draw this cropped edge, then repeat the process along the three remaining sides, leaving sufficient breathing space around the subject. Will the extra room be to the left or right, above or below your subject? Does this depend on the direction the subject is facing, its size in relation to the rectangle of space, the Western or Eastern reading of the picture plane you are most comfortable with, other factors you can't quite explain in words—or all of the above in some measure?

When you crop a drawing, you may discover you have made it stronger and, by reducing the quantity of space around the subject, increased its visual weight. As the *ground* grows smaller, the *figure* appears larger. This is sometimes stated as "less is more": less space, more emphasis; less distraction, greater focus (fig. 4.9; see also figs. 1.8 and 1.9).

As you develop a sense for the right relationship of space contained and space containing, of space inside and space outside an edge, the nicely balanced interrelationship among all the spaces on your page will become automatic,

4.8
Edgar Degas
Dancer Adjusting Slipper
1873
Pencil and charcoal on faded pink paper, heightened with white chalk
12⅞ × 9⅝" (32.7 × 24.4 cm)
The Metropolitan Museum of Art, New York. H. O. Havemeyer Collection, Bequest of Mrs. H. O. Havemeyer, 1929 (29.100.941)

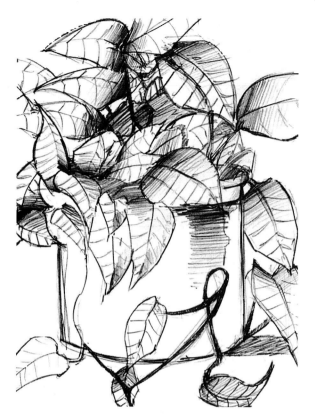

4.9 ABOVE
L.I.U. student: Errol
Coombs
Cropped composition,
detail of *Plant—"draw*
what you see"
1997
Pencil on paper
Sheet: 18 × 24" (45.7 × 61 cm)

4.10 TOP RIGHT
L.I.U. student: Hina Patel
Still life
1997
Pencil on paper
23½ × 18" (59.7 × 45.7 cm)

intuitive (fig. 4.10). Think of the rectangle as a stage on which the action of a drawing takes place. The entire stage is seen by the audience whether a full chorus or a single actor appears on the scene. Does this help clarify the idea of composition? After all, theater is a three-dimensional experience. Perhaps the idea of improvisational theater makes more sense, conveying the suggestion that, after you have done all the studying of parts and the memorizing of lines, you will be able to internalize these learned elements and, spontaneously, without conscious effort or thought, make a personal statement on the stage— that is, the page. When asked why you have made a certain choice, you will be able to say, "I don't know; it just looked...right." And it will.

Unit B
Picturing Space:
Perspective in Perspective

PERSPECTIVE AS A POINT OF VIEW

Asked to put an idea or event in perspective, we look at (consider) the big picture and see (understand) the particular example in relation to that overview. Similarly, in looking with our eyes at an object or scene, we perceive the subject in a structured way, within the context of a preconceived point of view. Looking at the real world, at things in space, we see in three dimensions, experiencing the sensation of actual depth, with volumes of space existing between and around things.

Objects that are physically the same size appear progressively smaller as they move away from us, according to the laws or system called perspective.

The key to understanding the idea of Western (vanishing-point) perspective is the flat-surfaced picture plane, which is seen to imitate the look of real space as recorded on the retinal screen of the eye. The moving, changing imagery we see may be compared with a film or video sweeping across our field of vision. The stopped, perfectly mapped perspective picture, however, more closely approximates a still photograph seen through a single lens at a given moment from an unchanging viewing point.

Now You See It, Now You Don't

Western perspective involves a horizontal line at eye level, on which at some point things appear so reduced in size that they are seen to vanish. Roads, for instance, or the famous telegraph poles running along both sides of a road, appear to shrink as they recede until, no matter how wide the roads, how tall the poles, they become a mere dot, a point on the horizon, and vanish from view. The actual poles remain just as tall, the roads as wide, beyond the horizon; it is our sight of them that has disappeared. If you climb the nearest pole to raise your viewing point, the horizon-line will be seen to follow and always remain at eye level. If you lie down on the road, the horizon will move down with you (fig. 4.11).

ONE-POINT PERSPECTIVE
Perceiving 3-D Space

In order to perceive depth or three-dimensional space in a drawing, the mind must be convinced that the eye is seeing a subject whose parts advance and recede away from the flat vertical and horizontal picture surface. Or the eye may visualize flat planes separated from one another by depth or space. Objects may be shown as nearer to, or farther from, one another in space, but there must be some tangible matter shown, or a spatial relationship between two (or more) shapes or forms.

4.11

Cooper Union student of

Sue Ferguson Gussow

Trees in a Space

1996

Charcoal on paper

18 × 24" (45.7 × 61 cm)

Exercise:

To demonstrate this idea, obtain or make a small cube (perhaps of board or heavy paper) plus a flat square exactly the size of one of its faces. Hold the single square directly in front of your eyes so that all four of its right angles are seen clearly and all its edges appear perpendicular and identical in length. (Attach a small holding piece behind the square to keep its front surface and edges clear.) You can easily identify this as a flat, square shape. Place the six-sided cube in precisely the same position, using a holder fixed to its rear surface. Can you tell that it is a three-dimensional form, not simply another flat square shape? Only the location of your hand behind the cube may suggest its depth. (To avoid even this hint, attach both the single plane and the cube to the wallboard, placing the single square the same distance from the wall as the front panel of the cube.)

Can you see any spatial difference between the square and the cube? If the latter were transparent, what would be the shape and position of its rear panel? Drawn in one-point perspective, the cube would show a vanishing point at the central common intersection of its front and back square surfaces. This demonstration suggests that at least two surfaces of the cube must show for it to be seen as three-dimensional. Imagine yourself standing in the middle of a flat road, looking toward the distant horizon at the single point where the road's two sides apparently converge and vanish. That vanishing point, centered directly ahead of the eye, establishes one-point perspective. Since each eye sees a slightly different view from its differing position, you will have to close one eye to eliminate the sensation of the third dimension and keep the picture planar or two-dimensional. This is the basis of the red-and-green or polarized images and eyeglasses used for creating 3-D art and films. When the distinct image seen by each eye is made to overlap the other, the brain attempts to reconcile the two into a single spatial whole. In the auto-stereogram, two slightly differing images of the same subject placed side by side overlap and suddenly snap into focus in the eye/brain/mind of the viewer.

Exercise:

Look at the scene directly ahead of you with both eyes, sweeping from extreme left to right visually, holding your head motionless. Roll your eyes in a complete circle (almost an almond-shaped oval), skimming the very edge of your visual field, and make a mental note of the entire area. Your own face will act as a border if you scan the full scene. Then close one eye, still looking straight ahead as much as possible.

Although your outside peripheral vision stays the same, the inner border will be considerably reduced, ending at the slightly out-of-focus edge along one side of your nose. Repeating this procedure with the other eye, note that although each eye sees more of the scene on its own side, there is a large area of overlap. Only in this central area do you perceive space in full three-dimensionality.

Test this by opening only the left eye and holding a finger at each edge of your visual field; then move your fingers as you demarcate the right eye's field. Bring the two fingers to the inner edge of the opposite eye's field to define the overlapping area seen by both eyes at once. Is the true range of three-dimensional vision narrower than you had expected? Remember that this limited scope of vision is an artificial boundary, imposed by physical immobility. In actuality, you are rarely this fixed, but in a constant state of motion, overlapping otherwise still views or shots, very much in the manner of animated films or flip books (see p. 243). As you continually turn your head or move your eyes, a full 3-D sense of space is achieved.

To draw in perspective, then, it is necessary to assume an arbitrary, one-eyed, motionless position to flatten the image on the surface of the eye's visual field. In one-point perspective, the result is frontal, formal, and symmetrical, encouraging exaggerated foreshortening (fig. 4.12).

Exercise (in the Mind's Eye):

To draw a three-dimensional object, for example a box, in one-point perspective, begin by visualizing the box placed squarely on a railroad track in front of you, or perhaps on a table on that track, to raise it nearer to eye level. Although you know that a rectangular box has six sides (three pairs of parallel surfaces), how many will be visible in this position? First, consider the top and bottom as horizontal planes (the railroad or table top plus a similar surface, parallel to and above it.) Of these, only the top will be visible in one-point perspective, unless the box is transparent. If the box fits exactly on the railroad from side to side, its width the width of the track, then the top and bottom edges of the face or front surface will be as wide as the railroad itself. The surface parallel to this—the back of the box—will not be seen. The upper edge of the face meets the forward edge of the top; they are the same edge. The far edges of the top and bottom surfaces, physically the same width, will be seen as narrower than the near edges. You can visualize each cross-tie of the track growing successively narrower up to the vanishing point. The box sits on several cross-ties, its more distant bottom edge therefore narrower than its nearer edge (and, parallel to that, the upper edge of the back surface as well). This edge is shared with the top surface of the box, farther from the eye.

4.12
Josef Albers
Introitus
1942
Lithograph
19⅞ × 11⅛" (50.5 × 28.3 cm)
Josef and Anni Albers
Foundation, Orange, Conn.
©DACS 1999

Follow these concepts in your mind's eye before verifying them by studying the illustrations given or making your own drawing. Quite a challenge, this provides a good foundation for later studies in conceptual drawing (see p. 259).

Where are the sides of such a visualized box? Can they be seen at all in one-point perspective? Absolutely not, unless the box is transparent. To see this in the mind's eye, imagine the receding telegraph poles again, but this time as mere yardsticks or rulers. Now visualize the two nearest verticals reaching exactly to the top of the box, on either side of its face. The two that stand along the side edges at the back of the box will appear somewhat shorter, so that a line drawn between the top of each side's verticals will continue on to the same central vanishing point.

A similar line, drawn between the bottom of these sticks and the vanishing point, would reach exactly to the lowest point of the back and front panels. Since the rear and bottom surfaces of the box appear smaller than, and overlapped by, the front and top panels, they cannot be seen. And, in the same way, the side panels are also hidden from view. (If you visualize a transparent box, only the back and front panels will show right angles.)

Exercise:
Place a box directly on the table in front of you and draw it in one-point perspective. Extend the diagonal upper edges to a common vanishing point as they converge.

What has happened? Has the material of which the box is made become part of the drawing? Are there wrinkles, bends, lids, or flaps in view? Is the location of the vanishing point quite clear? Where would this point exist—inside the room or somewhere off in space? Does the difference in width of the top surface front-to-back appear as great in actuality as it did in theory? Think of this kind of perspective as a general guide to perception rather than as an exact science to be applied with precision!

Exercise:
Place a book in a frontal position and draw it with an awareness of one-point perspective, but do not fix a vanishing point or other unseen helping points or lines.

Can the ideas of vanishing-point perspective help you even when they are not specifically used (fig. 4.13)?

TWO-POINT PERSPECTIVE

Two-point perspective is used to show objects or scenes from a turned angle, not a head-on frontal view. This means that one side of a cube, in addition to its top and face panels, will now be seen. The frontality of the face panel has

4.13
U.C.L.A. student of Lois
Swirnoff: Craig Polizzotto
Interior perspective study
1980s
Pencil on paper
18 × 24" (45.7 × 61 cm)

therefore been lost; it is now one of two diagonal panels, although it may in fact be considerably closer in position to a front than a side panel.

It may seem difficult to visualize the idea of constructing a box in two-point perspective from a verbal description, but it is well worth the effort, if only for the mental exercise. Actually, it may be easier to imagine than one-point perspective, since there are more lines moving together in each of the converging parallel groups.

One vertical edge of the face of the original cube, remaining in place, will be the tallest upright in the new drawing; the vertical on the other side of the face moves away with a slight turn of the cube. The face of the cube as it turns becomes, in effect, a side, bringing the other side into view as well. We can now see the top surface and two sides. All right angles are gone. An additional vertical has appeared at the rear of the newly visible side. This makes three parallel verticals, the masts of a new structure. (If it were transparent, the box would show a fourth vertical, as you will see.)

Returning to our railroad tracks, this time we will imagine them at an angle, continuing toward a vanishing point, but no longer directly in front of the eye; they move off to the side, still at eye level. The bottom of the box is seen at the intersection of two overlapping perpendicular sets of tracks, each moving off to its own vanishing point in the far distance. In this way, each pair of top and bottom edges, seen diagonally, moves toward a vanishing point in the opposite direction, two to the left and two to the right. We have now established the bottom panel of our box, sitting at the intersection of the tracks. Here is the place to imagine an additional panel placed upon the bottom panel exactly,

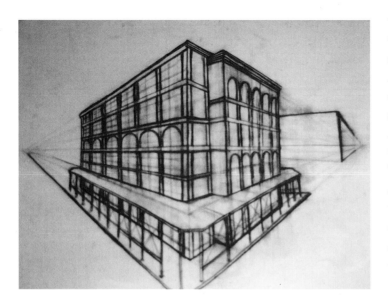

4.14
Cooper Union student
Two-point perspective
1998
Charcoal on paper
18 × 24" (45.7 × 61 cm)

then raised up vertically along the three visible uprights at each corner, stopping at the top point of each vertical. (Again, if it were transparent, there would be a fourth.) We have now created an additional pair of converging lines moving in each direction to demarcate the sides of the upper panel of the box. That means there are now three lines seen moving together toward each vanishing point, the top and bottom edges of each pair of sides. (One is not seen if the box is opaque.) The four edges are physically parallel in the box, no matter how it is positioned; seen in two-point perspective, the top and bottom edges of each pair of parallel sides converge (fig. 4.14).

Three-Part Exercise:

Draw a theoretically perfect box seen at an angle in two-point perspective. Are your vanishing points both located on the drawing paper? If so, this may give a very exaggerated and foreshortened appearance to your box. Try a second drawing with vanishing points far off the page, perhaps only visualized along a horizon-line that is also off the actual paper.

Look at many boxes: square, rectangular, paper, cardboard, wood, plastic, flapped, lidded, large, and small. Select several that you might like to draw together and place them in an interesting arrangement. Study and simplify the arrangement. Try to identify vanishing points for each box and each pair of visually converging parallel sides. Make a linear drawing of this arrangement, trying to use but not to exaggerate the basic ideas of vanishing-point perspective.

Exercise A:

Empty a transparent plastic photo-cube used for displaying five photos, open at the bottom. Make several drawings of this cube from a variety of angles until you feel comfortable with the three-way orchestration of its converging parallels.

Exercise B:

(For city dwellers) From a high window or rooftop, look down a street at a row of houses, so that you see their facades sequentially reducing in size

into the distance. Draw this scene, indicating the larger structures first; then add windows, doors, and other features, also in perspective, their horizontal edges seen along converging lines.

Exercise C:

Invent an interior, using bookcases and other furniture freely to show a room in two-point perspective. Be sure your vanishing points are well off the page to prevent excessive compression or foreshortening of space (see fig. 4.13).

Optional Exercise:

For studying perspective it is helpful to design and create a simple three-dimensional structure that demonstrates vanishing-point convergence. By carefully slotting together three squares of cardboard or foam board, make a freestanding description of three planes intersecting at right angles. A drawing of this construction will be of great assistance in your understanding of the nature of three-dimensionality as well as the concept of the interaction of filled and unfilled space. The three perpendicular planes show the very basis of vanishing-point perspective, as you can see their pairs of physically parallel edges converge in all three directions. A transparent plastic model would be even more useful.

THREE-POINT PERSPECTIVE

In three-point perspective, the convergence of parallels in all three dimensions is shown, although the vertical direction appears in our usual experience perfectly upright, its pairings equidistant and ramrod straight forever. If we consider the three perpendicular dimensional directions separately, the concept may become clearer.

As we have seen, true horizontality occurs only in one-point perspective, when we observe or invent a relatively limited left-to-right portion of our visual field in a frontal position at right angles to our line of sight. If we add a second vanishing point, this horizontal edge becomes a diagonal, actually one of two diagonal directions moving away from the eye. The only constant in both these perspectives is the supporting, upstanding vertical. If we modify our viewing point, however, we see that in a truly three-dimensional space, given sufficient length or distance from the eye, parallels in all three directions will be seen to converge. It is simply that in most of our experience the vertical dimension is limited to reiterations of our own up-and-down orientation in space. Can you verify this? If you lie down or observe a scene from an oblique angle, will you consider verticality the same as before, or will you feel more balanced by considering the position of objects in relation

4.15 RIGHT
U.C.L.A. student of Lois
Swirnoff
Spatial conceptualization:
transparent shapes
1980s
Pencil on paper
18 × 24" (45.7 × 61 cm)

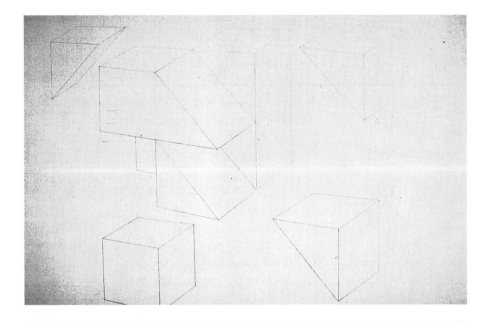

4.16 RIGHT
U.C.L.A. student of Lois
Swirnoff
Spatial conceptualization:
transparent shapes
1980s
Pencil on paper
18 × 24" (45.7 × 61 cm)

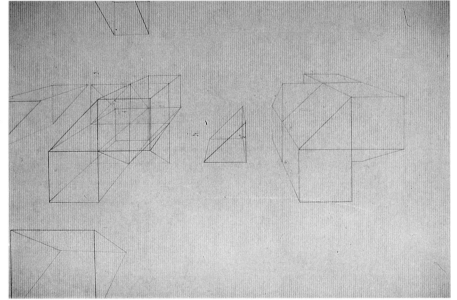

to the top-to-bottom path of your head? Is this a consideration in human adaptation to weightlessness in space? What can *vertical* mean away from the earth, other than parallel to an individual's own sense of up-and-downness, in relation to one's immediate environment, such as the cabin of a particular vehicle?

Verbal Perspectives

Sometimes language itself can help to clarify an idea. *True* is used to mean *straight* in carpentry, and *straight* to mean *upright* or *trustworthy* as well as *vertical.* Browsing through a thesaurus for synonyms can often lead to new

insights identifying relationships between surprisingly diverse ideas. Since drawing is about seeing with the eye and the mind, the way we speak about our perceptions may well affect what we observe (figs. 4.15 and 4.16).

We become aware of the equal visual diminution of parallels as they recede from the eye in all three directions, given enough distance. Stand at the base of any tall building and look up and you will be struck by a dramatic convergence of its sides as they approach the top. Stand at the corner of such a building to view the double convergence of both sides. Does the nearest edge remain visually vertical? If so, how can it also appear to converge with each of its neighbors? Are all three moving toward a single distant vanishing point? Where would their horizon be located?

Aerial photography has provided us with powerful examples of buildings seen from above, in which it is the tops, the rooflines, that appear larger while the sides dramatically converge down toward the ground. This effect has been used by illustrators, particularly in advertising, to suggest that certain hotels, apartment houses, or other structures are considerably taller than they are in fact. In what sense could such drawings be *true*?

It may be of greater value to be aware of three-point perspective than to make frequent use of it in your drawings. Or you may find it intriguing to invent never-seen structures and present them so convincingly that they cannot fail to be believed.

Exercise:
Invent a structure, building, or city using three-point perspective. Then show part of this subject from the opposite viewpoint—if you first showed it from the bottom looking up, now draw it from above, looking down. Or place the observer at a central horizontal position, showing visual recession in both directions away from the eye.

MULTIPLE PERSPECTIVES

Although vanishing-point perspective requires the motionless study of objects frozen in time and space, artists since the days of Cézanne have found ways to vary the viewer's apparent position and introduce a sense of movement around the subject. Cézanne's investigation of multiple-perspective views, particularly in his still lifes, paved the way for the later developments of Cubism (see fig. 4.6).

ISOMETRIC PERSPECTIVE

One of the most attractive features of vanishing-point perspective has been its ability to suggest reality or the illusion of deep space on a flat surface. During the latter part of the nineteenth century, when Post-Impressionist painters such as Degas, Gauguin, and Cézanne were seeking ways to flatten the visual surface of their canvases, to deny deep space, and to assert the two-

4.17

Ando or Utagawa Hiroshige

"Sudden Shower at Ohashi
Bridge at Ataka," from the
series "100 Views of Edo"

1857, published 1859

Color woodblock print

14³⁄₈ × 9⁵⁄₈" (36.5 × 24.4 cm)

Fitzwilliam Museum, Cambridge,

U.K. Photo: Bridgeman Art

Library, London/New York

dimensionality of the picture plane, they became intrigued by a system for describing space originating in Asia and newly introduced to the West. It completely rejected the vanishing point. In this *isometric* perspective, parallels remain equidistant even as they move higher in a diagonal fashion to suggest depth and space. The nearest plane of an object may be shown frontally with its corners at right angles, while the side and top recede yet remain on the surface—all at once. Objects, regardless of size or placement, appear, in a sense, tipped up to show a greater amount of top surface (fig. 4.17). This also enhances the sense of flatness. Artists as diverse as Mary Cassatt, David Hockney, and Al Held have employed isometric perspective. Cassatt's familiar aquatints, featuring women and children in domestic activities, were based on a series of Japanese woodcuts (figs. 4.18a and b).

Later, Picasso, Braque, and their followers incorporated isometric concepts and other perspective variants in a new system of subdivided, shifted, split, and tipped sectioning of the picture-plane known as Cubism (described in detail on p. 246).

OPTICAL ILLUSION

Since the space in isometric perspective is not based on convergence of parallels, designs using this method of spatial representation may often be viewed upside-down or sideways without losing their spatial orientation. Optical illusions that employ isometric space may be read alternately in two opposing directions as objects seem to turn themselves inside out or do a visual flip-flop (see p. 252). See Josef Albers' extensive inventiveness with this illusion (color plate 10). Maurits Escher's spatial ambiguities (fig. 4.19) often rely on elaborate interweavings of isometrically drawn structures.

Exercise:
Devise an impossible but believable scene using isometric illusions in the manner of Escher. Structures such as Schroeder's *Reversible Staircase* work very effectively (fig. 4.20).

Today, isometric elements may be found in visual works of many kinds, some of which simultaneously combine both vanishing-point and vanishing-pointless perspectives (color plate 7).

4.18a FAR LEFT
Mary Cassatt
The Letter
1891
State 1: drypoint
13⁹/₁₆ × 8¹⁵/₁₆" (34.4 × 22.8 cm)
The Metropolitan Museum of Art,
New York. Gift of Arthur Sachs,
1916 (16.3.2)

4.18b LEFT
Mary Cassatt
The Letter
1891
Color print with drypoint,
soft-ground etching, and
aquatint
13⁵/₈ × 8¹⁵/₁₆" (34.5 × 22.7 cm)

4.19 LEFT
Maurits Cornelis Escher
Waterfall
October 1961
Lithograph
15 × 11¾" (38 × 30 cm)
Photo: ©1998 Cordon Art, Baarn,
Holland. All rights reserved

4.20 ABOVE
Schroeder
Reversible Staircase
From William Seitz, *The*
Responsive Eye (New York: The
Museum of Modern Art, 1965)

FORESHORTENING

Foreshortening may result from the exaggerated application of vanishing-point perspective, when parts of the subject are very close to the eye. In these circumstances the field of vision covered by the nearest part of the subject is greatly enlarged, while the parts receding into the distance show a marked and rapid reduction in size (fig. 4.21; see also fig. 1.2).

Exercise:
To demonstrate this effect, place both hands directly over your face to cover your entire field of vision. Then slowly move one hand away, observing the speed at which it appears to be growing smaller. On a single sheet of paper, draw both hands at their greatest difference in size (or the same hand in each position, since you won't have an extra hand available).

A Note on Sequencing

In this and the following exercise, reference to a model appears before you have studied the figure, if you are using the text in sequential order. Will you choose to:

• Postpone the exercise until you have studied Section 5?
• Draw boldly from the model, regardless of knowledge of anatomy?
• Quickly scan Section 5 before trying this exercise?
 • Try the exercise now; then repeat it after studying Section 5?
 • Discuss these options, then decide?

4.21

Cynthia Dantzic

The Learned Astronomer

1994

Pencil on paper

24 × 18" (61 × 45.7 cm)

Collection of the artist

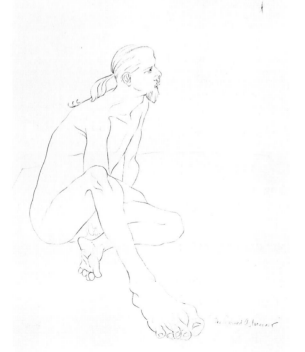

Exercise:
Sit on a low stool or the floor and pose a model (or friend) reclining, feet toward you, head stretching away. Or sit the model facing away, hands stretched toward you, leaning on the floor. Before you draw, mentally measure the amount of visual field actually covered by the feet, hands, head, or other part of the figure. Draw the model exactly as you see this exaggerated scale. Sneakers are recommended, or gloves, to provide plenty of detail for the extra expanse of space you will be covering with the enlarged up-front parts of the figure.

This is one way to see the idea of foreshortening. The artist John Sloan found it quite disturbing and unnatural, however, and advised making a mental adjustment to account for the apparently enlarged protruding portions so one could then reduce them

accordingly. This would involve shortening the distance, front to back, that such parts cover as they approach the fore-part of the field or ground. In this way, it is the depth of the foreground that is being shortened, and the term foreshortening makes a different kind of sense.

Exercise:
Ask the same model to assume the previous pose. This time, draw what you see, modified by the actual proportions you know the subject to possess. Try to correct your perception to accommodate the reality you know rather than the reality you see.

Which view of foreshortening do you prefer? Are there times when you might wish to use the other?

Become familiar with a full range of ways to describe depth and space, even those infrequently used, to recognize them when encountered in classroom, museum, slide presentation, or book, on wall, sidewalk, or poster.

REVERSE PERSPECTIVE

In reverse perspective the apparent reduction in size of retreating objects is turned around, with the narrowest parts of a subject approaching the viewer. Although this inversion of perception might be expected to appear in works of the self-taught or those unfamiliar with traditional drawing concepts, Eastern or Western, examples are seen throughout the history of art.

Imagine a vanishing point behind you with yourself as an interruption of space rather than the hub, and this way of interpreting the world may become clearer.

SIZE AND PLACEMENT

In sophisticated and complex works, discrepancies in size and placement of elements may be assumed as part of the total orchestration. But in the sparest, simplest drawings these factors achieve the same ends; indeed, in such works their power may be greatly enhanced. Among the elements in a drawing that can suggest spatial effects, whether in the simplest, unadorned way or within the context of an elaborate composition, are:

- *Overlapping of shapes:* If opaque, the covered (incomplete) portion is hidden and assumed to be behind the complete shape overlapping it (see fig. 6.10); if the shapes are transparent, a spatial ambiguity may be suggested, often creating the effect of an optical illusion (fig. 4.22).
- *Size discrepancy:* When objects physically the same size are drawn larger and smaller, the larger images are perceived as nearer (see fig. 4.11).
- *Vertical placement:* Working in conjunction with the factor of size, objects lower on the picture plane tend to look nearer to the eye (see fig. 4.21).
- *Contrast:* Generally, the stronger the contrast between an object and its environment, the nearer it will be seen; the softer its edge, the farther it will appear from the eye (see aerial perspective below and fig. 4.24).

- *The horizon:* Placement of a horizontal line across the picture plane creates the sense of solid form (possibly water) below and sky or space above. In a still life, space above the horizontal may be seen as a flat wall or drape, and space below as a surface perpendicular to the wall, such as a table. Even in abstractions, placement of a horizontal line is a powerful force on the planar surface (fig. 4.23).

These elements may be combined in endless ways in works of infinite complexity or subtlety (fig. 4.24).

Exercise:

Combine as many of these factors as possible in a single drawing, from imagination. Simplify the drawing several times until it is reduced to barest essentials. Save it for Section 4, Unit C.

Since the term *perspective* refers to methods of presenting the illusion of space or depth on a surface, would you include the final category, aerial perspective, among them? Can you suggest a new name or classification for this idea?

4.22

Paul Klee

Flight from Oneself

1931

State 1: pen and colored inks on paper, mounted on cardboard

16⅝ × 22⅞" (42.2 × 58.2 cm), irregular

Kunstmuseum, Bern, Switzerland. Paul Klee Collection.

©DACS 1999

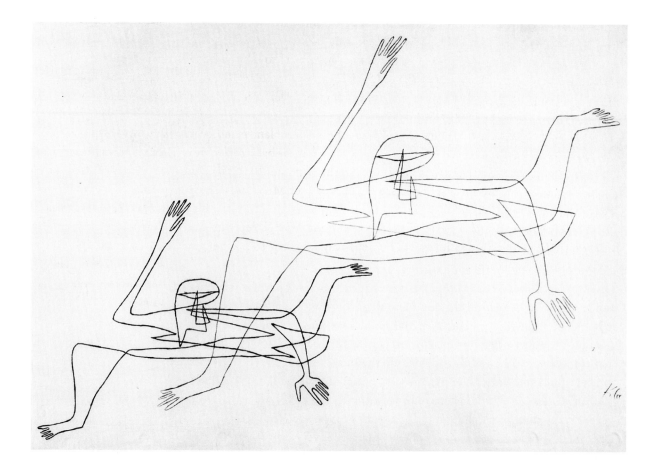

AERIAL PERSPECTIVE

Most commonly used in landscapes, seascapes, or other outdoor subjects, aerial perspective refers to the reduced contrast of edges seen among objects at a distance. Not only are colors shown with less intensity, but distinctions in light value blur as subjects recede from view. Graying of tones and softening of edges occur, so that even large and sharply defined forms seem to melt and fade as they move off into space. This explains the beginner's often too heavy horizon-line in land- and seascapes and an excess of clearly depicted details in areas of a work meant to be far from the viewer's eye.

Of course, in many contemporary works where the picture plane is intended to be seen as flat, aerial perspective may not be used. How far back would you have to search in the history of Western art to find the beginnings of this idea? Would you expect to find aerial perspective in the works of Millet, van Gogh, Cézanne, Gauguin, or Braque?

With this introduction to a rejection of one traditional way of depicting the visible world, we are ready to investigate what many consider to be the very basis of modern art, abstraction.

4.23 TOP LEFT
Richard Diebenkorn
Untitled #30
1981
Gouache and crayon on paper
25⅝ × 25" (65.1 × 63.5 cm)
Private collection

4.24 TOP RIGHT
Johann Thorn Prikker
Haystacks (detail on p. 148)
c. 1904
Crayon and watercolor on paper
19⅛ × 23¼" (48.7 × 59 cm)
Stichting Kröller-Müller, Otterlo, The Netherlands. Photo: Tom Haartsen

Unit C
Abstracting Form: Progressive Reduction

MAKING CHOICES

All drawing involves abstraction, that is, selection and omission, the making of choices. Since we can never draw everything in our visual field, we abstract, from all that might be shown, certain elements arranged in a particular way, and present them to the viewer. In perceptual drawing, we try to present again, to the viewer, the look of a particular subject the way that subject has presented itself to our eye. Therefore what we draw is a *re-presentation*.

Seen this way, representation is an attempt to show again what was previously directly presented to us. Even a camera will not record the entirety of a scene before its lens. We focus on a portion of the visual field, excluding much of what could have been included.

Before any drawing is made, even a realistic image of a subject, there are certain choices. We choose:
- This subject, not another;
- This distance from the subject, not nearer or farther;
- This angle of view, not higher, lower, to the left or right;
- This lighting (or we accept the lighting that exists);
- This position, standing at an easel or seated;
- These drawing materials to be used;
- This orientation of the page, vertical or horizontal.

What other selections are made even before a drawing is begun? Which could be considered abstracting?

4.25 RIGHT
Jean (Hans) Arp
Leaves and Navels
1929
Oil and cord on canvas
13¾ × 10¾" (35 × 27.3 cm)
The Museum of Modern Art, New York. Purchase. Photograph ©1999 The Museum of Modern Art, New York. ©DACS 1999

4.26 FAR RIGHT
Fernand Léger
Two Reclining Nudes
1921
Pencil on paper
19¼ × 14⅜" (48.8 × 36.5 cm)
Stichting Kröller-Müller, Otterlo, The Netherlands. Photo: Tom Haartsen. ©ADAGP, Paris and DACS, London 1999

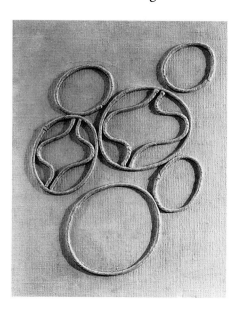

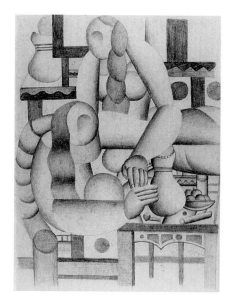

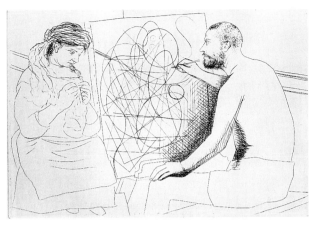

4.27 FAR LEFT

Pablo Picasso

"Painter and Model Knitting," plate IV from *"Le Chef d'Oeuvre Inconnu"* by *Honoré de Balzac*

Paris, Ambroise Vollard, Editeur, 1931 (print executed 1927)

Etching, printed in black

Plate: 7⁹/₁₆ × 10¹⁵/₁₆"

(19.3 × 27.8 cm)

The Museum of Modern Art, New York. The Louis E. Stern Collection. Photograph ©1999 The Museum of Modern Art, New York. ©Succession Picasso/DACS 1999

4.28 TOP RIGHT

Max Ernst

"The Habits of Leaves," plate 18 in *"Histoire naturelle,"* 1926

1925

Lithograph

19¹¹/₁₆ × 12³/₄" (50 × 32.4 cm)

Solomon R. Guggenheim Museum, New York. ©ADAGP, Paris and DACS, London 1999

Once we start to draw, additional decisions are made. We choose:

- This portion of our visual field;
- This boundary, beyond which objects will not be included (see the L frame, fig. 1.4);
- This placement of the subject within the rectangle of the page;
- This place on the page to begin.

Are any of these choices abstracting? Explain why you think so. Other choices remain. First, you might draw:

- A depiction of edges, the contour of form, using line;
- Areas of tone to establish general relation of forms;
- One fully developed object, showing its volume, lighting, and details, before moving to an adjacent object; or....

Which of these choices could be considered abstracting? Which can be emphasized, incorporated, minimized, or eliminated?

- An attempt to show deep space or a suggestion of the third dimension;
- Depiction of roundness, volume, light falling on a subject;
- Correct proportion or relation of parts to one another;
- Correct vanishing-point placement;
- Surface textural or structural details.

Which of the following choices result in works called abstract?

- Simplification of a subject to its most basic organic or geometric forms (fig. 4.25);
- Modification of perceived form by specific symbolic or other concepts (fig. 4.26);
- Reduction of solid or volumetric form to more simple linearity (fig. 4.27; see also fig. 1.31);
- Flattening of shapes on the picture plane, regardless of their original place in space (see fig. 1.3);
- Use of line as a decorative, pattern-making element (see fig. 7.29);
- Use of tonal areas and texture as decorative, pattern-making elements (fig. 4.28).

How many of these choices are seen in color plate 6?

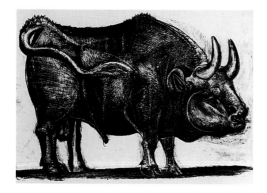

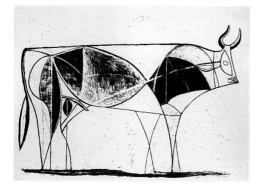

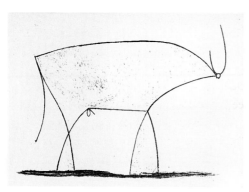

4.29a–c
Pablo Picasso
The Bull
1945–6
States 3, 8, and 11:
lithographs on Arches paper
Each 12¹³⁄₁₆ × 17½"
(32.5 × 44.4 cm)
National Gallery of Art,
Washington, D.C. Ailsa Mellon
Bruce Fund. ©Succession
Picasso/DACS 1999

BIOMORPHIC ABSTRACTION AND PERCEPTION

Since abstracting involves selection based on perceived information, not only are all realistic or perceptual drawings to some extent abstract, but only drawings in some way based on real perception may be called abstract! In other words, abstracting *always* implies abstracting-from-something. Drawings that are derived from pure invention, ideas, or geometric patterning not related to any object at all may be called non-objective or non-representational, but not abstract, a term that always relates to reality, to the world of perception.

Picasso created a famous series of lithographs of a bull, in which he successively reduced the three-dimensionality, volume, and tonality of his subject until in the eleventh state (or version) a bare, heroic, linear statement remained (figs. 4.29a–c). This 1945–6 sequence is most frequently shown as an example of abstracting as progressive simplification. The more Picasso removed, the more he gained in terms of economy, strength, and the essence of his subject. In a sense, the least realism gave the most insight. Picasso never lost sight of the bull or a representation of his subject; this is *biomorphic* abstraction.

From Drawing to Writing

If Picasso had continued to pare elements from his abstracted bull, he might eventually have reduced the image to a simple symbolic shape or mark, in much the way that our alphabet was developed. Each letter has been derived, over many centuries, from a drawing of an actual animal, object, or material, until we see the A as a crossed angle rather than an ox, the B as a double-looped curve attached to a vertical instead of a house, and the other twenty-four letters equally refined from their original subjects. Some languages have simplified their seminal drawings into graphic pictures or picto-graphs, rather than the sound-symbols or letters of an alphabet (fig. 4.30).

Exercise:

Select a Chinese character representing an animal, and find or create a picture of this subject in a pose resembling it. In a series of simple linear studies using a bamboo brush, develop sequential drawings that show a slow transition from the drawing to the symbol. How many drawings will this require? Keep the interval between the steps as equal as possible. Figure 4.31 retains a sense of calligraphic brushwork. Try other materials (see fig. 6.17).

小園香徑獨徘徊

似曾相識燕歸來

無可奈何花落去

Literal translation (to be read in three vertical lines from right to left):

(3)	(2)	(1)
small	as if	without
garden	once before	permission
fragrant	each other	what
path	recognize	
alone	swallow [the bird]	flowers
	return	fall . . .
wander	come	gone

4.30 LEFT
Jia-Xuan Zhang
A poem in Chinese characters written by the poet Yan Shu during the Song dynasty (11th or 12th century)
Chinese brush and ink on paper
13½ × 9¼" (34.3 × 23.5 cm)
Collection of the author

Poetic translation:
Nothing can be done when flowers fall away,
Swallows I seem to have seen before return,
A small garden's fragrant path I wander alone.

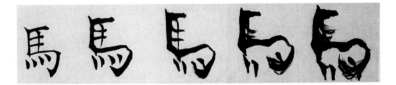

4.31 ABOVE
Cooper Union student: Ella Kruglyanskaya
Transformation from Chinese character to depiction of a horse
1998
Chinese brush and ink on paper
8 × 40" (20.3 × 101.6 cm)

Exercise:
Develop a convincing pictograph for a subject for which you do not have the Chinese character. Later, find the actual character to see how much resemblance your abstraction bears to it. If you prefer, invent a new language for this study.

Exercise:
In a re-creation of the Picasso series, begin with a detailed, volumetric, tonal drawing of an animal or other subject. Then, perhaps on a series of translucent vellum or heavy tracing paper overlays, draw an increasingly simplified sequence of studies, reducing your subject to its minimal linear essence. Or, if possible, draw on a lithographic plate and scrape, add, and modify directly on the stone, metal, or plastic surface with litho crayon, liquid litho ink (tusche), or other grease-based material. If you have access to a lithographic press, and instruction, make a series of prints.

CUBIST ABSTRACTION
In Section 4, Unit B, several of the plane-structuring devices introduced by Braque and Picasso to flatten the pictorial surface and suggest a more equal

interaction of figure and ground shapes and spaces were investigated. Abstraction played a key role in this process. Simplified shapes, given to objects and their surrounding spaces, became closer in importance and in appearance. In this way, chunks of combined figure-and-ground spaces assembled on the flat planar surface increased the degree of abstraction achieved. Then, when the picture plane was split along an axis, slipped up and down along that edge, or tipped to show the object and its surrounding space from a higher or lower angle, the equivalence of each newly subdivided shape was even more strongly asserted. Another outcome of Cubist experimentation was the illusion of seeing the same object from two or more viewing points at the same time, involving a sense of time's passage or the elusive concept of the fourth dimension (see p. 246).

Reduction to essential form, both biomorphically (in terms of growth forms) and geometrically, has been a major concern of many twentieth-century artists to the present day.

Exercise:

Set up a simple still life, using objects that recall early Cubist studies (a wine bottle or glass, guitar, fish skeleton, loaf of bread, newspaper with headline, or cup and saucer, for example). Make a simple linear drawing of this arrangement, including the shapes you see around the main objects (table, drapery, wall). Draw several lines or axes through your entire work, creating parallel strips or other simple geometric subdivisions. Separate, rearrange, and glue the sections to a new backing sheet, making any modifications that seem necessary to enhance your composition. Or place the sections beneath a sheet of translucent vellum and redraw the new composition. Finish the new drawing by adding tonal value and texture, emphasized line, or other pencil work. Use alternate shading (see fig. 1.23) at the edges of several shapes to help unify this study.

Exercise:

Additional levels of abstraction or simplification of this work may prove both satisfying and instructive. How far can you reduce the elements to enhance the quality of the finished drawings? Try one series that reduces forms in a biomorphic, organic direction and another in the curved or angled shapes of geometry.

Matisse's Drawings for the *Merion Dance Mural*

In a series of studies for a commissioned three-panel mural for the Barnes Foundation, Matisse revealed the creative process at work in a constantly reductive, simplified, ever more abstract direction. The first drawings show relatively realistic figures in a loose circle, derived from his paintings *Dance I* and *Dance II*. As work progressed, Matisse introduced flat areas of cut paper

4.32a TOP
Henri Matisse
*Study for "Merion Dance
Mural," version 1*
1930–1
Pencil on tracing paper,
mounted on cardboard
10½ × 31¾" (26.9 × 80.8 cm)
Musée Matisse, Nice, France.
Photo: ville de Nice, Service
photographique. ©Succession
H. Matisse/DACS 1999

4.32b CENTER
Henri Matisse
*Study for "Merion Dance
Mural," version 2*
1932–3
Pencil on wove paper
8⅛ × 21" (20.7 × 53.5 cm)
Musée Matisse, Nice, France.
Photo: ville de Nice, Service
photographique. ©Succession
H. Matisse/DACS 1999

4.32c BOTTOM
*Photograph of "Merion
Dance Mural" in progress*
9 November 1932
State 10
©Succession H. Matisse/DACS
1999

and increased the size of the figures, relating them more specifically to each of three rounded lunette shapes, creating a flatter, more architectural and less expressive surface. After discovering that a measuring error would necessitate starting again, he drew directly in clean, pure line on canvas, interlocking the figures in a violent, spinning movement. For the final work, he lowered the emotional tone, simplified the figural gestures and forms even further, and created a powerful interplay of filled figurative and unfilled ground spaces. Although these drawings were intended as studies for paintings, not as finished works, and were not produced as one continuous sequence, they show, in a way rarely available to any viewer, the progressive simplification and purification of a composition and its component elements, achieving a high level of figurative abstraction (figs. 4.32a–c).

Exercise:

Study Matisse's *Dance I* or *Dance II*. Ask several models or friends (preferably dancers) to assume a similar pose (leotard or body stocking will not detract) and try to re-create the gestures of the original. Then, in a series of

overlays on vellum, or in separate studies, simplify and pare the drawings to a minimal form with equal emphasis on the shapes around the figure. Consider a rounded or other than rectangular format.

GEOMETRIC ABSTRACTION

A clear movement toward geometric abstraction may be seen in the work of Piet Mondrian, from flowering apple trees to piers, cathedral facades, and dunes reduced progressively to perpendicular *plus and minus* markings, then to his signature works of *pure plastic* structure, or arrangements of asymmetrically balanced rectangular forms. Divided by heavy black linear bands with the addition of a few rectangles of primary color, these works move beyond abstraction to a new idea unrelated to perceptual reference (see figs. 2.11a–c). They refer to no object, and thus have been called non-objective. Other negatively worded names for such works are non-representational and non-associative. Since they present visual ideas directly, the name *presentational* has been introduced, but without much success.

Surprisingly, toward the end of his life, Mondrian reintroduced associative references in such works as *Broadway Boogie Woogie*, which indicates his response to the movement and feeling of a particular time and place. Was this a return to abstraction?

It is interesting to select a different sequence of Mondrian's works to discover a direction previously overlooked, particularly in his drawings of flowers (color plate 9 and figs. 4.33a–c). These occupied his attention continuously, yet have never been granted the importance of the geometric works. Do you see a relationship between the flowers and the more abstract work? Is there a point at which the representational becomes abstract and the abstract becomes non-associative in this grouping of Mondrian's seemingly unrelated works?

Exercise:

Select a subject from nature such as a flower, pine cone, or insect. In a series of drawings using any tonal or linear techniques, progressively reduce the representational aspect to discover an underlying geometry. Develop this sequence to the point of losing any perceptible link to the original subject. Study the entire series of drawings.

In this examination of abstraction, there has been an emphasis on a continuing reference to a subject, no matter how far from its originating inspiration a work may have moved. In Matisse's *Merion Dance Mural* the figure is reduced to the barest linear clues, yet there is no doubt that the artist was familiar with the details of human structure. In non-associative works, is such knowledge important?

Do you think some introduction to the structure of the human form is of value for any student of drawing, or only for those planning to work in a representational way? Would it be better to draw the figure first, getting a

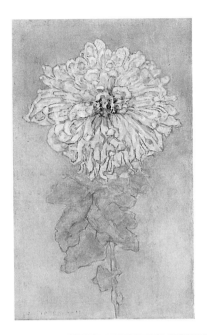

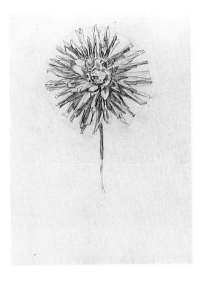

4.33a TOP LEFT
Piet Mondrian
Chrysanthemum
1908–9
Graphite and watercolor on
canvas
10⅜ × 6¼" (26.4 × 15.9 cm)
Sidney Janis Family Collection.
©Mondrian/Holtzman Trust,
ᶜ/₀ Beeldrecht, Amsterdam,
Holland/DACS, London 1999

4.33b TOP RIGHT
Piet Mondrian
Chrysanthemum
1908
Pencil on paper
12½ × 9" (31.8 × 22.9 cm)
Collection of Carroll Janis.
©Mondrian/Holtzman Trust,
ᶜ/₀ Beeldrecht, Amsterdam,
Holland/DACS, London 1999

4.33c LEFT
Piet Mondrian
*Composition in Line (Black
and White)*
1916–17
Oil on canvas
3'6⁹⁄₁₆" × 3'6⁹⁄₁₆" (1.08 × 1.08 m)
Stichting Kröller-Müller, Otterlo,
The Netherlands. Photo: Tom
Haartsen. ©Mondrian/Holtzman
Trust, ᶜ/₀ Beeldrecht, Amsterdam,
Holland/DACS, London 1999

feeling for the movement and gesture, perhaps, and then go back to study the parts that make such orchestration possible? If you prefer some background before working from the model, go on to the next Section, "The Human Figure: Structure and Movement." Leave this Section until later if you wish to draw first and then study.

The Human Figure:

Structure and Movement

Unit A

Skeletal Framework:
The Support System

DRAWING THE HUMAN FIGURE

The human figure may be drawn as a virtual copy of the reality seen, with all its volume, interacting anatomical elements, fluid rhythms, and grace, according to the individual skill, style, and concerns of an artist. Or it may be the merest point of reference in a work far removed or abstracted from that original perception. Between these extremes lies infinite variety.

Even in the most masterful drawings—the incredibly lifelike, subtle, anatomically detailed, often idealized nudes of masters such as Leonardo, Michelangelo, Raphael, Caravaggio, Rembrandt, and Dürer—the individual hand, the calligraphy of each artist is more immediately recognized and savored than mere recognition of the subject or its component parts (color plate 2). We take the artist's scientific knowledge for granted even as we enjoy (and perhaps learn from) the art. This is as true of works paying passing homage to the figure; we expect the artist to know the subject, not necessarily to show all that is known (fig. 5.1).

Any student of representational drawing (or related areas such as illustration, fashion design, medical illustration, graphic arts, advertising design, cartooning, or computer animation; see fig. 8.10 and p. 288) will find value in a brief introduction to the underlying skeletal framework; the elaborate system

of levers, pulleys, and flexible bands that make up the musculature of the body; and the general orchestration of these systems as they are seen, glimpsed, or sensed beneath its skin-clad surface. Even if you are more concerned with other than figurative subject matter or content, you will derive important understandings relating to structure and movement, proportion and form from this Section of our study.

If you prefer to do your initial figure drawings spontaneously, before undertaking any analytical investigation, defer reading these Units to a later time. Some instructors believe that for the first semester, even the first year of serious drawing study, it is quite acceptable, perhaps preferable, to begin with far less complex subjects until a certain facility has been developed. There is no more challenging, no more difficult subject to draw than our fellow human beings—certainly none that can elicit the emotional response and identification felt when we depict our own kind (fig. 5.2).

DRAWING THE SKELETAL FRAMEWORK: PRELIMINARIES

Few drawings can be less lifelike, less alive, or farther from the elegant flow and animation of the human figure than a bag-of-bones depiction of the articulated skeleton suspended from its stand. Mere knowledge of individual bones does not provide the spark, the kinetic harmony of this armature as it permits

5.1 BOTTOM LEFT
Egon Schiele
Aunt and Nephew
1915
Black chalk on paper
19 × 13¼" (48.5 × 33.5 cm)
Private collection

5.2 BOTTOM RIGHT
Cooper Union student:
Eric Azcuy
Figures playing volleyball
1995
Brush and ink on paper
24 × 18" (61 × 45.7 cm)

motion, locomotion, and limitless gestural positionings of its elements. A study of kinesiology—the types and range of movements possible at the joining of anatomical components—is highly recommended, as is a more thorough investigation of human anatomy, specifically directed to the visual artist. In any book the best that can be accomplished is a kind of frame-by-frame animated or stroboscopic stopped-motion sequence of images. Even a film will be flat and two-dimensional, while the actual movements of the body involve fully three-dimensional paths (fig. 5.3; see also fig. 5.55).

Exercise:

Swing your right arm in a broad figure-of-eight motion, first high and forward, then low and behind you, bending your elbow to accommodate the movement as your hand turns alternately palm up then palm down. Keep the momentum building as you increase the pulse of the rhythm this action creates. Visualize a drawing of the movement. From a single position, how many drawings would be required to show it fully? And what would the rest of the figure be doing—standing, sitting, running, dancing? Would the opposite arm be performing the same movement in a bilaterally symmetrical way? Imagine the fewest drawings you would need in order to show the full extent of this movement. Could it be done in a single work with overlapping or a kind of sketch/scribble expressive technique? With a model or fellow student performing the action, draw the figure in several different ways to capture the particular activity being demonstrated.

Would your drawings have benefited most from greater knowledge of the skeleton, of the musculature, or of the articulation and kinds of movement possible between the bones? All of the above would be valuable, but in what order should they be studied?

If you were working in clay, you would begin with an armature, a posable but strong understructure, on which the form of your figure would be built. Size, proportion, even gesture and rhythm of major parts would all be determined by this supportive framework. In much the same way, the bony armature of the body provides an inner structure as well as strong attaching-points for the muscles that contract and relax in interacting pairs to move the skeletal components within their range of possible positioning. In several areas of the body, skeletal elements appear close to the surface, providing the visible landmarks seen at the forehead, jawline, chin, collar-bones, elbows, wrists, knuckles, knees, ankles, heels, and toes.

Close your eyes and palpate or feel your own surface from forehead to toes in order to discover the bony protuberances and projections that mark skeletal

5.3
Suzanne Rosenblatt
Dancer
1980
Chinese brush and ink on paper
12 × 9" (30.5 × 22.9 cm)
Courtesy of the artist

features. Will you include the nose? Despite superficial or surface differences that distinguish one individual from another, the common structural similarities shared by all people (and not by any other creature in quite the same way) define our identity as a single human race. Yet it is these individual characteristics that provide the distinctly human variety artists never tire of observing, describing, interpreting, and even exaggerating. No two people, identical twins excepted, have exactly the same features, proportions, or gestures. There is no exact proportional relationship of parts to which we all correspond. The so-called ideal proportion—eight heads high—does not describe the majority of individuals, but it provides a general guide for study. And, of course, structural differences between young and old, male and female, must be considered (figs. 5.4 and 5.5).

An Overview

If possible, have a skeleton present, actual bone or acrylic, so long as your model is articulated correctly, permitting its joints to move in a natural way. From time to time, move around the skeleton to view various parts from other positions.

The exact number of bones in the body is not agreed upon; experts counting differently find from 197 to 206 separable bony structures. It is surely unnecessary to know them all.

Looking first at the skeleton as a whole, you can see that the tapered or chiseled ball of the head-bone or skull sits directly atop the long, curving, spiny backbone, a strong column of support along the axis of the body. This central powerful spine provides the impetus for movement as well as the attachment

5.6a FAR LEFT
Albers student: Harold Ford
*Skeletal studies—
comparative anatomy*
1950s
Pencil on newsprint
17³/₄ × 11³/₄" (45 × 29.8 cm)
Josef and Anni Albers
Foundation, Orange, Conn.

5.6b LEFT
Albers student: Norma-Jean
Koplin
Skeletal studies
1950s
Blue pencil on newsprint
11³/₄ × 17³/₄" (29.8 × 45 cm);
drawn horizontally
Josef and Anni Albers
Foundation, Orange, Conn.

place for the encircling upper rib cage and its shoulder girdle from which the arms depend, and at the lower end the bowl of the pelvis and its offset, mighty appendages, the legs. But it is the spinal column—the chain of vertebrae enclosing the spinal cord, our electrical power line from the brain's generator—that is the common characteristic we share with other vertebrates: reptiles, amphibians, fish, birds, and mammals. The skeleton of the snake is almost all undulating backbone and tiny skull. On the other hand, the bird has developed upper limbs into the elaborate wings dominating its entire skeletal structure. A study of the comparative anatomy of vertebrates is particularly valuable to any serious student of figurative art (fig. 5.6a; see also fig. 7.32). Although here we can provide only a glimpse of the understructure of our closest anatomical relatives, the mammals, such study will be amply rewarded with insights into the particularly human qualities we possess (fig. 5.6b). It can also give material for countless flights of reality-based fantasy, and other works of invention (see figs. 7.11 and 5.56).

As in the structure of other mammals, the human skull/spine core has upper and lower, or fore and rear, attachments. In the upper part, the rib cage protects vital inner organs, yet it must permit expansion and contraction of the lungs in breathing. To simplify greatly, at the top of the rib cage an encircling shoulder girdle is created by the triangular, spade-like shoulder blades (the scapulas) and the horizontal, rib-like collar bones (the clavicles) attached to the central flat placket of the breast-bone (sternum). This bony structure girds the rib cage and provides attachments for the arms, long limbs enabling the individual to move other objects and itself. For the purposes of holding, pushing, pulling, grasping, and manipulating small objects; for performing

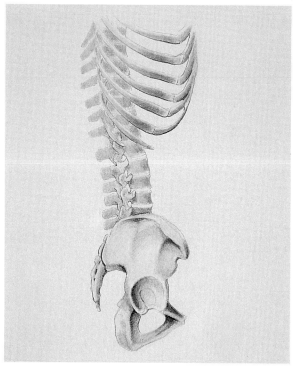

5.7a ABOVE

Virginia Cantarella

Spinal study

1998

Pencil and colored pencil

on paper

12 × 9" (30.5 × 22.9 cm)

Collection of the artist

5.7b BELOW

Four-arch curve of spine

From Stephen Rogers Peck,

Atlas of Human Anatomy for the

Artist (New York: Oxford

University Press, 13th printing

1971)

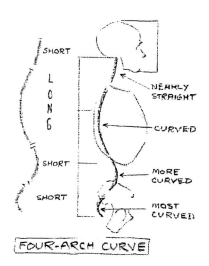

actions necessary to survival such as eating; and for engaging in uniquely human activities requiring the dexterity we associate with civilization (such as writing, playing musical instruments, performing the visual and other fine arts, typing, threading a needle, using a pair of tweezers or pliers), the forearm and its extension, the hand, with its opposable thumb, are surely masterpieces of skeletal and muscular design.

At the spine's lower end the massive pelvic basin attaches to the broad sacrum, five fused false vertebrae, providing protection for the inner organs (figs. 5.7a and b). The pelvis is a powerful support for the much stronger, longer limbs that facilitate locomotion and force, along with their extensions, the weight-bearing, resilient, springing feet.

Let us now look more closely at the skeleton's individual structures as they are seen from an esthetic, non-medical viewpoint.

THE SKULL

The head-bone or skull (fig. 5.8a) is composed of two separate structures, hinged just in front of the ear. The cranium, which cradles the brain, has several sutured non-movable segments: the large, rounded parietal at the top and rear, the flatter side plates of the temporals (yes, at the temples), and in front, defining the forehead, the sweeping curve of the frontal bone. The upper facial bones are part of the cranium, starting at the brow ridge above the eye socket or orbit.

The deep rounded rectangular orbits are separated by the short nasal bone, and each socket is protected by a brow ridge above and by a wide flaring cheekbone, the zygomatic bone, which sends a long curving arch to join the lower part of the cranium to the rear. The triangulated central nasal cavity, surrounded by bone protruding in front of the orbits, is on a line with the ear (a non-bony feature). The highest part of the nasal cavity is well above the lowest part of the eye socket. The lower edge of the cranium is ringed with the horseshoe curve of the upper teeth. Suspended in front of the knob or process behind the zygomatic arch (the mastoid), just in front of the ear-hole, sits the mandible or jawbone. A very elastic hinge at this joint permits chewing, talking, and sometimes wiggling the ears (fig. 5.8b)!

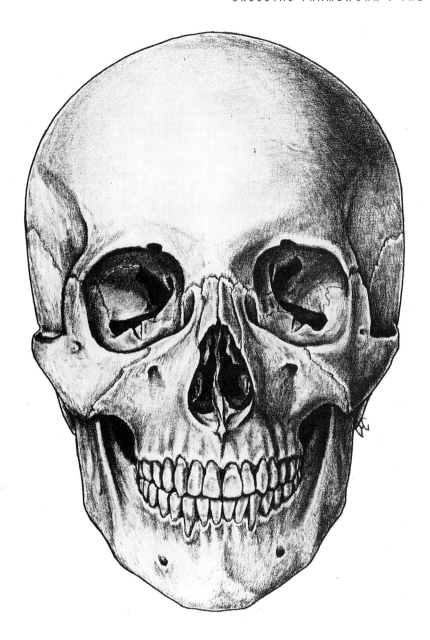

5.8a LEFT
Virginia Cantarella
Front view of skull
1997
Pencil on paper
Sheet: 14 × 11" (35.6 × 28 cm)
Collection of the artist

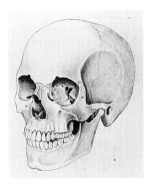

5.8b ABOVE
Virginia Cantarella
Three-quarter view of skull
1997
Pencil and colored pencil
on paper
Sheet: 12 × 11" (30.5 × 28 cm)
Collection of the artist

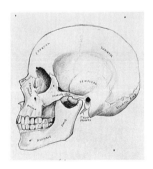

5.8c ABOVE
Virginia Cantarella
Side view of skull
1997
Pencil and colored pencil
on paper
Sheet: 12 × 11" (30.5 × 28 cm)
Collection of the artist

Exercise:

Put your hands in front of and slightly lower than your ears, and open your mouth. Move your jaw freely to become familiar with the full range of movement possible. Close your eyes and note the improvement in your ability to palpate, discerning tactile differences.

The jaw consists of two flattish side walls which slope down to a sharply angled, narrower chin. Above this is a rounded ridge following the lower ridge of the cranium and also ringed by a sharply angled curve of teeth, theoretically perfectly aligned (or occluded) with the upper teeth. Seen from the side, the midpoint of the skull, left to right, is at the earhole (fig. 5.8c). From top to bottom, the eye socket is in the center, just as it is seen from the front.

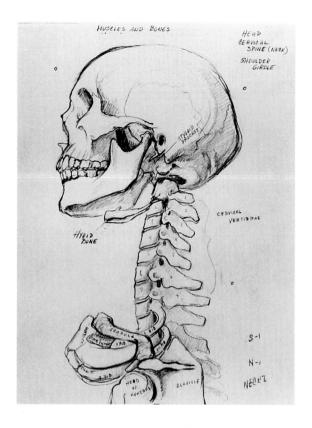

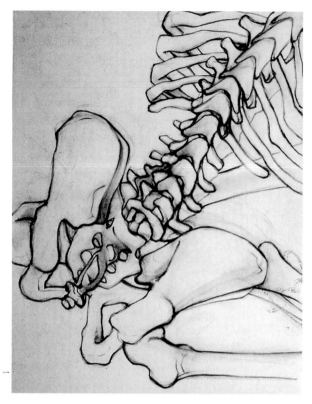

5.9 ABOVE
Virginia Cantarella
Skull tipped
1997
Pencil on paper
14 × 11" (35.6 × 28 cm)
Collection of the artist

5.10 TOP RIGHT
Cooper Union student of
Larry Brown: Wonsun
(Sunny) Sul
Rib cage, spine, and pelvis
1995
Charcoal on paper
24 × 18" (61 × 45.7 cm)

The back of the skull ends on a line horizontal with the bottom of the nose; the first four vertebrae under the cranium are located well above the line of the chin, making the neck much higher in the back than in the front. This explains the odd tilt of many drawings of the skull alone; lying it on a flat surface gives an improper sense of the placement of the head upon the neck and shoulders.

Exercise:
Place the skull on a drawing table, noting the tilt to the rear as the cranium and chin rest in a single plane. Stand the cranial portion of the skull on a small, preferably transparent, box or cube (try a clear plastic photo cube) to hold the head in a normal upright position. Now make a drawing to see how the change in position causes changes in your work (fig. 5.9). Save all your drawings of the skeletal structure for use in the following Units.

Exercise:
If you have access to a fully articulated skeleton, turn the skull carefully to the left and right, then tip it up and down, and finally rotate it in a continuous motion starting with the chin down, to the right, up and out, up and to the back (open the jaw slightly), left and out, left and down, and

chin down and center. Follow this with a similar sequence of movements by yourself, then with a fellow student. Make several small studies of the skull in different positions atop the cervical vertebrae. Simple contour line is recommended.

THE TORSO

Below the head and above the legs, the main trunk of the body is known as the torso. Consisting of the rib cage and pelvis connected by the spinal column, plus the girdle of bones at the shoulders, this portion of the skeletal structure shows itself at several places near the surface: in the back at the shoulder blades and along the spine, in front at the collar-bones, sometimes along the rib cage, and at the pelvic crests of the hips (fig. 5.10).

The thorax, or rib cage, may be seen as a rounded, tapering, conical barrel-like form, widest just near the bottom. Of its twelve pairs of ribs, all attached to the spine at the rear, the first seven are called true ribs, as they are also fixed to the breastbone. The top pair of ribs resembles a small tight circlet of bone, aimed upward toward the spine. Just above its intersection with the sternum the collar-bones are attached. The next pair of ribs is more horizontally placed, and the remaining five true ribs slant downward before they curve up and around the chest. Ribs eight to ten attach indirectly to the sternum by a band of cartilage, and the last two attach only to the spine and are therefore called floating ribs.

For several inches at the waist, the broad lumbar vertebrae comprise the only skeletal armature, permitting free and powerful rotating movement by the attached pelvis. To observe these movements in action, attend the athletic or dance performance of your choice; taking your sketch pad is optional.

The two flared wings of the pelvis's iliac crest may be detected by observation but, for the most part, this structure lies deep beneath the heavy musculature of the hips. We will return to the portion of the pelvis that serves as an attachment for the legs (see p. 209).

THE SHOULDER GIRDLE

The shoulder blades and collar-bones may be studied as a transition between the torso and the arms, as they attach to both (fig. 5.11). The triangular flattened scapula widens to a diagonal crest at the top and

5.11

Shoulder blades

From Jenö Barcsay, *Anatomy for the Artist* (London: Octopus Books, 1973)

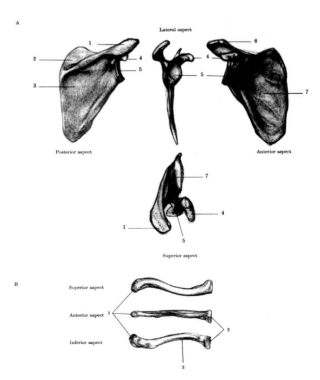

5.12

Albers student: Rita V. Forest

Animal skeletal study

1950s

Pencil on newsprint

11³⁄₄ × 17³⁄₄" (29.8 × 45 cm)

Josef and Anni Albers Foundation, Orange, Conn.

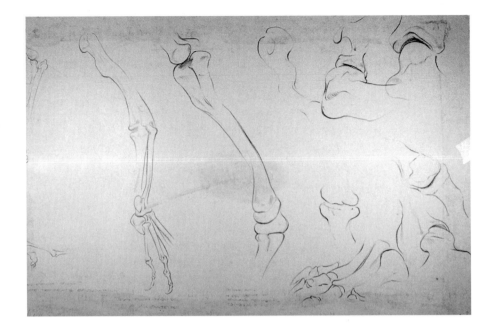

becomes an oval socket into which the upper arm bone, the humerus, fits. The slightly S-shaped collar-bones sit horizontally between the shoulders, attaching to the central sternum. This girdle of bones permits free movement of the shoulders and arms. Compare the skeletal structure of birds and bats—if possible at a natural history museum, otherwise at your library—to see the amazing development of the shoulder and upper limbs in these animals (fig. 5.12).

THE ARMS

The spherical head of the humerus matches the hollow of the scapula, permitting complete circular rotation of the upper arm. The long, powerful shaft of this bone thickens at the elbow into three forms of approximately equal size: the ball into which the smaller end of the forearm's radius fits, the central depression into which the protruding end of the forearm's ulna hinges, and the outer protuberance (which, along with a smaller inner protuberance above the ball on the other side, acts to protect the elbow; fig. 5.13).

One of two bones in the forearm, the ulna creates a strong hinge at the elbow, then follows the outer part of the arm to support the outer wrist and hand, where it is greatly reduced in size. The radius, on the other hand, starts as a small socket below the mighty ulna–humerus hinge, then continues about equal in girth to the ulna for most of its length, but sharply widens at the wrist to receive the thumb-side wrist bones or carpals. A unique feature of the radius is its ability to move along an extension of the upper part of the ulna to permit the thumb (and with it the hand) to rotate and pronate, or turn over. This makes tennis, swimming, and washing the hands possible, as well as conducting an orchestra.

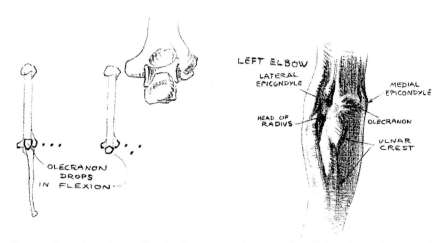

5.13 FAR LEFT

Arm, skele form

From Stephen Rogers Peck,

Atlas of Human Anatomy for the

Artist (New York: Oxford

University Press, 13th printing

1971)

5.14 LEFT

Radius and ulna at elbow

From Stephen Rogers Peck,

Atlas of Human Anatomy for the

Artist (New York: Oxford

University Press, 13th printing

1971)

Remember that the radius is always on the outside of the elbow, but on the thumb-side of the hand. The bone seen at the point of the elbow, when the arm is bent, is the hook of the ulna, swinging out of its notch between the two protuberances of the humerus (fig. 5.14).

Exercise:

Close your eyes and palpate this joining of the three interacting bones. Particularly note the strong hinge movement, which is unaffected by holding the wrist immobile. Place your thumb and third finger on the outer knobs of the humerus and your index finger on the point of the ulna while bending the elbow. Then pronate your hand at the wrist to note no change in this articulation at the elbow. Hold your elbow to prevent it from bending, and again pronate the hand and wrist together. Next, hold your wrist tightly so the radius cannot move, and notice that the elbow is still perfectly free to bend. This double movement of the forearm can only be appreciated by studying the skeleton (fig. 5.15).

Knowing the mechanics of the elbow, make several drawings in different positions. Save all your drawings of the elbow and adjacent parts of the arm.

THE WRIST AND HAND

The eight pebble-like bones of the wrist, the carpals, act in unison to allow free yet controllable movement between the arm and the hand. Watch a violinist's

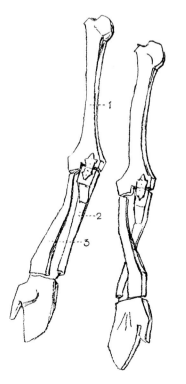

5.15 LEFT

Double movement of

forearm with turn

From George B. Bridgman,

Bridgman's Complete Guide to

Drawing from Life (New York:

Weathervane Books, n.d.)

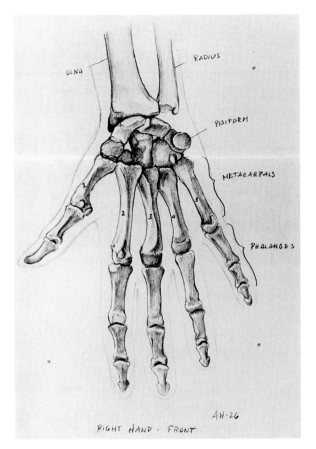

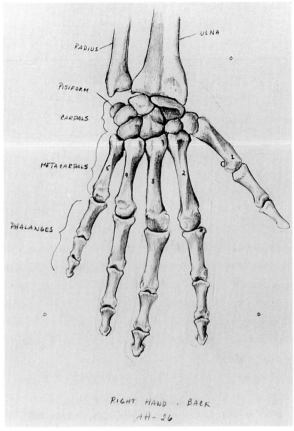

5.16a and b

Virginia Cantarella

Skeletal hand

1997

Pencil on paper

Each 11 × 8½" (28 × 21.6 cm)

Collection of the artist

trembling vibrato, or simply shake excess water from your hands to see this range of motion.

The hand and fingers comprise a single multi-part structure, whose sequentially tapered and smaller groups of bones can fold and work together in closing or opening spirals of concerted motion (figs. 5.16a and b). The four fingers, which are an extension of the long metacarpals of the palm, will be considered first. Tuck your thumb under and view the back of your hand as it folds and unfolds, then turn your palm up and watch this action again as you hold the thumb away. Each long metacarpal ends in a ball which meets the first finger-bone or phalanx in a strong hinge. The ends of the four metacarpals describe a curve, tapering in toward the outer part of the wrist. This curve is repeated even more strongly in the ends of the first phalanges, where they hinge with the second phalanges to become the knuckles. A softer curve is described by the hinging of the third and fourth phalanges. Notice that when the fingers are curled, the four fingertips are aligned in a row, but when the hand is held open, they form a steep curve with the middle finger by far the longest and the little finger ending a full phalanx-length shorter.

A Note on the Golden Mean

The size relationship of the hand and finger-bones fits the proportion of the

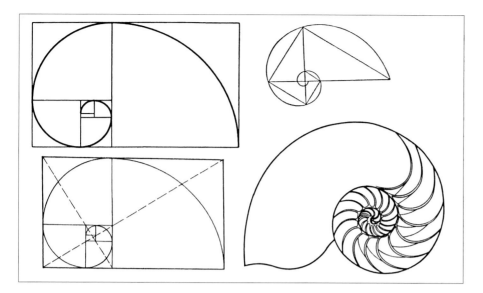

5.17
*Development of the Golden
Mean and Equiangular
Spiral*

Adapted from diagrams in texts

by Pedoe, Hambidge, and Scott

Golden Mean, a mathematical sequence considered by many artists and others to be a basis for beauty and harmony of elements in nature and the arts, and good design in general. Called the Fibonacci Sequence, this series calls for simply adding the first two numbers, dropping the first and adding the next two, and so forth, in a never-ending progression: 1, 1, 2, 3, 5, 8, 13, 21, 34 …. This proportional sequence is referred to in several places in our study (fig. 5.17; see also p. 113).

Exercise:

Measure the length of the long bones in the skeleton, particularly the bones of the hands, and see if there is a clear relationship to the Fibonacci Sequence. Design an artificial hand, perhaps for a robot or other "bionic" creation, according to this proportional sequence, and compare it with the actual structure provided by nature. Do you think you have made an esthetic improvement?

Now let us return to the thumb, the feature that gives the human hand its special distinction, its power, its ability to grasp and to perform the most precise and subtly controlled manipulations in concert with the other fingers. The metacarpal of the thumb is shorter than that of the other fingers, and is attached by a saddle-like connection to the saddle-shaped carpal known as the trapezium. This permits a much wider range of movement than that of any other finger, particularly as the thumb sits at an angle to the rest of the hand and can therefore rotate freely in its place. When the hand is held straight, the end of the first phalanx of the thumb is continuous with the curve of the endings of the palm's metacarpals. But, as we shall see, when the hand is balled into a fist, this joint becomes a fifth knuckle aligned with the sharply hinged first and second phalanges of the other fingers. The second and last phalanx of

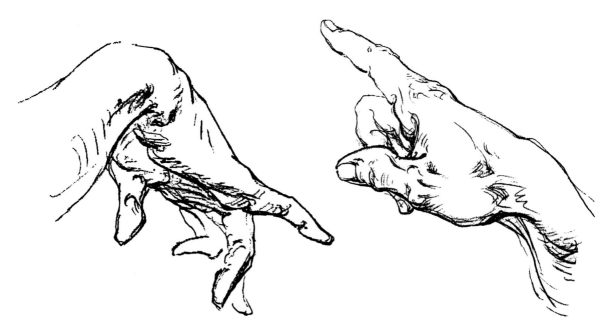

5.18a and b

Thumb, fingers in motion

From George B. Bridgman,

Bridgman's Complete Guide to

Drawing from Life (New York:

Weathervane Books, n.d.)

the thumb is close in size to the forefinger's second bone, but it is shaped more like that finger's third one (figs. 5.18a and b).

Exercise:

To study the hand, first look at the back of your palm. Bend the four fingers at the end of their metacarpals and the thumb at the end of its first phalanx to see if they can be made to align in a fluid curve. Straighten the thumb, and move it so that this same joint touches the forward knuckle-joint of the other fingers. Now turn your hand over as a fist and open the thumb to point out to the side. Next, bring it in a long curve over the fingers, turning and placing it flat atop the little finger. Hold it in this position as you straighten the other fingers. You have just demonstrated the famous opposable thumb, the single feature that is said to have made civilization possible. Look at the palm of your hand, form the fingertips into a claw, slowly close the five fingers into a circle, then bring them together in a tight, grasping unit. The handsome, handy hand deserves our special attention and admiration (see fig. 8.21).

Make several drawings of the skeletal hand in a variety of positions.

THE LEGS

The thigh bone, or femur, the longest and most sturdy skeletal support, is attached by a massive ball-and-socket joint to the outer part of the lower pelvis, offset from the main shank of the bone by a slimmer neck. From this widest space between the femurs, they move slowly closer until they almost meet at the knees, directly below the hip sockets. The leg rotates freely and can move

in almost any direction at the hip with great strength. At the knee, the leg is hinged to the massive tibia, as wide as the base of the femur. However, there is a gap between these bones, which is covered by the protective kneecap, or patella. This is particularly evident when the leg is bent and the two bones virtually separate. The kneecap also acts to prevent the leg from bending backward. The tibia is by far the larger and more supportive of the two lower leg bones. At the bottom end, it flares to a broad base to meet the major bone of the ankle, or tarsal area, the talus.

Attached below and behind the outer part of the tibia's head, the slender fibula remains more or less parallel with the larger bone until it ends, slightly lower than the tibia, in a visible protuberance at the outer edge of the ankle. A line between the knobs at the bases of the tibia and fibula is seen as an angle moving outward and down along the curve of the ankle. While at the knee the tibia closely resembles the elbow's ulna, both creating strong hinge joints, it remains the major bone at the ankle as well, serving in the lower leg as the radius does in the arms, with its broad attachment to the main large-toe side of the ankle and foot (fig. 5.19).

THE FEET

Although there are many similarities between the hands and the feet, these structures are also dissimilar and serve quite different functions (fig. 5.20). While the outer edge of the foot remains level with the ground, the inner bones are raised in a series of arches both front-to-back and side-to-side, with the greatest openings toward the center, so that, together, both feet complete a single large arch. The heel-to-toe arch rests on the backward directed heel bone, the calcaneus. The cluster of tarsals ends forward of the ankle, in a continuous line with the five metatarsals that curve to follow the sideward, or transverse, arch of the foot. These connect fairly tightly with the first five phalanges or bones of the toe in a series of limited hinges. The main hinge joints of the toes lie between the next pair of phalanges, which in the case of the big toe is the final bone in the series. The big toe is the strongest of these tarsal digits, and its two bones are considerably larger than the three in each of the other toes. While the ankle is capable of rotation, it has nowhere near the freedom of movement of the wrist, and its major action is hinge-like. The big toe, which provides support and leverage for the springing action of the arched foot, cannot repeat the opposable action of its counterpart, the thumb.

Described in architectural terms, the toes have been likened to "flying buttresses to the arches of the feet" by the renowned teacher of anatomy to artists, George B. Bridgman. Many articulations of parts of the body have been shown in

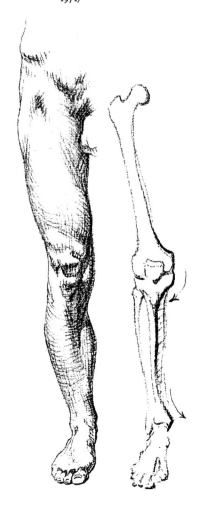

5.19

Legs, skeletal

From Stephen Rogers Peck,

Atlas of Human Anatomy for the Artist (New York: Oxford University Press, 13th printing 1971)

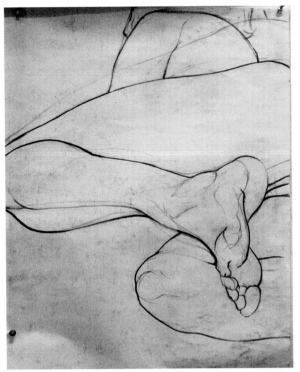

mechanical analyses and diagrams by distinguished anatomists (fig. 5.21). Consult the Bibliography for a selection of these texts, but always be ready to add to this listing, based on your own investigation and research.

 Exercise:
If you are able to detach the skeleton from its base or stand, arrange it in a pose that a living model can duplicate, seated or standing, preferably showing a bent knee. Make a series of drawings not of the entire skeleton but of specific parts, showing a particular articulation, such as the shoulder, elbow, wrist, knee, or ankle. If you can, make each drawing life size, even if this requires attaching two or more sheets of paper. (Use micropore paper surgical tape, which may be drawn on and will mask any attachment.) You might make a single multi-sheet drawing of the entire arm or leg, or perhaps of the hand resting on the knee. Save all these drawings for future study and use.

5.20 ABOVE
Cooper Union student
A study of foot and legs
1998
Charcoal and pencil on
paper
24 × 18" (61 × 45.7 cm)

Optional Exercise:
Visit a local natural history museum or a taxidermist's studio to make drawings of the skeletal structure of various animals. A detailed study of a single articulation of an elephant or, better yet, a dinosaur, can be almost overwhelming to a student of human anatomy.

5.21 RIGHT
*Mechanical analysis
diagram*
From George B. Bridgman,
*Bridgman's Complete Guide
to Drawing from Life* (New
York: Weathervane
Books, n.d.)

Unit B
Anatomical Basics: Building Bodily Form

APPROACHING ANATOMY

Between the inner framework (the skeleton) and the outer surface covering (the skin) is a complex upholstery of living tissue—cartilage, muscle, tendon, ligament, blood vessel, nerve fiber, and fat—much of what gives form to the external figure we see. For the artist, only those elements visible from or affecting the exterior need be considered.

We will investigate aspects of superficial or readily visible anatomy in addition to the bony landmarks already noted. These are the larger muscles whose changing forms determine the configuration assumed by the outer covering of the body, and the special features of sensory reception and expression on the facial mask of the head from ear to ear. We also survey ways in which a number of distinguished art-anatomists have suggested that the figure as a whole be understood or its larger elements be visually integrated,

5.22a (full image) and
b (detail)
Jules Feiffer
A Dance to Spring
1957
Pen and ink on paper
Photo: courtesy Fantagraphics
Books, Seattle, Wash.

beginning with the sofa analogy from Stephen Rogers Peck, who says, "the upholstery … cannot by itself have form but takes its broad lines from the frame over which it stretches." Of course, our stuffing is far from inert, yet the image is helpful. In another verbal picture Peck describes the "complex harness of muscles, weaving itself about the skeleton [as] the agent of driving force for bodily action." Before we begin to describe the specifics, let us consider a few more ways to see the figure as whole, mindful of Peck's admonition that "the facts require translation, for the artist will be exploring the aesthetics of anatomy" (figs. 5.22–5.24).

Points to View

The student must work at first to be correct, but … there is little virtue in sheer correctness. Ultimately … propose … to be convincing. (Peck)

One has to have some idea of the normal in mind or one can't know what's abnormal. (Robert Beverly Hale)

You always work from the secret figure in your mind. (Hale)

The facts must be learned, the aesthetics of anatomy perceived. (Peck)

[The aim], once in closer touch with the masterful design, is to enlarge your capacity for response to the world about [you]. (Peck)

[You] will want to gain … such mastery of structure … such command of human form and contours that [your] creation will become identified not with anatomy charts, but with [you] …. In fact it is those aberrations of the anatomical truth that so often make a piece of work personal and exciting. (Peck)

Knowledge of the figure does not mean that you [can] rattle off the Latin names for each minute part of the human anatomy—but you should know the basic and important parts … [so] that you can draw the figure with intelligence. (Walter T. Foster)

[To] the artist … the impact of the body is exclusively visual …. The [student] should therefore approach anatomy from an artist's point of view, not a doctor's … [to be] acquainted primarily with the bones and muscles whose forms and actions are visible or just below the surface. (Jenö Barcsay)

5.23

Sue Ferguson Gussow

Reclining Nude

1992

Charcoal on paper

24 × 18" (61 × 45.7 cm)

Collection of the artist

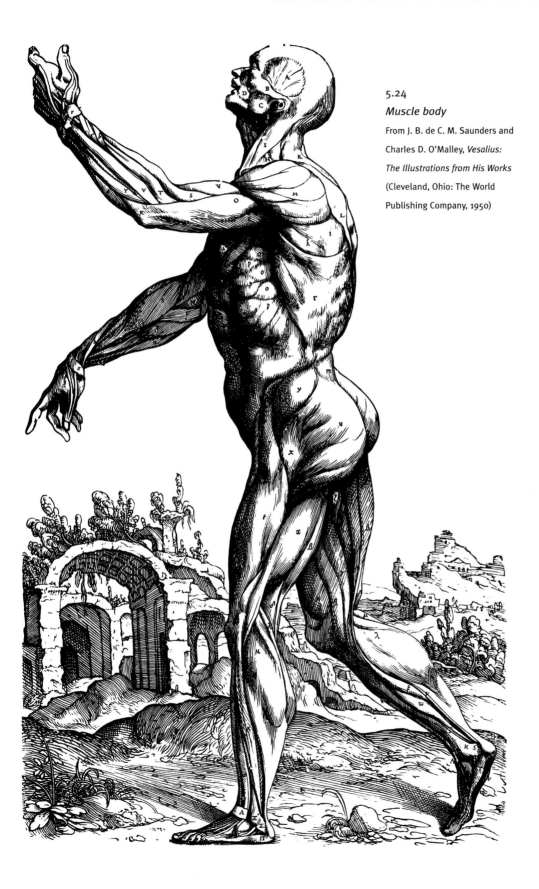

5.24

Muscle body

From J. B. de C. M. Saunders and

Charles D. O'Malley, *Vesalius:*

The Illustrations from His Works

(Cleveland, Ohio: The World

Publishing Company, 1950)

I have used drawing, since photographs offer only the impersonal viewpoint of a mechanical device, and not a selective one which emphasizes the essential details. (Barcsay; fig. 5.25)

Which of these ideas express your own thoughts and feelings? Which are interesting to consider but not important to you? With which might you disagree, and why?

GETTING IT ALL TOGETHER

Before defining the various kinds of upholstery or tissue that determine human form and describing their specific functions, we need a general picture of the figure-as-a-whole. A number of such images have been proposed. "The conception of the figure must begin with the thought of these [three] blocks [head, chest, pelvis] in their relation to each other.... They are unchanging masses ... to be thought of first as one thinks of the body of a wasp, with only one line connecting them or without reference at all to connecting portions" (Bridgman; fig. 5.26). Bridgman described the possible movements among these three blocks, limited only by the movements of their connecting spine, in three perpendicular planes of motion. The blocks may be bent forward and back, as in nodding "yes," twisted from side to side as in indicating "no," or tilted up and down as in lowering the ear to the shoulder. Of course, as he reminds us, "almost invariably ... all three movements are present, to different degrees." Another of Bridgman's images is that of the major masses of the body seen as interlocking or wedging into each other (fig. 5.27).

Perhaps the most familiar visualizing device to the student of life drawing is the division of the standing figure into a specific number of heads, generally seven-and-a-half or eight (fig. 5.28). Hale speaks against this arbitrary division, since the usual landmarks on the body that occur at the divisions of these visual segments vary in the individual, particularly with gender, weight, and age. These landmarks are the chin (the module, one actual head in height), nipples, navel, crotch (theoretical midpoint), mid-thigh, knee, mid-calf, and foot. Some artists recommend sketching eight ovals lightly above one another as a guide to drawing the standing figure. With the arms at the side, their

5.25 ABOVE

Selective viewpoint of essential details

From Jenö Barcsay, *Anatomy for the Artist* (London: Octopus Books, 1973)

5.26 ABOVE

Three blocks of torso with wasp-line

From George B. Bridgman, *Bridgman's Complete Guide to Drawing from Life* (New York: Weathervane Books, n.d.)

5.27 ABOVE

Wedging masses

From George B. Bridgman, *Bridgman's Complete Guide to Drawing from Life* (New York: Weathervane Books, n.d.)

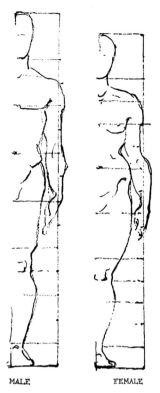

MALE FEMALE

5.28 FAR LEFT
Proportionally subdivided
figures
From George B. Bridgman,
Bridgman's Complete Guide to
Drawing from Life (New York:
Weathervane Books, n.d.)

5.29 LEFT
Figure with blocks
conceived as masses
From George B. Bridgman,
Bridgman's Complete Guide to
Drawing from Life (New York:
Weathervane Books, n.d.)

divisions would occur approximately in this way: angle of shoulder just below the midpoint of the second head, elbow aligned with navel, wrist with crotch, tip of fingers with midpoint of thigh. Joseph Sheppard thinks the eight-head-high body, modeled on classical Greek and Renaissance proportions, gives dignity to the figure and is the most convenient.

Bridgman's three rectangular blocks are conceived as masses sometimes composed of more than a single form, but always to be visualized before planes or lines. Although the line in actual construction comes first, he says, just as mental construction precedes physical, so the concept of mass comes first, plane second, and line last. "Think in masses, define them in lines," he advises (fig. 5.29).

MUSCLES

Attached by tendons to the armature of the bones, muscles provide the means of movement. By shortening their elastic, contractile fibers into bundles which swell in girth, they pull bones together, then relax to release this flexed tension. Muscles work in synergistic or complementary pairs, one flexing and pulling its freer end (insertion) toward its firmer support (origin), the other relaxing enough to permit the desired movement. Thus the body is in a constant state of contraction, known as muscle tone, even at rest.

The size of a muscle varies in relation to the length of the bone (or lever) to be moved. So tiny muscles of the fingers fit between their small phalanges, and the muscles of the fingers, forearms, upper arm, and shoulder increase geometrically in size and in power as their required leverage grows.

5.30
Henri Matisse
Etude de bras
1938
Pen and blue ink on paper
10⅝ × 8¼" (27 x 21 cm)
Private collection. Photo: Lumley
Cazalet, London. ©Succession
H. Matisse/DACS 1999

CARTILAGE

This firm, yet elastic, connective tissue may be continuous with a bony structure, such as the nasal bone's cartilaginous external nose, or may connect bones such as the ribs to the sternum. Cartilage also defines the visible form of the ear.

TENDONS

At the outer extensions of muscles, their fibers cluster into packed cords or flattened sheaths of tissue, focusing and attaching them to bones at either end. These tendons, holding the muscle fibers compactly, may carry their action over a great distance—even longer than the bone to be moved. Tendons serve to lighten and taper the form of limbs and fingers, adding elegance and beauty, often finely and imperceptibly blending with the contours of the bones to which they attach, according to the enthusiastic description of Walter T. Foster. In general, art-focused anatomy books approach their subject with a great deal of esthetic appreciation rather than a simple factual description of parts in order, as seen in many medical texts. "The graceful tapering of the forearm is due to the transition of muscle into long tendons," says Foster (fig. 5.30; see also fig. 0.9).

LIGAMENTS

Less visible than many tendons and muscles, these elastic strapping bands bind bones together or hold tendons and muscles in place. It is important to understand the difference in structure and function of tendons and ligaments.

BLOOD VESSELS

Carrying oxygen and nutrients to every cell, arteries, veins, and capillaries weave throughout the body, but only superficial veins need concern the art student. "More than a pictorial feature imparting ruggedness to flesh ... veins frequently help to clarify form by breaking a surface into clean planes," says art-anatomist Peck. Particularly in the elderly or the physically active, certain veins of the arm and hand, leg and foot may add valuable visual information and provide details of surface structure that can give character, expression, and verisimilitude to a drawing (figs. 5.31 and 5.32).

TERMS DEFINED

We cannot list all the scientific (Latin) names of even the major visible muscles (additional research is encouraged) but will explain the way in which such names are chosen and suggest various categories that have been established. Muscles are named for their location, their shape/description, or the action they perform. A summary follows.

5.31 LEFT
Simon Dinnerstein
Marie Bilderl, detail
1971
Charcoal and conté crayon
on paper
Full image 3'5½" × 4'1½"
(1.05 × 1.26 m)
Minnesota Museum of Art, St.
Paul, Minn. Photo: courtesy ACA
Galleries, New York

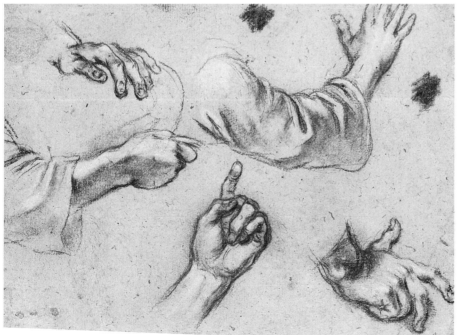

5.32 LEFT
Francesco Curradi
Study of hands and arms
17th century
Black and white chalk on
buff paper
7¾ × 10¾" (19.7 × 27.3 cm)
Photo: courtesy Stephen Ongpin,
London

Category	English	Latin	Example
location	upper, above	*super, supra*	*supraspinatus* (of scapula)
	lower, below	*infra*	*infraspinatus* (of scapula)
	back	dorsal	*latissimus dorsi*
shape or description	four-sided, not a parallelogram	*trapezium*	*trapezius*
	broadest	*latissimus*	*latissimus dorsi*
	triangular	*delta*-shaped	*deltoid*
	two + head	*bis + caput*	*biceps*
	three + head	*tres + caput*	*triceps*
action	rights, straightens	*rectus*	*rectus abdominus*
	flexes, contracts	*flexor*	*flexor carpi radialis*
	extends, relaxes	*extensor*	*extensor carpi radialis*
	draws toward center	*adductor*	*adductor magnus*
	draws away from center	*abductor*	*abductor pollicis*
	turns the palm up	*supinator*	*supinator longus*
	raises	*levator*	*levator scapulae*
	lowers	*depressor*	*depressor labii*
	turns the palm down	*pronator*	*pronator quadratus*

You should be able to decipher almost any anatomical term with this brief guide (plus a Latin dictionary). One or two special terms, too delightful to overlook, must be added: the calf muscle, *gastrocnemius*, named for its

resemblance to a frog's belly, and the *sartorius*, which crosses the thigh when one is seated in a cross-legged position, like a tailor at work. Where would you expect to find the *corrugator*? (Don't wrinkle your brow too much trying to figure that one out!)

✎ Exercise:

Using any illustrations in this and other Sections of the text, place tracing paper over a portion of the figure showing the musculature, and try to draw several muscles from their origin to their insertion. Refer to any anatomy texts the Bibliography or your library can provide. Repeat this exercise after you have studied the rest of this Unit.

BRIEFLY, FROM HEAD TO TOE

To draw the head, it is tempting to start with a simple, familiar, three-dimensional form, such as an egg, sphere, football, or cube. In two-dimensional terms, these would translate to an oval, circle, pointed oval, and square, made to appear three-dimensional in two-point perspective. The problem is that the skull, with all its added features, simply does not fit any of these symmetrical, geometric models (fig. 5.33). Robert Beverly Hale proposes a circle overlapped by an egg or oval, enclosed in a square (seen in profile). Foster likes a circle with overlaid cross lines. Both see the oval as too indefinite, with no landmarks, no points for comparison or basis for measurement. Bridgman, too, agrees and proposes the cubed square. He feels it is quite a revolutionary idea, but says, "the eye does not fix on any point in a curved line The block carries with it from any angle its perspective ... its foreshortening ... and the sense of mass, [as well as] the bilateral symmetry of the head." Into this cube Bridgman places the three masses of the head: the rounded cranium, stopped in front by the ridge of the brows and flattened by the temples on the sides of the forehead; the wedge of cheekbones, moving down in a long sweep to the corner of the chin, in the center of which plane sits the nose; and the jaw itself (fig. 5.34).

Taking a cue from Peck, we will focus our study of the head on facial features rather than the muscles that hinge the jaw, permit chewing and facial expressions, and wrinkle the brow. Describing the "cupola-skull with its balcony of cheekbones," he feels the head is little more than a skull adorned with ears, nose, eyes, and mouth. We will return to the facial mask at the end of this Unit and proceed with a survey of the major contour-forming, movement-producing muscles.

5.33 BOTTOM LEFT
Head (not an oval)
From Walter T. Foster, *Anatomy for Students and Teachers* (Tustin, Calif.: Walter Foster Art Books, 1997)

5.34 BELOW
Three masses of head on armature
From George B. Bridgman, *Bridgman's Complete Guide to Drawing from Life* (New York: Weathervane Books, n.d.)

HEAD, NECK, AND SHOULDER ACTIVATORS

The neck supports and positions the head and protects the air and food tubes. It turns the head from side to side using long powerful muscles originating at the joining of the sternum and clavicle and pulling upon the mastoid process of the skull. Since this cord-like visible muscle follows the path of the strings one might use to secure a hat, it is called the "bonnet-string" muscle as well as the more formidable sterno-cleidomastoid (fig. 5.35).

At the rear of the neck, a portion of the diamond-shaped *trapezius* rises in two strong bands to turn and pull the head backward (color plate 2). The broadest part of this muscle covers the area between neck and shoulders, raising the shoulder blades and pulling them together. The lower portion comes almost to a point just above the waist and helps to lower the shoulder blades.

Although from an anatomist's point of view the torso's musculature might be considered next, in terms of drawing the figure, the shoulder is seen as a complete form, leading to the arm. This brings us to the triangular *deltoid*, covering the shoulder-cap to raise and rotate the arm (fig. 5.36).

ARMPIT, ARM, AND HAND MOVERS

When the arm is raised, a number of muscles of the back, chest, and arm fit

5.35
Virginia Cantarella
Sterno-cleidomastoid
1997
Pencil on paper
8½ × 11" (21.6 × 28 cm)
Collection of the artist

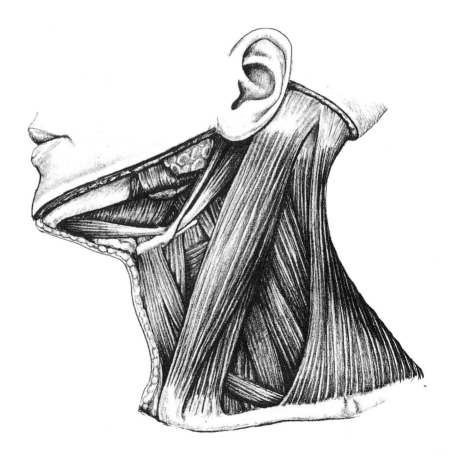

into and define its cavity. Raise your arm to palpate the extension of the *pectoral* or breast muscle moving across from chest to arm. Then, along the inner surface of the upper arm, on the thumb side, find the famous swelling *biceps*, the Popeye muscle, which also inserts deeply into the armpit or *axilla*. On the outer surface of the arm, its three heads acting to extend and draw the arm back, note the *triceps*, a major feature of the raised-arm *axilla*, seen from the front. Below the arm muscles, sweeping around the back to define the lower portion of the armpit, is an extension of the broadest muscle of the back, the *latissimus dorsi*, which pulls the arm back and rotates and lowers it from a raised position (fig. 5.37).

Giving a rounded form to the inner portion of the forearm is the long extensor of the radial (thumb) side of the wrist, in Latin the *extensor carpi radialis longus*. (There is a similar shorter muscle, the *e.c.r. brevis*.) And, on the back or outer surface (palm toward body), you will find the corresponding flexor of the radial wrist. A variety of flexors and extensors to pronate or supinate the forearm and hand gradually taper and lengthen into tendons of great intricacy, capable of extremely subtle movements, all the way to the fingers. The ball of the thumb contains several bulging *thenar* muscles, and the heel of the hand is rounded by less prominent *hypothenar* flexors and other motivators (fig. 5.38; see also figs. 2.23 and 8.21).

5.36 TOP LEFT
Michelangelo Buonarroti
Study for "The Libyan Sibyl" in the Sistine Chapel, detail
1510–11
Red chalk on paper
Full image 11⅜ × 8⁷⁄₁₆"
(28.9 × 21.4 cm)
The Metropolitan Museum of Art, New York. Purchase, 1924
(24.197.2). Photograph ©1995
The Metropolitan Museum of Art

5.37 TOP RIGHT
Guido Reni
Study of a Right Arm and Hand
1617–21
Black chalk on blue paper
9 × 13¾" (23 × 35 cm)
Private collection, California.
Photo: Margot Gordon, New York

5.38 RIGHT
Peter Paul Rubens
Blind Man with Outstretched Arms
Early 17th century
Black chalk, heightened with white, on paper
11⅛ × 16⅜" (28.2 × 41.7 cm)
Graphische Sammlung Albertina, Vienna

5.39 RIGHT
Michelangelo Buonarroti
*Studies of a reclining male
nude, for "The Creation of
Adam" in the Sistine
Chapel*
1510–11
Red chalk on paper
7⅝ × 10¼" (19.3 × 25.9 cm)
British Museum, London.
Photo: Bridgeman Art Library,
London/New York

5.40 BELOW
Leonardo da Vinci
*Studies of Naked Soldiers,
Riders, and Sketches of
Women*, detail
c. 1504
Pen and ink on paper
Full image 10 × 7⅝"
(25.5 × 19.5 cm)
Biblioteca Reale, Turin (15577r.).
Photo: Alinari, Florence

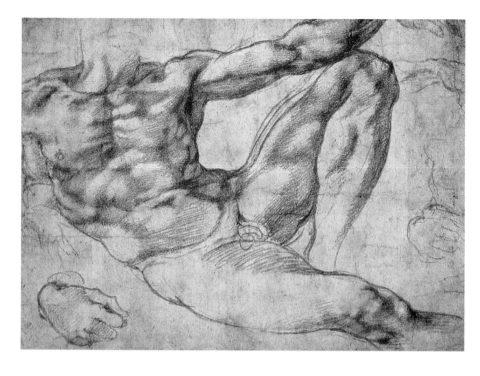

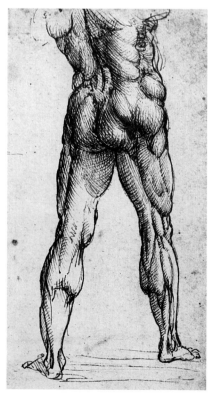

Exercises:

With tracing paper overlays atop your drawings of the skeletal arm and shoulder (see pp. 189–91), draw the arm of a male or female model in the identical position, trying to visualize the various muscles described here. Repeat this exercise with your studies of the skeletal hand in several positions. You may find it useful to have an illustrated anatomy text beside you as you work (consult the Bibliography).

THE TORSO

Encircling the cylinder of the torso are many overlapping, largely flat muscles. They reach out to activate the arms, draw the thorax down and the pelvis up, rotate the spine, and straighten the abdomen (fig. 5.39). Seen from the front, the torso is divided symmetrically by a long groove, the *linea alba*, from the pit of the neck to the pubic area. The chest walls hold the *pectoral* muscles, which flex to give great strength to the arms. In women, the mammary glands, covered by a cushion of fatty tissue, lie atop the pectorals, creating hemispherical breasts. The nipples, placed below the center of fullness, follow the general rounded form of the rib cage, and thus point outward along curved axes. Of course, there is great variety in the individual in this as in every visible feature. Position of the figure also determines the perceived form of the breast to a greater degree than for other more firmly fixed features of the body (see fig. 3.10).

Below the pectorals, covering the front of the torso, are the long straighteners of the abdomen, *rectus abdominus*. These muscles are interrupted by a series of tendons, giving them a sectioned, segmented appearance. The upper edge of the abdomen follows the contour of the arched space below the ribs.

Moving around the side of the torso, the outer margins of front and back muscles are seen. These bulge more prominently than the deeper *serratus* or sawtooth muscles which interlace with the bands of the *rectus abdominus* in an oblique sweep from upper front to lower back. The pectorals in front and the *latissimus dorsi* in back converge to enter the armpit, as previously described.

Padding the flanks are the external obliques, placed at an angle parallel to the *serratus*. These thick flank pads give form to the torso, particularly in the male figure, and are often emphasized in Greek sculpture, just above the iliac crest (fig. 5.40). The large, fat-enhanced *gluteus maximus* and *minimus*, which cover the rear portion of the pelvis, move around also to partially encircle the sides of the hips.

Seen from the rear, the torso begins at the top with the previously noted *trapezius*, terminating in two strong cords on either side of the back of the neck. The back of the *deltoid* gives form to the shoulder seen from behind. Girding the back like a corset of muscle are the *latissimus dorsi*. Below, tucking into the triangular lower tip of the *sacrospinalis*, which repeats the form of the *trapezius* in the lower spinal gutter, is the pair of *gluteus* muscles, larger and smaller, named above. These provide power to extend and rotate the thigh.

THE LEGS AND FEET

Below the buttocks' mighty *gluteus* muscles, seen from the rear, bulge the thighs' own *biceps* of the femur, *biceps femoris*. The narrow tendon of this muscle is seen strongly along the outer side of the knee, while the tendon of its partner, the *semitendinosus*, holds the inner side of the knee tightly. Known as the hamstrings on the sides of the thigh, these create a sort of pair of tongs with the thin tendons of two long muscles that move along the inside and front of the thigh (the tailor muscle, *sartorius*, and the graceful *gracilis*, which flex and rotate the thigh). The *sartorius*, the longest muscle in the body, has its origin on the iliac spine and curves in a spiral over the thigh to insert near the outer part of the knee articulation. Beneath the *sartorius*, the rounded and bulging straightener of the thigh, *rectus femoris*, extends from the top of the leg to the knee, where it has narrowed to become the *quadriceps* tendon, holding the patella (or kneecap) in place (fig. 5.41). In the rear and around to the sides, the calf of the lower leg is defined by the double-headed *gastrocnemius*, higher on the outside, lower and fuller on the inside. This most visible muscle of the leg narrows and flattens to become the thin band seen above the heel, the Achilles tendon. Long, slender muscles along the front of the lower leg barely cover the shin of the *tibia*, which can be palpated quite easily, forming a sharp bony vertical crest from knee to ankle. The cap of the knee remains visible through its covering of fatty pads and the *quadriceps* tendon.

5.41 RIGHT
L.I.U. student: Maria
Eastmond O'Brien
Figural study
1985
Pencil on paper
24 × 18" (61 × 45.7 cm)

5.42 RIGHT
Salvador Dali
Studies of a Nude
1935
Pencil on paper
6⅞ × 5½" (17.5 × 14 cm)
The Museum of Modern Art, New
York. The James Thrall Soby
Bequest. Photograph ©1999
The Museum of Modern Art, New
York. ©Salvador Dali—Fundacion
Gala-Salvador Dali/DACS,
London 1999

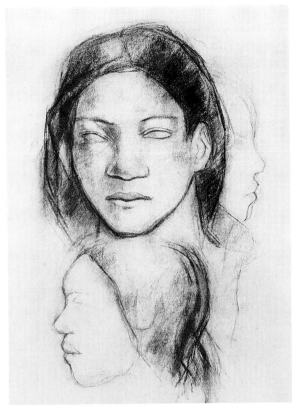

Most of the muscles of the foot are concealed beneath a layer of sheath-like tissue, ligaments, and the thin tendons of muscles located in the leg above. The sole is covered largely by fatty pads which cushion the foot in the great springing movements made possible by its complex arching of bones in two perpendicular planes (fig. 5.42).

FACING THE HEAD

By far the most complex and interesting portion of our anatomy is the facial mask of the head, including the features which receive sensory information relating to sight, sound, taste, and smell. The eyeballs, ears, inner part of the mouth, and exterior nose do not involve much movement that we can see. But the muscles—around the eyes and mouth particularly—permit an almost limitless array of facial expressions, communicating our feelings in subtle or forceful ways, either learned, through our specific cultural environment, or deeply recalled through our common human heritage (figs. 5.43 and 5.44). A few general guidelines as to how to approach the amazing variety of human facial features should be helpful.

THE EYE

The eyeball, set deeply in its protective orbit, is shielded by the forehead's ridge, the nasal bone, and the cheekbone. You can place the entire flat of your hand

5.43 TOP LEFT
Cynthia Dantzic
Mother
1974
Pencil on paper
14 × 11" (35.6 × 28 cm)
Collection of the artist

5.44 TOP RIGHT
Paul Gauguin
Tahitians
c. 1891–3
Charcoal on laid paper
16⅛ × 12¼" (41 × 31.1 cm)
The Metropolitan Museum of Art, New York. Purchase. The Annenberg Foundation Gift, 1996 (1996.418)

5.45a and b
Virginia Cantarella
Child's face before and
after cleft lip surgery
1992
Pencil and colored pencil
on toned paper
Each 9 × 7" (22.9 × 17.8 cm)
Collection of the artist

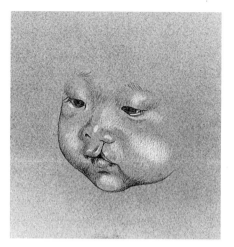

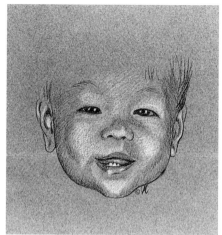

across these bony prominences and never touch the eye. This ball of the eye is curtained by an upper and a lower lid which move together to regulate the entry of light, the upper lid being larger and more active. In drawing, remember that in every position the eye's lids must be curved to follow its spherical form. Also note that between the slit of the lids and the inner ball there are small triangles of space, the outer and inner *canthus*. The inner *canthus* reveals a moist tear duct. In the Asian eye, there is an additional epicanthic fold of the upper inner lid, but the basic structure of all eyes is the same (figs. 5.45a and b).

THE NOSE

Differences in the external nose seem vast, as cartilaginous additions to the nasal bone vary enormously. From a flat almost nonexistent bridge to one that is high, thin, and prominent, the nose may show anything from a broad rounded nasal apex with wide and flared nostrils to long or short, pointed or rounded, flat or variously protuberant forms in profile. To the artist it is this very variety that appeals to the eye (fig. 5.46).

THE LIPS

Between the nose and lips lies a ridged depression, the *philtrum*, below the central dividing *septum* between the nostrils. This deep channel widens to meet the indentation between the two side wings of the upper lip. It is centered above the thicker wedge between these lateral lip extensions. The upper edge of the lips follows the same three-part bowed contour, terminating at points just below the center of the eyes. The dividing edge between the lips also follows this contour, often meeting the outer wings in a marked, accented way, then curving, in two bows, to join the thicker bulge of the central upper lip wedge. Since it marks an actual separation, the central lip line may be drawn with greater strength than the upper and lower contours. The lower lip, often the thicker of the two, consists of two rounded lobes, frequently softened in contour as they tuck under the longer upper lip's lower border. There is usually

a sharp indentation just beneath the center of the lower lip. As with the nose, individual variants of the mouth can be remarkably diverse; the slightest alteration in size, proportion, and positioning of any part of this most mobile part of the face can completely alter the look of the individual being drawn. In portraiture, it is largely the ability to orchestrate such subtleties that produces a recognizable likeness (fig. 5.47).

FACIAL EXPRESSION

Since what we call expression is created mainly by a combination of often small movements in the mouth-encircling *orbicularis oris*, the eye-encircling *orbicularis oculi*, and the frown-making *corrugator* muscles, you might wish to devote extra time to a study of this area of the facial mask.

Exercise:

Over your life-size drawing of the skull (see p. 187), place a sheet of thin, translucent paper. (Or use fig. 5.8a.) Position a large mirror so that you can easily see your face reflected frontally at eye level. Hold your mouth in a relaxed, expressionless way and draw the contours of your face in a simple linear manner, correctly positioned over the skull. Then place a second sheet, perhaps more transparent, over that study and, changing your expression only, redraw the facial mask. This series may be continued until you exhaust your repertoire of expressions or your facial muscles, whichever comes first!

5.46 BOTTOM LEFT

Selection of noses

From Joseph Sheppard, *Anatomy: A Complete Guide for Artists* (New York: Dover Publications, 1992)

5.47 BELOW

Selection of lips

From Joseph Sheppard, *Anatomy: A Complete Guide for Artists* (New York: Dover Publications, 1992)

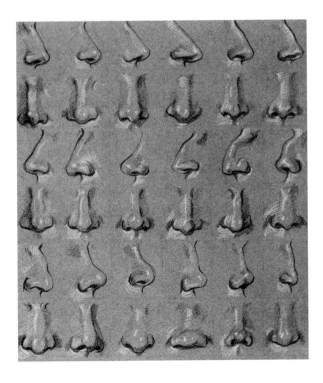

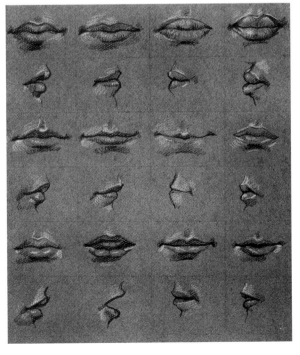

The idea of using oneself for such an experiment is not new; Rembrandt, in the seventeenth century, made a large number of self portraits, many with exaggerated facial contortions, often as miniature etchings. Perhaps only artists themselves will hold still for such a facial workout (fig. 5.48).

THE EAR

The ear does not elicit as much interest as other facial landmarks, perhaps because it is not at the center of the action, does not show appreciable movement, and is often covered by the hair. But its correct location is critical in achieving a convincing drawing of the head. In profile—and front view—the ear aligns with the brow ridge and base of the nose. The slightest tilt, twist, or tip of the head, though, can reposition the ear visually, often to a considerable degree. Seen from the front, when the head is tipped backward, the ear may appear on a line with the chin, lower than the mouth! (When you have a mirror handy, check this yourself.) The ear is thus a kind of pivot place for the head at the jaw's hinge, in any position.

The shape of the ear may vary greatly in the individual, though this is not often noted. Basically shell- or wing-shaped, it consists of a double-rimmed rounded helix, the outer rim curving in a spiral toward the ear's central opening, plus a number of swellings and lumps surrounding the opening, and a fleshy, often hanging lobe beneath. The inner rounded rim is a Y-shaped curve disappearing into the sharper curve of the outer helix ridge. The ear may lie flat to the head or project at various angles. As you study individual examples of this overlooked facial component, you may find that it does indeed add to the character of a drawing, even if only partially seen (fig. 5.49).

5.48

Rembrandt Harmensz van Rijn

Self Portrait in a Cap, Open-Mouthed

1630

State 1: etching

2⅞ × 2⁷⁄₁₆" (7.3 × 6.2 cm)

Rijksmuseum, Amsterdam

Exercise:

Over the same skeletal study (fig. 5.8a), draw a number of facial and head portraits, first frontally, then from different positions, using the original skull as a reference only. At first, you may wish to clothe the skull precisely in the specific surface forms perceived. Eventually, as you gain in skill and confidence, you may work more independently, especially as no two skulls are exactly the same. Be guided more by the proportions of the model than the specific bony structure available.

All Together Now

Having achieved a sense of the upholstery that forms the bulk of the human figure over its framework through the verbal and illustrated material in this Unit, you will need to orchestrate the full harness of muscles covered by its cushioning layers of fascia and fat, and place the entire figure in position.

Exercise:

In a series of drawings on thin paper placed directly on your earlier skeletal studies (see p. 187), select a particular area of articulation such as the shoulder, elbow, knee, or wrist and make a number of linear contour drawings of a model placed in the identical position. A second overlay, adding tonality and roundness of form, may be added.

Exercise:

Make a life-size study of both skeleton and fully-fleshed figure on one large sheet or a series of taped pages (see fig. 7.12).

In this Unit we have concentrated on components of the motionless figure, unrelated to the whole, seen at an articulation (joining place). When drawing the full figure, either nude or in clothing or costume, as part of a larger composition, in motion, from a combination of memory and imagination, or abstracted in varying degrees, this concise preparatory study will be a valuable resource. But the human figure reveals much more than its physical and mechanical components to the student of drawing. It is time to put the parts together and see how a sense of life and action may be imparted to the human form.

5.49
Jacob Lawrence
Self Portrait
1965
Ink on paper
15¼ × 11⅝" (38.7 × 29.5 cm)
Collection of Gwendolyn and
Jacob Lawrence. Courtesy of the
artist and Francine Seders
Gallery, Seattle, Wash. Photo:
Spike Mafford

Unit C

Imparting Movement: Activating the Figure

IMAGING THE FIGURE

We have been advised to visualize the figure in a number of ways: as wedged blocks, telescoping cylinders, upholstered articulated furniture, and various kinds of planed, cubed chunks, spheres, or other massed three-dimensional forms. Some of these images seem particularly appealing. If you think of the skeletal framework as a supporting structure—like a comfortably worn piece of furniture, with the muscles and fatty tissue as padding, fleshing it out, and the skin containing and covering it all, revealing the lumps and bumps of bony landmarks and major muscles beneath its surface, wrinkling its elastic or loosened fabric at corners and bends—you may feel almost a poetic kinship between yourself and your sofa. But when have you seen a sofa dance?

The image of an amazing machine, harnessed by elastic bands of musculature, hinged and turning like some electrically activated Erector Set, is attractive, since all neurological activity is said to be electrical at its most basic level.

Yet there is something missing in such models. Just as the Scarecrow, en route to Oz, seems to be in need of a skeleton as well as a brain, since he can never really stand or hold any position with security, so the Tin Woodsman, even oiled and positionable, is without any fluid, subtle flexibility. Each possesses an exaggerated excess of the other's lack, but neither is capable of true human movement. We can learn much from each of these models or visualizations of the figure, but unless we see them as aids, guides, or roadmaps of a vastly more complex reality, the uniquely living quality of the human form may elude us.

THE DOUBLE GOAL: WHERE TO BEGIN?

Bridgman's concept of wedging blocks of form helps us to feel as well as see the interconnecting of major bodily components. He presents this as "a story, … where the bending, twisting or turning of volume gives the sensation of movement held together by rhythm in stages. [Its] purpose is to awaken the sense of research and analysis of the structure hidden beneath." This double goal, of eliciting the rhythms of life and of analyzing the physical structure of the individual possessing that life, may indeed require separate kinds of study.

Is it preferable to focus first on a relatively static figure, posed and motionless but anatomically correct, and only then to breathe life into and animate that human form? Or is the desire to express a response to the living gesture so overwhelming that you will wish to defer more at-a-distance reflective investigation until you have experienced its satisfaction?

This choice is worthy of careful consideration, your decision determining the sequence in which the three Units in this Section ought to be studied. As with so many choices, there is no right or wrong.

A knowledge of kinesiology—the range of movements possible at each articulation of the skeleton—will help you select, edit, or exaggerate within credible limits. Cartoonists must have this understanding; just how far can the arm stretch, the leg bend, the head turn (fig. 5.50; see also figs. 5.22a and b)?

What assumptions do we make about an individual from unverbalized body language (color plate 7; see also the Bibliography)? Should the visual artist also study human psychology, abnormal psychology, acting, and dance?

POSING: A QUESTION OF MOVEMENT

Drawing a figure in the position it assumes in performing an activity will not necessarily assure a sense of aliveness in the finished work. In fact, drawing the posed model often seems to defeat this aim, as the model, intending to convey a single frame in a continuum of movement, may present instead a figure sinking, sagging, or heavily settled into a stopped position.

In an extended pose, the model may unintentionally allow such settling to occur. Humor may, sometimes apparently by accident, result from a

5.50

Al Hirschfeld

American Ballet (detail on p. 180)

Printed in an edition of 250 in 1980

Lithograph

Paper: 21 × 26" (53.3 × 66 cm); image 16¼ × 21" (41.3 × 53.3 cm)

Photo: ©Al Hirschfeld. Art reproduced by special arrangement with Hirschfeld's exclusive representative, The Margo Feiden Galleries Ltd., New York

discrepancy between gestural body language and the stated physical position of the model. This is another secret weapon of the astute caricaturist or cartoonist. The hand of the artist may recapitulate and reinforce a figure's main line of action, or deliberately counteract it (see fig. 7.25).

In order to present many kinds of gestural or physical movement, and focus in turn on a number of ways to study them, the major portion of this Unit will be a kind of visual smorgasbord of exercises, from which you may select those particularly applicable to your specific drawing goals. Of the several kinds of motion included, some refer to action or gesture of the figure being studied; others involve movement of the individual doing the studying, and some require both. Following an outline of the general categories you will find a detailed guide to specific exercises for each; there is no need to try to do them all.

Exercises:

If no figure model is available, draw the static exercises from a plaster cast or classical sculpture in your local art museum. Perhaps a friend will pose in a brief bathing suit. Avoid drawing from a photograph or other two-dimensional work, which will keep you from making decisions relating to the translation from three to two dimensions (see fig. 7.31).

Note the three perpendicular directions or planes of movement the figure can make at the joining of its three major forms (head, chest, and pelvis). These are called *sagittal* (bending forward and back, as in touching the toes), *horizontal* (twisting side to side, as in swinging the upper body and arms alternately to the left and right), and *transverse* (tilting laterally as though trying to touch the floor at your sides alternately, coming to a standing position between tilts). All three movements can be made fairly freely at the neck and at the waist, and to a lesser degree at the hips, and all are present during many bodily actions.

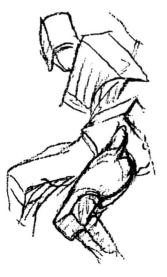

5.51

Overlay on three building blocks

From George B. Bridgman, *Bridgman's Complete Guide to Drawing from Life* (New York: Weathervane Books, n.d.)

Exercise A:

The figure is stationary, with one or more articulations flexed.

• Study the pose of your subject for at least a minute before drawing the three movable blocks of the figure in a simplified, perhaps geometric way, placing them in the correctly perceived relationship. Then, on a sheet of vellum or tracing paper over this under-structure, make a linear contour drawing of the figure. Options include other overlays

developed in planar subdivisions and a fully realized tonal rendering. In addition to the three building blocks proposed by Bridgman (fig. 5.51), you may choose to create an armature of cylinders, wedges, or other arbitrary forms that work better for you. (This is not the place, however, for a scribble study.)

- When you are satisfied with the placement of the three major body masses, add the limbs as attachments flowing from the basic gesture of the head and torso. Pay particular attention to the flexed arm or leg, visualizing the articulation of bones beneath. If possible, consult the skeleton or your earlier drawings.
- Rework this study on several tracing paper overlays until limbs, trunk, and head show a single unified flow of form and gesture.
- An optional assignment: Do research in the study of body language, or non-verbal communication through human gesture and positioning (see the Bibliography).

Do you agree that every pose and position of the figure reveals an expression of the human condition, and that showing life does not necessarily involve physical movement (fig. 5.52)?

Exercise B:

The figure's motion is stopped at one moment during a continuous action. Can you see or show the difference between stopped action captured on the run and deliberately halted, decelerated, carved immobility (color plate 8)?

- If possible, place the skeletal model in a position similar to that of the live

5.52
Edgar Degas
Three Studies of a Dancer
1879–80
Black chalk highlighted
with white on pink paper
18⁷⁄₈ × 24¹³⁄₁₆" (47.9 × 63 cm)
Private collection. Courtesy
Marianne Feilchenfeldt, Zürich,
Switzerland. Photo: Reto Pedrini

model frozen in the midst of a continuing action. On tracing paper over a study of the skeleton, draw the stopped action of the figure as a linear contour or a freer sketch. On another overlay, make a more detailed drawing, retaining the correct relationships of the framework while conveying a sense of the gesture. Visualize the moments prior to the present stopped instant, and those to follow; incorporate these as continuations of the action. With a bold crayon, follow on paper the main lines of the figure's movement. Simplify these on an overlay, or the same sheet of paper, perhaps smaller. As the model changes the pose, place a sequence of studies on a single page, building a lively, interesting composition.

- Use a bamboo brush and India ink to simplify these action lines in a calligraphic way. Make your linear gesture lines more specific by the addition of a prop, such as sports or household equipment.

- To provoke or incite unusual gestures, a second individual may interact with your model (throw an imaginary ball or punch, pretend to box or wrestle, then move away out of the picture).

- Call out a series of actions (pulling, pushing, falling, flying, swimming, sleeping, leaping, creeping, reaching, teaching …) to which the model responds (figs. 5.53 and 5.54). Categorize the actions: horizontal, vertical, diagonal, slow, fast, tentative, forceful ….

5.53 BELOW
L.I.U. student: Maria
Eastmond O'Brien
Gestural actions
1985
Pencil on paper
24 × 18" (61 × 45.7 cm)

5.54 BOTTOM RIGHT
Victor Obsatz
Figure study, detail
1960
Pencil on paper
Sheet: 24 × 18" (61 × 45.7 cm)
Collection of the artist

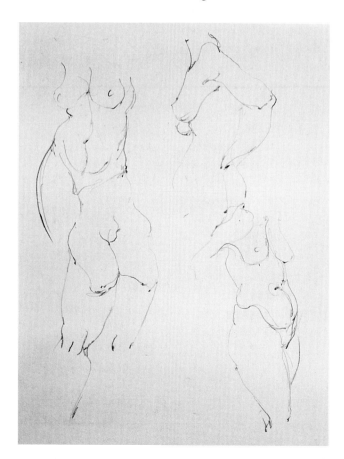

- Attend the performance of a mime. Take a small drawing pad. Capture the movements.
- Distinguish between a static, unmoving figure with one part or appendage working (fig. 5.55) and an entire body in motion, moving as a single entity through space. Consider differences between gesture and movement.
- Keeping one physical pose, alter its meaning, expressive quality, or even the apparent nature of the activity, by varying the treatment of your drawing. Try different linear or tonal techniques and materials, different lighting of the subject, the addition of props or compositional elements.
- Exaggeration of physical characteristics can enhance your work. Stretch the figure along its long axes, compress its width, and take other liberties (though you may prefer to wait until you have clearly understood the theme before attempting its variations; see fig. 8.5).
- Study the figure drawings of Rembrandt, Michelangelo, Daumier, Kollwitz, Diebenkorn, and others to see how the use of materials and techniques imparts action or stasis to a work (see fig. 2.34).

5.55
Frida Kahlo
Self Portrait
1937
Pencil and colored pencil on paper
4¹⁄₂ × 3¹⁄₄" (11.6 × 8.2 cm)
Private collection. ©Dolores Olmedo, Mexico City

Exercise C:

A sequence of stopped motions is shown during an action.

- A series of drawings showing stopped moments during a continuing action may be made on a single sheet, with the first, or theme, drawing taking the longest time, say 20 minutes. Subsequent drawings require successively shorter poses (say 10, 8, 5, 3, 2, 1 minutes; then 30, 20, 15, 10, 8, 5, 3, 2, 1 seconds) until you are actually drawing the figure in motion. Fewer moments and drawings may be selected. As an interesting variant, use a full pad of thin tracing paper, with the initial, longest drawing made on the bottom sheet, and each succeeding one on a single page lowered over the previous one until the last few are barely drawn as you turn to the next. Or you can make the first drawing on good white paper, the overlays on vellum. A kind of stroboscopic curved path develops at points of articulation (elbows, knees, wrists) in this study.
- This set of drawings will provide a transition between the serious slow study and the quick, unplanned gestural sketch or line. Here the model keeps his or her feet in the same spot, moving only other parts of the body, so that stroboscopic curves develop clearly on the page.

5.56
Ollie Johnston
Sequence depicting Bambi
learning how to stand
1939
From Walt Disney's animated
feature *Bambi*. Photo: ©Disney
Enterprises, Inc., Burbank, Calif.

- Simple flip-pad animations are a good development of this exercise. Use small 3 × 5" or 4 × 6" pads of thin, almost transparent notepaper, and make your first drawing on the last page. Release one sheet and, using the previous drawing as a general guide, modify the position of the figure and continue, one drawing per change in pose. Try very simple movements, subdivided minutely at first, such as the flexing of an arm or the blinking of an eye. Make several drawings of one position to vary the apparent velocity of the action. Imitations of an animal's or bird's movements may be attempted for this and other exercises involving sequential motion (see fig. 6.17).

- Study and then imitate Eakins' painting *The Swimming Hole*, in which a series of seemingly different figures suggest individual views of a single figure performing a continuous activity, leaping into and climbing out of the swimming hole. Vary the focus, clarity, line quality, and detail of each drawing, simplifying as you go.

- Study examples of animation to find a sequence of individual drawings or cels of a single action. Note the wonderfully authentic, subdivided movements that comprise the initial efforts of Bambi as he tries to stand and walk (fig. 5.56). Study other Disney classics of convincing animated movement: Mickey Mouse sweeping floods of water in *The Sorcerer's Apprentice*, Dumbo's discovery that he can fly, and Pinocchio's realization that although a puppet, he needs no strings to move. A large number of realistically studied drawings preceded the stylized cartooning of each character, enhancing the credibility of the finished illusion. Look for particularly detailed analyses of very small movements in early film animation.

- Study the Cubist drawings of Picasso, Braque, Gris, and others to find a related kind of sequential presentation of moments during an activity, or of a figure seen from several viewpoints at the same moment. These compress the actual time it would take to move around the figure and see each view separately (figs. 5.57 and 5.58; see also fig. 7.25).

Exercise D:
The figure in motion is drawn as the activity takes place.

- Drawing while the figure continues to move presents new opportunities but

5.57a FAR LEFT
Pablo Picasso
Standing Female Nude
1910
Charcoal on paper
19 1/16 × 12 5/16" (48.4 × 31.3 cm)
The Metropolitan Museum of Art,
New York. Alfred Stieglitz
Collection, 1949 (49.70.34).
©Succession Picasso/DACS 1999

5.57b LEFT
*Skeleton key for Picasso's
"Standing Nude"*
From H. W. Janson, *The Story of
Painting* (New York: Harry
N. Abrams, 1986). ©Succession
Picasso/DACS 1999

5.58 LEFT
Umberto Boccioni
Muscular Dynamism
1913
Pastel and charcoal on
paper
34 × 23 1/4" (86.3 × 59 cm)
The Museum of Modern Art, New
York. Purchase. Photograph
©1999 The Museum of Modern
Art, New York

5.59
Albers student
Figure—scribble study
1950s
Pencil on newsprint, glued
to cardboard (tone at
edges is aged rubber
cement on reverse)
23 × 17¾" (58.4 × 45 cm)
Josef and Anni Albers
Foundation, Orange, Conn.

limits the choices previously available. Place a good supply of paper on your table or easel ahead of time, turning to the last page before you draw. As you complete each drawing, turn down the next sheet quickly and continue. This can be done with a bound pad or a number of individual sheets clipped at the top.

- Use a responsive, scribbled, linear technique to get started with this direct, energetic, kinetic kind of drawing. Instead of depicting clearly perceived contours of form, with your hand follow lines of action seen and felt by your eye and inner rhythmic sense. The amount of descriptive detail you choose to include will depend on your speed of observation.
- A small emphasis of a significant part—a wrist, finger, chin, or ear—may turn a generalized action-line into a sensitively seen gestural study.

- Attend performances where movement is primary (dance recitals or sports events) to help you discern and capture the very essence of human motion. Consider leaving your drawing materials at home the first time, for the purpose of developing your perceptive abilities. Then draw from memory at home. The next time, equipped with pen or pencil, you will more readily respond to each change of movement.

- Develop a kind of continuum of the figure's movement, with selective references to anatomical details, subordinated to the overall effect of continuing lines of rhythmic action (fig. 5.59). In this study, is it necessary, or even possible, to consider the overall composition of your drawing beforehand?

5.60
Charles Cajori
Figures
1983
Mixed media
34½ × 28" (87.6 × 71.1 cm)
Collection of the artist

Exercise E:

The figure is in motion, as above, but only a sense of the movement itself is drawn.

- These exercises may seem similar to the previous group, but the focus is quite different. Here you are not concerned with anatomy or showing the actual figure. It is the line of movement, the pure gestural dance itself, you are after.

- Use a bamboo brush and India ink, letting your arm and hand move only in response to broad choreographic lines of movement observed. Unplanned, unexpected markings may appear on your paper as you permit your hand to draw the action of the figure, not the individual human being (see fig. 5.3). It may be possible to work on Exercises D and E at the same time, but separate the actual drawings from one another. If you are drawing at a performance or event to which you cannot bring elaborate supplies and equipment, a broad felt marking pen or thick laundry-marking crayon will do. You will not want to bring materials such as smudgy, finger-discoloring charcoal with you for this study.

Dance costumes and other garments may help you see the action of the body in long, swirling lines, although most figurative work will benefit from seeing the fully unencumbered nude figure (fig. 5.60).

Early reactions to certain Cubist works, such as Duchamp's *Nude Descending a Staircase*, were often inappropriate, since the public was not accustomed to looking for the *descending* rather than the nude or the staircase (fig. 5.61). How has this changed since 1912?

5.61

Marcel Duchamp

Nude Descending a
Staircase, #2

1912

Oil on canvas

58 × 35" (147.3 × 88.9 cm)

Philadelphia Museum of Art.

Louise and Walter Arensberg

Collection. Photo: Bridgeman Art

Library, London/New York.

©ADAGP, Paris and DACS,

London 1999

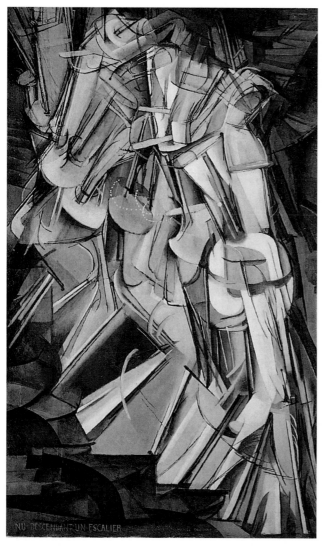

Another advantage of the generalized action-line study is the possibility of extending the moment, of suggesting time slowed or delayed, accelerated or compressed. It is on occasions such as these, when you are drawing so quickly you cannot stop to do any analytical left-brain thinking, that your earlier study of the body and its anatomical structure proves its worth. Just as a pianist cannot stop during a performance to consider how many sharps and flats there are in the piece being played, or what notes will follow the ones being struck, you cannot pause to consider which muscle or articulation lies beneath the fluid line of action being drawn. Indications of energy and repose, spirals and loops of free or restricted action, will reveal understandings so internalized you may not be aware they are at work. This is one reason some instructors encourage the study of anatomy before introducing gestural, responsive drawing.

Directional sweep, varying velocities, and other emphases may be the focus of specific studies as you pursue this form of linear abstraction in your own way. The following sequence can help to bridge the space between perception and response.

- Visualize a plate of glass standing on your table, through which you can see the model. Hold your brush or pencil in the air and trace unseen action lines directly over the figure in motion on this imaginary surface. Then stand an actual sheet of glass, acetate, or Plexiglas on the table and draw (first with water or a dry brush, then with ink or a litho pencil) on that transparent surface. Place the clear sheet beside, but not covering, the figure, and draw lines of action next to the figure itself. Slowly repeat this step, bringing the acetate farther away from the subject and closer to a horizontal position on your table, at which point it may be removed, so that you can draw directly on your page.

Exercise F:
The figure is at rest while a sense of its gesture or stopped action alone is drawn.

- Avoid the trite, conventional, studied look of carefully pre-planned, so-called gestural drawings that impart neither life nor freshness to a work. Take the luxury of time to study and to devise a plan of action, but

also to develop the understanding necessary to permit improvisational, spontaneous calligraphy to burst upon the page. It is almost as though you can observe, in an interested but non-judgmental way, the independent drawing activity of that energized appendage at the end of your arm "doing its thing," without conscious direction. This is admittedly a difficult task when the model continues to hold a motionless pose. The urgency and impulse come from within you.

- Play with unusual stopped-action poses, such as activities in which the feet are higher than the head (diving, sledding …) or other, acrobatically inspired positions. Ask volunteers to mimic the stances assumed by birds and animals. Amusing, amazing results are guaranteed.

- A different result will be achieved by drawing action-only studies of classical statuary and sculpture. Breathing life into marble forms can be quite a challenge. Perhaps this is the implicit invitation that inspired artists such as Eakins to use as a theme the image of Galatea, the statue-come-to-life from Greek mythology. (Do you require an illustration of every reference made, or are you a regular library consultant?)

- If necessary, draw from any available figurative sculpture; in general, avoid working from photographs or the drawings of others (but Giacometti did! See fig. 8.12). Perhaps most difficult of all, try this exercise with the figure in a completely inert, reclining pose. Start with a relatively simple line drawing that retains descriptive elements; then, on several transparent overlays, reduce and energize until you have arrived at the very minimal marking possible. Use a drier and drier brush during this sequence, making the final statement as spare and bare as you dare.

Exercise G:

The figure holds a pose on a revolving or turning surface, stopped for specified periods of time while drawing takes place.

- In this variant, it is your viewpoint of the figure that moves. Ideally, this is accomplished easily by placing the model on a manually or electrically revolving surface. As an alternative, place a large sheet of masonite beneath the model, who maintains a single pose as the support is slowly turned in stages. Seated or recumbent poses are best; they will not upset the model (literally)!

- In addition to the expected slowly changing contours and arrangements of forms unfolding before you, a surprising and unexpected fluidity of line may appear—a kind of linear continuum. To capture this elusive figure-in-the-round, unreeling as it turns, try drawing the sequence as a single overlapping stretch on a long roll of paper. If an electrically driven surface is available, continue a single drawing while observing the moving figure. Vary the lighting as the figure turns, to create even greater variety of visual experience.

Exercise H:

The model poses, still, in the center of the studio, as you move from one seat to the next, making sequential drawings, until you have returned to your original place.

Exercise I:

The model performs a single repetitive action in the center of the studio while you move from place to place around the room, drawing the motion itself.

Exercise J:

The model responds with movement to several kinds of music, spontaneously, while you, also moved physically by the music, draw the figure or its motion alone.

- As the music changes dramatically in style, tempo, beat, or volume, begin new drawings more appropriate to the altered sound. Listen to a wide range of music, from classical to contemporary. Be sure to include a waltz and some good early jazz. (Piet Mondrian worked to the sounds of jazz in the 1940s while creating his precise, geometric compositions!)

Exercise K:

The model holds exaggerated postures with varied facial expressions, each of which inspires a different drawing treatment.

- All the movement in this sequence of studies will appear only on your page; neither the model nor the student is physically activated. Through strongly intensified posturing (find a model who has studied Latin dance, mime, or acrobatics) and broadly intensified facial expressions, the model inspires you to extremes of visual expression.
- For one part of this study, the model may maintain a single pose, with a dramatic change in facial expression alone, after each rest. Will you draw these on one sheet, on transparent overlays, or use another format? A full gamut of emotions may be suggested sequentially.
- How small a physical change will affect the entire pose of your model? Will the twinkling of an eye suffice? Where does the essence of life lie, visually speaking?

Exercise L:

The model presents unusually detailed surface features, whose depiction creates a heightened sense of humanity through age, enhancements of costume, or additional props.

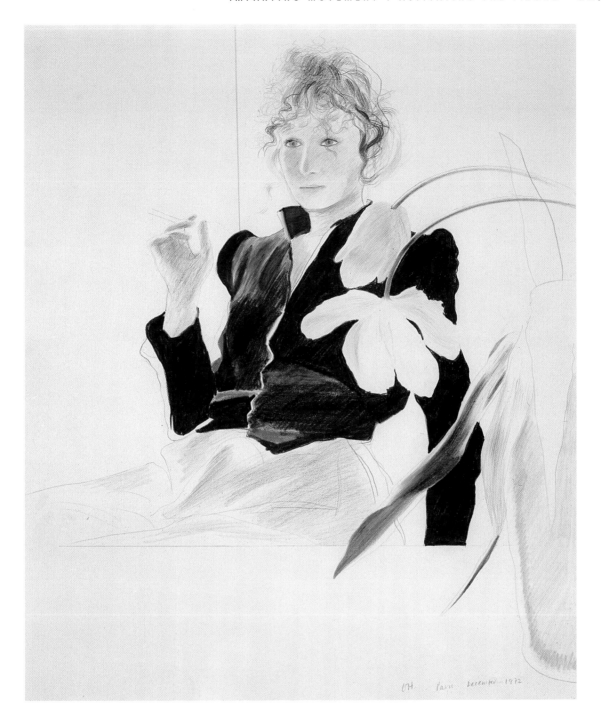

Plate 7

David Hockney

Celia in Black Dress with White Flowers

1972

Crayon on paper

17 × 14" (43.2 × 35.6 cm)

Collection of the artist. ©David Hockney

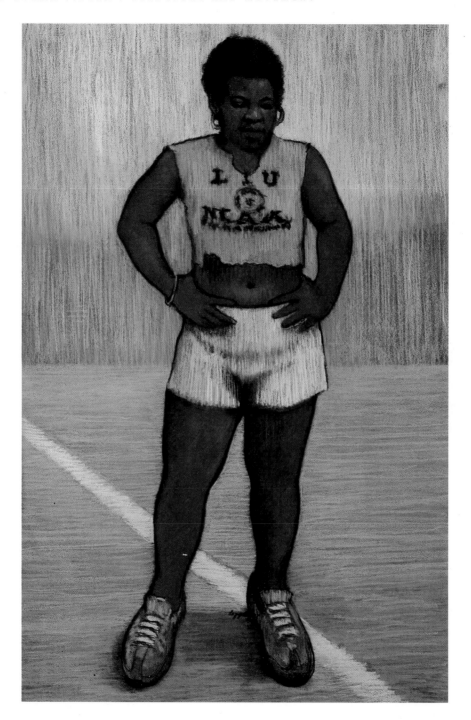

Plate 8

Arthur Coppedge

The Athlete

1992

Pastel on paper

50 × 30" (127 × 76.2 cm)

Collection of the artist

- The concluding drawing for this series of exercises involves several long, perhaps twenty-minute, periods of time in which you develop a single, carefully structured work. For this study, include as many objects, props, or other elements seen as part of the figure-plus-environment needed to create the composition you want. Be inclusive, but selective; include the kitchen sink, but only if it is a necessary part of your visual statement. Draw every wrinkle and drapery of skin and fabric you can identify; look with a magnifying glass, but maintain a sense of the overview. If you had made this drawing earlier, it might have suffered from the rigidity of over-control. At this point, however, your eyes will have been opened to the freedom and life-enhancing delights of a variety of means of expression. Whether or not these have been sufficiently mastered to your satisfaction, this drawing should bring you special enjoyment (see fig. 1.33).
- Will it be easier to make all the inclusions recommended here in a broad, sketchy medium or using a finer, more controllable material? Is this the time to try a variety of tools and mediums—perhaps a light tonal wash of diluted ink, plus brush, or even pen work? Maybe the entire drawing can be executed in pencils, from a soft, dark 4B to a middle-weight HB and a crisp, lighter 2H.

In several places we have investigated ways to show an apparent expansion of space or extension of time (see pp. 217, 220, and 222). As these do not necessarily involve the figure, the subject of the present Section, this seems a good time to gather and develop such ideas, to focus our attention on a particularly timely concern.

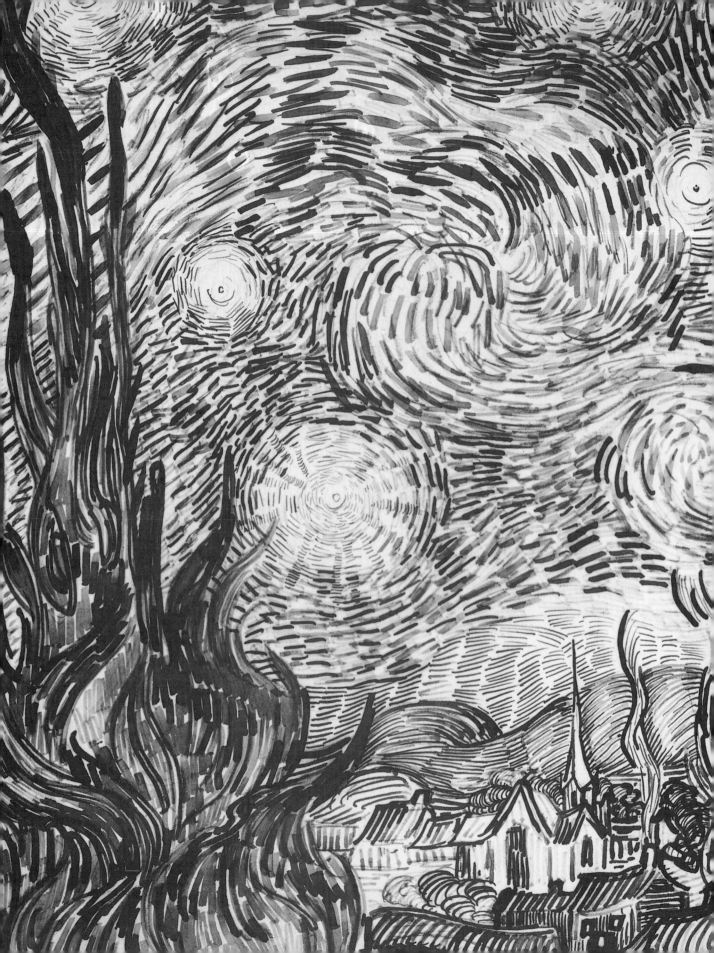

Expanding Space and Time:

Stretching the Space, Extending the Moment

Unit A
Enlarging the Field: Multi-Unit Formats

SHAPING FLAT SPACE

Before any drawing is begun, the major factor determining choice will be the very sheet of paper on which the work is to be drawn.

To start, you may look at the subject and visualize it reduced in size and flattened to fit within the $18 \times 24"$ or so of the page. Then, selecting a horizontal or vertical placement of the paper and mentally cropping the subject (imagining it to fit a shape similar in proportion to the page), you begin. You may not have visualized a precise border around the subject-and-its-surrounding-forms, but will already have a good idea of what is to be included and what will lie outside that area of interest, off the page. In effect, the space to be contained in the drawing has been shaped.

This is an arbitrary choice; we do not usually observe the world through

a viewfinder or a stationary rectangular frame. Yet through years of conditioning, we accept the four-sided edge of photographs, paintings, and movie screens and the rounded rectangles of ever-present television sets and computer screens. If you use a camera, you experience the many options such a predetermined format presents. Every shot snapped represents countless decisions, as the rectangular viewfinder is moved nearer to or farther from the subject, enlarging or reducing its image, to the left or right, up or down, instantaneously adding or eliminating visual elements to create the composition. (All these are in addition to choices of focus and lighting.)

The L frame (see p. 35) can help you delineate the exact shape-and-its-contents of a composition, a selected portion of your full visual field, on your paper. Is this always a choice? Have artists, from time immemorial, been able to reach for a rectangular sheet of paper? Certainly not; the earliest recorded drawings were made on the walls of caves—irregular, edgeless, rock-lined surfaces below the ground in France and Spain (color plate 1).

Perhaps the works being produced today nearest in feeling to these early cave-wall drawings of animals, plus an occasional stick figure, are chalk pictures made on the sidewalks of city streets by children, or wall-covering graffiti sprayed on the rough bricks of urban centers.

In the Middle East and Asia, where the two-dimensional surface is read from right to left (see fig. 4.1), often in broad sweeps of written and pictorial imagery, the lengthy, rolled scroll has been in use for many centuries. Contemporary Western applications of this idea (as well as implications relating to the duration of time involved in their perception) will be studied (see p. 237).

MAKING IT FIT

In planning a drawing or other two-dimensional work, you may wish to "respect the picture plane" by arranging all the visual elements as interrelating shapes fitting in a level way, side-by-side on the flat surface, framed by its four perpendicular edges (see fig. 1.70 and p. 58). It is possible to indicate three-dimensional space in such works, but their spatial illusion never overpowers the intrinsic flatness of the planar surface (figs. 6.1a–d). The given structural forces at work within the rectangular format may provide a sufficient invisible armature into which to fit a desired composition. Alternative ways to arrive at the final dimensions and arrangement of forms in a drawing, some of which will not fit within the confines of a single-unit picture plane, are the subject of this Unit.

DOUBLES AND TRIPLES

If the individual rectangle comes fully equipped with hidden lines of force that compel our visual attention, how much more complexity must accompany double-panel (diptych) or triple-panel (triptych) compositions (see figs. 4.32a–c)? In such works, look for underlying directional indications reaching across the physical edges of individual component shapes. In Matisse's

early drawings for his three-panel *Merion Dance Mural*, he was concerned with creating a ring of dancing figures moving through the three lunette-shaped panels, reminiscent of his earlier paintings of this subject (see figs. 4.32a and b). As the work progressed, Matisse moved farther from such a preconceived plan to a more freely interpreted and simplified abstraction, condensing the essence of the dancers' movements within each unit, pulling all together as a single unified work (see fig. 4.32c).

6.1a–d
Richard Anuszkiewicz
Working drawings
1998
Pencil on various papers
Each approx. 11 × 8½"
(28 × 21.6 cm)
Collection of the artist. ©Richard Anuszkiewicz/DACS, London/VAGA, New York 1999

6.2

Bart van der Leck

Study for the left panel of the triptych "Mine with Miners"

1916

Gouache, charcoal, and pencil on paper

45⅞ × 27¾" (116.5 × 70.5 cm)

Stichting Kröller-Müller, Otterlo, The Netherlands. Photo: Tom Haartsen. ©DACS 1999

Is it easier to discern fidelity to underlying geometric structural forces in a more familiar rectangular format (fig. 6.2)?

Exercise:

Make three drawings of a still-life arrangement, including several clearly rectilinear elements, extending across a strongly horizontal space.

- In the first, select a portion of the entire still life which you can easily visualize within the rectangular shape of a single page, held vertically or horizontally. Exaggerate lines and forms that repeat this geometric framework.
- For a second study, place two sheets of paper side by side (use a large drawing board, piece of cardboard, or masonite as a support), and plan a double-rectangular composition, using the geometry of the still-life arrangement as a guide. You may wish to leave the sense of a space between the two drawings, or to separate them in actuality by several inches. To work on a smaller scale, cut one full sheet in half and proceed as above, but do use two physically separate shapes, not simply two rectangles drawn side by side on one sheet.
- The third study, a triptych, requires three sheets of paper, treated with additional sensitivity to the added subtleties of its newly complicated, more intricate visual interrelationships.

If you find more guidelines included than you wish to follow in any one work, select and simplify (this is true throughout the book).

Optional Exercise:

Draw a diptych or triptych using non-sequential or even unrelated subject matter. Unify the elements in visual ways other than as literal continuations of forms seen together.

OVERFLOWING COMPOSITIONS

In the drawings described above, you arrive at a multiple-sheet work without knowing its precise configuration or exact size in advance. We have already seen this described in the large multi-sheet drawing of a plant, starting with the study of a single leaf, taped and folded in road-map fashion as the work grows (see p. 80). For the simple overflow study, a different effort is called for.

Exercise:

Visualize a portion of the subject (a still-life arrangement or a figure) starting in the center of your page, perhaps life-size, but clearly larger than the sheet of paper. Draw from the center out to the edges left and right, up and down, allowing the image to flow over onto a second sheet as necessary. Let the drawing find its own border, define its own space. You may need only an inch or two of an adjoining sheet. If so, crop away the rest along a carefully placed edge. Perhaps you will need the entire second sheet, or a third.

Optional Exercise:

Try a composition with a strong vertical overflow (a standing figure, skeleton, or hanging plant, for example; see fig. 8.5).

Begin a life-size drawing of part of the subject on a single $18 \times 24"$ sheet. (Avoid a spiral-bound pad for this or any multi-page work.) Without changing your position, draw other areas of the subject on separate sheets, as necessary, until you have included the entire figure, repeating or overlapping portions as you wish. Then fit the entire work together using micropore paper tape to attach the pages. Add additional blank sheets as needed to complete a rectangular or other satisfactorily shaped composition. If you have maintained a consistent sense of size and proportion, the parts should work in a convincing way.

This exercise may be done with the full figure, an interesting costume adding to the challenge and the often surprising result, when lines and edges that ought to join in one way actually meet in unexpected places, or perhaps not at all.

THE FILMIC FLOW

Earlier we noted the twentieth century's influence on our way of seeing two-dimensionally, in the many rectangular images encountered daily in illustrated publications and even the family album. But the continuously moving sweep of motion pictures and television have added a panoramic flow, a seamless continuity to that picture, so that we often become dissatisfied with the confinement of the small rectangle and look for a horizontal expansion of our visual field.

At last we in the West are catching up with our neighbors in Asia, who for centuries have depicted the world in broad stretches of space, on scrolls. As additional portions unroll, these expanded fields always promise further details and an extension of their subject to the left.

Additive, taped, unit-by-unit scroll drawings can act as a transitional bridge between multi-panel and continuously unfolding space—two kinds of depiction of our visual world. The single-surface scroll drawing, slowly extending not only across space but over time in an unbroken continuum, will be considered (see p. 242).

Exercise:

You will need micropore paper tape for this study. A small page is advisable, perhaps notebook size; again, not spiral-bound. Try to work out-of-doors, somewhere where you have an extensive view of the horizon. If there is no beach, mountain top, farmland, or other clearly extended vista, find a rooftop, high bridge, park, or large garden. Sit in the center of the open space so that you can see a clear and continuous scene in all directions, as you try to turn a full circle. Begin at any point on the perimeter of your viewing field and simply draw what you see, with the horizon more or less in the center of the page. Continue drawing until you need more space to the right; then add it by attaching a second sheet (butt the two together and tape behind, if possible). When you have attached three sheets, fold the first underneath and continue, adding and folding accordion-style as necessary, until you have turned a complete circle and are surprised to discover you are drawing a particular feature a second time. Then open the entire drawing and see how many sheets you have used. Would you have undertaken so lengthy a work if you had started with a single sheet the length of your completed scroll? Does the whole drawing have visual unity? Does it hold together as a single composition? Does it need more work to strengthen an area, reinforce a linear movement, or ...?

Multi-Panel Variants

The folding screen—a multi-panel, often large, room-dividing or decorative structure—has a long history in Asian and Western art. These self-standing works may be seen either as a series of related modular units or as an interrupted but continuous flow of design, and are scroll-like in concept. A similar idea is expressed in smaller accordion-paged books, also found extensively in Asian art (fig. 6.3).

GRID GAMES

Dividing a shape into smaller units (frequently squares fitting into a larger rectangular format) seems to have intrigued humankind from the start. The

6.3

Antonio Frasconi

A Sunday in Monterey

1951/1964

Offset lithography after original woodcuts

Page: 5³/₈ × 2¹/₄" (13.6 × 5.7 cm), accordion fold, opens to width 10'7" (3.23 m)

©Antonio Frasconi/DACS, London/VAGA, New York 1999

earliest known are in the famous caves at Lascaux, side by side with the bison and reindeer: strangely geometric nine-square patterns remarkably like the latest minimal or non-objective art, and very like prehistoric game boards (fig. 6.4)!

Grids have been useful to artists for enlarging works from small studies to huge murals, by simply copying the exact content of each smaller module into its larger corresponding unit. If the proportion of the new unit is altered, interesting transformations may be created. Study the traditional Golden Section (a proportional relationship of parts to the whole, considered classically beautiful by many artists, designers, and architects) for a variety of historic examples (see p. 192).

The grid structure provides opportunities for subdividing visual works in countless individually inspired ways. The following exercises suggest a few, but do invent and add your own.

6.4
Anonymous prehistoric
artist
Grid emblem, Lascaux,
France
c. 30,000 B.C.
Pigment on limestone rock
Grid emblem approx. 12 × 12"
(30.5 × 30.5 cm)
Photo: Colorphoto Hanz Hinz,
Allschwil, Switzerland

Exercises:

Make any linear drawing within a format that can be divided into square units, dividing it by one of the following methods.

- Use a right angle and soft pencil to mark a regular series of vertical and horizontal lines.
- Place a clear sheet of vellum, tracing paper, or acetate over the drawing and mark your grid on this overlay.
- Place a gridded page beneath, and make your drawing on the clear covering sheet.
- Use a pre-squared sheet of graph or quadrille paper with certain lines heightened to create squares the size you prefer.
- Try a combination of these methods.

The drawing itself may develop in several ways:

- If you have made the grid structure first, draw your subject directly over (or onto) the grid, acknowledging the edges of each unit by linear or tonal emphasis of features occurring at its borders. Perhaps combine several grid units into larger squares. As a variant, leave some units blank, working in a regular checkerboard or random arrangement. Develop one or more as a complete composition. Put the multi-unit study aside as you develop the single section, or use a mask to cover the rest of the work.
- Place a transparent overlay on a drawing that has been divided into squares. Without reiterating the outline of each unit, complete them in different drawing techniques or styles. For instance, use only parallel lines of varying

weight and distance to show a range of tonality in each square, orient the parallels within each unit differently from those in adjacent squares, or alternate units in line and tone.

- Divide a reproduction of a well-known drawing into squares, each student choosing one unit to enlarge to a predetermined size. Combine. Discuss. Adjust your unit. Will the assembled work appear seamless? Should it?

- Prepare a gridded structure with $1/4$ or $1/2$" spaces separating 3" squares. Draw a still-life arrangement in this sectioned format, including or omitting the edges of each unit.

- As a relief from over-gridding, tear a drawing by hand into uneven parts, which are then reassembled as a collage or distributed and completed individually by each participant.

- Reassemble the cut sections of a gridded drawing, omitting or adding units as desired to create non-rectangular, shaped-field works.

- Using a variety of pencils, fill an entire page with a changing tonal field; in other words, create a full-page gray scale (see fig. 3.6). Divide this sheet into square units and cut them apart into paper tiles (tesserae) which may be used to create paper paintings or paper mosaics. Spray the entire sheet with workable fixative before cutting or assembling the gray-scale units. (An egg carton contains a dozen convenient sections in which to store your paper tesserae.)

- For the paper painting, glue the units to a large backing sheet without preliminary sketching, or work over a grid on a transparent or translucent surface in order to keep the units aligned.

One advantage of working over a gridded base sheet is the freedom to consider but not to be bound by the geometry of the underlying structure. Secondary, multi-unit shapes may be selected within a fully squared sheet in a number of regular patterns: the nine-square quilt format, vertical and horizontal groupings, assorted secondary squares. Later, we shall see how artists have derived inspiration from the geometric potential of the grid alone (see figs. 6.4, 7.17, and 7.20).

Can you think of any shape other than a square that can be used as a surface-covering grid? Try circles and triangles. (One of these will work, not the other, without the creation of additional, interstitial shapes; consult the Bibliography for geometric sources.)

Exercise:

Use the new surface-covering shape to create a non-square grid, and make at least one drawing within this format.

NON-RECTANGULAR FORMATS

Circles, triangles, and other non-rectangular shapes have all been used as drawing formats; the studies for the three-panel *Merion Dance Mural* by Matisse are examples we have already seen (see figs. 4.32a and b). Individual

circular works, called *tondos*, occur frequently from the time of the Renaissance.

Exercise:
Set up a still-life arrangement, planned in advance to fit within a non-rectangular format. Make this drawing, letting the forms fill the space.

THE MOEBIUS STRIP DRAWING

In addition to serving as a challenging model, the Moebius loop (see fig. 1.43) will provide a unique surface for the final drawing of this Unit. (This mathematical teaser shows a single continuous surface which eventually returns to the reverse side of the same strip of paper.) A simple one-sided scroll drawing will not work, even if it is twisted and glued in a seamless flow. How would you plan a single-surfaced but double-sided strip, to meet itself in just the right way? If you wish, try to solve this problem independently, before referring to the following explanation.

Exercise:
Prepare a long strip of strong white paper, perhaps 3 × 15" or 5 × 30", twisted once and taped into a Moebius loop; experiment to find a size you like before starting to draw. Use both surfaces of the same strip of paper to begin two areas of a single landscape or interior scene directly behind each other, facing in opposite directions.

Slowly expand each drawing toward the edges on its side, until you have overlapped the image sufficiently for completion as a Moebius loop. Will these scrolled drawings move in the same direction or be reversed? Test this first with a simplified study, in order to understand the technical aspect of the twist-and-loop effect, then tape or glue carefully to hide any sign of attachment.

If you feel that you have entered the "twilight zone" with this step into warped and convoluted Space, are you now ready to do the same with the dimension of Time?

Unit B
Enlarging the Scope: Multiple Viewpoints

DRAWING OUT TIME

We have looked at a number of ways to stretch or structure the flat space on which drawings are made; here we will explore the notion of suggesting duration—the passage of time—through visual means.

In a sense, the very terms *space* and *time* have been an anachronism since 1905, when Albert Einstein published his Special Theory of Relativity, indicating their inseparability. After all, *time* refers to the continuation of a spatial relationship, and *space* refers to an expanse which can only be experienced over a period of time. For a fuller investigation of this idea, consult the Bibliography; perhaps this will inspire further study in physics or philosophy. However, to increase our appreciation of the two-dimensional experience we call drawing, and investigate ways to develop our perceptive and imaginative faculties, we are arbitrarily considering the concepts separately, as emphases rather than actualities.

The ideas and exercises in the preceding Unit focused on the spatial concerns of organizing and extending the physical surface occupied by drawings; here we will consider ideas more clearly associated with an extension of the time required to move from image to image, or to the changes occurring in and between images over time. In both Units we are working with actual subjects that may be studied in the studio, at home, or out-of-doors. Later we will also pursue the extensions of *inner space*, bounded only by the extent of the imagination (see fig. 8.10).

THE CONTINUOUS SCROLL

This is no longer the age of the snapshot, in which we see, as through a rectangular viewfinder, in individual still frames selected from the whole of our visual field. We are now accustomed to seeing as with a motion picture (or video) camera, moving the eye across a scene at a certain speed, acting as a kind of rolling viewfinder. Sweeping across a panoramic space, we perceive only a small portion at any given moment, immediately blended into a succession of equally transient, fast-disappearing glimpses of the whole.

Exercise:
To simulate this effect, draw a continuous landscape or other scene on a roll of narrow paper a foot or more in length (adding-machine tape will do). Then devise a simple "shoe box theater" by spooling the drawing past a cut-out 2×2" screen between two reels (which may be paper towel rollers) fitted into circular openings in the box.

- By turning the reels at different speeds, or stopping entirely, you can duplicate the experience of reading space in momentary snapshots. Is this our normal way of seeing the constantly changing visual field? Did Christopher Isherwood have such an idea in mind when he selected the title *I Am a Camera*?

- A scroll can be neither seen nor created all at once. As it is unrolled from one edge, disclosing parts previously concealed, then spooled into the opposite side, covering portions just seen, the effect is very much like that of the panning camera—revealing a continuous scene through its fixed frame. One difference is that a scroll fixes no set size for its opening; it can unreel completely and be displayed as a fully extended panorama. Can such a scroll be viewed in the same way as a single-frame image? How is the folded screen (see fig. 6.3) related to a continuous scroll?

Exercise:
Using a 10 or 12"-wide roll of bond, rice, or shelf-lining paper several feet (preferably yards) in length, go to the same location you used for the multi-panel panoramic study in Section 6, Unit A (see p. 237), and draw the vista again from the left-hand edge of the paper, starting at a different point on its circumference. Open the roll to the right, to a length that seems comfortable (say 12 or 15") and maintain that frame as you work by reeling the paper in at the left and opening it to the right, as necessary.

Turn your easel, table, or seat from time to time as you work. As with the earlier exercise, you may not immediately recognize your starting point when you return to it. Just as you cannot step into the same river twice (because the water is continually being replaced and you are at a different place in your life) so the same scene, seen again, isn't seen the same.

Exercise:
If you are left-handed, you will find the reversed scroll a welcome choice; in fact, you may want to try it first, and consider the previous exercise the option. If you write or read any of the right-to-left languages (Chinese, Arabic, Japanese, Hebrew, Korean) you will feel comfortable starting at the right-hand edge of the scroll, unwinding to the left as you draw. You decide which direction to pursue first, but make a point of trying both.

ANIMATING THE SURFACE

Individual-frame animation is a related concept which requires a separate drawing for each moment in a continuing action, or each glimpse of a changing view as the eye sweeps over a scene larger than the frame or screen. In motion picture filming each drawing is seen for $1/24$ of a second, so many look much the same, but for simple flip-book animation a single drawing may

suffice for each step. To alter the sense of time, more images with fewer alterations between them slow the action, while fewer images with larger transitions accelerate the sense of movement or change. An advantage of hand-drawn animation is the freedom to create and alter images in any way skill and imagination may lead. For the most part, the camera must rely on mere physical reality.

Beyond the scope of this text, which is concerned with hand-created drawing, are recent developments in increasingly sophisticated computer animation technology. Any special interest or study in this direction will be enhanced by your preparation in perceptual and responsive drawing.

Earlier sequential studies in anatomy may be the basis for your first study in this miniature medium, a simple flip-book (see p. 227).

Exercise:

Turn to the last sheet in a small, unlined notepad, perhaps 3 × 5", and draw the first image of a sequence you plan to activate. Release the next sheet to cover your drawing and trace the next image, making small modifications in the direction you intend to proceed. If you have chosen an anatomical study, retain the size and proportion of the first drawing, changing only the relationship of parts at an articulation, such as the elbow or knee. Release each succeeding sheet to draw sequential steps, stopping to review your progress every few pages. Pace the changes between drawings evenly; a flow of frameless movement should be the result. In convincing animation it is this fluid

6.5a–c
Cooper Union student:
Carol Pereira
Selected frames from animation sequence of fifty
1998
Pencil on paper
Each 7 × 5" (17.8 × 12.7 cm)

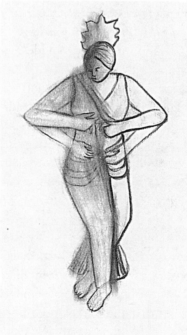
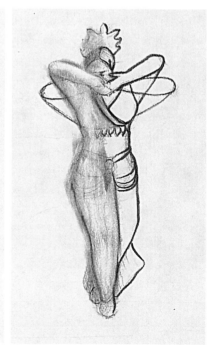

path uniting images (almost the movement *between* separate frames) that confers a sense of continuity or life, rather than the accuracy of each individual drawing. There are just as many successful animated films that use sketchy, idiosyncratic markings as those that are meticulous about their attention to detail (figs. 6.5a–c).

"THE MOVING FINGER WRITES . . ."

This familiar Biblical image has been interpreted in many ways, but can be seen as a reference to the path of a point in motion, the focus of much experimental work in drawing as well as other two-dimensional studies. In sequences on film, even "paper film," as you have just seen, the line followed by the eye from frame to frame often animates a sequence of images. Early investigations into stopped motion through the use of sequential imagery, and subsequent multi-frame motion pictures, by Muybridge, Eakins, Marey, and others may be studied to enrich your personal repository of visual ideas. Find Eakins' painting *The Swimming Hole* to follow the path suggested between apparently unrelated views of several figures—in actuality, moments stopped along the continuous line of movement described by a single swimmer.

The idea of showing the locus or path of moving points may be seen in works by Futurists such as Balla, and in the stroboscopic works of Edgerton and other photographers, but perhaps the most clearly linear examples are Picasso's actual drawings with light, made as the small rounded lens of a flashlight recorded its curvilinear path through a darkened field of space.

Exercise:
Select the work of one artist noted above or a series of observed images and use any materials to draw a single-sheet work showing a linear eye-path based on your research. Devise a new method of showing this idea.

SEEING EVERY SIDE OF THINGS

Have you ever been complimented on your ability to see several points of view, to see the other person's viewpoint? This is said to be a good thing. But can you really see two sides at the same time? In art, this has been shown not only to be possible, but often desirable. The early Egyptians combined profile and frontal images of figures for ceremonial purposes. During the late nineteenth century, Gauguin and Cézanne often fused differently perceived views of a subject so skillfully that their multi-perspective innovations were not always recognized. Study the still-life compositions of Cézanne to find tables (and objects placed on them) tipped and tilted at varying angles, so that some are seen from above, others at eye level, and others from below; yet all work together on the picture plane in exquisite visual harmony. Find similar liberties taken with traditional two-point perspective in the works of van Gogh (color plate 3) and other Post-Impressionists.

Exercise:

Set up a still-life arrangement similar to one by Cézanne—including a table edge, white cloth, basket of apples, and wine bottle, for example. Make about five drawings of this set-up from different vantage points not too far from one another. Cut the drawings apart into several major sections along lines suggested by structure or composition, then rearrange and blend them into more than one finished work. Study these side by side to see their spatial differences. Make any adjustments called for, regardless of allegiance to the original drawings.

• Do you see a relationship between this idea and the stretched, foreshortened figure studies discussed on page 168 (see fig. 4.21)? In what way?

FRACTURING TIME ON THE PICTURE PLANE: CUBISM

Many of the Cubists' innovative ideas may be studied and dissected to discern their surprising power to affect so many schools and styles of art that followed their few decisive years. But what most distinguishes Cubism from other revolutionary visual concepts is probably the incorporation of techniques that permitted a sense of the actual passage of time—a shift of position accompanied by the duration of time necessary to move through that space. Although it would be a mistake to think of these separately, as they are found inextricably structured into the works of Braque, Picasso, Gris, and others, for the purpose of study we will look at several specific methods used to put time in the picture (fig. 6.6; see also figs. 1.3 and 1.35).

6.6
Lyonel Feininger
Church at Gelmeroda
1914
Pencil on paper
6¼ × 8⅛" (16 × 20.7 cm)
Photo: courtesy Achim Moeller
Fine Art, New York. ©DACS 1999

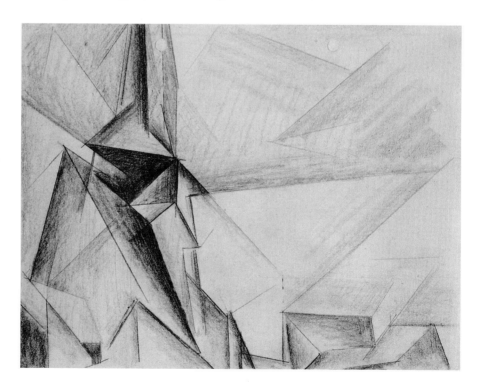

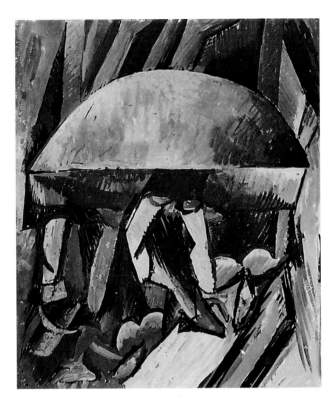

6.7 LEFT
Pablo Picasso
Carnival at the Bistro
1908–9
Gouache and ink on
paper
19½ × 12⅝" (49.5 × 32 cm)
Musée Picasso, Paris.
Photo: ©R.M.N., Paris.
©Succession Picasso/DACS
1999

6.8 BELOW
Georges Braque
Dé et Journal/JOU
(Newspaper and Dice/JOU)
1912–13
Charcoal on paper
12¼ × 9½" (31 × 24 cm)
Öffentliche Kunstsammlung
Basel, Kupferstichkabinett,
Inv. 1963.18. Gift of Dr. H. C.
Raoul Laroche. Romilly 152.
©ADAGP, Paris and DACS,
London 1999

The Split Plane

Lines or axes cutting through the surface divide not only objects so "sliced" into sections but also areas surrounding them, in other words, the entire object-plus-background or "figure" plus "ground." Clear separation of chunks of space provides edges for changing light value, texture, and other surface treatment, often alternating in a kind of checkerboard fashion. Alone, this technique is mainly a space-splitter, not necessarily involved in picturing the passage of time (figs. 6.7 and 6.8). Does figure 2.16 show a prefiguring of this idea?

The Slipped Plane

Sliding or slipping split planes along their axes is a truly Einsteinian concept for, along with the idea of newly positioned portions of objects plus pieces of space itself surrounding them, it introduces the notion of an amount of time required to reposition the eye to see the object from the new viewpoint. Several of these splits in one work can cause a strong time-warp sensation, particularly if accompanied by equally powerful treatment on either side of the original split plane (fig. 6.9).

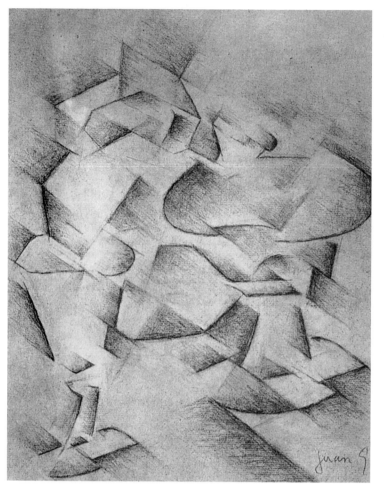

6.9
Juan Gris
Glass, Pitcher, and Fruit Bowl
1912
Pencil on paper
13½ × 11" (34.5 × 28 cm)

The Tipped Plane

The most time-dislocating of the Cubists' effects, this idea allows the viewer to look at portions of the picture plane from different angles—above, below, or at eye level—all in the same glance. The impossibility of seeing things at the same physical moment, yet clearly at different moments perceptually, may provoke a dizzying response in the spectator. Particularly when partitioned or compartmentalized into the often geometric structuring of the split and slipped plane, this third Cubist device brings the idea of the fourth dimension into the open for many viewers for the first time (see figs. 5.58 and 7.21). The indivisibility of the space–time continuum can be experienced, if not intellectually comprehended.

The Cubing of Space

Fragmenting objects and their surrounding space into small, often seemingly squared, chunks or shards of the pictorial surface dissolves forms and background areas equally. This shimmering, faceted imagery can often come into focus briefly, then lose itself in a great play of fractured form plus environment. Not only does a sense of time permeate such works, but also a compelling need to devote serious attention to visual interaction with them (see fig. 5.57a). In this way, Cubism was the first interactive, participational art form.

Exercises:

Set up a simple still-life arrangement, including some of the objects favored by the early Cubists.

- Study the arrangement of forms and create more than one drawing, including the Cubist techniques described (not all in one work!).
- Using the same still-life arrangement, draw the subject from two or three different positions. Cut these drawings into several rectangular or other sections, rearrange, and attach to a backing to make one or more finished works. Make final adjustments and orchestrate the treatment of each as a

unified composition. Compare the time–space readings of each work.

- Make a single-focused drawing of the still life. Place a rectangular window or overlaid flap of paper on a portion of the work and change your viewpoint before re-studying the arrangement. Draw the covered portion from this new angle, trying to adjust edges of forms as needed to unify the composition and pictorial surface. Do you need another window or flap?
- Draw a frontal portrait of a model, life-size. Then, on a tracing paper overlay, place portions of a profile and other views, until you have created a sense of the head turning in several positions.
- Use the portions you need in order to draw a strong and multi-positioned finished work. How many eyes will you show? Are you limited to the mere two of scientific fact? Can you find new meaning in the familiar phrase, "Now you see it; now you don't"?

If we are not limited to drawing what we can see, what new possibilities for showing time and space may be open to us? That will be the challenge of our next Unit.

Unit C
Beyond the Horizon: Fantasy and Illusion

PICTURE THIS...

Visual ideas may be drawn from the mind as well as the eye, our inventive imagination often as inspiring as the perceptual faculties, the two even working together in unpredictable, refreshing ways to evoke purely visual pleasure and intellectual delight. Akin to the satisfactions of geometry or certain classical music, these feelings differ from the expressive, sense-related responses often associated with the idea of emotion.

The freedom to invent combinations of elements not limited to the possible, but also to the credible, the convincing, gives the artist tremendous power to restructure the very appearance of time and space.

In this Unit, we will look at a number of ways to create a reality on the page that does not or cannot exist in the so-called real world.

WHAT IF...

The specific ideas we will investigate may begin as responses to the thought, "What if...?" Consider:

What if I:
- Combine some of this subject with some of that, in the same space?
- Turn this into that, in the same place?
- Show different things in the same space at the same time yet, somehow, separately?
- Hold this work first with the top this way, then with the top that way, changing the identity of each along with its position?

Perhaps the more outlandish the hypothesis, the more satisfying the solution. In drawing, nothing is beyond the realm of possibility (fig. 6.10).

FITTING TWO THINGS INTO THE SAME SPACE: THE OPTICAL ILLUSION

It is said that two things cannot occupy the same space at the same time. As a scientific fact this may be so, but such facts have never been seen as limitations by artists. Elaborately constructed optical illusions can expand the inner space of a drawing, providing surprising,

6.10
René Magritte
The Thought Which Sees
1965
Graphite on paper
15¾ × 11¼" (40 × 29.7 cm)
The Museum of Modern Art, New York. Gift of Mr. and Mrs. Charles B. Benenson. Photograph ©1999 The Museum of Modern Art, New York. ©ADAGP, Paris and DACS, London 1999

6.11 LEFT
Oscar Reutersvärd
Optical illusions
From Bruno Ernst, *The Eye Beguiled, Optical Illusions* (Cologne: Taschen, 1992)

delightful, or perplexing visual multiplicity, or different readings of its elements (fig. 6.11; see also p. 252). Lines that seem to lead clearly to one resolution may suddenly melt or be transformed in unexpected ways to reveal hitherto impossible conclusions. A knowledge of geometry may be necessary to pursue this direction very far, but you can play with some of the possibilities in an almost intuitive way. As an example, see the variant of the famous three-pronged fork, redrawn as a triple-flamed double candlestick (fig. 6.12). There are a number of well-known "flip-flop" illusions which alternately show two differing forms and their altered surrounding space (figs. 6.13–6.15; see also color plate 10). Use the Bibliography to find more.

✎ Exercise:

Draw a variant of one of the classic optical illusions, such as the three-pronged fork, the Schroeder "reversible staircase," the "embedded figure," or the "flip-flop cube." Choose either a geometric variant or a representational interpretation of the basic idea. Use tracing paper or vellum over a gridded sheet of graph or quadrille paper.

Do you see a relationship between optical illusions and the innovations of the Cubists (making it possible to show objects from more than a single viewpoint at the same time)?

The attempt to depict objects that cannot exist in the physical world as they are seen has generated a great deal of inventive experimentation to discover still newer means of creating such effects (fig. 6.16).

6.12 BELOW
Sandro Del-Prete
Three Candles
1970
Pencil on paper
11¾ × 8¼" (29.8 × 21 cm)
Private collection

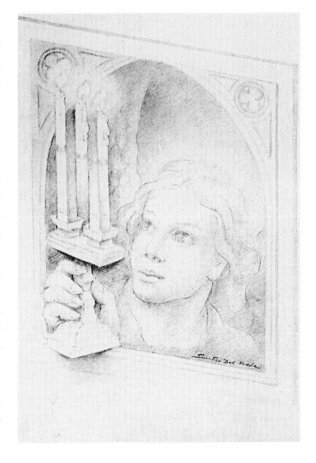

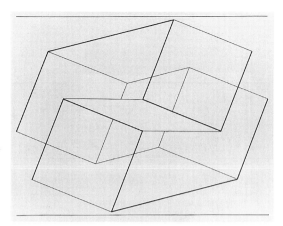

6.13 LEFT
Josef Albers
Structural Constellation
c. 1958
Pen and ink on paper
14½ × 23⅞" (36.7 × 60.7 cm)
Josef and Anni Albers Foundation,
Orange, Conn. ©DACS 1999

6.14 BELOW
Ambihelical hexnut
From Bruno Ernst, *The Eye*
Beguiled, Optical Illusions
(Cologne: Taschen, 1992)

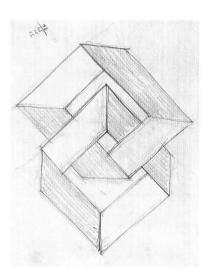

6.15a–d ABOVE and RIGHT
Richard Anuszkiewicz
Working drawings
1998
Pencil on paper
Each 14 × 11" (35.6 × 28 cm)
Collection of the artist. ©Richard
Anuszkiewicz/DACS,
London/VAGA, New York 1999

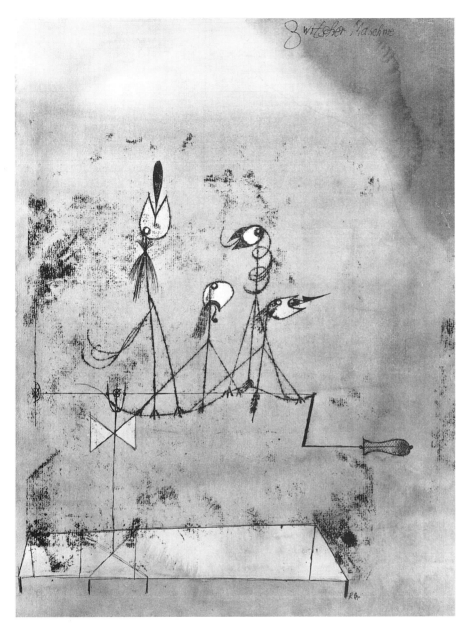

6.16
Paul Klee
Twittering Machine
(*Zwitscher-Maschine*)
1922
Watercolor, and pen and
ink on oil transfer drawing
on paper, mounted on
cardboard
25¼ × 19" (63.8 × 48.1 cm)
The Museum of Modern Art, New
York. Purchase. Photograph
©1999 The Museum of Modern
Art, New York. ©DACS 1999

Exercise:

Invent one new way to show believable but impossible space. Study some of the recommended sources to confirm the originality of your solution. Work on or over graph paper. Don't erase early efforts; make a new start each time to keep a record of developing ideas.

• Select a drawing by Escher or Albers which is based on an optical impossibility or ambiguity, and after analysis (with graph paper and tracing paper overlays) create a variant, simplification, or other work inspired by your investigation (see fig. 4.19). Use the library or visit a museum to supplement the examples shown here.

TRANSFORMATION OVER TIME

We have seen an image instantaneously transform itself into something other than what was first perceived, as our perspective changed. The drawing didn't change; there was a shift in our perception of it.

In a different way, a series of images can slowly convince us that what we were seeing is no longer the subject before our eyes. The transition between one stage and the next can be so slight, or so smoothly wrought, that we are carried along visually by the flow of similarity between images, until the total effect is completely altered and the new elements outweigh or overtake any trace of the original. Figure 6.17 presents a delightful application of this idea, as a drawing of an animal is seen to change sequentially until it has become not only a simplified abstraction, but a symbolic shorthand, in actuality the Chinese character or word for the animal itself. This transformation can sometimes be achieved in no more than three steps, but a slow development offers the opportunity to savor the subdivisions and recapture the historic transformation that occurred over many centuries as graphic pictures became true pictographs (see fig. 4.31).

Exercise:

In a series of five to eight steps, reduce the visual elements in a simple drawing of an animal until you have created a linear symbol suggesting the subject. Then find the appropriate Chinese or Japanese character and compare. Do you see similarities? Does your symbol contain elements of the actual character?

- As an alternative, find the character first. Working from a drawing or photograph of the subject itself, create a progression. Make each image the same size and present them as a single linear series. As in figure 6.17, visualize the subject from the viewpoint or angle that most clearly suggests its source. The sequence may be presented left to right or right to left (or even vertically). Which do you prefer? Why?

Do you find a similarity to individual-sheet flip-book animation (see fig. 6.5)? In both, sequentially modified images carry the eye along, but here we are more interested in the stopping places—in each transitional drawing—and less in the movement or activation of a single unchanged subject. We are seeing the mouse turn into a written word; we are not watching it scamper into a hole.

SUMMARY: ASPECTS OF ACTIVATION AND TRANSFORMATION

Animation can take the form of activating a constant subject or transforming

6.17
Cooper Union student:
Kaming Liu
*Chinese character
transformed into a mouse*
1993
Ink on paper
3⅝ × 18⅛" (9.2 × 46 cm)

one image into another. Do these affect our notion of time and space in different ways? How? What other kinds of visual change, over time, can you imagine? If an idea is carried out in a variety of ways, does the idea itself remain the same? Marshall McLuhan said "the medium is the message." Is this what he might have had in mind? Do any of these seemingly interrelated variants of the idea of transformation stretch the definition of a single concept farther than you are willing to accept? Here are some we have already encountered in differing contexts.

- Individual panels, such as multi-panel folding screens or accordion-folded books (see fig. 6.3).
- Sequential images, such as multi-panel transformations, animated film, or flip-books, emphasizing action: a subject shown in motion; time-lapse or physical growth: a subject developing in stages; and image transformation: one subject to another, or a variant, from picture to symbol.

Is this listing complete? What can you add?

Exercise:
Visualize or make a series of small thumbnail sketches of a single simple theme, in several of these forms. Develop at least two into completed works in any linear or tonal black-and-white materials. This exercise need not be limited to perceptual experience, but may include a combination of perceived and imagined imagery.

THE ILLUSION OF PLACE

One problem encountered in the studio is the seemingly inevitable similarity of drawings based on still-life arrangements. Any set-up of objects, draperies, surfaces, or other elements brought into the studio and composed, however attractively, still risks suggesting the same idea: These objects were arranged to be drawn; this is not a real place. There are many ways to convey the sense that you have gone to an actual non-studio location.

You can often re-create a specific place, within the studio, so that its elements completely fill the picture plane you establish. For example, an empty window frame may be placed in front of a traditional still-life arrangement to serve as a border for your composition, or as a partial periphery. A decorative frame, perhaps with draperies, or an elaborately bordered mirror can add details to enhance your work. Mirrored reflections duplicate objects you have arranged, to provide a richer, more rhythmic scene.

A change in your viewing point may be helpful. For a beach still life (fig. 6.18) that looks quite authentic, objects found on the beach can be dropped according to the laws of chance (see p. 285) on a sheet of rough sandpaper placed on the floor alongside your chair. Without making any alterations to the composition (other than choosing a specific rectangle within which to work) you then develop a careful representation of the subject in pencil. An overhead bird's-eye view can

add to the apparent realism of the works drawn. (For this particular scene, re-creating a section of Old Orchard Beach in Maine, the student received a shell, a length of string or rope, a sea-soaked autumn leaf, plus one additional individual object such as a piece of driftwood or seaweed.)

Exercise:

Carry a container, such as a shoebox, with you for several days, until you encounter a promising subject for scenic illusion: a park, beach, city sidewalk, attic, or other likely locale. Collect a selection of appropriate small objects. Choose or devise an authentic-appearing ground or other surface against which to place (or drop) your selected subjects. Textured floor tiling or linoleum can be virtually indistinguishable, for drawing purposes, from brick, slate, parquet wood, or other natural materials.

Or, in the fashion of Harnett, suspend objects from nails on wooden door panels or boards and draw them with dramatically lighted shadows. The main criterion of success here is the degree to which you are able to create a sense of presence, an illusion of reality in the scene you present through your drawing.

Which Way Is Up?

The horizon may be seen as the edge between firm, filled space (terra firma, the earth) and empty, unfilled space (the airy sky). Or it may separate land from water, sea from sky, or other broad sweeps of solid or vaporous material. Artists such as El Greco and van Gogh have filled the so-called emptiness of

6.18
L.I.U. student: Marcia Schackner
Beach study
1991
Pencil on paper
8½ × 11" (21.6 × 28 cm)

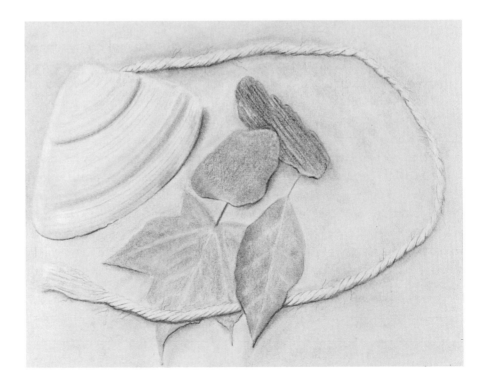

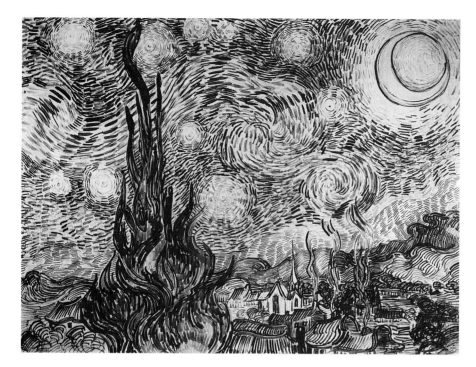

6.19
Vincent van Gogh
Cypresses and Stars (Study for the painting "The Starry Night") (detail on p. 232)
1889
Paint over pencil
18½ × 24¾" (47 × 62.3 cm)
Lost during the Second World War; formerly Kunsthalle, Bremen, Germany

sky with as much form and structure as masses of earthbound features on the other side of the horizon (fig. 6.19).

Exercise:

Create a landscape drawing whose horizontal separation serves a double purpose when the work is inverted, so that in each placement a different but equally believable landscape is seen (see figs. 1.5a and b). Make a number of preliminary studies of landscapes with distinct or indistinct horizon-lines, with various cloud formations or other visual elements in the upper or sky portion of the picture plane. One option is to place your entire field of vision below the physical horizon to show the edge between land and water, as at the shore of a pond, ocean, lake, or marsh. While working on this double-positioned drawing, turn it frequently in order to maintain an equality between both viewpoints.

It may not be necessary to use any actually perceived referent; this final work of the present Section may be visualized completely with the inner eye the poet Wordsworth called "the bliss of solitude." In his poem "Daffodils," images of these blossoms are "oft" seen to "flash upon that inward eye," through the power of memory. Memory, imagination, and pure inventive conceptualization will be the subject of our next Section, named for Wordsworth's surprisingly prophetic pre-videoscreen imagery.

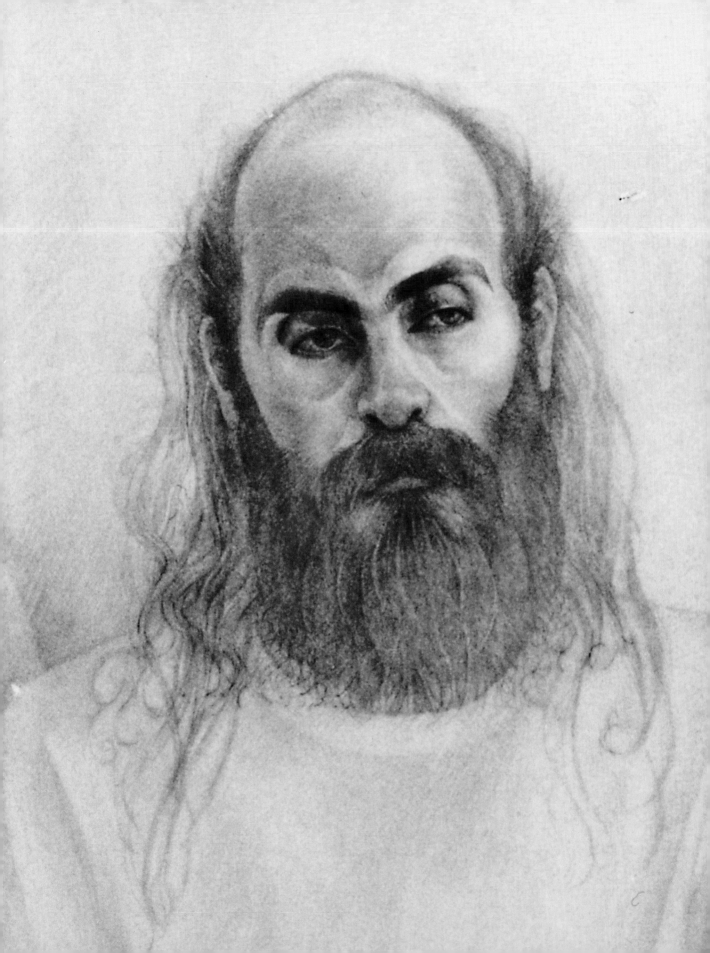

Seeing with the Inward Eye:

The Conceptual Vision

Unit A

The Mind's Eye:
Sur-Reality and Dreams

VARIETIES OF CONCEPTUAL IMAGERY

Artists and writers often use the terms *perceptual* and *conceptual* art, not always in the same ways. Perceptual drawing can refer to studies made of objects seen or perceived at the time they are being drawn. But the term perceptual is also used to designate works that intentionally elicit a retinal or physical response in the eye, as in Optical (or "Op") Art (see fig. 2.15). Conceptual drawing is based on an idea, a system or structure in the mind of the artist. The Conceptual artist may see the world through a system or special framework, or from a specific point of view (see fig. 0.5). Can these coexist in the same works?

Drawings based on conceptual vision may make reference to the world of perception. As seen with the inner or inward eye, described by Wordsworth (see p. 257), such visualization may spring from memory and dreams. Ideas unrelated to perceived experience may inspire another kind of conceptual art, often derived from purely intellectual sources, such as geometry. (We will investigate this aspect of conceptual drawing in the next Unit, "Depicting the Unseeable"; see fig. 7.19 and color plate 4.) In addition, visual works may be created, accidentally or intentionally, as a response to pre-arranged or preconceived conditions, the result of a specific point of view or style of

drawing, designed for a predetermined use or application. They will be our concern in the last Unit of this Section, "Control and Content: Criteria for Choice" (see figs. 7.25, 7.26, 8.8, and 8.10).

THE WORLDS OF SURREALISM

To explore the associative or referential aspects of conceptual vision, we will focus first on a number of features collectively known as Surrealism. Over and above the merely real, such imagery moves to the super-real, the domain of sur-reality. In *The Merchant of Venice*, when Shakespeare has Bassanio muse, "Tell me where is fancy bred, ... in the heart or in the head?", he poses a basic question regarding the source of dreams and imagination: Do these arise from our emotional, perceptual, or intellectual nature? To a more contemporary fictional character, Cinderella, the answer is clear: "A dream is a wish your heart makes." "Such stuff as dreams are made on," another Shakespearean image, relates always to the world of reality, although its elements may appear rearranged, reassembled, or distorted (fig. 7.1). A combination of images recalled, hoped for, even feared, may trigger dreams and surreal visions which appear real, but are in fact invented. Is it always necessary to determine the nature, the meaning, or the possible symbolic content of such creations of the mind? The famed Surrealist René Magritte disavowed any specific symbolic meaning in his famous reassembled, re-seen, combined-image works. So, for instance, the sectionally proportioned *Delusions of Grandeur* (fig. 7.2) or the half feet, half boots of *The Red Model* (fig. 7.3) may be interpreted freely by each viewer, without the imagination-limiting imposition of a single reading set by the artist. The mystery remains.

Several visual devices may be seen in works by Magritte and other Surrealist artists, which generally show individual elements depicted with great attention to realistic detail:

7.3 LEFT
René Magritte
The Red Model
1964
Crayon on cardboard
8³⁄₄ × 12" (22.2 × 30.5 cm)
The Menil Collection, Houston,
Tex. Photo: F. W. Seiders.
©ADAGP, Paris and DACS,
London 1999

- Seamless integration of separate, seemingly incongruous images;
- Exchange of filled and unfilled spaces;
- Differing light sources in a single composition;
- Use of the word—often apparently inappropriate—for the thing;
- Two objects occupying one space at the same time;
- Exaggerated scale, unusual proportional relationships;
- Heavy objects defying gravity, suspended in space (figs. 7.4 and 7.5).

Which of these are shown in this Unit? (All may be found by using the Bibliography.)

7.4 FAR LEFT
René Magritte
Study for "The Castle of the Pyrenees," detail
1959
Ink and pencil on paper
Sheet: 5¹⁄₈ × 5¹⁄₈" (13 × 13 cm)
Collection of the Israel Museum,
Jerusalem. Gift of Harry
Torczyner. Photo: ©Israel
Museum/by Josh Kamien.
©ADAGP, Paris and DACS,
London 1999

7.5 LEFT
Paul Colinet
Untitled
1933
Pen on paper
Private collection

7.6 ABOVE
Pablo Picasso
Guernica, detail
1937
Oil on canvas
Full painting 11'5½" × 25'5¾"
(3.5 × 7.77 m)
Museo Nacional Centro de Arte
Reina Sofía, Madrid. Photo:
Bridgeman Art Library, London/
New York. ©Succession Picasso/
DACS 1999

"A sun (source of life), a radiant eye of the dark night, an electric-artificial-light-bulb (man's fateful discovery), all-seeing-God's-eye-witness' (Ad Reinhardt, *How to Look at a Mural [Guernica]*. Sunday feature, P.M., January 5, 1947)

Certain human features, such as the eye (figs. 7.6 and 7.7), occur frequently in Surrealist imagery in the works of Escher, Magritte, and Dali. Is the disembodied smile of Tenniel's Cheshire Cat (for Lewis Carroll's *Alice in Wonderland;* fig. 7.8) an example of Surrealism?

7.7 RIGHT
René Magritte
The False Mirror (Le Faux Miroir)
1928
Oil on canvas
21¼ × 31⅞" (54 × 81 cm)
The Museum of Modern Art, New York. Purchase. Photograph
©1999 The Museum of Modern Art, New York. ©ADAGP, Paris and DACS, London 1999

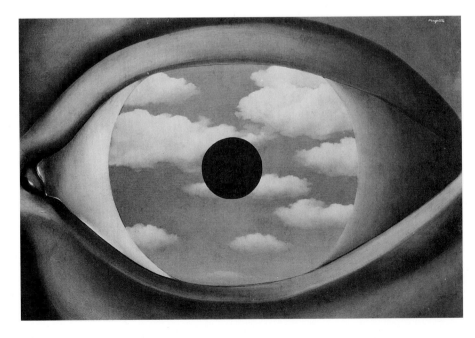

Exercise:

Combine portions of inanimate and living subjects in convincing ways, choosing objects for their visual compatibility rather than a symbolically meaningful relationship.

- Using tracing paper, create a work in which the periphery of an object contains its background space, and the actual unfilled space around the original subject is treated in a different, positive way (fig. 7.9).
- Study the drawings or other works of Magritte, and adapt one of the devices noted above in order to show a variant of the idea in a new way.

The works of another Surrealist artist, Giorgio de Chirico, often include a strong distortion of spatial relations and perspective in order to create a sense of isolation, unreality, and an unfamiliar kind of dreamworld (fig. 7.10).

7.8 ABOVE
Sir John Tenniel
Cheshire Cat's Smile, detail
From Lewis Carroll, *Alice in Wonderland* (New York: McLoughlin Bros., 1867)

7.9 LEFT
René Magritte
La Grande famille
1963
Oil on canvas
39⅜ × 31⅞" (100 × 81 cm)
Private collection. Photo: Lauros-Giraudon, Paris. ©ADAGP, Paris and DACS, London 1999

7.10

Giorgio de Chirico

The Mathematicians

1917

Pencil on paper

12⅝ × 8⅝" (32.1 × 21.9 cm)

The Museum of Modern Art, New York. Gift of Mrs. Stanley B. Resor. Photograph ©1999 The Museum of Modern Art, New York. ©DACS 1999

"De Chirico's multiple and conflicting vanishing points create spatial confusion and disorder, and far from opening space, close it claustrophobically, flattening it to the eye," according to the noted historian and curator John Elderfield. This kind of spatial distortion may be considered one of Surrealism's special magic tricks. The ability to change the very nature of space, weight, gravity, proportion, and other facts of earthly existence (if not in fact, then on the reality of the picture plane) marks a special creative power of the Surrealist. Perhaps there is more to the idea that *seeing is believing* than we often think.

Exercise:

Using an exaggerated two-point perspective, show simple architectural features receding in a barely suggested exterior space, then place a figure engaged in a convincing solitary activity. Let your imagination guide you in the addition of specific details, drawing as though you are recalling a scene from a recent dream, or one you might care to experience.

- Select a quality such as weight or disproportionate scale and create a drawing showing a physically impossible, but visually believable, situation.
- Set up a still-life arrangement including a window frame or an open box. Complete your drawing including the scene apparently outside the window or inside the box, but actually inside your imagination.

CREATING CREATURES IN THE MIND

Would you consider the created mythological creatures of Picasso—his half-man, half-beast satyrs and centaurs—to be Surrealist (fig. 7.11)? Are all such human/animal creatures, even mermaids or Pegasus, part of a Sur-real mythology?

Insects and reptiles provide deliciously formidable parts for our reassembling fancies. Dragons are often pictured as part dinosaur, part lizard, with a human characteristic or two added. But no matter how many eyes, claws, fangs, scales, or antennae we add, our most terrifying inventions seem largely to be an amalgam or collage of pre-existing features, however rearranged or drawn to fearsome, improbable proportions.

7.11
Pablo Picasso
Harpy with Head of a Bull, and Four Little Girls on a Tower Surmounted by a Black Flag (*Harpye à tête de taureau et quatre petites filles sur une tour surmontée d'un drapeau noir*)
December 1934, printed 1939
Etching, printed in black
Plate: 9⁵⁄₁₆ × 11⁵⁄₈"
(23.7 × 29.6 cm)
The Museum of Modern Art, New York. Abby Aldrich Rockefeller Fund. Photograph ©1999 The Museum of Modern Art, New York. ©Succession Picasso/DACS 1999

Exercise:

Visit a natural history museum or library and fill a small drawing pad with powerful portions of animals drawn in great detail. Later, assemble a new and monstrous creature using some of your studies, adding features from memory or imagination.

Are you surprised to discover that even when complete freedom is available, as here, it still seems impossible to invent completely novel body parts, objects, or environments without some real-world referents? Why is this so? Are our imaginations bound to experience after all? Could this be a reason for the often minutely, almost microscopically rendered detail in some Surrealist works, such as those of Dali (see fig. 7.1)? Do we compensate for an inability to invent by our insistence on super-realism in the depiction of the rearrangements and re-combinations we can devise? Is there a hint of envy in Joyce Kilmer's plaintive declaration that "only God can make a tree"?

DEITIES AND SUPERHEROES

Cynthia (Diana, Artemis, or Selene), the Greek goddess of the Hunt, is often shown preceded by a tethered pair of sleek greyhounds, beneath a crescent moon (she is also known as the goddess of the Moon). How would you depict a new deity, Video, or his partner, Computa? Instead of deities, would these be more appropriately rendered as contemporary superheroes, such as Batman, Spiderman, or Catwoman? Does every generation, every society, need to picture heroic individuals with more than mere human qualities and capability?

How have artists responded to this apparently universal need to picture individuals with greater than human attributes as larger-than-life role models, champions, or deities? Study the human, anthropomorphic (human-formed), and supernatural figures of importance in the folklore, mythology, religion, and history of a particular people, period, or geographic area.

Look for Egyptian deities such as the Sphinx, Horus, Set, and others that incorporate human and animal attributes. How do these differ from Sumerian eagle-headed deities?

A full study of the differing tribal masks, figures, and headdresses of the vast number of African cultures (such as the Bambara Tji-wara antelope forms found in Mali) could be a life's work (fig. 7.12).

From the Western hemisphere look for the Quetzalcoatl, an Aztec feathered serpent deity of Old Mexico. Would an Iroquois false face mask, carved from a living tree, belong to the category we are discussing?

Exercise:

After studying the specific symbolic imagery of a selected people, time, or place, devise one convincing, historically appropriate individual, possibly incorporating anthropomorphic features. Create your own deity or heroic

7.12
L.I.U. student: Kiambu
Zawadi
Tji-wara Antelope
Headdress and Dan Mask
(objects from the collection
of the author)
1997
Pencil, multi-sheet drawing
6 sheets, each 18 × 24", taped
and cropped (45.7 × 61 cm)

individual for a specific culture by clothing a figure in garments and implements of your invention, suggesting his or her special attributes.

SURREAL OR SYMBOLIC?

It can be hard to distinguish between *Symbolism*, in which elements represent or stand for certain qualities or attributes, and *Surrealism*, in which elements appear in relationships and rearrangements that are not possible, despite convincing depiction. Although in works of Symbolism the message of the artist is not always meant to be deciphered, usually such images do carry political, social, or other meanings (see fig. 0.11). Surrealist imagery, on the other hand, can appear more open, arbitrary, even capricious (see fig. 7.2). In fact, it was the intention of Magritte and the original Surrealists to disturb the viewer—to leave questions unresolved and puzzling. Would this satisfy the Symbolist? Must there be a definable concept behind every conceptual vision?

Exercise:

Have a friend carefully wrap an object of irregular shape. Draw what you see, then what you visualize inside the wrapping. Unwrap the object and draw it in the same position, comparing the actuality with the imagined reality. Which makes the more interesting drawing? Which looks more like the actual unwrapped object? Rewrap the object as similarly to the original package as possible, replace it, and redraw it as you did the first time. Is it possible to see this object now as objectively as you did before you knew what it was? Can you still envision its purely visual or esthetic relationships without being influenced by its identity? Do you find yourself trying to show more than you see, to help

the drawing along by enhancing your perception of what you see with your conception of what you ought to be able to see? What are the most surprising results of this study?

Do you agree with the painter Julian Stanczak, who said in another context, "Visual perception is here secondary to memory … as recollection overwhelms sensation." In what other parts of this Unit might this idea also apply? (See the Bibliography.)

LEAVING PERCEPTION BEHIND

How far can a drawing be removed from its original association, yet retain something of that inspiration, still be able to come into focus, and assume a unity that transcends its apparently non-associative, purely visual interaction of forms? Perhaps through the cohesive force of Gestalt psychology such a work may still be seen as a representation, a picturing of something or someone in the world of actuality. The small geometric shapes so widely separated and apparently independent of one another in the works of the Dutch de Stijl artist Bart van der Leck can suddenly jell or cohere and be seen quite clearly as representational forms (fig. 7.13). At what point do the associative but simplified, abstracted drawings of Mondrian's trees, piers, churches, and other landscape features lose their pictorial connotations and assume the *pure plastic* relationships of visual elements he sought to convey (see figs. 2.11a–c and 4.33a–c and color plate 9)? Is there a clear point at which the perceptual may be relinquished and the purely conceptual exists? Such works are not derived from Surrealist ideas; as pointed out by Rubin and Lanchner in their study of Masson, "Surrealists never made non-figurative pictures." Their conceptualism remained within the sphere of the perceptual; important

7.13
Bart van der Leck
Flowering Branch
1916
Watercolor and charcoal on
paper
12³/₈ × 17⁵/₈" (31.2 × 44.7 cm)
Stichting Kröller-Müller, Otterlo,
The Netherlands. Photo: Tom
Haartsen. ©DACS 1999

works of both kinds continued to be made during the same period of time. (Refer again to the Bibliography.)

Exercise:

Starting with a strongly representational study of an object or a still-life arrangement, sequentially reduce the elements in your composition until you have reached the point where purely visual, relational elements overtake the descriptive. At this point, orchestrate the visual content, the visual components, into a new unity, a work unrelated to the original subject. Have you moved from a perceptually based to a purely conceptual approach in your drawing? Have you moved beyond abstraction to a new non-associative kind of drawing?

Do you feel we are asking too many questions and not supplying enough definite answers? Are we repeating certain basic concepts in a number of different contexts? Do you agree with John Elderfield that "The basics, it often seems, are not spoiled by repetition. All art is framed in an interrogative mode"

Let us depart, for a while, from the perceptual, take our rulers and graph paper, and enter the world of purely conceptual drawing.

7.14a BOTTOM LEFT
Claes Oldenburg
Alphabet as Good Humor
Bar
1970
Colored pencil and crayon
on paper
28½ × 22½" (72.4 × 57.2 cm)
Photo: courtesy Leo Castelli
Gallery, New York

7.14b BOTTOM RIGHT
Jasper Johns
0 Through 9
1960
Lithograph, edition of 35
Sheet: 30 × 22" (76.2 × 55.9 cm)
Photo: courtesy Susan Sheehan
Gallery, New York. ©Jasper
Johns/DACS, London/VAGA, New
York 1999

Unit B
Depicting the Unseeable: Conceptual Drawing

IDEAS ABOUT PERCEPTION AND CONCEPTION IN ART

Conceptual drawing relies upon a concept or idea, often one that can be discussed in enthusiastic detail in words, as well as shown on the visual surface.

WORDS AND SYMBOLS

A fascination with the power and mystery of words as symbols has influenced a number of visual artists to select the picturing of words themselves as their sole subject matter. Working under self-imposed limitations of systems and predetermined structurings, these artists use words, letters, and other symbols in conceptually inspired drawings (fig. 7.14a).

7.14c LEFT

Edward Ruscha

City

1967

Graphite on paper

13¼ × 21⁷⁄₁₆" (33.7 × 54.5 cm)

Photo: courtesy of the artist

Exercise:

Using a particular alphabet (perhaps a solid or outline type font such as Bodoni or Caslon with serifs, or Helvetica or Futura *sans serif*), create a drawing in which numbers, letters, or words are included primarily for their graphic form or structure (figs. 7.14b and c).

THE NATURE OF PERCEPTION

Compare your initial response to the following statement with your considered opinion, after studying the analysis presented. "Even when we draw

7.15 LEFT

René Magritte

L'Air et la Chanson ("This Is Not a Pipe")

1962

Etching

4½ × 5¾" (11.4 × 14.6 cm)

Private collection. ©ADAGP, Paris and DACS, London 1999

perceptually, that is, when we draw what we see, we are not actually drawing the *thing* we are looking at." Philosophers, examining the nature of visual perception, have proposed a great variety of hypotheses, such as the preceding apparently self-contradictory statement. Is *what we see* the same as *the thing we are looking at* (fig. 7.15)? Do we perceive objects or the appearance of objects? Certainly we see the contents of our visual field but, just as surely, we do not see the entirety, the full three-dimensionality of the things before our eyes. If we consider *how things appear to us* as opposed to *the way they really are*, "only in a very marginal sense is a description of one's visual experience to be called *seeing* at all." (See the Bibliography for a development of these thoughts, presented in detail in *Perceiving, Sensing and Knowing*, edited by Robert J. Swartz.)

7.16
Shunji Sakuyama
Prospect Park West
1971
Watercolor on paper
30 × 24" (76.2 × 61 cm)
Collection of the artist

Relating perception to art, philosopher Susanne K. Langer explained: "All genuine art is abstract [since it] is the recognition of a relational structure or form, apart from the specific thing in which it is exemplified." She feels "the artist's task is the making of [the] symbol," an act requiring abstraction (fig. 7.16). Emphasizing creative use of language, she looks at "the word *imagine*, which contains the key to a new world, *the image*," and says "the meanings of a work of art have to be imaginatively grasped through the forms it presents to the senses." Langer calls this "expressive form," which is something in the work itself, and not something apart from it. In a related way, the poet Archibald MacLeish has said:

A poem must not mean
But be.

If purely concept-related drawing is derived from some source other than whatever it is we see when we look at the world and record our visual perception of the experience, memory, or rearrangement of the elements of perception, then where in our human experience can it be found?

NON-PERCEPTUAL SUBJECT MATTER

Another word for *concept* is *thought*; as Langer says, "Conception is the first requirement for thought." In the work of Albers, this *in-sight*, derived from "a disciplined return to visual events which sharpen our awareness," is based on the "exploration of universal phenomena," as opposed to *out-sight*, which is stressed in purely perceptual work. He searched for visual truth in the "plastic experience inherent in geometric forms," and limited his mature drawings to the richness he found in the many permutations and modulations of the straight line (color plate 10; see also fig. 6.13).

Geometry has been the source of much conceptual work in drawing and other mediums, inspired, no doubt, by observations such as this thought of the fourth-century B.C. philosopher Plato:

I ... speak of the beauty of shapes, and I do not mean, as most people would think, the shapes of living figures, or their imitations in paintings, but I mean straight lines and curves and the shapes made from them These are not beautiful for any particular reason or purpose ... but are always by their very nature beautiful and give a pleasure of their own. [See fig. 7.17.]

An allegiance to the basic structures of geometry does not exclude an acknowledgment of the relationship of geometry to the world of nature. After all, it was Cézanne who found that everything in nature was related to the sphere, the cone, and the cylinder. These basic forms are to be found as an implicit armature in much of his work, but Cézanne never departed from the world of nature completely. To him it was still the subject that mattered most as subject matter, not the bare bones of geometric structure, which were pared down by the Cubists then abandoned as subject in the *pure plastic* works of Mondrian (see figs. 4.6, 4.33c, and 2.11c).

We like to think of geometric form, particularly the squared grid, as very modern, but evidence of human concern with this particular construction may be found as far back in the documented history of art as it is possible to trace, in the caves at Lascaux, perhaps 30,000 years old (see fig. 6.4). These nine-square grid forms appear side-by-side with the more familiar bison and reindeer, yet are not nearly as well known. They are often called mysterious or unknown figures, suggesting a quality of mysticism—also quite up-to-date. Recent studies have suggested that they may be the picturing of rudimentary numbering systems, the very beginnings of calculus!

Nicholas Fox Weber, Director of the Albers Foundation, whose thoughts on Albers' drawings are briefly summarized above, feels that he "reached out for a geometric dream" and that his work, "which at first seems purely conceptual, partakes of the irrational and in essence searches for the absolute."

A WORKING TERMINOLOGY

One hindrance to understanding and communication is the great variety of meanings assigned to even the most common terms. When one person speaks of *perceptual,* meaning *seen by the eye,* another may be hearing *perceptual,* meaning *having a strong effect on the retina, producing an optically irritating effect.* Some of the most frequently used terms relating to categories of Conceptual art or drawing may have these meanings:

Conceptual: (i) based on other than directly perceived imagery; concerned with a specific idea, theory, system, or plan; based on geometric relationships.

(ii) works proposed or described, but not actually given form.

Systemic: based on intellectual, structured relationships of elements; constructed on a squared grid; employing a specific geometric idea.

Minimal: using the fewest possible markings on the page or the smallest number of elements to create a work; using the sparest application of materials to a surface; reduction to the essence of form.

Modular: composed of replicated elements; based on an underlying repeated-unit structure; composed of units or groupings of units, often including the option of rearrangement or repositioning of components (figs. 7.17 and 7.18a and b).

Geometric: based on straight lines, curves (particularly arcs or portions of a circle), and shapes composed of these; using only straight lines in a perpendicular or diagonal relationship (usually at a 45° angle); employing any lines or shapes that can be constructed with a straight edge and compasses.

Grid: based on a checkered or boxed format composed of equally spaced vertical and horizontal divisions; drawn on a squared

7.17 LEFT
Cynthia Dantzic
Geometric modular drawing (theme)
1981
Pencil on paper
15 × 15 " (38.1 × 38.1 cm)
Collection of the artist

sheet, either retaining or concealing the underlying structure of the grid; drawn on a squared sheet but using only certain of its lines in the final work (color plate 10; see also figs. 4.8 and 6.4).

Other ideas often employed by artists using the general term Conceptual art include:

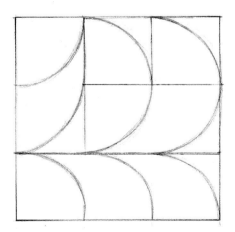
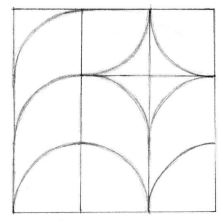

7.18a FAR LEFT and b LEFT
Cynthia Dantzic
Geometric modular drawing (variants)
1998
Pencil on paper
Each 3 × 3" (7.6 × 7.6 cm)
Collection of the artist

Non-verbal: unrelated to nameable objects or ideas, directly perceivable. "The meanings which pure visual forms … convey are nameless … because they are logically uncongenial to the structure of language," according to Langer. This does not exclude words themselves or individual letters from forming the subject of some Conceptual works. The idea of the word as a visually interesting form, rather than its verbal content, may make it an appropriate subject for such work (see figs. 7.14a–c).

Plastic: concerned with the relationship of visual elements alone. "The Cubists and Constructivists explored a plastic experience inherent in geometric forms," says art historian François Bucher (color plate 10).

Mechanical: in other contexts this term might suggest an impersonal rigidity, highly undesirable. But in their Conceptual drawings LeWitt, Albers, and others disregard the significance of the handmade or originally drawn in favor of various mechanically produced or generated works. Albers said he created "illusionary modulation" through the use of "equally thick lines … through their light and dark relationships and their constellation. The use of a ruler and drafting pen establishes unmodulated line … opposing a belief that the handmade is better than the machine-made, or that mechanical construction is antigraphic or unable to arouse emotion …" (see fig. 6.13). LeWitt supplies instructions for others to produce his often wall-size drawings. He "sets up a system within which the execution of his system can only produce a LeWitt," says art historian and curator Bernice Rose (color plate 4).

Do you feel it is important for the artist personally to execute drawings, or to produce them in some way by hand? Each Conceptual artist sees these criteria in an individual way. Attempt to create drawings using the method of several Conceptual artists; then devise an approach that is truly your own.

SOL LEWITT

Sol LeWitt's works have changed considerably over the years, but he has stated several criteria on which his wall drawings and other linear works are based. Says art historian Alicia Legg: "LeWitt believes the initial idea is paramount …. It must be fully understood by the artist before a work is carried out …. [If the thinking is done in advance] the execution is a perfunctory affair …. The idea becomes the machine that makes the art." His drawings are based on formulas that may actually be drawn by anyone. The titles, which always appear with the works, are detailed descriptions of the rules or guidelines by which each work is to be drawn. Here are two:

Four Basic Kinds of Straight Lines and all their Combinations in Fifteen Parts
Lines Not Straight, Not Touching, Drawn on a Brick Wall

The idea of strict straight-line precision is not always required for a LeWitt work; in fact, the scribble quality of some of the wall drawings gives them an individuality, almost a softness, not found in other Conceptual works (see the Bibliography).

Exercise:

Using a LeWitt formula or title, make a drawing in pencil on a large surface. Is it a LeWitt drawing, though drawn by you? Do other questions arise, unexpectedly?

• Devise your own formula for a similar drawing to be executed by others. Compare the results of several drawings made to your specifications. Do you consider these last works to be *your* drawings? Follow the same guidelines yourself.

Do you feel a greater identity with the work drawn personally by you? Are individual feelings of concern to the Conceptual artist, or is intelligence offered in their place? As expressed by Bernice Rose, "there is a new balance in which intuition in concert with rational ordering creates a significant space …. LeWitt's wall drawings, reduced to the absolute and addressed to our immediate perception rather than to our conventional responses, preserve the contemplative and rationalizing functions … of drawing." Do you agree that the Conceptual artist provides the conception; is it up to us to provide the perception to appreciate it?

KENNETH SNELSON

Kenneth Snelson, a scientist as well as an artist known primarily for panoramic photography and three-dimensional linear constructions, is mainly concerned with structure in nature and art. In his efforts to picture the invisible he has created original works based on his analysis of atomic form. To Snelson "the serious Conceptual artist drops the image entirely in favor of an abstract text." He sees that "art, for its inspiration, is free to draw upon all of knowledge and experience as its raw material …. The human capacity to imagine frees our creativity from mere slavish imitation of what already is and allows us to recombine elements into things that do not exist in nature" (see the Bibliography).

Exercise:

Consult scientific sources for depictions of structure, such as the spirals, helices, and pentagonal forms of DNA as seen with an electron microscope. Use these nature-derived geometries in a series of drawings based more on their concept than their forms.

DOROTHEA ROCKBURNE

Dorothea Rockburne has created a number of drawings in pencil and watercolor based on her interpretation of certain philosophical and mathematical concepts presented by Blaise Pascal in the sixteenth and seventeenth centuries (fig. 7.19). Her work, according to Susan Stoops at Brandeis University's Rose Art Museum, "encourages us to reflect on the language of geometric abstraction … [yet] points ultimately to something beyond itself, to a knowledge and meaning that reside outside representation. … [However] reason can never resolve her [work]. [As] Pascal wrote, 'reason's last step is to recognize that there are an infinite number of things beyond it.'"

Rockburne's ongoing involvement with the Golden Section has led to a number of works that show sectional, diagonalized, shaped-panel forms, often with folded and layered elements. Frequently, a geometric idea can be grasped—that is, seen—without the necessity of verbal description. In this way, geometry can be understood as a direct visual experience.

Despite the seemingly impersonal aspects of work so informed by

7.19
Dorothea Rockburne
Arena IV
1978
Colored pencil on vellum
4'6½" × 3'11" (1.38 × 1.19 m)
Photo: courtesy André Emmerich
Gallery, New York. ©ARS, New
York and DACS, London 1999

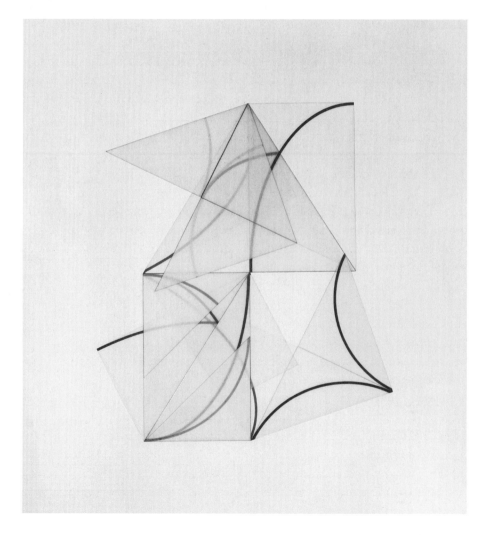

Plate 9 RIGHT
Piet Mondrian
Chrysanthemum, detail
c. 1908–9
Graphite and watercolor on
canvas
Full image 10³/₈ × 6¹/₄" (26.4 × 15.9 cm)
Sidney Janis Family Collection.
©Mondrian/Holtzman Trust,
ᶜ/₀ Beeldrecht, Amsterdam,
Holland/DACS, London 1999

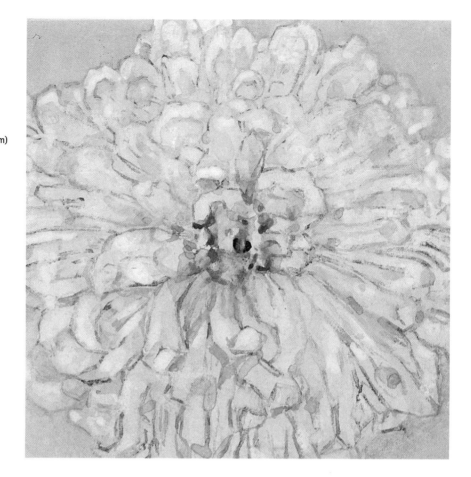

Plate 10 RIGHT
Josef Albers
Structural Constellation VIII
c. 1955–60
Pen and ink on wove graph
paper ruled in orange
18 × 23" (45.7 × 58.4 cm)
Josef and Anni Albers Foundation,
Orange, Conn. ©DACS 1999

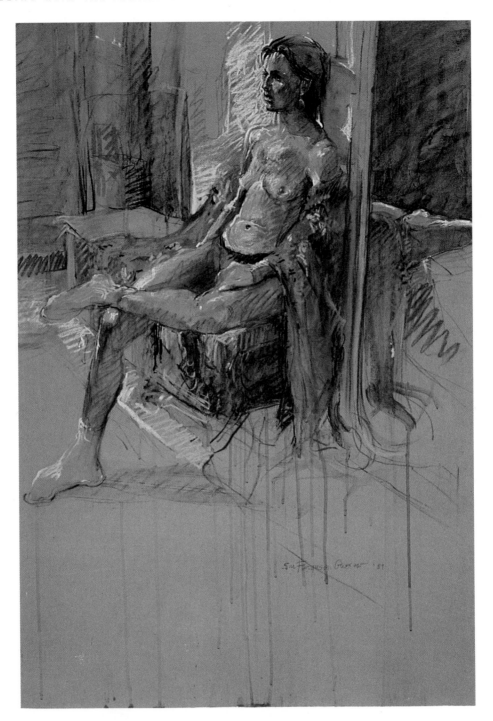

Plate 11

Sue Ferguson Gussow

Linda in a Spanish Wrap

1990

Pastel and wash on paper

42 × 31^1/$_2$" (106.7 × 80 cm)

Collection of Dr. Elizabeth White

geometric, linear limits, Rockburne is very much concerned with intuitive, unknowable forces, with risk, and with that "unnameable space between clarity and obscurity, certainty and doubt."

Perhaps for different reasons, yet in a surprising parallel to a decision of LeWitt, Rockburne always titles a work before it is made. She begins "with a desire to visualize language, a conceptual process that evolves from the general to the specific." (See the Bibliography.)

Exercise:

Review the description of the Golden Mean and the Golden Section on page 193. Draw a geometric study with only the straight lines and curves necessary to describe this proportional relationship.

- Using tracing paper, simplify your drawing to create a work with the fewest possible visual elements, the minimal markings needed to show the idea.
- Study the theorems of Pythagoras or the writings of Pascal (Rockburne was introduced to these in the fourth grade!) and select a single concept to demonstrate in a visual way. Experiment with individually cut shapes, perhaps folding along significant edges, in order to make a layered, free-form drawing acknowledging the Rockburne concept and technique.

FRANÇOIS MORELLET

François Morellet accepts the term *Minimal* with regard to his work, based on systematic and geometric principles. His "self-generating" process of choosing random numbers to determine the location of identical elements on a picture's surface produces pictures that "make themselves" (fig. 7.20). A summary of his specific systems includes:

Juxtaposition:	an orderly, non-overlapping arrangement of lines, bars, discs, crosses, or triangles covering the entire picture surface.
Superimposition:	two or more identical grids overlapping, each shifted a precise number of degrees.
Fragmentation:	a straight or curved line drawn across several non-contiguous panels.

7.20

François Morellet

Dashes 0°–90°

1960

Oil on canvas

3'11¼" × 3'11¼" (1.2 × 1.2 m)

Musée de Grenoble, France. Gift of the Fondation Abstraction et Carré, 1987. ©ADAGP, Paris and DACS, London 1999

Interference: juxtaposed or superimposed groupings of identical elements at irregular intervals.

Randomization: avoidance of arbitrary artistic decision-making by borrowing numbers and numerical sequences (from telephone directories or mathematics) as compositional elements.

Morellet aims for the "maximum of directness and accessibility ... a total demystification of the artistic process; [yet] he has ... placed himself among the truly individualistic, uncompromising artists."

Exercise:
Make a series of pencil drawings in the manner of Morellet, using one of his stated compositional systems. Then select one and enlarge it. Will any adjustments be made subjectively, or according to a random method? Try both approaches, then see if these can be distinguished by a group of viewers.

JULIAN STANCZAK
Julian Stanczak, whose geometric abstractions "address the conditions under which the eye perceives movement, energy, and vibration within a defined space," relies less on intellect than on intuition, which he calls "the judgment of the eye." He doesn't try to imitate or interpret nature, but "to create relationships that ... run parallel to man's experience with reality." Rejecting the idea that analysis is a hindrance, he asserts that "analysis satisfies the brain" (see the Bibliography).

Synthesis
The exercises in this Unit have been designed to help you understand the ideas and methods of artists whose work can be called Conceptual, by attempting to re-create the conditions under which their works have been achieved. At this point, you may wish to devise your own system or rules.

Exercise:
Devise an original set of conditions or rules under which a series of drawings to be called Conceptual, Systemic, Minimal, or Geometric may be created. Might it be better to complete a drawing or series of drawings using your own guidelines first? How would this compare to the LeWitt final exercise on page 277? Is it worth doing the same exercise twice? Explain.

THE BIG IDEA: ALBERS HAS THE LAST WORD
In this Unit we have looked at a selection of the great diversity possible when the human mind decides to remove itself from the making of choices or to

remove subjectivity in the creation of visual works. Note the number of Conceptual artists who make a point of stressing the irrational, almost spiritual inspiration beyond the geometry, beyond the seeming simplicity of their work. "The cool look ... may prevent the spectator from sensing the often irrational fervor behind the best of this work," says art professor, historian, and writer Robert Rosenblum. The art historian John Chandler writes, "Not all art should be systemic, but all systems are art."

For his treatise on twentieth-century drawing, John Elderfield studied the subject deeply and concluded, "theories, finally, are irrelevant when faced with the work itself." In *Despite Straight Lines*, an analysis of Albers' graphic constructions and drawings, Bucher says, "the artist, an originator as well as a sensitive interpreter ... has ... transformed complex philosophical and theoretical systems into images which can be understood by all who have sharpened their visual perception Forced to test again and again all that we see, we learn to see more." And, Albers added, "Therefore ... cultivate vision."

The greatest appeal of Conceptual drawings may well lie in our participation in their visual realization. Only in an interaction between the work and the viewer do such drawings actually exist. Perception is still the key (color plate 10)!

Unit C
Control and Context: Criteria for Choice

IDEAS AFFECTING THE WAY WE SEE

New ideas and concepts have determined the major directions of the visual arts, including drawing, since the late nineteenth century—the very beginning of the now comfortably old-fashioned sounding tradition known as "Modern Art." Since the time of the Impressionists and Post-Impressionists, who painted and drew according to ideas about light, structure, space, and form, and the Cubists, who questioned dimensionality itself, artists have often thought first and looked second. Put another way, an idea about looking often affected what was perceived and what was placed on paper or canvas (fig. 7.21).

No longer was it sufficient for many artists to hold the idea that a pictorial surface is seen as a mirror (reflecting back at the viewer a re-presentation or imitation of reality perceived) or a window (through which the viewer looks at a re-creation of the artist's perception of a subject). Other choices became available; the artist remained in control (fig. 7.22).

This question of artists' control over various aspects of their work—one of the continuing subjects of discussion in the twentieth century—merits our attention here. At one extreme, as we have just seen, are drawings whose creators leave the world of the perceptual image and find their inspiration in the linear structure of geometry or carefully prescribed formulas and instructions. At the opposite end of the scale are works derived from an idea that has captured the fancy of many artists from the early days of this century:

7.21 RIGHT
Piet Mondrian
Self Portrait
1911
Charcoal on paper
11⅛ × 9⅛" (28.3 × 23.2 cm)
Photo: courtesy Sidney Janis Gallery, New York.
©Mondrian/Holtzman Trust, ᶜ/₀ Beeldrecht, Amsterdam, Holland/DACS, London 1999

7.22 FAR RIGHT
Richard Haas
Mondrian
1965
Pencil and colored ink on paper
11 × 8½" (28 × 21.6 cm)
Collection of the artist. Photo: courtesy of the artist

the search for ways to circumvent making choices or imposing oneself or one's feelings upon one's works.

CONTROL: SELF-DIRECTED DRAWINGS

Arp, Schwitters, and Klee, working in Europe in the Dada period during the 1920s and 1930s, often set up situations in which works would create themselves determined *according to the laws of chance.* Allowing sections of previously cut or torn works to fall undirected on a surface, or permitting a tool to produce unguided or automatic lines and markings, often resulted in works describing universal truths about the visual surface, unaffected by the specific prejudices or preferences of the artist (fig. 7.23). Historically, such efforts have often been considered part of the Surrealist or Dada movements; however, as they do not require perceptual references to subject matter or the objects of reality, but are the result of a specific idea about the way drawings may be evoked, they may be seen as an early foray into one kind of concept-related drawing (see p. 259).

More recently, Ellsworth Kelly, LeWitt, Morellet, and others have created situations in which undirected, often geometric, linear drawings have come into being without their own specific decision-making or hands-on participation. These artists prefer to acknowledge the primacy of their concept, the informing plan or system under which their works have been made (see p. 281).

Exercise:

Set up a situation in which a drawing can be created according to the laws of chance, including a means by which a pencil or other mark-making implement will be made to come in to contact with a sheet of paper under circumstances you will not specifically control. This may involve doors, scissors, springs, levers, even automobiles passing over previously placed materials. Be inventive.

What criteria can you formulate to evaluate the success or the artistic quality of such works?

- Set up a situation in which another individual or group of individuals completes a drawing according to a formula or set of plans devised by you. These may be geometric, based on material introduced in Section 7, Unit B.

7.23
Jean (Hans) Arp
Automatic Drawing
1917–18; dated on work
1916
Brush and ink on gray
paper
16¾ × 21¼" (42.6 × 54 cm)
The Museum of Modern Art,
New York. Given anonymously.
Photograph ©1999 The Museum
of Modern Art, New York.
©DACS 1999

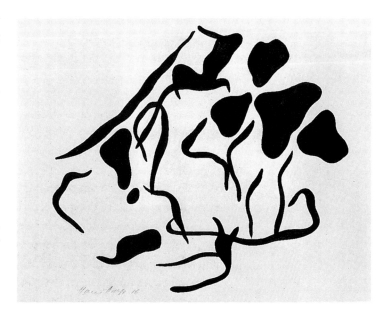

EVALUATING SELF-DIRECTED DRAWINGS: THE IMPORTANCE OF CRITERIA

What are the areas of similarity between these apparently different ways of achieving the anonymity of the artist and the impersonal, purely concept-related nature of a work? Have such drawings succeeded in eliminating all traces of feeling, of human response?

A few questions may clarify your own thinking and feelings. After you have collected a number of self-directed works, do you find them all equally successful, well-designed, artistic, or even interesting? If not, on what basis can you distinguish the good from the not quite so good or the unacceptable? Are there underlying, universal standards or criteria by which you evaluate your drawings, or those of others? Do you find yourself judging different works by differing criteria? If so, on what factors do you base these varying standards? Would you rather look for factors that make a drawing "work" or "be convincing"?

Historical Context

Do you consider the criteria of the individual who has created a drawing to be an important factor? This is related to a point long debated by students, instructors, and art historians: the importance of studying art works in the context of their time. The general social, political, economic, and cultural conditions within which a particular work was produced are seen by some as factors vital to its real understanding. Surely this is too large an issue to be resolved here, but it is one with which you may wish to engage in a life-long inner discussion—with yourself and with others. Study the three works in figures 0.4, 2.20, and 7.1, first with no thought to their context or the historical or other conditions under which they might have been created. Can you establish criteria for your evaluation or response? Come back to these works again, following a period of time devoted to research into the life and times of one of the artists represented. In what ways do you find your response modified by the additional information? Or do you think a visual work must stand on purely visual criteria? Do you think your ideas or feelings about this may be subject to modification, over time?

Thinking and Feeling: Contradictory or Supplementary?

Can you distinguish or separate:
- *An artist's feelings* toward a subject (how can you know them?);
- *A viewer's feelings* (yours?) about a drawing;
- *An artist's idea*, the concept that led to a drawing (how can this be known?);
- *Your response* to your own drawing, not as maker but as viewer;
- *The viewer's predetermined attitude* about drawings in general?

Do these distinctions make a difference in the way you create your own drawings or respond to the drawings of others? Investigate the thoughts of philosophers and others in category 6 of the Bibliography.

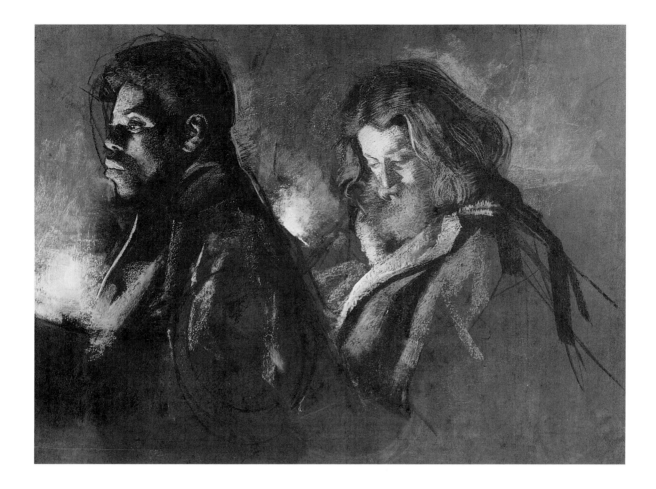

Making Conceptual Distinctions

Other than direct perceptual drawings made in visual or expressive response to a perceived subject, might we say that all drawings based on a previously held idea—made for a predetermined purpose or in a preselected style—are basically concept-related and therefore a special kind of conceptual drawing? Although there are many ways to look at such drawings-based-on-a-concept or on a conceptual vision, they may not all be called *Conceptual*; the term has been given specific meanings, as discussed in Section 7, Unit B.

Predetermined Choices

Some drawings may be made to satisfy predetermined objectives or criteria. How might a study of the war in Vietnam and the passions it evoked affect your response to figure 7.24? If you prepare to make a drawing by selecting certain materials and tools with a particular aim in view, whether political or simply to make the subject as attractive to the eye as possible, are these equally instances of a concept or predetermined idea being the main criterion, rather than a direct visual response to the subject before your eyes?

7.24

Harvey Dinnerstein

Moratorium Vigil

1970

Pastel on board

22 × 30" (55.9 × 76.2 cm)

Collection of the artist

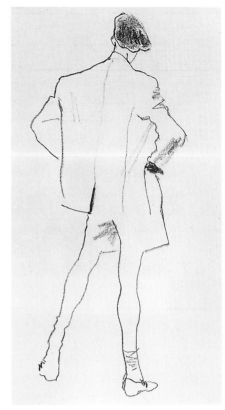

7.25 ABOVE
Al Hirschfeld
Duke Ellington
1973
Etching
20 × 16" (50.8 × 40.6 cm)
©Al Hirschfeld. Art reproduced
by special arrangement with
Hirschfeld's exclusive
representative, The Margo Feiden
Galleries Ltd., New York

7.26 ABOVE
Anita Dantzic Rehbock
Fashion figure
1978
China marker on paper
24 × 18" (61 × 45.7 cm)
Collection of the artist

7.27 LEFT
Andy Warhol
Untitled (Paratrooper Boots)
c. 1984–5
Synthetic polymer paint on
paper
40 × 30⅛" (101.6 × 76.5 cm)
©The Andy Warhol Foundation
for the Visual Arts, Inc./DACS,
London 1999

Exercise:

Pose a model whose costume includes such items as a jacket, boots, scarf, and perhaps sunglasses, seated on the edge of a high stool or table, with an exaggerated fashion magazine gesture. Make several different studies, choosing from this menu:

- *A linear pencil drawing* of the subject and adjacent elements;
- *A tonal study* of a selected portion of the subject;
- *A gestural study*, using minimal brush and ink line. Show the elegance of the pose and the flair of the outfit;
- *An exaggerated caricature*, emphasizing humor of pose, scale of costume elements (fig. 7.25; see also figs. 5.22a and b and 8.10);
- *A cartoon character* based on the costumed figure;
- *A portrait study* with surrounding elements;
- *A fashion study* emphasizing costume and textures. Use bamboo brush and India ink or China marker (fig. 7.26);
- *An illustration* of one of the garments, emphasizing texture (fig. 7.27). Use pen and India ink;
- *A geometric study* related to, but not necessarily identifiable as, the subject seen, based on the edges of planes, the turning points of forms, or the articulation of certain parts of the figure.

Describe the major differences between these drawings. Do you think that for each, your prior concept, your idea of what was to be drawn (and perhaps of how it would be drawn) determined to an extent the way you looked at and saw the subject? How did the differences in your way of looking at the subject affect your actual perceptual experience?

LOOKING AHEAD: FUTURE STUDY DIRECTIONS

These experiments with various ways of seeing, perceptually and conceptually, can be most important in determining the next stage of your development in drawing. You may discover that your abilities in one area are clearly stronger, that you possess a natural proclivity, or feel more comfortable working under certain conditions or toward certain goals. Only if you try a wide variety of techniques and ideas about drawing will you learn which particular inclinations may develop into a life-long pursuit. You could develop skills and technical knowledge in a number of areas before making a commitment in any specific direction, whether to commercial or to so-called "fine art" drawing— that is, drawing for its own sake, perhaps for exhibition, and not to anyone's specifications but your own (color plate 11; see also fig. 0.19). Particular areas of drawing for further study (and possible careers) include: medical illustration, illustrations for books and book jackets, magazines, graphic arts, posters, greeting cards, advertising, fabric design, industrial design, interior design, children's books, caricatures, cartoons, courtroom sketching, portraiture, fashion illustration, animation, video graphics, video animation, botanical drawing, engineering, architecture, cartography (map-making),

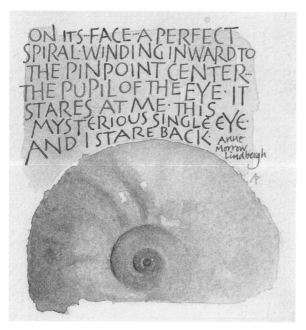

7.28
Anna Pinto
Calligraphy with moonshell
1997
Watercolor on paper
4 × 3¾" (10.2 × 9.5 cm)
Collection of the author

calligraphy, type design, and typography. The ability to draw is a vital part of each of these professional directions (see figs. 4.30, 7.28, 8.13, and 8.14 for calligraphy alone).

SHOWING ATTITUDES OR FEELINGS ON PAPER

Whether you draw for the sake of drawing as art or for more specific professional purposes, your feelings about drawing and about the subject of your drawing are important. Attitudes toward or feelings about a subject may include a strong emotional response, opinion, or thought, or a desire to affect the viewer's response to the subject of the drawing (see fig. 7.24).

Specifically, a drawing may be intended to convince the viewer to laugh, to feel sympathy, to decide to take action, to buy a product (or an idea), to learn how to do something, to appreciate the beauty of a subject, to accept a new idea (fig. 7.29).

Do you feel (or think) that your point of view or your attitude toward your subject will necessarily affect the resulting drawing? If you have a clear idea of your purpose, there are many choices to be made before you begin to draw. Refer to Section 1, Preliminaries, for a menu of choices.

Certainly, expression or attitude toward your subject is affected by your use of the materials selected to create a particular drawing. In Section 8 we will consider the materials for making drawings, plus a number of suggestions relating to their specific uses.

INTUITIVE, SELF-TAUGHT, AND TRIBAL FORMS

It is possible to identify drawings that have clearly been made from a particular viewpoint, or with a certain idea or concept in mind, in which choices have been made, whether consciously or unconsciously. Certain self-taught artists, particularly those unfamiliar with the traditions of a specific culture or civilization (vanishing-point perspective, for instance), create a body of consistent work, adhering closely to a personal world view or visual style, not necessarily aware of having made a choice in these matters (color plate 6).

The forms of tribal art are often passed down through the generations largely unchanged by the individual artist. In civilizations which do not have a means of preserving works physically over time, such replication is a way of extending the life of the individual form (see fig. 7.12).

Children's art often resembles tribal or self-taught work, as the young artist has yet to be influenced by a culture's accepted or traditional methods of representing visual reality (fig. 7.30; see also fig. 0.3).

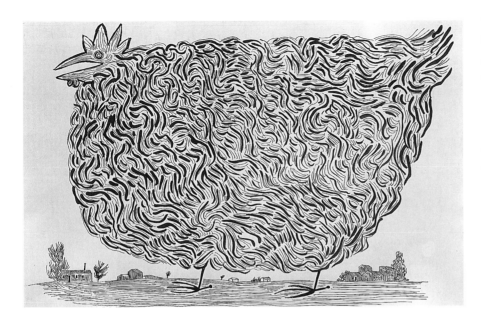

7.29 LEFT
Saul Steinberg
Hen
1945
Pen and brush and India
ink on paper
14½ × 23⅛" (36.8 × 58.8 cm)
The Museum of Modern Art, New
York. Purchase. Photograph
©1999 The Museum of Modern
Art, New York

"KNOW THYSELF"

In this Unit we have moved from a consideration of ways to eliminate all choices on the part of the person making a drawing to methods of determining in advance as many of the variables as possible. We have looked at works determined by accident and chance as well as those carefully planned in every detail before they are drawn according to specifically chosen or unknowingly selected criteria. Explore as many of these dimensions of drawing as possible before you choose the particular path you will follow and make your own.

7.30 LEFT
Sarah Manzo
Swivel Chair
1991 (age 6)
Cray-pas
18 × 24" (45.7 × 61 cm)
Collection of Hélène K. Manzo

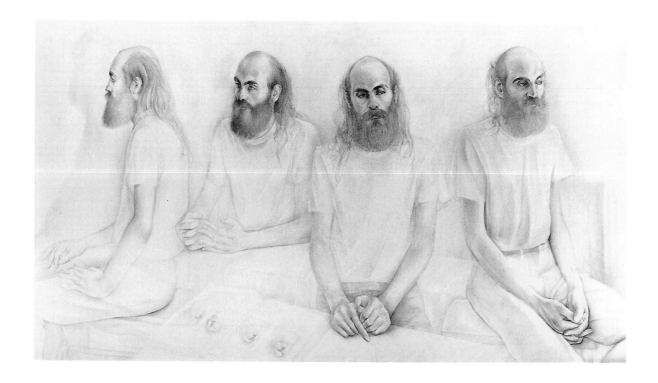

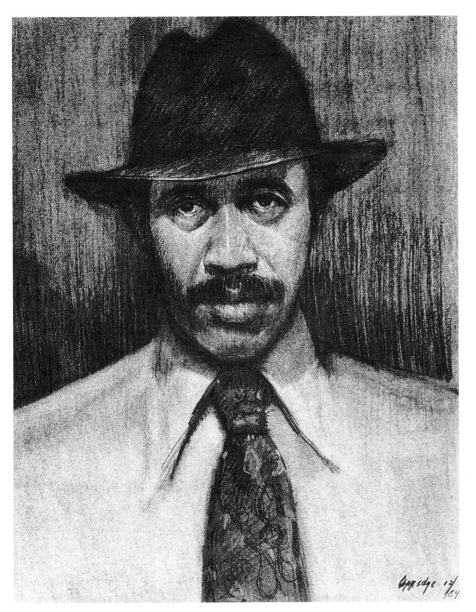

7.31 OPPOSITE TOP
Simon Dinnerstein
Quartet "Wajih Salém"
(detail on p. 258)
1995
Pencil and powdered
graphite on paper
3'6" × 6'2⅛" (1.07 × 1.88 m)
Photo: courtesy ACA Galleries,
New York/Steven Tucker

7.32 OPPOSITE BOTTOM
Rosa Bonheur
Study of Horses' Legs
c. 1851
Pencil on brown paper
11⅝ × 16¾" (29.5 × 42.5 cm)
Musée National du Château de
Fontainebleau, France (on loan
from the Musée du Louvre,
Paris). Photo: ©R.M.N., Paris

7.33 LEFT
Arthur Coppedge
Self Portrait
1984
Charcoal on paper
24 × 18" (61 × 45.7 cm)
Collection of the artist

Do you aim to open the eyes of the viewer through your eyes? Will your goal also be the continual unfolding of your own perceptive abilities, so that with each new drawing you see a wider world? To paraphrase the response given by the photographer Garry Winogrand when asked why he made pictures, we could respond when asked why we draw a particular subject, "to see what it looks like drawn." Can you think of a better reason to draw (figs. 7.31–7.33)?

Appendix:

Materials and Supplies, Presentation and Direction

8

A complete description of all available art materials could occupy an entire volume (and does—see the Bibliography) and is easily obtained in catalogues at your favorite art supply store. Here a general description of materials frequently used for drawing will be presented. Although it may seem arbitrary to designate certain multi-use tools or materials as clearly wet or dry, it is recommended that you consider these categories when acquiring and choosing supplies, as a kind of menu from which to select and combine the best choice for each use. In this Section, we shall take a somewhat novel approach, looking at the specific recommendations of a number of artists and instructors with widely differing viewpoints.

These professionals, who act as a Silent Panel, include a classically trained traditionalist who feels "if it was good enough for Rembrandt and Vermeer, it's good enough for my students," a medical illustrator, a cartoonist, a fashion illustrator, and a figure-drawing instructor whose students always work to music in order to "loosen up."

Associated tools, studio equipment, and related commentary will be included, plus a discussion of ways to present finished works.

Unit A
Using Dry Materials

PENCIL

Pencil and charcoal lead the list of dry marking materials used for drawing; pencil is generally recommended by those concerned with line and charcoal or conté crayon more often chosen by those interested in tonal study (figs. 8.1 and 8.2). Pencil is often referred to as graphite, although this form of carbon is in fact mixed in varying amounts with clay, baked or fired to produce leads of differing softness or hardness. The almost shiny, metallic look of the harder pencils is accompanied by their ability to hold a point for a long time while producing a relatively light mark, although the hardest—9H or 7H—may seem to incise rather than apply a line to certain thin or smooth surfaced papers. You will not need to experiment with every available pencil. They range from these crisp super-fine high-numbered Hs via the all-purpose 2H (which holds a point, doesn't smudge, and offers a good range of tonality, depending upon pressure applied, sharpness of the point, and the angle at which it is held to the page), and the darker and richer HB (which still retains the controllable qualities of the 2H), to the even blacker, softer, smudgier, and less controllable array of Bs—from the standard writer's 2B via the first really black pencil, the 3B, the very soft but somewhat pointable 4B, and the almost charcoal-like 6B, to the creamy, sketchy, almost wash-producing 8B. Tones as well as lines may be produced with all these pencils. Parallel linear tonality is

8.1

William Bailey

Untitled

1991

Graphite on paper

32$\frac{1}{16}$ × 42$\frac{1}{4}$" (81.4 × 107.3 cm)

Photo: courtesy André Emmerich

Gallery, New York

8.2
Shunji Sakuyama
Figure
1970s
Charcoal on paper
25 × 19" (63.5 × 48.3 cm)
Collection of the artist

more successful with the harder leads, up to the HB or 2B, and continuous tonality is achievable with every lead. Graphite in several hardnesses is available in stick form and also as a powder, which may be applied as a toning agent with Q-tip cotton swabs or other tools (see fig. 7.31).

Other pencils often recommended include the IBM, Ruwe Mark Sensing, or Ebony varieties which are very black, and "excellent for smudging," according to our medical illustrator. Smudging or blending of tones may be achieved with the finger, a rolled paper stomp, or a Q-tip. Done in a controlled way, this can create an edgeless effect of modulated tonality.

Many of the leads described are obtainable in chisel-shaped, broad-edged carpenter's pencils. In addition, string-pull pencils containing soft leads or lithographic crayon cores provide a desirable transition between the standard pencil and the stick or chunk of uncovered litho crayon. The range of control

8.3
Harvey Dinnerstein
Shaka
1976
Silverpoint on board
14 × 10" (35.6 × 25.4 cm)
Collection of Nicholas and
Griselda Healy

and hardness of this material may prove surprising—the hardest litho pencils keep a point and produce a clean, consistent line, while the softer litho crayons can almost simulate a wash of charcoal. (However, unlike the charcoal or graphite, this is a wash that will stay in place and resist smudging to a large extent.)

For drawing in black-and-white a selection of color pencils in tones of black, white, and gray can give a softer, more painterly, blendable surface than traditional graphite alone. Derwent provides a large number of intermediary tones; Berol and Prismacolor give a softer, more intense effect. Thin graphite leads may be placed in a mechanical pencil or clamp-vise holder where the lead is released as needed, to avoid frequent pencil sharpening.

SILVERPOINT

You may wish to try the classical silverpoint, a thin silver wire gripped in a slender holder. Its hard metallic line has a distinctive pale silvery look, permitting great subtlety of detail and an almost infinite level of soft linear shading when applied to a slick, hard-surfaced paper (fig. 8.3).

CONTÉ

Conté crayon generally appears as a squared stick of relatively greaseless, compact, chalky material, denser and crisper than pastel. In addition to black and white, conté is frequently chosen in tones of deep brown and sepia, a medium red-brown color often used for figurative drawing (color plate 2).

PASTEL

Pastels, which ideally are pure powdered pigment held together with gum tragacanth, can be made without much difficulty, although you may prefer the convenience of the store-bought varieties. An advantage of producing these yourself is the certainty of the ingredients, as commercial pastels may contain considerable inert materials as filler. Although we are principally concerned with black and white there is available, in addition to a great assortment of grays which are a mixture of these achromatic or colorless tones, a full range of chromatic grays (slightly tan, bluish, olive, etc.), plus a complete rainbow of chromatic hues. Depending upon the way these soft pigment sticks are used,

work in pastels has been classified as (and included in exhibitions of) either drawing or painting (color plates 5, 8, and 11).

CHARCOAL

Charcoal is available in several forms: soft, impermanent, easily erasable vine charcoal; heavier compressed charcoal in less easily erased chunks, sticks, and string-pull; and paper-bound pencils in varying degrees of hardness (fig. 8.4).

CRAYONS

Oil sticks, crayons, Cray-pas, and oil pastels are additional options which may be used dry or, as we will note later, wet, when supplemented with various liquids. The viscous, waxy quality of oil-related materials facilitates blending of tones and the creation of textural surfaces (fig. 8.5).

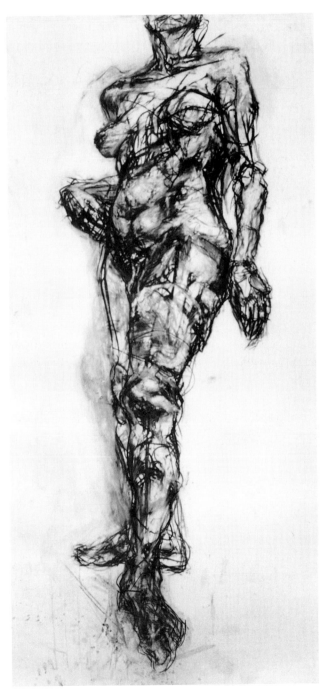

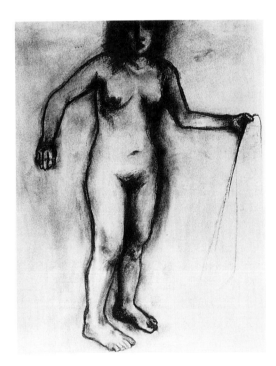

8.4 ABOVE
Diane Miller
Standing figure
1985
Charcoal on paper
25 × 19" (63.5 × 48.3 cm)
Collection of the artist

8.5 RIGHT
Cooper Union student of
Susan White:
Hilary Ciment
Large figure
1995
Dry crayon and oil stick
on paper
72 × 30" (182.9 × 76.2 cm)

ASSOCIATED EQUIPMENT

With these mark-making mediums, you will need tools to sharpen them, correct or erase the marks you have made, blend tones if desired, and keep the material adhered to your drawing surface.

SHARPENERS

For sharpening pencils, conté sticks, and crayons, a single-edge razor blade may be used, or an X-acto pencil knife with a #11 blade, as well as the traditional cylindrical rotating sharpener attached to a desk or wall. A small steel sharpener may be carried for frequent pointing, but avoid the variously shaped plastic varieties with attached clear containers; they generally fail to provide reliable or lengthy service. Carry a small paper or plastic bag for the sharpenings if you draw in a public or indoor location.

For sharpening charcoal pencils, use a small sheet of 3M fine #150 sandpaper. Avoid commercially sold sandpaper blocks as they wear out too quickly and are too expensive. If you prefer mechanical pencils with refillable leads, or clamp-vise holders, use a small lead pointer, resembling a miniature pencil sharpener.

ERASERS

8.6
Loren MacIver
Diable et Cetera
1963
Charcoal on paper
29¾ × 42" (75.6 × 106.7 cm)
Photo: courtesy Tibor de Nagy
Gallery, New York

The use of erasers is discouraged by some, as your work may tend to be less certain, and commitment to a particular line or mark less complete if it can be easily erased. Too much time can be spent trying to correct and perfect each mark if an eraser is available. A square of yellow gum, the traditional soap eraser, does a good job of cleaning most soft markings, but may fail to remove heavy, deeply set lines. It also leaves a swath of crumbled yellow eraser-bits on your page which, if you brush them away by hand, can cause you to smudge your work. The gray square kneaded eraser by Eberhard Faber is one of the most useful as it can, with pressure, remove most pencil work and can also be twisted (kneaded) into small, pointed shapes to remove, selectively, the least blemish. In addition, a press and wiggle technique may be used to lighten, soften, or reduce the intensity of a line or area (fig. 8.6).

The white plastic "MagicRub" eraser cleans nicely without leaving any residue. It also comes as a pencil, in either string-pull or mechanical form. For simple pencil work on strong paper, the "Pink Pearl" is often selected.

PAPERS

By far the cheapest paper is newsprint, obtainable in rough or smooth varieties. Since this off-white paper is an impermanent material at best, the life of any work drawn on newsprint is limited. It will darken, dry at the edges, and eventually crumble. Although some recommend its use, many, including this author, do not. Reasons given for the use of newsprint include its low price, which encourages starting over when a drawing isn't going well; an attitude of experimentation focusing on the sheer excitement of making lines and markings rather than being overly concerned with each mark; and interest in the kinetics or action of each visual experience, as opposed to the look of each drawing (or sketch). On the other hand, there are those who do care about each line and each mark, whether freely and spontaneously achieved or delineated with care. It may be seen that one's attitude toward the use of newsprint is often an indication of one's general attitude to and philosophy of drawing! Or it may be unfamiliarity with the paper's fragility, as evident in many Albers student drawings (see Sections 1 and 2).

A great many types of medium-weight white drawing paper may be found in bound pads. Avoid spiral-bound pads if possible; they don't present a clear rectangle of space, require cropping if a page is removed (for matting or display), discourage quick attachment of several sheets for multi-sheet works (because of the time required to stop and cut or trim the top edges evenly to a common height), and generally provide a ragged, unfinished page or picture plane. Be sure the paper you select is opaque; you don't want one drawing peeking through another as you review your work. One book and advertising illustrator advises, "Always use acid-free paper unless you plan to throw it away. Non acid-free deteriorates." Of course, this adds to your expense, but consider the alternative.

Generally, the paper you select will be determined by the medium you plan to use and the techniques studied. For this reason, the listings that follow have been specifically recommended by the Silent Panel (of individual artists and instructors teaching drawing from a number of different points of view) for varying pre-professional and other purposes. Some of the suggestions reflect personal preferences for their own work as well as for their students' drawing studies.

THE SILENT PANEL'S INDIVIDUAL REQUIREMENTS: PAPERS AND PENCILS

1 Traditional figure-drawing panelist; an artist who teaches
- 12 × 18" rough newsprint;
- 14 × 17" Bristol plate, 2-ply;
- Series 500 1-ply Strathmore plate, for sketching;
- Canson (neutral tones—mid-grays, tans, neutral blues of medium value);
- Strathmore 4- or 5-ply plate or kid finish ("for myself");
- Strathmore illustration board, double weight.

2 Traditional drawing panelist; an artist who teaches
- Canson pastel or *mi-teinte* paper, with slight tooth (texture) or smooth;
- Any gray paper, not too dark;
- Hot-press, plate finish paper (smooth): 9 × 12" loose sheets, not pads, or larger, "but this is the size used by Ingres, Rembrandt, Rubens, Eakins, Watteau … all the good ones";
- No newsprint ever: "Crummy, it won't last" (see fig. 1.76).

3 Figure-drawing and sketching panelist; an artist who teaches
- 18 × 24" newsprint and "charcoal squares, medium Berol pencils" (see fig. 8.4).

4 Drawing panelist; an artist who teaches
- 18 × 24" newsprint "and a plain #2 pencil—that's all!"

5 Drawing panelist; an artist who teaches
- 18 × 24" non-spiral bound pad, medium-weight white paper;
- Notebook-size non-spiral bound pad of white drawing paper;
- 18 × 24" pad of thin tracing paper (for corrections, overlay studies);
- Options: scratchboard, white and pre-coated black;
- Plate finish 2-ply Strathmore rag "for my own use" (see fig. 1.2).

6 Drawing panelist; an artist who teaches
- 18 × 24" white drawing paper—Strathmore, 400 series pad;
- 18 × 24" newsprint pad;
- Small sketch pad, 6 × 8" or larger;
- Various pastel and watercolor papers (to be specified);
- Brown paper, charcoal paper, etc. (fig. 8.7).

7 Drawing panelist; an artist who teaches
- 14 × 17" or 18 × 24" heavy Bristol or neutral pH *toothy* paper pad: "I give students a choice of sizes and surfaces; after a while, they trade" (see fig. 8.4).

8 Medical illustrator panelist; an artist who teaches and has a professional medical and scientific illustration studio
- Bristol plate finish paper;
- Vellum of various weights;
- Paris bleed-proof paper (for pen and ink), #234, 34lb;
- Arches, Acquerelle, plate finish (see figs. 0.6, 0.19, 5.8a–c, 5.45a and b, etc.).

8.7
Posoon Park Sung
Two Women
1990
Charcoal on paper
32 × 46" (81.3 × 116.8 cm)
Collection of the artist

9 Book and advertising illustrator panelist; an artist who does advertising illustrations, largely of food products, and makes portraits as well as children's book illustrations

- BFK Rives "for washes";
- Arches etching paper: "velvety surface, doesn't erase well";
- Cameo paper, "clay-coated, not white, but a dream to draw on";
- Vellum tracing paper, "may be scratched off to make corrections";
- Strathmore "use either side" 140lb paper, "even with an electric eraser you can get down below the mistake—even with wet materials—and have the paper surface stay consistent—until you come to the other side! Caution: beware sketchpads—even expensive ones—that have a mushy, soft surface and don't pick up enough lead, but dent with a hard lead. Experiment. Test sample sheets in a large art supply store to find stock that is comfortable for you" (fig. 8.8).

8.8

Julia Noonan

Christine

1980

Pencil on Arches etching paper

8 × 8" (20.3 × 20.3 cm)

Collection of the artist

10 Fashion illustrator panelist

- 18 × 24" (or larger) slick, white paper;
- "I use only a Dixon #77 black string-pull china-marking pencil, for speed, gesture, spontaneity" (see fig. 7.26).

11 Advertising illustrator panelist; an artist who does graphic design, advertising illustration, and art direction in a graphic arts studio

- 9 × 12", 11 × 14" 1-ply Plate Strathmore paper;
- "I use a plain #2 Ticonderoga or Eberhard Faber pencil, a K & H mechanical pencil with 6H lead, a black BIC ballpoint pen, no eraser (occasionally a Faber-Castell Magic Rub little white chunk eraser which also comes in pencil form) and black and white pastel."

12 Book illustrator panelist

- Halftone paper, gray paper, "never white";
- "A 2B charcoal pencil and General's #558 charcoal white pencil";
- #80 Bainbridge board "as an underpaint I coat the board with Mars Black acrylic paint and draw with the white pencil";
- Tracing paper, "only #2 pencils work with this paper";
- Scratchboard. "I don't use standard tools. American board chips. I use Essdee, a British 'scraper' board up to 19 × 25", mounted on a 2-ply board using rubber cement on both surfaces";
- Pre-blackened scratchboard "for large surfaces such as posters; otherwise I coat the board myself with Higgins India ink (not extra dense, as it's too thick). I let two or three coats at a 45° angle to each other dry overnight. I prefer an

X-acto #11 pencil knife or #16 blade for lines or areas. A fine Grip-hold with a retractable-button blade is best—I can keep it in my pocket!" (fig. 8.9).

13 *Editorial illustrator and cartoonist panelist*

• Arches or Rives smooth hot-press paper: "To flatten the paper, I'll soak it, tape it with brown water-glue tape—the old package wrapping tape—to

8.9
Leonard Everett Fisher
Number Art, Four Winds, NY
1982
Scratchboard
11 × 8½" (28 × 21.6 cm)
Collection of Westport Public
Library, Conn.

masonite. When dry I cut the drawing out. I use graphite 2H, H, and HB pencils, probably Derwent, and a kneaded eraser or two";

- Any papers, "I'm a 'draw it on the back of an envelope' kind of guy" (fig. 8.10).

OTHER GENERAL SUPPLIES FOR DRAWING IN DRY MEDIUMS

Select from this additional listing of basic support supplies, recommended by the panel.

Panelist 1

- 3M #150 fine, thin sandpaper, to sharpen charcoal pencils; "Sandpaper blocks wear out";
- A plumb line, obtainable at a hardware store, "for sighting verticals";
- A hand-held small mirror "for observing work backwards, to check composition, placement, balance, symmetry";
- Large and medium stomps (to blend tones). Use an assortment from $1/4$" to $1/2$" or $3/4$" in diameter, from 5" to 7" in length;
- A knitting needle or barbecue skewer "for eye measuring";
- Black fold-back clips to hold paper to a drawing board;
- $1/4$"-thick sheet of masonite, 1" all-around larger than your paper;
- A metal spirit level (with three directional bubbles) to check verticality and horizontality.

Panelist 2

- Stomp, rag, or chamois (to clean whites in charcoal work);
- Mahlstick, as a plumb line and for resting your hand, to avoid touching and smudging work in progress, when standing at an easel;
- Two large pieces of chipboard and wide masking or white archival tape to

8.10
Tom Connor
Cartoon illustration
1996
Ink on board
5 × 6" (12.7 × 15.2 cm)
Collection of the artist

make a binder for loose sheets of drawing paper (leave space to contain at least $\frac{1}{2}$" worth of paper);

- Spray can of fixative for charcoal work. [Never use without proper ventilation or a correctly fitted mask with proper filters. Do not breathe in any solvents. Use markers with good air circulation only. Because something is labeled non-toxic, that doesn't mean it actually is. Don't eat at your drawing board.]
- Soft brush or feather to remove erasure particles;
- Clay-coated paper (for silverpoint work);
- File and emery paper or Arkansas stone to sharpen silverpoint.

Panelist 3
- Music, "all the time."

Panelist 5
- Micropore paper tape (for multi-sheet drawings).

Panelist 6
- Krylon workable fixative "for finish and during the drawing process";
- Many French curves, oval and circle templates;
- Stomps: small, medium, and large.

Panelist 7
- Clip-on pencil sharpener (attaches to drawing board);
- Electric sharpener (saves time—for own use).

Panelist 8
- Workable fixative spray;
- Tape;
- Portfolio.

Panelist 10
- White artist's masking tape (no pins);
- T-square and ruler (Schaedler precision 12", of "space age plastic");
- Several plastic transparent triangles: 45°, 30/60/90° angles; "plastic won't tear the paper");
- A point-centered pencil compass;
- French curves (a full set of eight);
- A circle template with several sizes from $\frac{1}{4}$" to $2\frac{1}{2}$" in diameter;
- A hand-held pointer to sharpen mechanical pencil leads.

Panelist 11
- A sponge and piece of cloth, for texture (for dry or wet work);
- A light box for tracing ("also with studio equipment").

Panelist 12
- Rubber cement "for mounting Essdee scratchboard on 2-ply board, on both surfaces";
- "#11 and #16 X-acto knives, not commercial scrapers; a fine Grip-hold X-acto with a retractable-button blade";
- A 45° triangle;
- 2B charcoal pencils;
- General's #558 white pencils.

Panelist 13
- An assortment of 9B or 8B, 6B, 4B, 2B or HB, 2H, 4H, 9H pencils;
- Kneaded eraser and a separate one for charcoal; two plastic erasers;
- One stick of compressed charcoal (Char-cole) and three sticks of vine charcoal;
- Strip of chamois cloth;
- Fixative;
- Materials used with newsprint for perspective studies: masking tape; 36" straight edge; 18" ruler; light yellow hard pencil (Caran d'Ache) for guidelines; fine-point black pens.

MAKING YOUR OWN LIST

This selection of materials is recommended and actually used by a representative sampling of teachers and professional artists. Experiment with any that seem interesting or useful for your own purposes. A lengthy visit to at least one or two art supply stores, simply for the purpose of looking, touching, asking, experimenting with samples, and generally familiarizing yourself with the full range of drawing materials available will be most rewarding.

Bring a notebook for listing materials that appeal to your eye, budget, or fingers. Then, after reflection and a little time to recall and compare mentally, without pressure or in haste, make your decisions and your purchases. Also refer to the Bibliography, especially Ralph Mayer's classic *The Artist's Handbook of Materials and Techniques*, for detailed information on traditional materials and their uses. Several newer compilations are available, too.

Although many prefer to begin working only in dry materials, others use inks or paints from the start. In the following Unit, we will discuss a selection of these, emphasizing a black-and-white or monochromatic approach.

Unit B
Using Liquid Materials

OPTIONS

Even if you plan to use only dry materials for your first studies in drawing, you may wish to scan this Unit in a general way, to provide yourself with an overview of basic pen-and-ink, brush-and-ink, and other wet drawing supplies for later study (fig. 8.11). Interesting options are available, depending upon the category into which certain materials are placed. For instance some, such as ballpoint pen, can be used as either a wet or dry medium, or excluded entirely from consideration as an appropriate tool for drawing! (Did you know that the renowned sculptor Giacometti made many portraits and other drawings in ballpoint; fig. 8.12?)

Powdered graphite may be rubbed, smudged, and blended in a drawing as a dry tonal material, but it may also create a wash, with the addition of various liquids. Oil sticks and oil pastels may be used relatively dry or wet with a number of solvents. Still other materials, apparently wet, become quite dry during use, as in the case of dry-brush work, and may combine features of both in a single drawing (see fig. 1.37).

TOOLS FOR APPLYING WET MATERIALS

Pens and brushes have been the traditional tools used for applying liquid materials to paper, although contemporary artists often experiment with any carrier that can be made to hold a mark-making substance and convey it to a receptive surface. These include Q-tips, twigs, toothpicks, corks, Stim-u-dents, and wooden skewers.

We will look first at a selection of classical tools, liquids, and drawing surfaces before the recommendations of the Silent Panel are presented, to provide a range of choices for your experimentation, along with personal commentary relating to the uses, advantages, and limitations of various materials.

PEN AND INK

Although most of our daily experience with pens may be limited to the familiar ballpoint, this inflexible implement bears little resemblance to the infinitely variable range of dip pens with separable points (nibs) and holders.

Most steel, split-tip nibs, whether pointed, chisel-edged, or flat-ended, are interchangeable and may be inserted into a standard wooden or plastic holder. The smaller crow-quill nib requires a separate, narrower handle. This pen-point provides the greatest flexibility and the finest line, particularly useful in precise illustration and rendering.

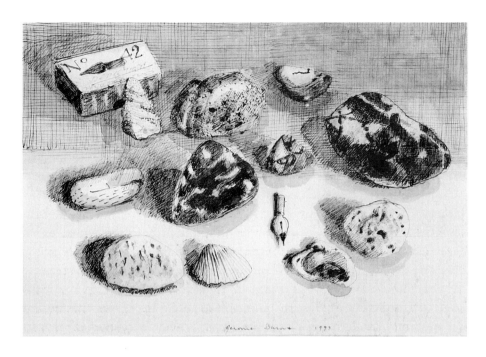

8.11 LEFT
Jerome Burns
Spencerian No. 42 (detail
on p. 294)
1993
Pen and ink on paper
10³/₄ × 15¹/₄" (27.3 × 38.7 cm)
Collection of the artist

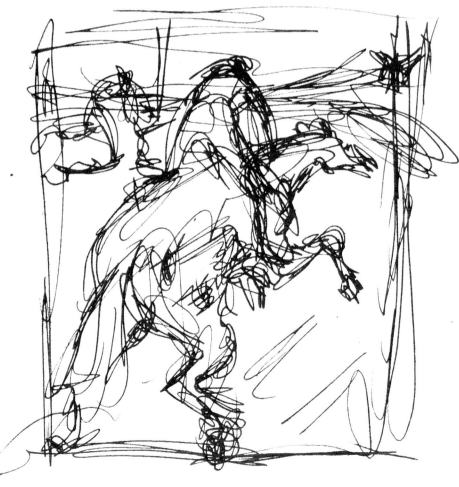

8.12 LEFT
Alberto Giacometti
*Drawing after Toulouse-
Lautrec's "Jockey"*
1965
Ballpoint pen on paper
8 × 6" (20.3 × 15.2 cm)
©ADAGP, Paris and DACS,
London 1999

Dip-pen nibs may be supplied with attached brass reservoirs (small ink-holders), but still require relatively frequent refilling or dipping into a bottle or well of liquid ink (use an eye dropper to keep pens and fingers clean). For most drawing purposes, the finer pointed or chisel-edged nibs are used, though broader and snub-end nibs are useful in illustration and various professional applications.

Speedball nibs are available in sizes from #0 (very broad, almost ¼" in width) to #6 (very narrow, not quite fine). They are produced in four shapes. *A* nibs terminate in a flattened square shape, making a broad, inflexible ribbon-line that must start, stop, and change direction with square-cornered endings. *B* nibs end in a flat round surface, producing a line similar to that of *A* nibs except for rounded endings, bends, and corners. *C* nibs are quite different—their chisel-shaped edges permit a great range of continuously changeable thicks and thins as you vary the angle at which the pen is held to a drawn or imagined horizontal line. Even when the pen is held at a constant angle, the turnings of the drawn line cause variation in its thickness, producing an effect particularly desirable in calligraphy (fig. 8.13). In a similar way, the flat oval endings of the *D* nibs respond to the changing angles at which the pen is held, and so produce a wider range of ribbon-lines than *A* or *B* nibs. In general, the wider nibs show these variants more readily than the finer, higher-numbered points. Experiment with as many as possible; you needn't try all twenty-seven!

A great many pressure-sensitive, split-tip pointed nibs have been made, originally for writing by book-keepers, scribes, and stenographers. By varying pressure, you can create lines with subtly graduated thicks and thins—even the elusive Spencerian script or Copperplate hand—and produce elegant curvilinear decorative writing and calligraphic drawings (fig. 8.14). Such nibs may often be found at flea markets and antique shops (sometimes by the boxful) as well as at your local art supplier's. Unfortunately, they are rarely equipped with wells and require frequent dipping. Although a number of attachable ink reservoirs are available, they do not fit every nib easily.

8.13

Paul Shaw

Italic alphabet, minuscules: pen angle affecting line thickness

1986

Pen and ink

8½ × 11" (21.6 × 28 cm)

From Paul Shaw, *Letterforms, an Introductory Manual of Calligraphy, Lettering and Type* (New York: Paul Shaw/Letter Design, 1986)

A Word about Pen Holders

A penpoint holder should be selected with great care, as it governs the feel of the tool in your hand and therefore your comfort and pleasure in using the pen. Holders may be of wood or plastic, thick or slender, with parallel or tapering sides. They can be fitted with a cork or rubber gripping collar, indented to fit your fingers, or display other special features. Plastic tends to collect moisture and feel slippery after a time; cork is easily stained by ink and tends to dry and break off in pieces. A cylinder that is too thick or thin for your fingers will surely be uncomfortable. Look for the most comfortable holder that is the lightest in weight.

Non-Dip Pens

To avoid the necessity of even infrequent dipping, and to enjoy a consistent, unmodulated, narrow ribbon-line, try a number of commercially available roller-ball, razor-point, uni-ball, and other disposable pens, used particularly by artists in advertising and graphic design. The refillable Rotring was named by several artists on the Silent Panel. Any pen designed for writing may also be used for drawing; experiment with many.

Although calligraphers often avoid the fountain-pen style or cartridge-refillable pens (Osmiroid, Sheaffer, or Pelikan) that come with inter-changeable, varied width nibs, as they do not permit sufficiently crisp precision of detail for the professional eye, these may be an excellent choice for drawing, particularly with the finer nib sizes.

8.14
Anonymous
Spencerian exemplar
Undated
Pen and ink on paper
6 × 8" (15.2 × 20.3 cm)
Collection of the author

MARKERS

Felt-tipped markers an inch or more in width may be used for oversize drawings on large rolls of brown wrapping paper. Oil- and water-based markers, found in more delicate sizes as well, are among the tools that may be used either wetter or drier. Allowing the tip to become almost dry (without pressing to release more ink) permits the irregularly textured, soft-edged, scumbled effect known as dry-brush. Dissolving the marking ink with an appropriate solvent (water, transparent marker medium, turpentine, or a less toxic substitute) permits washes and more painterly effects. Even the controversial ballpoint line may be softened and modified by rubbing before dry with a Q-tip, stomp, or finger, or by using a solvent in various ways.

THE BAMBOO OR REED PEN

A bamboo or reed split-point pen may produce a very responsive, variable line as well as interesting dry-brush-like effects. These pens can be purchased or simply carved from the back end of your bamboo brush.

PRE-MIXED INKS

Generally, any pre-mixed India ink or drawing ink will be satisfactory for your work with dip pens or the brushes described later. Certain technical pens, such as the Rotring, recommend their own special ink. Although the differences may appear slight at first, more frequent use will make you aware of variables in viscosity, opacity, thickness, even the blackness of various brands of ink. Try Higgins, Pelikan, or FW brands in several varieties.

BRUSHES

Any brush can be used as a linear marking device. Surely, if you can dip a twig in liquid and drag it across a surface to produce a drawing, there is no brush, designed for any purpose, that cannot be used in this way. However, some brushes have been superbly designed for particular uses, and can facilitate the kinds of drawings you may wish to produce. For drawing, brushes may be divided broadly into two groups: those that can come to a point, and those that cannot. The latter remain broad, whether rounded, sharply chisel-edged, or softly diffused, at their filaments' periphery.

Watercolor brushes or Asian bamboo brushes (discussed below) are generally chosen for drawing. All of these may be used with diluted acrylic paint or drawing ink, moistened watercolor cakes or pre-mixed semi-paste watercolor paint. For our achromatic (colorless) or monochromatic (single-hued) studies, choose blacks, grays, or deep browns; a full range of colors is available.

Round brushes (those round in cross-section) often come to a point when wet and may hold a large quantity of paint or ink. Even longer are the fibers of slim *riggers* and *liners*; fine detailing brushes have shorter hairs. The straight-edged *flat*, or its shorter-haired version the *bright*, may also be used in linear or tonal drawing, particularly in the smaller sizes. But the curved-silhouette,

fully-rounded, softly edgeless *filbert* is best for blending, for eliminating one or both edges of a ribbon-line by melting it—actually dissolving it—into a wash with a sufficient amount of water or other solvent.

Since you will want to use any new brush for either water- or oil-soluble mediums, but not both, buy at least two.

THE BAMBOO BRUSH

In Asia, these versatile brushes are used for calligraphic writing as well as for traditional forms of painting and drawing (see fig. 2.13). They offer the greatest range of flexibility, particularly when used with the traditional stick ink (a caked mixture of plant soot and hide glue) scraped or rubbed onto a wet inkstone. The bamboo-handled, tapered-filament brush can be used to create a limitless range of linear and tonal effects. It is indeed the ultimate pressure-responsive artist's tool. Held almost perpendicular to the paper in the classic manner, with its single-haired tip barely touching the surface, this brush can leave the merest trace of a fine line. With gradually increased pressure, the line grows heavier and thicker until the broad belly of the brush leaves a wide swath of ink in its path. As the brush holds less and less ink the line becomes drier, until an uneven, rough-edged, dry-brush effect is achieved (see fig. 2.7).

The flexibility of the bamboo brush and the fluidity of Asian stick ink combine to make possible linear and tonal drawings of great power, subtlety, and beauty (fig. 8.15). The additional variable of tonal modulation, by the use of washes and various dilutions of the stick ink, adds another dimension to this most versatile of mediums in wet drawing.

Another subtlety of the bamboo brush is realized with the use of the deep-welled inkstone which holds enough water to facilitate a full range of tones of black and gray. The brush may be controlled to hold and release differing

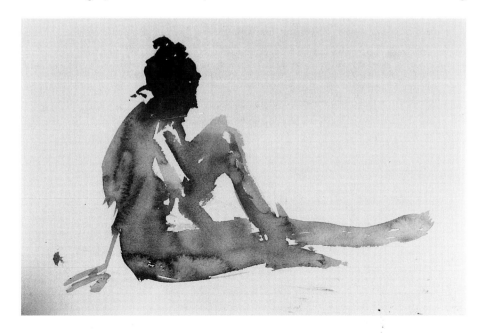

8.15
Anthony Martino
Seated figure
1998
Brush and ink on paper
12 × 18" (30.5 × 45.7 cm)
Collection of the artist

quantities of the various levels of diluted ink (see fig. 3.7). Any pre-mixed India or other drawing ink can be used with considerable success. There is even a pre-mixed stick ink, if you can find it.

Sets containing a simple rectangular inkstone, stick ink, and one or more brushes, presented in a wooden or padded silk-lined container, are generally available in art stores and Asian gift shops. Does the use of such esthetically pleasing materials have an effect upon the quality of work produced with them?

PAPER FOR USE WITH SUMI OR OTHER BAMBOO BRUSH WORK

Papers traditionally used with the bamboo brush and Chinese ink or Japanese Sumi ink are called rice papers, although the fibers of rice alone are not sufficient to create a durable paper. Instead, rice fibers are often supplemented with *kozo*, a mulberry fiber, or chemically reduced wood pulp, called sulphite, when they are used at all. In addition to being particularly receptive to Sumi and other inks, these papers have the advantage of being available in rolls as long as ten yards, well-suited to the traditional Asian scroll form and also to panoramic works such as those described on page 242.

Many of the traditional papers are Japanese and are used for woodblock printing as well as calligraphy and Sumi painting. Some of the most popular papers are: mulberry, *goyu, masa, okawara, sekishu, iyo* glazed, *kochi,* and *gampi.* These are the most well-known names; a visit to your art supply shop will enable you to see the surface, color, texture, and flexibility of individual sheets and feel their weight and other indescribable tactile qualities.

OTHER MATERIALS THAT MAY BE USED WET

Watercolor pencils used in the standard way may be blended with a wet brush to create a continuous tonal wash. By selective application of the wash effect, interesting transitions between pencil and watercolor can be suggested.

Try Cray-pas or crayon pastels and oil sticks, oil or acrylic paints, thinned by their respective solvents in linear or tonal ways on paper or canvas (figs. 8.16 and 8.17).

WORKING WET

In order to discover the range of differences and similarities between working with dry and wet materials, try these paired exercises, to be completed by simply changing the materials or the ways in which they are used.

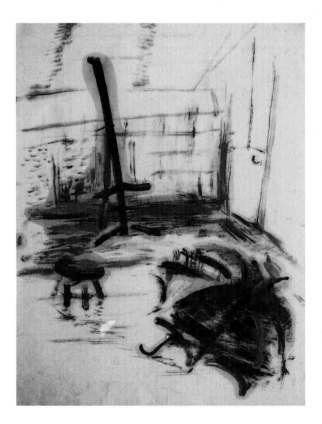

8.16
Vivian Tsao
The Studio
1974
Oil and linseed oil on paper
25 × 19" (63.5 × 48.3 cm)
Collection of the artist

Exercise:

Prepare a sampler, as a practice sheet: With a moist sponge, wet half a large sheet of absorbent or watercolor paper divided down the middle, then blot any excess moisture, leaving only a trace of dampness. Draw a series of horizontal bands, lines, or linear forms straight across the page, on both the dry and dampened sides, using as many different tools and materials as possible. Note any differences in receptivity of the paper, when wet or dry, to the various tools and mediums used. Where does the greatest amount of bleed (spreading of the colorant) occur? Where is the most crisp and detailed line? Using a wet filbert brush, if possible, attempt to melt away one edge of each line on the dampened surface. Where does this work best? Try additional experiments of your own devising.

- Set up a simple still life and, using a combination of wet and dry materials and techniques, complete a series of drawings of that same subject. Each work should be relatively small—no more than 8 × 10". Make a number of studies on a single sheet, drawing individual format rectangles first, with perhaps 2" between them.

8.17

Miriam Beerman

Swimming Turtle

1973

Oil wash on paper

35 × 45⅛" (88.9 × 114.6 cm)

Collection of the artist. Photo: Don Richards

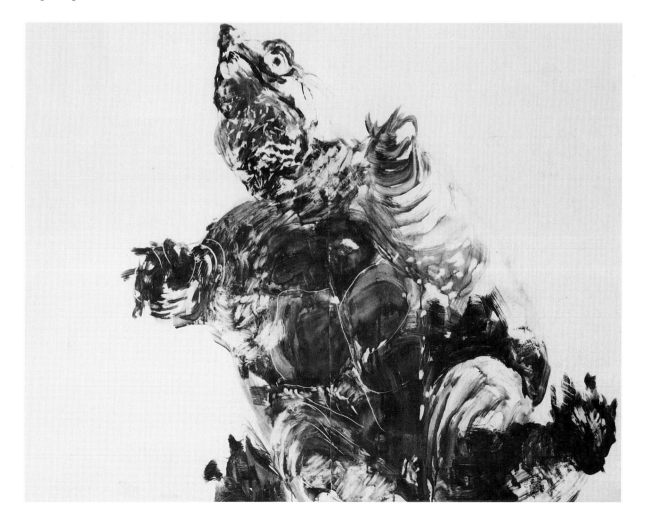

- Selecting one of your smaller studies, make a fully developed larger drawing on a single sheet of your favorite rice paper. Leave a margin of at least 2" on each side, with 3" at the bottom. Try for simplicity, spontaneity, a calligraphic feeling, even if you are using tonality and wash. Let a sense of linearity shine through your work. Use a blotter to stop tones from running where you do not wish them to extend, or to lighten areas before they dry and are set permanently.

SPECIAL RECOMMENDATIONS OF THE SILENT PANEL
(Note: See pp. 301–4 for details of the panelists' professional fields. Panelists 3, 4, and 10 do not use wet mediums with their beginning students.)

Panelist 1
- "I don't usually use wet media for beginners, but may include 'wash-ins' with ivory black oil paint and linseed oil."

Panelist 2
- "I draw with black oils on paper with mineral spirits, using an oval-shaped filbert brush, first isolating the paper with shellac (50% alcohol) or glue size."

Panelist 5
- "Work with bamboo brushes and any black drawing inks, first practicing on paper toweling before using more costly papers."

Panelist 6
- "My materials list: India ink; a good quality and size watercolor brush; 1–2"-wide flat soft wash brush; #6 Japanese bamboo brush; watercolor paper and illustration board; watercolor paints (optional); acrylic paints (optional); turpentine; house paintbrush, 2–3" (optional); oil pastels or oil sticks (to use with turps)."

Panelist 7
- "Materials list: for ink-and-wash drawings, the same heavy Bristol used for dry mediums; one bottle of black India ink; small covered jars for washes; watercolor brushes; water container; sponge; liquid frisket or white wax crayon; bamboo pen; pen holder with crow-quill points; soap and soap dish."

Panelist 8
- "I use a Rotring rapidograph pen with .25, .35, and .50 nibs, a crow-quill pen with FW or Higgins drawing ink; Pro-White-out (for corrections); a good Winsor and Newton sable brush, #100, series 7. For ink work, I use Paris Bleed-proof Paper for Pens, No. 234, 34lb, from the Borden and Riley Paper Co., Inc."

Panelist 9

- "I use vellum tracing paper with ink, which I scratch off to make corrections; BFK Rives paper for washes; and Strathmore 'use either side' 140lb paper, which can be erased down below the mistake, even with wet materials. I recommend buying good ink and half a dozen pen points. Experiment. Cut your own bamboo pens … keep your brushes clean! Use a good sable brush (Winsor and Newton series 7 is a good investment). Write to Pro Arte, Box 1043, Big Timber, Montana 59011 for their catalogue. Their brushes are springier than pure sable, but don't feel cheap as most second-class natural or synthetic brushes do."

Panelist 11

- "I use black ballpoint pens (BIC) because then I can't erase, Magic Markers with a clear marker as a blender, for technical illustrations, a Rapidograph pen with India ink (too acidic but OK) or drawing ink "for technical pens," a crow-quill pen, Speedball C-line pen nibs (chisel-edge), single-ply Strathmore plate paper (9 × 12" or 11 × 14" maximum for advertising work."

Panelist 12

- (A combination of wet and dry materials:) "For scratchboard work, I use Higgins India ink (not extra dense, as it's too thick). Sable brushes—rounds at point, in varied sizes; crow-quill pens, ruling pens (to sharpen straight edges)."

Panelist 13

- "I use India ink, small round sable brushes (pointed), fine crow-quill pens, Stylist or Pilot pens (very like crow quill but I don't have to dip); a variety of commercially available razor point pens, Arches and Rives smooth hot-press paper, for washes a heavier, still smooth paper. To flatten this heavy paper, I'll use a water-glue brown tape, and if working very wet, I'll soak the paper, then tape it to masonite and cut the drawing out when it's dry."

MAKING YOUR OWN LIST

As in the previous Unit, this selection of materials is recommended and used by professional artists and drawing instructors. The division is somewhat arbitrary, as many tools and materials may be used in both contexts, and indeed have overlapping uses. Beyond the range of works that have traditionally been considered drawings, you may wish to include experimentation in related areas that have been incorporated as a single all-inclusive category by some artists, instructors, galleries, museums, and critics: Works on Paper. Exhibitions of "Works on Paper" may include, in addition to established forms of drawing, watercolors, pastels, works in printmaking, collage, montage, xerography, rubbings, photographic collage and montage,

8.18
Antonio Frasconi
Travels through Tuscany, II
1976/1994
Color xerox after color
woodcuts
Page: 14 × 9" (35.5 × 22.9 cm),
accordion fold, opens to width
11'4" (3.45 m)
©Antonio Frasconi/DACS,
London/VAGA, New York 1999

and computer-generated art (fig. 8.18). Although outside the scope of this book, these are areas you may wish to pursue on your own initiative. Consult the Bibliography for assistance in investigating any of special interest to you.

Whether your drawing studies are conducted in a classroom, studio, or your own home, a few recommendations about the drawing environment, basic studio equipment, and ways to present or display your works for exhibition or portfolio will be helpful. The varied suggestions of the Panel should be of particular interest as you consider further study or drawing-related professional development. With the following Unit devoted to these considerations, we will bring our present study to a close.

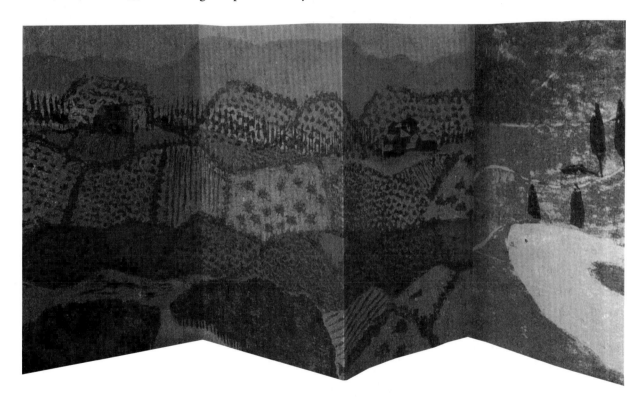

Unit C
Basic Studio Needs
and Presentation of Your Work

SURROUNDINGS

Two kinds of surroundings are of concern in relation to drawing. First, the physical situation in which you work—whether a classroom, art studio, or special place at home—may need to be modified to make the experience of drawing practical and comfortable. Second, the surroundings of your finished works—their presentation—need consideration.

This Unit includes specific suggestions to assist you in making the most appropriate choices in both areas. It also provides the opportunity for the Silent Panel to address you once more.

YOUR WORKING ENVIRONMENT

Although you may not always be able to select your general, larger environment (perhaps a generous, well-lighted studio space, perhaps merely a corner of your kitchen or bedroom), usually certain modifications can be made to improve the quality of your drawing experience. Some of the choices will be limited by unchangeable physical conditions—size of the space and number of individuals sharing it, natural window light available, artificial illumination provided—but much may be quite flexible, giving you more options and choices than are at first apparent (see figs. 4.27 and 8.16).

WHY YOU SHOULD STAND

The apparent discomfort of standing for a long period while working at an easel may have benefits that outweigh comfort. Standing provides you with the greatest amount of freedom of movement; your arms can sweep freely without restriction in any direction. You can quickly pivot on your heel to see to the left or right. A high stool can help so long as your head remains at the same height as when you are standing. In this way you merely pivot from your waist or hips, never collapsing into the sitting position but remaining poised, alert, responsive to your subject and its movement. Be sure your feet easily reach the floor. If not, choose a lower stool or move closer. Adjust the easel rest so that your pad or drawing board is chest high, or directly in front of your upper arm.

All the materials and tools you plan to use for working and for cleaning up should be placed on a small taboret or table (or another stool) within reach at the start. Consider a little box for rings, keys, and other personal items. Include a small container of the appropriate solvent (even if it is simply water), rags or newspaper, a sponge, and perhaps a tube of waterless hand cleaner to save time at the end of the work period and avoid a possibly lengthy wait at the sink.

TURNING THE TABLES

You may wish to use a small collapsible table easel instead of working flat on a table's surface. This can be adjusted to a vertical or tilted angle to prevent the previously noted foreshortening or distortion that can be caused either by a too-close vantage point to the subject or by a discrepancy between your angle of perception and your angle of drawing (see fig. 4.21). This occurs even when you leave your pad flat on the table while you study the subject from a normal angle of vision.

A movable table easel and a high stool can provide far greater flexibility than simply sitting in a standard height chair and working flat on a table-top. In the latter position your elbows may be well below the table, causing strain and discomfort as well as a distorted perspective. You could instead stand your pad or board resting against the back of a second chair, facing you, creating the effect of an easel.

LIGHTING YOUR WAY

Although you might be able to set up elaborate lighting of the subject to be drawn, you may not have considered that you also need as much light as possible on your drawing surface. If the light is insufficient or wrongly located, get an extension cord and place a clamp-on lamp on an adjoining chair or table.

THE SILENT PANEL SPEAKS

In addition to providing suggestions about wet and dry materials and their uses, some members of the panel wish to share additional ideas and suggestions. These are included here toward the conclusion of our study as notes to enrich the discussion of the studio environment and to add a certain style! As you will note, some panel members have taken this opportunity to share pet ideas about their philosophy and techniques of drawing.

Panelist 1
- "Use your small hand-held mirror frequently to study your work and the subject itself in reverse—to check symmetry, proportion, gesture, figure/ground shapes, and other compositional elements. Use a sheet of masonite, 1" all around larger than your paper, as a drawing board; use black fold-back clips or long pincer-like clips to hold paper to the board. For informal sketching, it's all right to work on your lap, but sit at a table to do any serious drawing. A tilt-table (drafting table) is best to avoid perspective distortion, but try to sit at an easel, which is most like "painting posture."
- An upright easel can be used for classical *sight-size* work. (This means "same size as seen," not "same size as in life.") In this technique, you place the easel alongside the model, to see both at once, and line up various points across both together. (For self portraits, use a mirror and measure.)
- My concern is with the basics of academic drawing—measurement,

accuracy, placement, light and shade, gesture, motion, simplification, the turning edge of light and shade. This point is critical, being able to see another edge inside the form, what might be called the third contour. For checking verticality and horizontality use a three-bump spirit level of metal, a plumb line to drop a perfect vertical for alignment, and a knitting needle or barbecue skewer for eye-measurement.

- With charcoal, build form in this way: On newsprint, with charcoal pencil (not vine or compressed charcoal) start with the envelope—a free-form geometric shape with angles—and blocking-in of the basic subdivisions. Then erase your construction lines and draw with charcoal. Follow this with broad laying-in of form and shadow, and cast shadow. For simple tones, place a middle tone over the lights. Show the turning edges between the shadow and the light, then add darker tones and highlights, which travel as you move around a form. For light use a Luxor lamp or Varilux, preferably with color-corrected daylight fluorescent tubes."

Panelist 2

- "I use the *sight-size* method to assure accuracy in drawing the figure. For life-size work, put a sheet of large paper alongside the model; walk back about 18 feet so you can view the figure from head to toe without moving your head. Make parallel measurements from your subject to your drawing surface, marking the top and bottom. Other sightings, made from a distance, can be marked up close, without looking. If your subject is smaller, pull back to the appropriate distance, and make parallel measurements. With still lifes, this can be done smaller. Guess first, and then check. Ideally, you should stand at an easel or, if sitting, use a lower easel, but work vertically.

- Lean work on a drawing board, not your sketchbook. Make a binder of chipboard by taping a wide binding between two boards, leaving at least 1/2" of space between them to hold a quantity of paper. Use masking tape or white archival tape to attach paper to your drawing board. Some like to use a sheet of Plexiglas with 1" gridlines to hold over the view. You can scratch the lines or make them with a ruling pen and ink. The sheet should be large enough to cover a full head size. You can get one prepared with an eyepiece over the grid, or a metal frame with magnets, to hold a sheet of gridded Plexiglas. They are also available with two metal strips to view a landscape or figures. The strips follow perspective lines in some magnetic way …. With charcoal, work dark to light, or slowly build up your drawing. Tint and wipe with the charcoal. Try to work only in natural light. Use matt workable fixative, but only with good ventilation. Rest your hand against a mahlstick to prevent smudging the surface of your work. It also makes a good plumb line. All my teaching is what I do myself."

Panelist 3

- I use music, greatly varied, all the time. I like to think of the courtroom

sketch artist at work, catching the form and movement all in two or three minutes ..." (see fig. 2.34).

Panelist 4

- "I just teach the basics. Include the exercises from Betty Edwards' book about drawing on the right side of the brain [figs. 8.19a and b]. Work from a drawing held upside down, for instance."

Panelist 5

- "A transparent sheet of plastic held in front of the subject can help you translate three-dimensional perception onto the flat picture plane of the page. You can actually visualize the subject as though it has already been drawn on the flat surface of the Plexiglas. An empty box frame can be used for this purpose.
- Use tracing paper over your drawing to make proposed changes or modifications before erasing the actual work. Place a small piece of tracing paper under the heel of your hand as you draw to prevent smudging but permit you to see the entire work. A large goose quill or turkey feather can sweep away erasure dust without smudging your work."

8.19a ABOVE and b RIGHT
Before, and After
From Betty Edwards, *Drawing on the Right Side of the Brain* (Los Angeles: Jeremy P. Tarcher, 1989)

Panelist 6

- "A large muffin tin makes a good mixing tray. Use acrylic gesso for resurfacing anything—masonite, old canvas board, canvas, heavy paper—to use as a large drawing surface."

Panelist 7

- "I like the precision and the ease of an electric pencil sharpener (portable, with batteries—the dip-style model). For very fine detail and control, in adding lights, I recommend an electric eraser. I use flash lights and clip-on lights, mirrors … anything to help put the light and shadow where I want them. A huge collection of ribbons, cylinders, and other still-life materials is essential" (see fig. 8.4).

Panelist 8

- "I generally draw the outline, the contour, first, then add the tonal values fully developed as a kind of scroll from top to bottom of the drawing, using much Krylon workable fixative. I use many pencils to build tone and texture, but particularly enjoy the old IBM pencil (if you can find one!). I work rather small, more or less life size with still-life objects. Of course, the medical illustrations are greatly enlarged for subjects actually seen through the microscope!" (see fig. 0.19).

Panelist 9

- "I use a tiny vacuum cleaner for pastels and charcoal work. Also, an electric pencil sharpener saves time. Since a kneaded eraser can leave the paper surface a bit roughened, I prefer a Peel-off Magic Rub by Faber for some work, but only for light pencil work, as it can make a mess."

Panelist 10

- "I am mostly interested in speed, gesture, spontaneity …. If it's to be a drawing—other than an illustration—the center, the focus, is what it's about. I recall my old teacher. When I'd say, 'I'm doing my best,' he'd say 'I want better than your best'" (see fig. 7.26).

Panelist 11

- "I like the black ballpoint BIC pen because you can't erase! I draw on a drafting table which can be raised, lowered, and tilted to the most comfortable position. Paper is attached with white artist's tape … or masking tape … no pins. And … a cup of coffee would help! Really, these days, to be up-to-date, I do a lot of work on the computer, so I advise learning computer basics—not instead of drawing, but in addition."

Panelist 13

- "I use a light-box to trace over sketches, even with heavy paper if working in ink.
- I'll use a xerox to *size* drawings larger or smaller and to help correct proportions, then trace on the light-box."

Keep in mind that the Silent Panelists are speaking from widely divergent viewpoints and that another group of artists who teach would have added further ideas, recommendations, and personal experiences to those of the author. The purpose of including these notes is not only to provide the specific enrichment of these dozen or so viewpoints, but also to show how valuable is the contribution of as many diverse ways of seeing and of working as you can experience. Every instructor, every artist you encounter, will add a unique style of presenting even seemingly identical ideas and procedures—the result of individual experience as well as personality. No one point of view, no one collection of points of view, can exhaust the subject, can show all that might be shown or tell all that might be told. The more you draw and study, the more you will find to study and draw, and the more there will be left to discover.

SHOWING YOUR WORK TO ADVANTAGE

Different methods of presentation are appropriate for differing purposes. From the simple act of displaying daily studio work to the group at large, for general discussion, to the formal presentation of a selected number of works—when applying for admission to a school, for an award, a juried exhibition, a professional assignment, or perhaps employment—you will want to show your work as directly, as simply, and as attractively as possible.

Predetermined rules for presentation are given in some circumstances to act as general guidelines, adaptable to the particular situation, while in other instances set procedures must be followed precisely at the risk of disqualification or rejection.

WINDOW MATTS

As a general rule, there are advantages to showing works of a single size together. Just as the pages of a book are usually all of a size, so a series of matts or backing boards of a standard size can confer a pleasing uniformity and harmony to your presentation. They are also easier to handle than a collection of varying sizes and appearances. If the works are of different sizes and shapes, use a standard size matt board that can accommodate your largest piece. A number of smaller works may be shown on boards of this larger dimension. If you wish to avoid the precise measuring and cutting required for the window matt (see below), simply affix each drawing with double-stick artist's tape to the matt board. In this way, the works are protected and no one will see the back of each drawing. The reverse of each board may be used to provide appropriate information if there is not sufficient space on the face.

Window matts with openings the size of individual drawings can make an attractive display. Allow a small overlap of the matt in front of the drawing so the physical edges of the paper are concealed. Generally, a border of 2–4" of matt board may be left at the top and along both sides of a work, with a broader margin at the bottom. Use a T-square, a transparent plastic right-angle guide, and very light pencil lines to establish the rectangle to be removed. Locate the four corner-points of the window, align your straight edge, and cut each side with a razor knife or matt knife. The trick to cutting a neat window matt is to use a clean, new sharp blade, with consistent even pressure on the tool from start to finish. Hold your knife perfectly vertically or at a slight angle, and press very strongly from the first placement of the blade on the face of the board, after which you can assume a slightly more pulled, lower angle and maintain it. Avoid many choppy, light strokes, which can rip and mar the edge of your cut line. Begin and end your cut slightly outside the mark, so the corners will separate freely (figs. 8.20a–d).

A beveled edge may be achieved by using a special matt-cutting tool with an angled guide. This may be done freehand by a highly skilled professional, and can be an impressive sight, but is not to be attempted by the novice.

Pre-cut matts from the art store cost more, and the pre-cut window will rarely be the precise size you need for a particular drawing, so you will be tempted to compromise. "This looks all right. The inch won't make a difference." But it may make all the difference.

For matting two or more drawings together, use tracing paper over each drawing to sketch a rough rectangular outline around the portion to be matted and establish the best window size—not too confining, not too open. Using a ruler and small T-square, accurately measure and cut these rectangles out of tracing paper and place them several ways on the full matt board to determine the best visual arrangement and spacing. Consider lines of direction, action, or movement in each drawing to be included. In a multiple-window matt you

8.20a–d

Author's snapshots of Anthony Martino's matting demonstration at L.I.U.:
(a) measuring the matt;
(b) cutting the matt;
(c) cutting the window;
(d) removing the window

(a)

(b)

(c)

(d)

may place the individual openings a little more freely than in the single-window matt—perhaps side-by-side, aligned vertically, or along a diagonal axis if you prefer a symmetrical arrangement (arrange them asymmetrically but balanced for weight by eye if you wish to create more visual tension and energy). Then, with T-square and triangle, draw the rectangles lightly on the face of your matt board and cut away the windows.

The traditional matt consists of two boards, a *face matt* with its neatly removed window and an often heavier *back board* on which the art work is taped. To make a classical matt, follow this procedure:

- Prepare two same-size matt boards; cut away the windows in the face matt.
- Place the two boards flat on a large table or cutting surface, top to top, with the inside of the window matt butted against the top edge of the back board's outside or face surface. Place a single length of wide white artist's tape or masking tape across both at their touching top edges, from side to side. Smooth the tape with a wooden spoon if you wish.
- Bring the faceboard over to close the double matt, and place the drawing beneath the window as neatly as possible on the top surface of the backing board.
- Lift the upper matt board carefully and attach a small piece of artist's tape, masking tape or, if you like, archival quality rice-paper museum tape (adhered with pH-neutral wheatpaste glue) to the very top corners of your drawing and the backing board itself.
- Close the matt to see if the drawing is centered correctly.
- Make any slight corrections before the tape is firmly pressed in place.
- With the matt closed, sign the drawing, in pencil, legibly, near its lower right-hand corner. A title may be lettered or written in the center and the date added, perhaps near the lower left-hand corner. If the drawing is very small or if you are placing several drawings in a single matt, you may prefer to use only your initials and to place date, name, and titles near the bottom, on the matt itself. Some artists cut a separate window for a name, title, and date panel. It is up to you.
- For protection of your work, tape a sheet of clear acetate beneath the top matt, over the drawing. Use a single sheet of acetate to cover all the works in a multiple-window matt.
- Be sure the tape corners cannot be seen when you close the upper matt.
- Check that you have left sufficient space around each drawing so that its physical edge cannot become engaged in the window opening of the upper matt. (This can happen in transit or during the hanging of an exhibition.)
- You may enclose the entire matted work in a single envelope of thin plastic to protect its surface. Place the matted folder face down on a larger sheet of thin plastic or acetate. Fold then tape each side to the back surface neatly, making hospital corners (folding a triangulated section from each corner precisely and making a sharp crease before taping it flat). Tape all four sides in this way using white artist's tape, masking tape, or clear plastic packing tape.

PRESENTATION BINDERS

For relatively small drawings you can purchase presentation binders, either loose-leaf or permanently bound, with clear mylar or acetate envelope pages. Inside each transparent envelope they usually contain black, gray, or white mounting paper. It is advisable to fix your work within these pages using a small piece of double-stick tape, as drawings otherwise tend to slip and move about. Particularly in clear folders without central backing sheets this can create an untidy effect, with the back of one drawing showing up against another unrelated work. You can crop each finished drawing precisely and tape it to the central black, gray, or white sheet.

Exercise:

Select a number of drawings to be matted individually or in small groupings. Prepare all materials in advance, then cut, tape, or otherwise create appropriate, attractive matts for these works. Display or use them as a portfolio for any creative purpose.

Remember, there is never an end; keep drawing (fig. 8.21)!

8.21

Maurits Cornelis Escher

Drawing Hands

January 1948

Lithograph

11⅛ × 13⅛" (28.2 × 33.2 cm)

Photo: ©1998 Cordon Art, Baarn,

Holland. All rights reserved

Glossary

For specific terms relating to anatomy, see Section 5,
and for specific terms relating to tools and materials, see Section 8.

Abstraction Reduction or simplification to essential geometric or organic (bio-morphic) elements. An original associative subject is implied.

Alternate shading Shading created by softening and melting one edge of an applied line to become part of the surrounding tone, alternating on and off the form; this technique is used to merge figure and ground areas.

Animation A sequential subdivision and transformation of a subject's form or movement, with each frame on a separate cel (film) or sheet (flip-book). When shown in a continuous flow, this sequence creates the illusion of movement.

Anthropomorphic Suggesting human qualities in inanimate or animate, but other than human, subjects.

Art therapy Methods of using art-related activities to identify or to resolve psychological and behavioral difficulties.

Background Objects or undetermined spaces surrounding the main subject of a work, often toward the top of a composition.

Back-lighting Placing the source of light behind the subject to create a diffused glow and haze at the outer portions of a form.

Balance A sensed equivalence of weight and form within a composition, often along a central axis.

Bio-morphic Based on forms found in nature, especially in the structure of plant and animal life.

Calligraphy Any of several methods of drawing, generally with a chisel-edged or pointed tool, to produce or resemble beautiful, consistent, freehand writing whose weight and thick-and-thin structure is determined by the angle at which the tool is held to the page, or the pressure with which it is applied.

Chiaroscuro (from the Italian *chiaro*, meaning clear, and *oscuro*, meaning obscure, dark, shadowed; pronounced "kyaro-skooro") A traditional technique in which white and black or light and dark materials (such as chalks) are applied to a middle-toned ground to give a rich sense of full three-dimensionality. Middle gray tones particularly gain from this technique as they melt into the ground tone without an edge. Also used to describe the all-over placement of light and dark tones in a representational work.

Collage A work glued or attached, usually to paper, incorporating complete or partial images and possibly several different materials.

Composition Arrangement of elements on the picture plane, often with an implied geometric understructure.

Conceptual drawing Drawing based on an idea or system.

Crop To reduce the area around the main subject in order to create the best relationships between all elements in a work.

Crosshatching A webbing of linear tonality, created by applying a second set of hatching lines across the surface of a subject more or less at right angles to the first, to suggest a sense of modeling, volume, and form.

Cubism An early twentieth-century idea used by artists in many ways to show the concepts of time and space as indivisible, the inseparability of an object and its environment, and the artificiality of showing a subject from one stopped position at one moment in time.

Cubist techniques (1) *Split plane*: An axis through the picture plane unifying portions of the subject and its (back) ground. (2) *Slipped plane*: Sections of a work moved along its split-plane axes in order to separate areas of figure-and-ground in time and in space. (3) *Tipped plane*: Parts of a subject and its surrounding space shown from differing viewpoints, along split- or slipped-plane axes. (4) *Cubing space*: Simplifying the subject and its surrounding spaces into subdivisions often resembling small faceted geometric forms. (5) *Fragmenting space*: Similar to cubing, but often in a freer, more open, ambiguous way.

Dimension The extension of a point, line, or surface plane in space.

A geometric line is *one-dimensional*; flat shapes, including applied lines, such as those on a sheet of paper or canvas, are *two-dimensional*; and a free-standing object or sculpture is called *three-dimensional*. (Fractal geometry has introduced the idea of intermediate dimensions.) Cubists and others challenged the separability of time and space, seeing the world as a four-dimensional space-time continuum.

Diptych A work consisting of two related or attached panels.

Economy of Means A way of stating the idea that focus, clarity, and strength result from simplification and a reduction of distracting excess.

Edge The widthless boundary between areas, shapes, or forms. (See also *Transitional edge*.)

Fibonacci Sequence A specific proportional relationship found in nature (also called the Golden Mean), often considered an ideal for form and design, created by adding the previous two numbers to determine the next (1, 1, 2, 3, 5, 8, 13 …). Using the Fibonacci Sequence, an equiangular or Nautilus spiral can be developed by drawing a spandrel curve in each increasingly enlarged square that can be constructed.

Figure In addition to the human model, any object or shape used as a subject in a drawing, as opposed to its surrounding space, or ground.

Figure-ground The inseparable interrelationship of two elements on either side of an edge; seeing the surrounding area or shape as an integral part of any subject, the equivalence of complementary elements on the picture plane. Also called *positive/negative* space (avoid this, as it denies equivalence); *filled/unfilled*; *determined/open*.

Foreground Elements in a drawing that seem to come forward toward the viewer, generally in the lower portion of a composition.

Foreshortening An exaggeration of perspective in which elements nearer to the viewer are shown much larger, and elements at a distance appear much reduced in size.

Form The three-dimensional quality or mass of a subject on the picture plane. Also used to refer to the general orchestration and composition of elements in a visual work.

Geometric Based on straight lines, angles, and curves that can be constructed with a straight edge and simple compass.

Gesture The pose, stance, or immediate disposition of a subject, often captured best on paper in a quick, unplanned, spontaneous linear response.

Golden Mean See *Fibonacci Sequence*.

Graphic art Generally, the field of design in which works are created for publication, broadcasting, or reproduction, to meet the requirements of a client.

Gray Any mixture of, or tone between, white and black is called an achromatic, or colorless, gray.

Gray scale A sequential, evenly stepped series of tones from white to black. May be seen as a continuous sweep or separated into areas at evenly spaced intervals.

Highlight The spot or shape of intense light setting off the roundness and tonality of a three-dimensional subject.

Horizon Generally, a horizontal edge at eye level, separating the ground or surface on which a subject is resting

from deeper space behind it. (See also *Perspective*.)

Intaglio (pronounced "in-tally-o") In printmaking, a process in which the line, removed from the plate by acid or gouging directly, is filled with ink and transferred to paper under pressure when run through a press (making an etching or engraving).

Intensity A measure of brilliance or strength of light illuminating a surface, tone, or color—may be interchangeable with richness, brightness, or luminosity.

Kinesiology The study of motion of the human figure, including leverage and muscle action at the various articulations or joints.

Less is More See *Economy of Means*.

Line Generally, in drawing, the continuous or broken markings left on paper or another receiving surface as material is deposited by a tool such as a pencil, pen, or brush pulled (or drawn) across it. There are various categories of line. (1) *Applied line*: Drawn line, used to show edges; it always has a degree of width, which can be varied or constant. (2) *Calligraphic line*: Reminiscent of Asian brush-writing, in which both edges of the direct, fluid, curvilinear ribbon put down by the drawing tool may describe very different paths as they move apart or closer together. (3) *Contour line*: A linear path along the visual edges, transitional peripheries, and other carefully observed outer and inner boundaries of form, often seen to disappear and emerge from behind other contours. (4) *Broken contour line*: Contour line which fades away, disappears, or moves behind other contours to reappear at a distance. (5) *Expressive line*: Pressure sensitive, responsive line, conveying or revealing the feelings of the artist toward the subject.

(6) *Geometric line*: As "the distance between two points," this line has only length—no width or thickness—and cannot be drawn with a pencil. It may be seen at the edge of shapes. (7) *Implied line*: A path continued by the eye where drawn contour and other line has disappeared, or where two points are clearly pulled toward one another by the eye alone. (8) *Incised line*: The linear markings left by a tool removing material from a surface such as scratchboard.

Lino cut See *Woodcut*, but substitute "linoleum" for "wood."

Lithograph A print made by inking a stone, acrylic, or other plate on which a lithostick (a special grease-pencil or crayon) or wash (tusche) has been used to create a drawing by combining grease-resisting and water-resisting materials.

Montage Generally photographic, a work combining portions of images often printed in layers on a single sheet of paper.

Non-associative Without reference to an associative subject or object.

Non-objective See *Non-associative*.

Oeuvre (French for "work," pronounced "oo-vra") The entire body of an artist's production.

Organic See *Bio-morphic*.

Outline The visual edge of an entire form, without regard to inner structure, subdivision, or contour.

Parallel Remaining the same distance apart, not converging or diverging.

Pattern A regular arrangement of visual elements in a design. When the individual elements are so small in relation to the overall surface that they become a field rather than an arrangement of clearly separate units, a pattern may be seen as a texture. This is a matter of scale. (See also *Texture*.)

Penumbra Secondary area of shadow; darkness remaining when more than one source of light illuminates a subject. Each source reduces the degree of original total darkness, creating overlapping, sequentially softer penumbras. The overlapping portion appears darker than each primary shadow; if the light sources are equal it will have half the light.

Perceptual drawing Drawing based on direct observation.

Perspective Any system used to represent depth or space on a flat surface by reducing the size and placement of elements to suggest they are further from the viewer. (1) *Isometric perspective*: Often seen in Asian art, a system that depicts depth by maintaining equidistant parallels. Objects appear to recede in space through size and placement without converging parallels or vanishing points. (2) *One-point perspective*: A frontal, head-on view with an implied or indicated central point at eye level, at which all receding parallels appear to converge and vanish; or a frontal view, with a constructed, single vanishing point off to the side. (3) *Two-point perspective*: A system for representing space on the flat picture-plane in which physically parallel elements of the same size appear progressively reduced along converging rays to the left and to the right; reaching a single point on an eye-level horizontal edge, they appear to vanish, one to the left and one to the right. (These vanishing points need not be shown; they are often implied at a great distance and would be far off the actual picture plane.) (4) *Three-point perspective*: A system for representing objects in space with exaggerated three-dimensionality, through the use of three perpendicular sets of converging parallels.

Picture plane The flat, two-dimensional surface on which a drawing is made. The phrase "respecting the picture plane" means emphasizing, through the shape and placement of elements, the flatness and planar dimension of a two-dimensional work.

Proportion The relative size of one part to the whole, or of one part to another. The Golden Mean is a specific proportional relationship.

Relief print See *Woodcut* and *Lino cut*.

Rhythm A pulse or regular sense of movement within a work relating the component elements in a harmonious orchestration.

Scale Relative size of parts to the whole. (See also *Pattern* and *Proportion*.)

Scratchboard A work produced by scratching away ink on a clay-coated board to reveal clear white lines or other markings.

Shades Sequential darkening of a tone by the addition of black or a darker medium. (See also *Tints*.)

Shading Application of tone at the edge or across the surfaces of a form and its surrounding environment to suggest light striking or falling, revealing its form and the remaining shadow; form and space described by the use of light and dark tone. May be shown as a continuous wash of tone or in linear clusters.

Shadow Absence or reduction of light. (See also *Penumbra*.)

Shape A contained, edged area on the two-dimensional surface, or an area with the suggestion of containment. A shape always implies an area on the other side of its containing periphery.

Thus you cannot draw just one shape, alone.

Silhouette See *Outline*.

Spandrel The curve placed within a right angle; a square can contain four, thus creating a circle.

Style The personal way of mark-making or drawing that reveals the unique quality of an individual artist. This appears eventually, and much like an individual's handwriting it should not and cannot be forced.

Surface The actual texture or degree of smoothness (tooth) of paper used for drawing, such as matt, glossy, or pebble.

Surrealism An early twentieth-century movement in art and literature which presented realistically depicted elements in unreal environments, juxtapositions, and interactions to achieve the illusion of heightened reality.

Symbolism The use of objects or images to represent general qualities or meanings other than the literal reality presented, as in written language and signs.

Symmetry The regular placement of identical or mirror-image repetitions of units of design around a central point (as a flower) or a central axis (as an inkblot).

Texture Actual or apparent surface feel. The look of physical texture may be achieved by rubbing a crayon over a paper placed on a textured surface (frottage), by using a rough, coarse, or granular material or working surface, or by skillful drawing techniques. (See also *Pattern*.)

Tints The sequential lightening of tone to reach higher light values (lighter tones) by the addition of white or a clear medium such as water. (See also *Shades*.)

Tonal relativity The changing visual identity of tones in juxtaposition, sometimes called mutual contrast.

Tone The relative light or dark quality of an area. Visual tone is determined by a tone's relationship to that of adjacent areas.

Transitional edge The apparent edge of form, seen by the eye, but not in fact existing in a physical sense (such as verticals on either side of a glass). The edge of perception, not of physical form, is seen. Also called visual edge, perceived edge, or apparent edge; terms such as transitional line, visual line, perceived line, and apparent line may be used to indicate lines drawn to show these edges. (See also *Edge*.)

Triptych A work consisting of three related or attached panels.

Turgor Fullness of form; often conveyed by confident, apparently inflated contour line.

Value Often used interchangeably with tone, value can suggest a specific level of lightness; the higher the visual value, the lighter the tone.

Vanishing point See *Perspective*.

Volume See *Form*, in its three-dimensional sense.

Woodcut A print created by rolling ink over the surface of a block of wood after areas to remain uninked have been cut away. Paper is then pressed to the surface to create an impression.

Bibliography

*Numbers in **bold** appearing at the end of each entry refer to the following categories:*

1 Artists, Periods, Styles
2 Methods and Materials
3 Anatomy, Kinesiology
4 General Drawing Texts
5 2-D Design and Concepts, Geometry
6 Philosophy, Language and Meanings
7 Perception, Color, Seeing
8 Illustrated and Children's Books
9 Calligraphy, Lettering

This listing includes books and other writings on many of the topics and artists referred to in the text. Some may be out of print; keep searching in old bookshops. Visit local public and school libraries for additional sources relating to specific Old Masters (da Vinci, Rembrandt, and Ingres, for example), as well as contemporary and emerging artists and concerns. Use the *Reader's Guide to Periodic Literature* for current subjects in art-related publications such as *Art News, Art Forum, Art in America, The New York Times*, and *Drawing*, the International Review published by The Drawing Society.

Ades, Dawn. *Dalí*. London: Thames & Hudson, 1982. **1**

Albers, Josef. *Despite Straight Lines.* New Haven, Conn.: Yale University Press, 1961. **4, 7**

——. *Interaction of Color*. New Haven, Conn.: Yale University Press, 1963. Paperback with unabridged text and selected plates, 1975. **7**

American Abstract Drawing, 1930–1987. Little Rock, Ark.: The Arkansas Arts Center, 1987. **1**

American Drawings 1963–1973. New York: Whitney Museum of American Art, 1973. **1**

Anderson, Donald M. *Elements of Design*. New York: CBS Publishing, 1961. **5**

Anderson, Walter. *Birds*. Jackson, Miss.: University Press of Mississippi, 1990. **1**

A Quintessence of Drawing, Masterworks from the Albertina. Milan and New York: Electa and The Solomon R. Guggenheim Museum, 1997. **1**

Arnheim, Rudolf. *Art and Visual Perception*. Berkeley, Calif.: University of California Press, 1954. **7**

Ashbery, John. *Ellsworth Kelly, Plant Drawings*. New York: Matthew Marks Gallery, 1992. **1**

Axson, Richard H. *The Prints of Ellsworth Kelly, A Catalogue Raisonné*. New York: Hudson Hills Press, 1987. **1**

Baker's Historical Calligraphic Alphabets. New York: Dover Publications, 1980. **9**

Barcsay, Jenö. *Anatomy for the Artist*. London: Octopus Books, 1973. **3**

Barnett, Lincoln. *The Universe and Dr. Einstein*. New York: Mentor Books/The American Library of World Literature, 1954. **5**

Baro, Gene. *Claes Oldenburg, Prints and Drawings*. London: Chelsea House, 1969. **1**

Baskin, Sculpture, Drawings and Prints. New York: George Braziller, 1970. **1**

Bataille, Georges. *Lascaux or the Birth of Art*. New York: Skira, 1955. **1**

Beerman, Miriam. *The Enduring Beast*. New York: Doubleday, 1972. **8**

Behrens, Roy R. *Design in the Visual Arts*. Englewood Cliffs, N.J.: Prentice Hall, 1984. **5**

——. *Art and Camouflage: Concealment and Deception in Nature, Art and War*. Cedar Falls, Iowa: North American Review, University of Northern Iowa, 1981. **6, 7**

Benson, John Howard. *The First Writing Book, Arrighi's Operina*. London and New Haven, Conn.: Oxford University Press and Yale University Press, 1955. **9**

Birren, Faber. *Color Perception in Art*. West Chester, Pa.: Schiffer, 1986. **7**

The Books of Antonio Frasconi. New York: The Grolier Club, 1996. **1, 8**

Bossom, Naomi. *A Scale Full of Fish, and Other Turnabouts*. New York: Greenwillow Books, 1979. **1, 2, 8**

Bridgman, George B. *Bridgman's*

Complete Guide to Drawing from Life. New York: Weathervane Books, n.d. **3**

———. *Constructive Anatomy.* New York: Dover Publications, 1973 (originally 1920). **3**

Bulla, Clyde. *A Place for Angels.* Illustrated by Julia Noonan. Englewood Cliffs, N.J.: Bridgewater, 1995. **8**

Castelman, Riva. *Prints of the Twentieth Century: A History.* New York: The Museum of Modern Art, 1976. **2**

Chaet, Bernard. *An Artist's Notebook: Techniques and Materials.* New York: Holt, Rinehart & Winston, 1979. **2**

———. *The Art of Drawing.* New York: Holt, Rinehart & Winston, 1983. **4**

Chappeuis, Adrien. *The Drawings of Paul Cézanne.* Greenwich, Conn.: New York Graphic Society, 1973. **1**

Chernow, Burt. *The Drawings of Milton Avery.* New York: Taplinger, 1984. **1**

Clark, Kenneth. *The Drawings by Sandro Botticelli for Dante's Divine Comedy.* New York: Harper & Row, 1976. **1, 8**

Collier, Graham. *Form, Space and Vision—An Introduction to Drawing and Design.* Englewood Cliffs, N.J.: Prentice Hall, 1985. **4, 5**

Comini, Alessandra. *Egon Schiele.* New York: George Braziller, 1976. **1**

Cowart, Jack, Jack D. Flam, Dominique Fourcade, and John Hallmark Neff. *Henri Matisse: Paper Cut-Outs.* New York: Harry N. Abrams, 1977. **1, 2**

Daix, Pierre. *Cubists and Cubism.* New York: Rizzoli, 1982. **1**

Dantzic, Cynthia. *Design Dimensions, An Introduction to the Visual Surface.* Englewood Cliffs, N.J.: Prentice

Hall, 1990. **5**

———. *Sounds of Silents.* Englewood Cliffs, N.J.: Prentice Hall, 1976. **8, 9**

Davidson, Gail S. *Drawing the Fine Line: Discovering European Drawings in Long Island Private Collections.* Brookville, N.Y.: Hillwood Art Gallery, Long Island University, C. W. Post, 1986. **4**

DeLaCroix, Horst, and Richard G. Tansey, eds. *Gardner's Art through the Ages.* 10th ed. New York: Harcourt Brace & Company, 1995. **5**

Dewey, John. *Art as Experience.* New York: Capricorn Books, G. P. Putnam's Sons, 1958. **6**

Doczi, Gyorgy. *The Power of Limits— Proportional Harmonies in Nature, Art and Architecture.* Boston: Shambhala Publications, 1981. **5**

Doerner, Max. *The Materials of the Artist and Their Use in Painting.* Trans. Eugen Neuhaus. New York: Harcourt Brace Jovanovich, 1949. **3**

Dorothea Rockburne, New Paintings: Pascal and Other Concerns. New York: André Emmerich Gallery, 1988. **1, 5**

The Drawings of Gauguin. Los Angeles: Borden, 1965. **1**

Drawings: Recent Acquisitions. New York: The Museum of Modern Art, 1967. **1**

Driskell, David C. *Two Centuries of Black American Art.* New York: Alfred A. Knopf, 1976. **1**

Dürer, Albrecht. *Of the Just Shaping of Letters.* New York: Dover Publications, 1965 (originally 1525). **9**

Edwards, Betty. *Drawing on the Right*

Side of the Brain. Los Angeles: Jeremy P. Tarcher, 1989. **4**

Ehrensweig, Anton. *The Hidden Order of Art.* Berkeley, Calif.: University of California Press, 1967. **4, 5**

Eisler, Colin. *The Seeing Hand, A Treasury of Great Master Drawings.* New York: Harper & Row, 1975. **1**

Elderfield, John. *Kurt Schwitters.* London: Thames & Hudson, 1985. **1**

———. *The Modern Drawing.* New York: The Museum of Modern Art, 1983. **1**

Escher, M. C. *Escher on Escher, Exploring the Infinite.* New York: Harry N. Abrams, 1989. **1, 5**

Fairbank, Alfred. *A Book of Scripts.* London: Faber & Faber, 1977. **9**

Fast, Julius. *Body Language.* New York: M. Evans and Company, 1970. **3, 6**

Fisher, Leonard Everett. *The Homemakers.* Colonial American Craftsmen Series. Philadelphia, Pa.: Franklin Watts, 1973. **2, 8**

Foster, Walter T. *Anatomy for Students and Teachers.* Tustin, Calif.: Walter Foster Art Books, 1997. **3**

Franke, Herbert W. *Computer Graphics, Computer Art.* London: Phaidon Press, 1971. **2**

Frasconi, Antonio. *Against the Grain.* New York: Macmillan, 1974. **2**

———. *See and Say, A Picture Book in Four Languages.* New York: Harcourt, Brace & Company, 1955. **2, 8**

Gablik, Suzi. *Magritte.* New York: Thames & Hudson, 1988. **1**

Gardner, Martin. *The Annotated Alice (Alice's Adventures in Wonderland*

and Through the Looking Glass).
New York: Clarkson N. Potter,
1960. **4, 8**

Garroued, Ann, ed. *Henry Moore
Drawings.* New York: n.p., 1988. **1**

Gauguin, Paul. *Noa, Noa.* Paris: Jean
Loize, 1966. **1, 2**

Geometric Abstraction in America. New
York: Whitney Museum of
American Art, 1962. **1, 5**

*George Grosz, Love Above All, and Other
Drawings: 120 Works by George
Grosz.* New York: Dover
Publications, 1971. **1**

Getlein, Frank. *Mary Cassatt, Paintings
and Prints.* New York: Abbeville
Press, 1980. **1**

Ghiselin, Brewster, ed. *The Creative
Process, A Symposium.* New York:
Mentor Books/The New American
Library of World Literature,
1952. **6**

Ghyka, Matila. *The Geometry of Art
and Life.* New York: Dover
Publications, 1977. **5**

Giacometti, Alberto. *Giacometti, A
Sketchbook of Interpretive Drawings.*
New York: Harry N. Abrams,
1967. **1, 2**

Goldstein, Nathan. *The Art of
Responsive Drawing.* Englewood
Cliffs, N.J.: Prentice Hall,
1973–92. **4**

Goldwater, Robert, and Marco Treves,
eds. *Artists on Art from the XIV to
the XX Century.* New York:
Pantheon Books, a Division of
Random House, 1972. **6**

Gombrich, Ernst H. *Art and Illusion.*
Princeton, N.J.: Princeton
University Press, 1969. **7**

Gordon, Robert, and Andrew Forge.
Monet. New York: Harry N.
Abrams, 1983. **1**

Grohmann, Will. *Paul Klee.* New York:
Harry N. Abrams, 1945. **1**

Guare, John. *Chuck Close: Life and
Work 1988–1995.* London:
Thames & Hudson, 1995. **1**

Guerin, Marcel. *Gauguin's Graphic
Works.* San Francisco: Alan Wofsy
Fine Arts, 1980. **1**

Gussow, Sue Ferguson. *Draw Poker.*
New York: The Irwin S. Chanin
School of Architecture/The Cooper
Union of the Advancement of
Science & Art, 1997. **1, 8**

Hajek, Lubor. *Japanese Graphic Art.*
London: Octopus Books, 1976. **1**

Hale, Robert Beverly. *Master Class in
Figure Drawing: The Art Students
League Lectures.* Compiled and ed.
Terence Coyle. New York: Watson-
Guptill Publications, 1991. **3**

Haley, Gail E. *Go Away, Stay Away.*
New York: Charles Scribner's Sons,
1977. **2, 8**

Hambidge, Jay. *The Elements of
Dynamic Symmetry.* New York:
Dover Publications, 1967. **5**

Hammacher, A. M. *Mondrian, De Stijl
and Their Impact.* New York:
Marlborough, 1964. **1**

Harris, Mary Emma. *The Arts at Black
Mountain College.* Cambridge,
Mass.: The MIT Press, 1987. **1, 6**

Haverkamp-Bergemann, Egbert.
*Creative Copies, Interpretative
Drawings from Michelangelo to
Picasso.* New York: Philip Wilson
Publishers/The Drawing Center,
1988. **2**

Hayakawa, S. I. *Language in Thought
and Action.* New York: Harcourt
Brace Jovanovich, 1972. **6**

Hayakawa, S. I., ed. *Language,
Meaning and Maturity.* New York:
Harper & Brothers, 1954. **6**

Hinz, Renate, ed. *Käthe Kollwitz:
Graphics, Posters, Drawings.* New
York: Pantheon, 1987. **1**

Hockney, David. *A Retrospective.* Los
Angeles: Los Angeles County
Museum of Art, 1988. **1**

Hofstadter, Douglas R. *Gödel, Escher,
Bach: An Eternal Golden Braid.*
New York: Vintage Books/Random
House, 1980. **5, 6**

Holt, Michael. *Mathematics in Art.*
New York: Van Nostrand Reinhold,
1971. **5**

Huntley, H. E. *The Divine
Proportion—A Study in
Mathematical Beauty.* New York:
Dover Publications, 1970. **5**

The I.S.C.A. Quarterly. New York: The
International Society of Copier
Artists. **2**

Itten, Johannes. *The Art of Color.* New
York: Van Nostrand Reinhold,
1974. **7**

Ivins, William M., Jr. *Art and
Geometry—A Study in Space
Intuitions.* New York: Dover
Publications, 1964. **5**

James, Jane H. *Perspective Drawing, A
Directed Study.* Englewood Cliffs,
N.J.: Prentice Hall, 1981. **5**

Janson, H. W. *History of Art.* Rev. 5th
ed. Englewood Cliffs, N.J., and
New York: Prentice Hall and Harry
N. Abrams, 1998. **1**

Jonas, Ann. *Round Trip.* New York:
Greenwillow Books, 1983. **7, 8**

Jopling, Carol F., ed. *Art and Aesthetics
in Primitive Societies.* New York: E.
P. Dutton, 1971. **1, 6**

Kandinsky, Wassily. *Point and Line to
Plane.* New York: Dover
Publications, 1979. **4, 6**

Kaupelis, Robert. *Learning to Draw.*

New York: Watson-Guptill Publications, 1972. **4**

Kepes, Gyorgy, ed. *Language of Vision.* Chicago: Paul Theobald & Co., 1964. **5, 6**

———. *The Module, Proportion, Symmetry and Rhythm.* New York: George Braziller, 1966. **5, 6**

———. *Sign, Image, Symbol.* New York: George Braziller, 1966. **6, 7**

Klee, Paul. *Pedagogical Sketchbook.* London: Faber & Faber, 1953. **4, 6**

Knobler, Nathan. *The Visual Dialogue.* New York: Holt, Rinehart & Winston, 1980. **5**

Konheim-Kramer, Linda. *Milton Avery in Black and White.* New York: The Brooklyn Museum, 1990. **1**

Krantz, Les, ed. *American Artists.* Chicago: American References, 1989. **1**

Lanchner, Carolyn, ed. *Paul Klee.* New York: The Museum of Modern Art, 1987. **1**

Langer, Susanne K., ed. *Philosophy in a New Key.* Baltimore, Md.: Johns Hopkins University Press, 1958. **6**

Lawlor, Robert. *Sacred Geometry, Philosophy and Practice.* New York: Crossroad Publishing Co., 1982. **5, 6**

Legg, Alicia, ed. *Sol LeWitt.* New York: The Museum of Modern Art, 1978. **1**

Lewis, John, and Peter Rigby. *The Chinese Word for Horse and Other Stories.* New York: Schocken Books, 1980. **8, 9**

LeWitt, Sol. *Four Basic Kinds of Straight Lines.* London: Studio International, 1969. **1, 5**

Lipman, Jean. *Provocative Parallels.* New York: E. P. Dutton, 1975. **2, 6**

Lippard, Lucy. *Pop Art.* New York: Oxford University Press, 1973. **1**

Livingston, Jane. *The Art of Richard Diebenkorn.* New York: Whitney Museum of American Art, 1997. **1**

Lord, E. A., and C. B. Wilson. *The Mathematical Description of Shape and Form.* New York: Halsted/John Wiley & Sons, 1984. **5**

Lowry, Bates. *The Visual Experience, An Introduction to Art.* New York: Harry N. Abrams, 1967. **5**

Lucie-Smith, Edward. *Late Modern, the Visual Arts Since 1945.* New York: Frederick A. Praeger, 1971. **1, 6**

Lunde, Karl. *Anuszkiewicz.* New York: Harry N. Abrams, 1977. **1**

MacGillavry, Caroline H. *Fantasy and Symmetry, The Periodic Drawings of M. C. Escher.* New York: Harry N. Abrams, 1976. **1, 6**

Mandelbrot, Benoit. *The Fractal Geometry of Nature.* New York: W. H. Freeman & Co., 1982. **5, 7**

Maresca, Frank, and Roger Ricco. *Bill Traylor, His Art, His Life.* New York: Alfred A. Knopf, 1991. **1**

Marsh, Reginald. *Anatomy for Artists.* New York: American Artists Group, 1945. **3**

Mathews, Nancy Mowll. *Mary Cassatt.* New York: Harry N. Abrams, 1987. **1**

Matisse, Henri. *Jazz.* New York: George Braziller, 1983 (originally Paris: Editions Verve, 1947). **1, 2**

Matisse as a Draughtsman. Greenwich, Conn.: New York Graphic Society/Baltimore Museum of Art, 1971. **1**

Matthaei, Rupprecht. *Goethe's Color Theory.* Trans. Herb Aach.: New York: Van Nostrand Reinhold, 1970 (originally 1790). **7**

Mayer, Ralph W. *The Artist's Handbook of Materials and Techniques.* Rev. ed. New York: Viking Press, 1970. **2**

McKillip, Patricia. *The Throme of the Erril of Sherill.* Illustrated by Julia Noonan. New York: Atheneum, 1973. **8**

Mendelowitz, Daniel M., and Duane A. Wakeham. *A Guide to Drawing.* 5th ed. New York: Harcourt, Brace, Jovanovich, 1993. **4**

Miller, Joni K., and Lowry Thompson. *The Rubber Stamp Album.* New York: Workman Publishing, 1978. **2**

Muybridge, Eadweard. *Human and Animal Locomotion.* New York: Dover Publications, 1979 (originally 1887). **1, 3**

Nicolaides, Kimon. *The Natural Way to Draw.* Boston: Houghton Mifflin, 1941. **4**

Oppler, Ellen C., ed. *Picasso's "Guernica."* New York and London: W. W. Norton, 1988. **1**

Peck, Stephen Rogers. *Atlas of Human Anatomy for the Artist.* New York: Oxford University Press, 13th printing 1971. **3**

Pedoe, Dan. *Geometry and the Visual Arts.* New York: Dover Publications, 1983. **5**

Pellegrini, Aldo. *New Tendencies in Art.* New York: Crown Publishers, 1966. **1, 6**

Peterdi, Gabor. *Printmaking.* New York: Macmillan, 1959. **2**

Philip Pearlstein—Watercolors and Drawings. New York: Alan Frumkin Gallery, n.d. **1**

Picasso: His Recent Drawings 1966–1968. New York: Harry N. Abrams, 1969. **1**

Pilon, A. Barbara. *Concrete is Not Always Hard.* Middletown, Conn.: Xerox Educational Publications, 1972. **9**

Pintauro, Joseph, and Corita Kent. *To Believe in Man.* New York: Harper & Row, 1970. **9**

Quong, Rose. *Chinese Written Characters, Their Wit and Wisdom.* New York: Cobble Hill Press, 1968. **9**

Rewald, John. *Seurat.* New York: Harry N. Abrams, 1990. **1**

Reynolds, Jack, and Andrea Miller-Keller. *Sol LeWitt: Twenty-Five Years of Wall Drawings, 1968–1993.* Seattle, Wash.: University of Washington Press, 1995. **1**

Richard Anuszkiewicz, Constructions and Paintings: 1986–1991. New York: ACA Galleries, 1991. **1, 5**

Richard Diebenkorn, Paintings and Drawings, 1943–1980. Buffalo, N.Y.: Rizzoli, for Albright-Knox Art Gallery, 1980. **1**

Rock, Irwin. *Perception.* New York: Scientific American Books, 1995. **7**

Romano, Clare, and John Ross. *The Complete Printmaker.* New York: Free Press, 1972. **2**

Rose, Barbara. *Drawing Now.* New York: The Museum of Modern Art, 1976. **1**

Rose, Bernice. *Jackson Pollock: Works on Paper.* New York: The Museum of Modern Art, 1969. **1**

——. *Picasso and Drawing.* New York: Pace Wildenstein, n.d. **1**

Rosenthal, Mark. *Juan Gris.* New York: Abbeville Press, 1983. **1**

Roudebush, Jay. *Mary Cassatt.* New York: Crown Publishers, 1979. **1**

Rowell, Margit. *The Captured Imagination: Drawings by Joan Miró from the Fundacio Joan Miró, Barcelona.* New York: American Federation of the Arts, 1987. **1**

——. *The Planar Dimension.* New York: The Solomon R. Guggenheim Foundation, 1979. **1, 6**

Rubin, William. *Dada, Surrealism, and Their Heritage.* New York: The Museum of Modern Art, 1968. **1**

Rubin, William, ed. *"Primitivism" in 20th Century Art.* New York: The Museum of Modern Art, 1984. **1**

Rubin, William, and Carolyn Lanchner. *André Masson.* New York: The Museum of Modern Art, 1976. **1**

Ruskin, John. *The Elements of Drawing.* New York: Dover Publications, 1971. **6**

Russell, Frank D. *Picasso's Guernica.* Montclair, N.J.: Allanheld, Osmun & Co., 1980. **1**

Saff, Donald, and Deli Sacilotto. *Printmaking, History and Process.* New York: Holt, Rinehart & Winston, 1978. **2**

Sanders, Rhea. *The Fire Gardens of Maylandia.* Charleston, S.C.: Tradd St. Press, 1978. **8**

Saunders, J. B. de C. M., and Charles D. O'Malley. *Vesalius: The Illustrations from His Works.* Cleveland, Ohio: The World Publishing Company, 1950. **3**

Schmalenbach, Werner. *Kurt Schwitters.* New York: Harry N. Abrams, 1967. **1**

Schwartz, Paul Waldo. *Cubism.* New York: Praeger/Holt, Rinehart & Winston, 1971. **1**

Scott, Robert Gillam. *Design Fundamentals.* Huntington, N.Y.: Robert E. Krieger Publishing Company, 1980. **5**

Seitz, William C. *The Responsive Eye.* New York: The Museum of Modern Art, 1965. **1, 7**

Seuphor, Michel. *Piet Mondrian, Life and Work.* New York: Harry N. Abrams, 1974. **1**

Shahn, Ben. *The Shape of Content.* New York: Alfred A. Knopf/Random House, 1957. **6**

Shapiro, David. *Jasper Johns: Drawings, 1954–1984.* New York: Harry N. Abrams, 1984. **1**

Shaw, Paul. *Letterforms, an Introductory Manual of Calligraphy, Lettering and Type.* New York: Paul Shaw/Letter Design, 1986. **9**

Shedletsky, Stuart, ed. *Still Working/Underknown Artists of Age in America.* New York: Parsons School of Design, 1995. **1**

Sheppard, Joseph. *Anatomy: A Complete Guide for Artists.* New York: Dover Publications, 1992. **3**

——. *Drawing the Living Figure.* New York: Dover Publications, 1991. **3**

Snelson, Kenneth. *The Nature of Structure.* New York: The New York Academy of Sciences, 1989. **5, 6**

Soby, James Thrall. *Juan Gris.* New York: The Museum of Modern Art, 1958. **1**

Spies, Warner. *Max Ernst—Frottages.* London: Thames & Hudson, 1986. **1, 2**

Strand, Mark, ed. *Art of the Real, Nine*

American Figurative Painters. New York: Clarkson N. Potter, 1983. **1**

Swartz, Robert J., ed. *Perceiving, Sensing and Knowing.* Garden City, N.Y.: Anchor Books, Doubleday, 1965. **7**

Taylor, Charles H., and Patricia Finley. *Images of the Journey in Dante's Divine Comedy.* New Haven, Conn.: Yale University Press, 1997. **1, 8**

Thompson, D'Arcy. *On Growth and Form.* Rev. ed. Cambridge, UK: Cambridge University Press, 1977. **5, 6**

Troy, Nancy J. *Mondrian and Neoplasticism in America.* New Haven, Conn.: Yale University Art Gallery, 1979. **1, 6**

Tuchman, Maurice, and Stephanie Barron. *David Hockney: A Retrospective.* New York: The

Museum of Modern Art, 1988. **1**

VanDerMarck, Jan, and Charlotta Kotik. *François Morellet: Systems.* Buffalo, N.Y.: Albright-Knox Art Gallery, 1985. **1, 6**

Vitale, Lamberto. *Giorgio Morandi.* 2 vols. Florence, Italy: Uffizi, 1983. **1**

Waldman, Diane. *Roy Lichtenstein.* New York: Rizzoli/The Solomon R. Guggenheim Museum, 1993. **1**

Wang, Chi-Yuan. *Essentials of Chinese Calligraphy.* New York: Grosset & Dunlap, 1974. **9**

Watrous, James. *The Craft of Old Master Drawings.* Madison, Wis.: University of Wisconsin Press, 1957. **1, 2**

Weber, Nicholas Fox. *The Drawings of Josef Albers.* New Haven, Conn.: Yale University Press, 1984. **1**

Weyl, Hermann. *Symmetry.* Princeton, N.J.: Princeton University Press, 1982. **5**

White, John. *The Birth and Rebirth of Pictorial Space.* London: Faber & Faber, 1957. **5**

Whitfield, Sarah. *Magritte.* London: The South Bank Centre, 1992. **1**

Wiese, Kurt. *You Can Write Chinese.* New York: Viking Press, 1945. **9**

William Bailey, Paintings and Drawings. Dayton, Ohio: University Art Galleries of Wright State University, 1987. **1**

Zelanski, Paul, and Mary Pat Fisher. *Color.* 3rd ed. Upper Saddle River, N.J.: Prentice Hall, 1998. **7**

Zigrosser, Carl. *Käthe Kollwitz.* New York: George Braziller, 1951. **1**

Index

For information on artists see the Bibliography, pp. 332–337

Abdullah, Goduwa: *Ball of yarn* **1.57**
abstraction 63, 172–173, 174, 328; biomorphic 174–175; Cubist 175–178; geometric 178–179
accordion folds 238, 254, **6.3**, **8.18**
acrylic gesso 323
acrylic paints 314, **1.17**, **1.70**, **2.10**
action drawings *see* movement
Adoration of the Magi, study for (Leonardo) **1.1**
aerial perspective 170, 171
aerial photography 165
Air et la Chanson, L' (Magritte) 272, **7.15**
Albers, Josef 16, 27–28, 48, 76, 82, 273, 274, 276, 283; *The Interaction of Color* 132; *Introitus* 159, **4.12**; *Schoolgirl VIII* **4.2**; *Structural Constellation* 251, **6.13**; *Structural Constellation VIII* 166, **Plate 10**
Alleyne, Stuart E.: *"House on the Prairie," after Hale Woodruff* **0.8**
Alphabet as Good Humor Bar (Oldenburg) 270, **7.14a**
alphabets 271; *Calligraphic alphabet* (Baker) 98, **2.9**; *Italic alphabet* (Shaw) 310, **8.13**
alternate shading 57–58, 129, 147, 328
Ambihelical hexnut 251, **6.14**
American Ballet (Hirschfeld) **5.50**
anatomy, human 197–205; *see also* skeleton, human *and specific parts of the body*
Animal skeletal study (Forest) 190, **5.12**
animals: imaginary 265–266; skeletons 185, 190, 196; *see also specific animals*
animation 32, 222, 328; flip–book 243–245, 254
Animation Sequence (Pereira) **6.5a–c**
anthropomorphic: definition 328
Anuskiewicz, Richard 90; *Green, Blue, and Gray Knot* **1.70**; *Working drawings* 234, 251, **1.69a–c**, **6.1a–d**, **6.15a–d**
Arabic prayer (anon.) 150, **4.1**
Arena IV (Rockburne) 278, **7.19**
arms, the 190–191, 201, 202, **5.13–5.15**, **5.25**, **5.30–5.32**; muscles 206–208, **5.36–5.38**

Arneson, Robert: *A Nuclear War Head* **0.11**
Arp, Jean (Hans) 285; *Automatic Drawing* 285, **7.23**; *Leaves and Navels* 173, **4.25**
art therapy 21, 328
At the Theater (Cassatt) **Plate 5**
Athlete, The (Coppedge) **Plate 8**
attitudes: to drawings 137; showing on paper 290; *see also* emotions; evaluation
Aunt and Nephew (Schiele) 181, **5.1**
Automatic Drawing (Arp) 285, **7.23**
auto-stereograms 150, 158
Avocado (Kelly) **1.10**
Azcuy, Eric: *Figures playing volleyball* **5.2**

Bach, J. S.: manuscript of Two-Part Invention No.4 **0.15**; *Still Life Bach* (Braque) **0.16**
background: definition 328; *see also* figure/ground relationships
back-lighting 144, 328
Bailey, William: *Untitled* 90, 296, **8.1**
Baker, Arthur: *Calligraphic alphabet* 98, **2.9**
balance: definition 328
Balla, Giacomo 245
ballpoint pens 308, **7.2**, **8.12**
Bambi 222, **5.56**
bamboo brushes 93, 94, 122–123, 312, 313–314, **2.1**, **2.2**, **2.12**, **2.13**; inks 313–314; paper 314
Barcsay, Jenö: *Anatomy for the Artist* 198, 200
Barnet, Will 54; *Mother and Child* 152, **4.5**
Beach study (Schackner) 255–256, **6.18**
Beerman, Miriam: *Swimming Turtle* **8.17**
belts 68
binders, presentation 327
biomorphic: definition 328
biomorphic abstraction 174–175
bird skeletons 185, 190
Bittleman, Arnold: *From the Feather to the Mountain* 90, **1.75**
Blind Man with Outstretched Arms (Rubens) **5.38**
blood vessels 202
Blue Goat (Traylor) **Plate 6**
Boatwright, Paul: *Linear study of wood* 107, **2.21**
Boccioni, Umberto: *Muscular Dynamism* 222, **5.58**

Bonheur, Rosa: *Study of Horses' Legs* **7.32**
Bossom, Naomi: *Figures in a Landscape* 48, **1.21**; *Rabbits* 46, 97, **1.18**
Branche de Roncier (Matisse) 57, **1.32**
Braque, Georges 32, 129, 153, 166, 175, 222, 246; *Dé et Journal/JOU* 247, **6.8**; *Still Life Bach* **0.16**
Bridgman, George B.: *Complete Guide to Drawing from Life* 195, 200, 201, 205, 216, **5.26–5.29**, **5.34**, **5.51**
bright brushes 312
Broadway Boogie Woogie (Mondrian) 178
Brown, Ashley: *Two-handed self portrait* **1.72**
brush and ink drawings 93, **2.1**, **2.12**, **2.13**, **3.7**, **4.30**, **4.31**, **5.2**, **5.3**, **7.23**, **7.29**, **8.15**
brushes 312–13; *see also* bamboo brushes; brush and ink drawings
Bucher, François 276; *Despite Straight Lines* 283
buckles, belt 68
Bull, The (Picasso) 174, **4.29a–c**
Burns, Jerome: *Spencerian No. 42* **8.11**
Bust of a Female Figure (Prud'hon) 137, 142, **3.10**
Butterfly (Kwang-Min La) 126, **3.1a**
BWXX (Held) 46, **1.17**

Cai, Chris: *Horse* 46, **1.16**
Cajori, Charles: *Figures* **5.60**
Calligraphic alphabet (Baker) 98, **2.9**
calligraphic lines/calligraphy 45–46, 93, 97, 328; mono-lines (single thickness) 99; tonal variations 99; using bamboo brushes 93, 94; using lettering brushes 93, 95–96; using pen and ink 98; *see also* Chinese calligraphy
Calligraphy with moonshell (Pinto) **7.28**
Candella, Robert: *Knitted hat* **1.55**; *Paper bag* 78, **1.62**
Cantarella, Virginia: *Child's face before and after cleft lip surgery* 212, **5.45a,b**; *Crook tool* 48, **1.20**; *Drawing of an egg* 140, **3.12**; *Scissors* **0.6**; *She's Disappearing* 27, **0.19**; *Skeletal hand* **5.16a,b**; *Sketch of hands making framing L* **1.4**; *Skull views* **5.8a–c**, **5.9**; *Spinal study* **5.7a**; *Sterno-cleidomastoid* **5.35**

caps, corduroy 73–74
careers 289–90
Carnival at the Bistro (Picasso) 247, **6.7**
cartilage 202
Cassatt, Mary 150, 166; *At the Theater (Woman in a Loge)* **Plate 5**; *The Letter* 166, **4.18a,b**
"Castle of the Pyrenees", Study for (Magritte) 261, **7.4**
Catalpa Leaf (Kelly) 57, **1.31**
Catlett, Elizabeth: *Sharecropper* 107, **2.20**
cave paintings 234, 239, 274, **6.4**, **Plate 1**
Celia in Black Dress with White Flowers (Hockney) **Plate 7**
Cézanne, Paul 165, 245, 273; *A Corner of the Studio* 153, **4.6**; *"Milo of Crotona,"* after Pierre Puget 105, **2.17**
Chaet, Bernard: *Study for Spring Light* 53, **1.24**
Chair with Cushion (Hirsch) 27, **0.18**
chalk drawings **0.7**, **1.1**, **2.23**, **2.34**, **3.10**, **5.1**, **5.32**, **5.36–5.39**, **5.52**, **Plate 2**
chance, laws of: and artworks 285
Chandler, John 283
charcoal drawings 296, 298, 299, 300, 321, **0.16**, **0.17**, **1.3**, **1.35**, **2.11b**, **2.32**, **2.33**, **3.5**, **3.18**, **4.8**, **4.11**, **4.14**, **5.4**, **5.10**, **5.20**, **5.23**, **5.31**, **5.44**, **5.57a**, **5.58**, **6.8**, **7.21**, **7.33**, **8.2**, **8.4**, **8.6**, **8.7**
chiaroscuro 85, 142–143, 328; exercise 143–144
children's art 290, **0.1**
Child's face before and after cleft lip surgery (Cantarella) 212, **5.45a,b**
Chinese calligraphy/pictographs 101, 174–175, 254, **2.12**
"Chinese Horse" (Lascaux cave drawing) **Plate 1**
Chirinos, Evelyn: *Plant – "draw what you see"* 40, **1.9**
Christensen, Dan: *Untitled (#003–78)* 95, **2.3**
Christine (Noonan) **8.8**
Chrysanthemum (Mondrian) 26, **0.17** (charcoal, 1906); 117, **2.32** (charcoal, 1908–9); 178, **4.33a**, **Plate 9** (graphite and watercolor); 178, **4.33b** (pencil)
Church at Gelmeroda (Feininger) 246, **6.6**
Ciment, Hilary: *Large figure* 299, **8.5**
circles, freehand 86; *see* spandrels
circular formats 240
City (Ruscha) **7.14c**
closure effect 55
Colinet, Paul: *Untitled* 261, **7.5**
collage 126, 127, 328, **0.13**, **1.15**
color pencils 298
composition 328; choices 39–41, 152–154, 233–234; and cropping 40–41, 328; using framing Ls 35–36, 40, 152–153, 234, **1.4**
Composition, Black and Red (Matisse) 45, **1.15**

Composition, Black, White, Yellow (Mondrian) 99, **2.11c**
Composition in Line (Black and White) (Mondrian) 178, **4.33c**
concept-related drawings 287; and laws of chance 285
conceptual art/drawings 147, 259, 268, 273, 282–283; and geometry 273–274; terminology 274–276
cones *see* pine cones
Connor, Tom: *Cartoon illustration* **8.10**
conté crayon drawings 298, **1.58**, **3.3**, **3.8**, **5.5**, **5.31**
context, historical 286
continuous tone 77
contour drawing/contour lines 52, 53, 64–66, 329; broken 110–113, 329; sequential linear studies 66–79
contrast: and spatial effects 169
control, artists' 284–285
cookie cutters 70, 71, **1.48a,b**
Coombs, Errol: *Plant – "draw what you see"* 40, 155, **1.8**, **4.9**
copies 118
Coppedge, Arthur: *The Athlete* **Plate 8**; *Self Portrait* **7.33**
corduroy caps 73–74
Corner of the Studio, A (Cézanne) 153, **4.6**
Coutsis, John: *Spandrel studies* 87, **1.71**
crayons/crayon drawings 299, **1.34**, **2.11a**, **4.23**, **4.24**, **7.3**, **8.5**, **Plate 7**; *conté see* conté crayon drawings; lithographic 297–298, **3.9**
Cray-pas 299, 314, **7.30**
Crook tool (Cantarella) 48, **1.20**
cropping 40–41, 155, 233, 328
crosshatching 113–114, 328, **2.28**
Cubism 32, 58, 82, 119, 129, 165, 166, 175–178, 225, 284, 328; and illusion 251; techniques 328; and time and space 246–249
cups, drawing 57–58
Curradi, Francesco: *Study of hands and arms* 202, **5.32**
Current (Riley) 103, **2.15**
curved lines 109–110
cylinders, drawing 57–58, 69–70, **1.45**
Cypresses and Stars (van Gogh) 256–257, **6.19**

Dada movement 285
Dali, Salvador 262, 266; *Paranoiac Face* **7.1**; *Studies of a Nude* **5.42**
Dance to Spring, A (Feiffer) **5.22a,b**
Dancer (Rosenblatt) **5.3**
Dancer Adjusting Slipper (Degas) 151, 152, 155, **4.8**
Dantzic, Cynthia: *Geometric modular drawings* 274, **7.17**, **7.18a,b**; *The Learned Astronomer* 168, 169, **4.21**; *Michael, Pulled* 33, **1.2**; *Mother* 211, **5.43**; *Nana Reciting "The Blacksmith's Story"* 57, **1.33**; *Sketch showing alternate*

shading 58, **1.34**; *"What Can You See?"* 45, **1.13**
Dantzic, Gray: *First Mark on Paper* **0.1**
Dashes 0°–90° (Morellet) 281, **7.20**
Daumier, Honoré: *Men of Justice* 121, **2.34**
de Chirico, Giorgio: *The Mathematicians* 263–264, **7.10**
Dé et Journal/JOU (Braque) 247, **6.8**
Degas, Edgar 150, 165; *Dancer Adjusting Slipper* 151, 152, 155, **4.8**; *Three Studies of a Dancer* **5.52**
deities 266
Del-Prete, Sandro: *Three Candles* 251, **6.12**
"Delusions of Grandeur", Drawing for (Magritte) 260, **7.2**
Device for representing perspective (Dürer) 154, **4.7**
Dewey, John: *Art as Experience* 19
Diable et Cetera (MacIver) 300, **8.6**
Diebenkorn, Richard: *Untitled #30* 170, **4.23**
dimension: definition 328
Dinnerstein, Harvey: *Moratorium Vigil* 287, **7.24**; *Shaka* 298, **8.3**
Dinnerstein, Michael: *A Goat for Grandfather* **0.3**
Dinnerstein, Simon: *Marie Bilderl* 202, **5.31**; *Quartet "Wajih Salém"* **7.31**; *Winter Apples* 134, **3.8**
diptychs (double-panel compositions) 234–236
drafting tables 320
drapery *see* fabric
drawing: definitions 22–23, 25–26; preliminaries 31–38; satisfactions 19–20; studying 27; themes and subject matter 21, 24–25; *see also* composition
drawing boards, using 33, 37
Drawing Hands (Escher) **8.21**
dry media 296–307
dry-brush technique 122, 312, 313
drypoint **2.28**, **4.18a**
Duchamp, Marcel: *Nude Descending a Staircase, #2* 225, **5.61**
Dürer, Albrecht: *Device for representing perspective* 154, **4.7**; *Six Pillows* **2.27**

Eakins, Thomas 227; *The Swimming Hole* 222, 245
ear, the 214
easels 33, 320
Eclipse (Kasian) **0.7**
economy of means 329
edgeless tonality 130–131
edges 36–37; melted 57–58, *see also* alternate shading; physical 48, 51, 52; transitional (visual) 48, 51, 52–53, 63–64, 331; *see also* line(s)
egg drawings 54, 57–58, 63, 139–140, 141–142, **3.12**
E.J.C. (student): *Cookie cutters* **1.48b**; *Knitted collar* **1.56**

Elderfield, John 264, 269, 283
Elisa Garcia (Gussow) **3.18**
Ellington, Duke (Hirschfeld) **7.25**
emotions/emotional responses 119,
120–123; showing on paper 290; *see also*
expressive line; evaluation, criteria for
engravings 114
equal figure-ground 152
erasers 38; 308, 323; and lightening tones
56, 141; removing particles 56, 322; and
removing smudges 56
Ernst, Max: *"The Habits of Leaves"* 173,
4.28
Escher, Maurits Cornelis 262; *Drawing
Hands* **8.21**; *Waterfall* 166, **4.19**
etchings 114, **1.30**, **3.16**, **4.5**, **4.27**, **5.48**,
7.11, **7.15**, **7.25**
evaluation, criteria for 286–287
Evening Star, III (O'Keeffe) 45, **1.14**
expressions, facial 213–214
expressive line 119–123, 329
eyes 211–212

fabric 68, 73–74, 113, **1.44a,b**, **1.52**,
1.76, **2.27**
face, the 211–213; expressions 213–214; *see
also* self portraits
False Mirror, The (Magritte) 262, **7.7**
fantasy 250; and animals 265–266
feelings *see* emotions
feet, the 195–196, **5.20**, **5.42**; muscles 211
Feiffer, Jules: *A Dance to Spring* **5.22a,b**
Feininger, Lyonel: *Church at Gelmeroda*
246, **6.6**
felt-tipped markers 312
Fibonacci Sequence 193, 329
Figure (Sakuyama) 296, **8.2**
figure, human *see* human figure
figure-ground relationships 35, 47, 128,
152, 155
Figures (Cajori) **5.60**
Figures in a Landscape (Bossom) 48, **1.21**
Figures playing volleyball (Azcuy) **5.2**
filbert brushes 313
fingers *see* hands
Fisher, Leonard Everett: *Number Art, Four
Winds, NY* **8.9**
flags 73
Flight from Oneself (Klee) 169, **4.22**
flip-book animation 222, 243–245, 254
flip-flop optical illusions 58
Flowering Branch (van der Leck) 268, **7.13**
flowerpots 69, **1.46**
Flowers in a Vase (Gris) **1.3**
Footprints of bamboo brush (Kwang-Min La)
94, **2.2**
Ford, Harold: *Skeletal studies* **5.6a**
foreground: definition 329
foreshortening 162, 163, 168–169, 329
Forest, Rita V.: *Animal skeletal study* **5.12**;
Cylinders 69, **1.45**
form 329; and line 109–114

Foster, Walter T.: *Anatomy for Students and
Teachers* 198, 202, 205, **5.33**
fragmentation: definition 281
fragmenting space 328
frames, gridded drawing 154–155, **4.7**
framing Ls 35, 234, **1.4**; adjustable 35–36,
152–153
Frasconi, Antonio: *A Sunday in Monterey*
238, **6.3**; *Travels through Tuscany, II*
8.18; *A Vision of Thoreau ...* 97, **2.8**
From the Feather to the Mountain
(Bittleman) 90, **1.75**
Fruit Bowl, Glass, and Newspaper (Gris)
129, **3.2**
Furious Suns (Masson) 43, **1.12**
Futurists 245

Gauguin, Paul 150, 165, 245; *Tahitians*
211, **5.44**
geometric: definition 274
geometric abstractions 178–179; Stanczak's
282
Geometric modular drawings (C. Dantzic)
274, **7.17**, **7.18a,b**
geometry: and conceptual art 273–274, 278,
281
Gestalt effect 55
Gestalt psychology 268
gesture(s) 329; *see* movement
Giacometti, Alberto 227; *Drawing after
Toulouse Lautrec's "Jockey"* 60, 308, **8.12**
Glass, Pitcher, and Fruit Bowl (Gris) 247, **6.9**
goats: *Blue Goat* (Traylor) **Plate 6**; *A Goat
for Grandfather* (Dinnerstein) **0.3**
Gogh, Vincent van 118; *Cypresses and Stars*
256–257, **6.19**; *Olive Trees with the
Alpilles in the Background* 111, **2.24**;
Portrait of Joseph Roulin 114, **2.29**; *Red
Cabbages and Onions* 245, **Plate 3**; *Three
Hands, Two with a Fork* 110, **2.23**; *Tree
with Ivy in the Asylum Garden* 105, **2.16**
Golden Mean 113, 192–193, **5.17**
Gothic calligraphy (Winters) **2.4**
gouache and crayon drawings **4.23**, **6.2**, **6.7**
graffiti 19, 234
Grande famille, La (Magritte) 263, **7.9**
graphic art: definition 329
graphite/graphite drawings 296, 297, **4.6**,
4.33a, **6.10**, **7.14c**, **8.1**, **Plate 9**;
powdered 308, **7.31**
gray: definition 329
gray scale 59, 102, 132, **3.6**; exercises
132–137
Greco, El 256
Green, Blue, and Gray Knot (Anuskiewicz)
1.70
gridded drawing frames 154–155, **4.7**
grids 238–240, 274–275
Gris, Juan 222, 246; *Flowers in a Vase* **1.3**;
Fruit Bowl, Glass, and Newspaper 129,
3.2; *Glass, Pitcher, and Fruit Bowl* 247,
6.9; *Head of a Woman* 58, **1.35**; *Portrait*

of Max Jacob 37, **1.6**; *Still Life* 53, **1.23**
ground *see* figure-ground relationships;
space(s)
Growth is Stirring (Klee) 43, **1.11**
Guernica (Picasso) 24, 262, **0.14**, **7.6**
guitar cases 70–71
Gussow, Sue Ferguson: *Elisa Garcia* **3.18**;
Linda in a Spanish Wrap **Plate 11**;
Reclining Nude **5.23**
Gwathmey, Robert: *Topping Tobacco* 53–54,
1.25, **1.26**

Haas, Richard: *Mondrian* 284, **7.22**
"Habits of Leaves, The" (Ernst) 173, **4.28**
Hale, Robert Beverly: *Master Class in Figure
Drawing* 198, 200, 205
Hand (Ko) 63, **1.38**
hands 63, 110–111, 112–113, 192–194,
201, **1.38**, **2.23**, **2.26**, **5.16a,b**, **5.18a,b**,
5.32; muscles 207
Harpy with Head of a Bull ... (Picasso) 265,
7.11
hatching 113, 114, 117, **2.27**
Haystacks (Prikker) 170, **4.24**
head, the 205, **5.33**, **5.34**; *see also* ear; face;
skull
Head of a Woman (Gris) 58, **1.35**
Held, Al 166; *BWXX* 46, **1.17**; *Phoenicia II*
99, **2.10**
Hen (Steinberg) 290, **7.29**
highlights 142; using erasers 56, 141
Hiroshige, Ando *or* Utagawa: *"Sudden
Shower at Ohashi Bridge"* 166, **4.17**
Hirsch, Stefan: *Chair with Cushion* 27,
0.18
Hirschfeld, Al: *American Ballet* **5.50**; *Duke
Ellington* **7.25**
historical context (of artworks) 286
Hockney, David 166; *Celia in Black Dress
with White Flowers* **Plate 7**
horizon/horizon lines 36, 37, 51, 52, 53,
157, 170, 256–257
horses: *"Chinese Horse"* (Lascaux cave
painting) **Plate 1**; *Horse* (Cai) 46, **1.16**;
Study of Horses' Legs (Bonheur) **7.32**;
transformation from Chinese character
(Kruglyanskaya) 174, **4.31**
Houk, John: *Drawing of spaces around
wooden stools* 48, **1.19**
"House on the Prairie," after Hale Woodruff
(Alleyne) **0.8**
Hsu Wei: *Twelve Flowers and Poems* 97, **2.6**
human figure 181, 182, 197–198, 200, 215;
imaging 216; and movement 216–231;
proportions 184, 200–201, **5.28**; skeletal
framework 182–186; *see also* nudes *and
specific parts of the body*

illusions, optical 166, 250–253
Impressionists 284
individuality 60–61
inks/ink drawings 94, 312, 316, **0.2**, **0.5**,

0.15, 1.7, 1.12, 1.21, 1.75, 2.2, 2.6, 2.7, 5.49, 6.17, 7.4, 8.10; for bamboo brushes 313–314; *see also* pen and ink
insects 265
intaglio: definition 329
intarsia 126
intensity: definition 329
interference: definition 282
Interior (Villon) 117, 2.31
Introitus (Albers) 159, 4.12
isometric perspective 58, 165–166
Italic alphabet (Shaw) 310, 8.13

Jansyn, Leon: *Shadow study* 141, 3.14a
Japanese woodcuts 150
Jia-Xuan Zhang 2.13; *Chinese calligraphy* 2.12; *A poem in Chinese characters* 174, 4.30; *"To Fly," Chinese character* 2.1
Johns, Jasper: *0 Through 9* 7.14b
juxtaposition: definition 281

Kahlo, Frida: *Self Portrait* 5.55
Kasian, Charlotte: *Eclipse* 0.7
Kelly, Ellsworth 285; *Avocado* 99, 1.10; *Catalpa Leaf* 57, 99, 1.31
Kilmer, Joyce 266
kinesiology 183, 217, 329
Klee, Paul 285; *Growth is Stirring* 43, 1.11; *Flight from Oneself* 169, 4.22; *Letter Ghost* 151, 4.3; *Twittering Machine* 251, 6.16
knees *see* legs
Ko, Betty: *Hand* 63, 1.38
Kollwitz, Käthe: *Self Portrait* 0.4; *Self Portrait, Drawing* 117, 120, 2.33
Koplin, Norma-Jean: *Skeletal studies* 5.6b
Kruglyanskaya, Ella: *Transformation from Chinese character to depiction of a horse* 174, 4.31
Kwang-Min La: *Butterfly* 126, 3.1a; *Footprints of bamboo brush* 94, 2.2

L, framing *see* framing Ls
"Lagoon, The" (Matisse) 126, 3.1b
Landscape (Schwarzburg) 1.7
landscapes: and horizon line 256–257
Langer, Susanne K.: *Philosophy in a New Key* 273, 276
language: creative use 273; verbal perspectives 164–165; words as symbols 270–271
Lascaux cave paintings 239, 274, 6.4, Plate 1
Lassaw, Ibram: *Untitled linear study* 0.2
Laurie, Posing (Miller) 4.4
Lawrence, Jacob: *Self Portrait* 214, 5.49
Learned Astronomer, The (C. Dantzic) 168, 169, 4.21
Leaves and Navels (Arp) 173, 4.25
Leck, Bart van der: *Flowering Branch* 268, 7.13; *Study for "Mine with Miners"* 236, 6.2

Léger, Fernand: *Two Reclining Nudes* 173, 4.26
Legg, Alicia 276
legs, the 194–195, 5.19; muscles 209, 5.41
Leonardo da Vinci: study for *Adoration of the Magi* 1.1; *Studies of Naked Soldiers ...* 5.40
Letter, The (Cassatt) 166, 4.18a,b
Letter Ghost (Klee) 151, 4.3
lettering brushes, chisel-edged 93, 95–96
LeWitt, Sol 46, 109, 276–277, 281, 285; *Three-Part Combinations of Four Directions in Three Colors* Plate 4
ligaments 202
light 138; and shade 138–142, *see also* chiaroscuro; lighting effects
lighting, studio 320, 321
lighting effects 144; back-lighting 144; dramatic lighting 144; highlights 56, 141, 142; Rembrandt lighting 144–145; of space(s) 145–147
Linda in a Spanish Wrap (Gussow) Plate 11
linear surfaces 117–118
liners 312
line(s): applied 43, 45, 46, 52, 329; back-stitched/overlapped 56–57; calligraphic *see* calligraphic lines; contour *see* contour drawing/contour lines; drawing 43; drawing out 55–56; drawn by eye 55; and edges 48, 51–53; as edge of space 125–129; expressive 119–123, 329; and form 109–114; geometric 43, 52, 330; horizon *see* horizon lines; implied 57, 330; incised 330; and line-less tonality 59; mono-tonal and multi-tonal 57; parallel 36; shaping space 47–48; straight (without ruler) 83, 1.64; studying 53; and texture 105, 107; and three-dimensionality 63–64; and tone/tonality 57–58, 76–77, 84–86, 102–105, 1.65–1.68; *see also* circles; spandrels
lino cuts 97, 330, 0.9, 2.5
Lion Resting (Rembrandt) 122, 2.35
lips 212–213, 5.47
lithographic crayons and pencils 297–298, 3.9
lithographs 330, 1.31, 2.20, 3.14b, 4.12, 4.19, 4.28, 4.29, 5.50, 6.3, 7.14b, 8.21
Liu, Kaming: *Chinese character transformed into a mouse* 254, 6.17
Loen, Alfred van: *Tiger* 97, 2.5

Mabry, C.: *Linear pine cone* 1.59; *Tonal pine cone* 1.61
MacIver, Loren: *Diable et Cetera* 300, 8.6
MacLeish, Archibald 273
McLuhan, Marshall 255
Madame Seurat, Mother (Seurat) 131, 3.5
Magritte, René 267; *L'Air et la Chanson* (*"This Is Not a Pipe"*) 272, 7.15; *Drawing for "Delusions of Grandeur"* 260,

7.2; *The False Mirror* 262, 7.7; *La Grande famille* 263, 7.9; *The Red Model* 260, 7.3; *Study for "The Castle of the Pyrenees"* 261, 7.4; *The Thought Which Sees* 6.10
mahlsticks 305, 321
Mamunes, Lee: *Sensuous Trunks* 105, 2.19
Man, The (Polishchuk) 138, 3.11
Manzo, Hélène K.: *Two-way landscape* 36, 1.5
Manzo, Sarah: *Swivel Chair* 290, 7.30
Marie Bilderl (Dinnerstein) 202, 5.31
markers, felt-tipped 312
Martino, Anthony: matting demonstration 8.20a–d; *Seated figure* 313, 8.15
Maslow, Peter: *Gray scale with central band* 132, 3.6
Masson, André: *Furious Suns* 43, 1.12
Mateo, Martin: *Screw* 1.54; *Violin* 71, 1.47
Mathematicians, The (de Chirico) 263–4, 7.10
Matisse, Henri 97, 125; *Branche de Roncier* 57, 1.32; *Composition, Black and Red* 45, 125, 1.15; *Etude de bras* 5.30; *"... fraichie sur des lits de violettes"* 97, 0.9; *"The Lagoon"* 126, 3.1b; *Merion Dance Mural* 176–177, 178, 234–235, 4.32a–c; *Nue au coussin bleu à côté d'une cheminée* 141, 142, 3.14b
matts, window 324–326
Mayhew, Richard: *Spring Thaw* 55, 1.29
mechanical: definition 276
Men of Justice (Daumier) 121, 2.34
Merion Dance Mural (Matisse) 176–177, 178, 234–235, 4.32a–c
Michael, Pulled (C. Dantzic) 33, 1.2
Michelangelo Buonarroti: studies for *The Libyan Sibyl* 5.36, Plate 2; *Studies of a reclining male nude* 5.39
Miller, Diane: *Laurie, Posing* 4.4; *Standing figure* 299, 8.4
"Milo of Crotona," after Pierre Puget (Cézanne) 105, 2.17
minimal 274, 281
mirrors, using 320
Model in a Horn Chair with Kimono (Pearlstein) 140, 3.13
models: and drawing movement 217–221, 222, 224–228
Modern Art 284
modular: definition 274
Moebius loops 66–68, 1.43
Moebius strip drawings 241
Mondrian (Haas) 284, 7.22
Mondrian, Piet 26, 46, 178, 228, 268, 273; *Broadway Boogie Woogie* 178; *Chrysanthemum* (various) 26, 117, 178, 0.17, 2.32, 4.33a,b, Plate 9; *Composition, Black, White, Yellow* 99, 2.11c; *Composition in Line (Black and White)* 178, 4.33c; *The Sea* 99, 2.11b; *Self Portrait* 284, 7.21; *Tree #2* 99, 2.11a

Monica Lying on a Blanket (Wesselmann) **0.10**
montage 330
Morandi, Giorgio: *Still Life* 59, **1.36**
Moratorium Vigil (H. Dinnerstein) 287, **7.24**
Morellet, François 281–282, 285; *Dashes 0°–90°* 281, **7.20**
Mother (C. Dantzic) 211, **5.43**
Mother and Child (Barnet) 152, **4.5**
movement: and the human figure 182–183, 216–231
Mu Ch'i: *The Six Persimmons* 134, **3.7**
multi-unit formats 80–81, 234–240, 255
muscles 197, 201, 226, **5.24**; arm and hands 206–208; head and face 205, 206, 211, 213; legs and feet 209, 211; neck 206, **5.35**; scientific names 202, 204–205; torso 208–209
Muscular Dynamism (Boccioni) 222, **5.58**
musical accompaniment 96, 321
mutual contrast 132–133, 134
mythological creatures 265
Mz. 88. Red Stroke (Schwitters) **0.13**

Nana Reciting "The Blacksmith's Story" (C. Dantzic) 57, **1.33**
neck muscles 206, **5.35**
Neuhaus, Michael: *Linear tone pine cone* **1.60**
nibs *see* pen and ink
non-associative/non-objective/non-representational drawings 174, 178, 330
non-rectangular formats 240–241
non-verbal: definition 276
Noonan, Julia: *Christine* **8.8**
noses 202, 212, **5.46**
Nowak, Eugene: *Automatic two-handed symmetry* 89, **1.73**; *Study of flowerpots* 69, **1.46**
Nuclear War Head, A (Arneson) **0.11**
Nude Descending a Staircase, #2 (Duchamp) 225, **5.61**
nudes: *Monica Lying on a Blanket* (Wesselmann) **0.10**; *Reclining Nude* (Ferguson) **5.23**; *Studies of a reclining male nude* (Michelangelo) **5.39**; *Study for "Two Nudes"* (Picasso) **5.5**; *Two Reclining Nudes* (Léger) 173, **4.26**
Nue au coussin bleu à côté d'une cheminée (Matisse) 141, 142, **3.14b**
Number Art, Four Winds, NY (Fisher) **8.9**

O'Brien, Maria Eastmond: *Figural study* **5.41**; *Gestural actions* 220, **5.53**
Obsatz, Victor: *Figure study* 220, **5.54**
oil pastels 299, 308
oil sticks 299, 308, 314, **8.5**
O'Keeffe, Georgia: *Evening Star, III* 45, **1.14**
Okiishi, Ken E.: *Self Portrait* 108, **2.22**
Oldenburg, Claes: *Alphabet as Good Humor Bar* 270, **7.14a**

Olive Trees with the Alpilles in the Background (van Gogh) 111, **2.24**
one-point perspective 157–160
Op(tical) Art 103, 259
optical illusions 58, 166, 250–253
Optical Illusions (Reutersvärd) 251, **6.11**
outlines 64–65, 125, 330
overflowing compositions 236–237
overlapping of shapes 36, 169
Ozenfant, Amédée 129

paper 37, 301–305; for bamboo brush work 314
paper bags 58, 77–78, **1.62**
paper loops and curls 66, **1.41**, **1.42**; *see also* Moebius loops
papers, folded 79, **1.63**
parallel lines 36
Paranoiac Face (Dali) **7.1**
Paratrooper Boots (Warhol) **7.27**
Pascal, Blaise 278
pastels 298–299, 308, 314, **5.58**, **7.24**, **Plates 5, 8, 11**
Patel, Hina: *Sliced Pepper* 130, **3.4**; *Still Life* 155–156, **4.10**
pattern 330
Pearlstein, Philip: *Model in a Horn Chair with Kimono* 140, **3.13**
Peck, Stephen Rogers: *Atlas of Human Anatomy for the Artist* 198, 202, 205
pen and ink drawings 98, 308, 310–311, **1.29**, **1.32**, **1.40**, **1.53**, **2.4**, **2.9**, **2.19**, **2.26**, **2.27**, **2.31**, **2.35**, **4.2**, **4.22**, **5.22a**, **5.30**, **5.40**, **6.13**, **7.5**, **8.11**, **8.13**, **8.14**, **Plates 4, 10**
pencil sharpeners 37, 38, 300, 323
pencils 37, 38, 65–66, 296–298, 303; watercolor 314
penumbras 139, 140, 330
perception 271–273; of depth 35; and viewpoints 37
perceptual art/drawing 147, 259, 268, 330
Pereira, Carol: *Animation sequence* **6.5a–c**
perspective 32, 150, 330; aerial 170, 171; isometric 58, 165–166, 330; multi-viewpoint 165, 245–246; one-point 157–160, 330; reverse 169; three-point 163–164, 330; two-point 160–163, 330; vanishing-point 32, 36, 52, 157
Phoenicia II (Held) 99, **2.10**
photocopies, use of 108, **2.22**
photography: aerial 165; black and white 143, 144; using for composition 152
Picasso, Pablo 32, 153, 166, 175, 245, 246; illustrations for Balzac's *Le Chef d'Oeuvre Inconnu* 55, 173, **1.28**, **4.27**; *The Bull* 174, **4.29a–c**; *Carnival at the Bistro* 247, **6.7**; *Guernica* 24, 262, **0.14**, **7.6**; *Harpy with Head of a Bull ...* 265, **7.11**; *"The Pigeon"* 105, **2.18**; *Portrait of Madame Picasso, II* (Olga) 113, **2.28**; *Standing Female Nude* 222, **5.57a,b**; *Study for*

"Two Nudes" **5.5**
pictographs 174–175
picture plane 330; flattening 36, 58; reading surface 149–150; slipped 176, 247, 328; split 126, 176, 247, 328; tipped 176, 248, 328
"Pigeon, The" (Picasso) 105, **2.18**
pine cones 76–77, **1.59–1.61**
Pinto, Anna: *Calligraphy with moonshell* **7.28**
plane *see* picture plane
plant drawings 39–40, 97, 126, 127, 128–129, 155, 173, 268, **1.3**, **1.8**, **1.9**, **1.31**, **1.32**, **2.6**, **4.9**, **4.28**, **7.13**; multi-page 80–81; *see also* Mondrian
plastic: definition 276
Plato 273
Pliers, study of (Welliver) 71, **1.49**
Polishchuk, Slava: *The Man* 138, **3.11**
Pool, Leendert van der: *Ship's rope* **1.58**
Portrait of Joseph Roulin (van Gogh) 114, **2.29**
Portrait of Max Jacob (Gris) 37, **1.6**
Portrait of Madame Picasso, II (Olga) (Picasso) 113, **2.28**
Post-Impressionists 153, 284, *see also* Cézanne, Paul
predetermined choices 287
presentation (of artwork) 324
presentation binders 327
Prikker, Johann Thorn: *Haystacks* 170, **4.24**
printmaking: engravings 114; and linearity 97–98; *see also* etchings; lino cuts; lithographs; woodcuts
proportion 330; *see* Fibonacci Sequence; Golden Mean
Prospect Park West (Sakuyama) 273, **7.16**
Prud'hon, Pierre-Paul: *Bust of a Female Figure* 137, 142, **3.10**

Quartet "Wajih Salém" (S. Dinnerstein) **7.31**

rabbits: *Rabbits* (Bossom) 46, 97, **1.18**; *Sketch of a Rabbit* (Seihō) **2.7**
Rahim, Rahil: *Cookie cutters* 71, **1.48a**; *Draped striped fabric* **1.52**
randomization: definition 282
Rauschenberg, Robert: illustration for Dante's *Inferno* **0.12**
Ray, Man: *Self Portrait* **0.5**
reading pictorial surfaces 149–150
realism and creativity 81–82
Reclining Nude (Ferguson) **5.23**
rectangles, structuring 149–156
Red Cabbages and Onions (van Gogh) **Plate 3**
Red Model, The (Magritte) 260, **7.3**
reed pens 312
reflections 255
Rehbock, Alix: *Drawing of hand with skeleton* 113, **2.26**
Rehbock, Anita Dantzic: *Fashion figure* **7.26**
relief prints *see* lino cuts; woodcuts

Rembrandt van Rijn 144–145; *Lion Resting* 122, **2.35**; *Rembrandt's Father* (?) 144, **3.16**; *Self Portrait in a Cap, Open-Mouthed* 214, **5.48**; *The Shell* 114, **2.30**; *Young woman sleeping, her head resting on her right arm* **1.37**

Reni, Guido: *Study of a Right Arm and Hand* **5.37**

repetitions of drawings 41

reproductions of drawings 99

reptiles 265

responses *see* attitudes; emotions

Reutersvärd, Oscar: *Optical Illusions* 251, **6.11**

reverse perspective 169

rhythm 330

ribbons 68, **1.44a,b**

riggers 312

Riley, Bridget: *Current* 103, **2.15**

Rivera, José de: *Working drawings* 146, **3.17**

Rockburne, Dorothea 278, 281; *Arena IV* 278, **7.19**

rope 75, **1.58**

Rose, Bernice 276, 277

Rosenblatt, Suzanne: *Dancer* **5.3**

Rosenblum, Robert 283

round objects 109–110, 111–112

Rubens, Peter Paul: *Blind Man with Outstretched Arms* **5.38**

Rubin, William and Lanchner, Carolyn: *André Masson* 268–9

Ruscha, Edward: *City* **7.14c**

St. Martin's Nature Reserve (Yee) 65, **1.40**

Sakuyama, Shunji: *Figure* 296, **8.2**; *Prospect Park West* 273, **7.16**; *Reversed tonal figure* 137, **3.9**

Scadron, Warren: *Figure study* **2.25**

scale 330

Schackner, Marcia: *Beach study* 255–256, **6.18**

Schiele, Egon: *Aunt and Nephew* 181, **5.1**

Schoolgirl VIII (Albers) **4.2**

Schroeder: *Reversible Staircase* 166, **4.20**

Schwarzburg, Peter: *Landscape* **1.7**

Schwitters, Kurt 285; *Mz. 88. Red Stroke* **0.13**

Scissors (Cantarella) **0.6**

Scissors, Study of (Welliver) **0.20**

scratchboard 303, 317, 330, **0.8**, **3.11**, **8.9**; exercises on light 138–139

screen print **1.26**

Screw (Mateo) **1.54**

scribble technique 224, **5.59**

scroll drawings 237–238, 242–243

scumbled markings 123

Sea, The (Mondrian) 99, **2.11b**

Seated Boy with Straw Hat (Seurat) 129, **3.3**

Seated figure (Martino) 313, **8.15**

Seifert, Ruthe: *Alternating tonal bands* **2.14**

Seihō, Takeuchi: *Sketch of a Rabbit* **2.7**

self-directed drawings 285; evaluating 286–287

Self Portrait in a Cap, Open-Mouthed (Rembrandt) 214, **5.48**

Self Portrait, Drawing (Kollwitz) 120, **2.33**

Self Portrait, Two-handed (Brown) **1.72**

self portraits: Coppedge **7.33**; Kahlo **5.55**; Kollwitz **0.4**; Lawrence 214, **5.49**; Mondrian 284, **7.21**; Okiishi 108, **2.22**; Ray **0.5**; Vasiliu 144, **3.15**; *see also above*

self-taught artists 290

Seurat, Georges: *Madame Seurat, Mother* 131, **3.5**; *Seated Boy with Straw Hat* 129, **3.3**

shades 330

shading 330; alternate 57–58, 129, 147, 328; parallel (linear tonality) 84–86, **1.65**–**1.68**; *see also* chiaroscuro

shadows 58, 131, 138, 140–142, 330; *see also* penumbras

Shaka (H. Dinnerstein) 298, **8.3**

shapes 330–331; and figure/ground interaction 35; and line 47–48, 125–129; overlapping 36, 169

Sharecropper (Catlett) 107, **2.20**

sharpeners, pencil 37, 38, 300, 323

Shaw, Paul: *Italic alphabet* 310, **8.13**

Shell, The (Rembrandt) 114, **2.30**

shells, 75, 114, **1.53**, **2.30**

Sheppard, Joseph: *Anatomy* 201, **5.46**, **5.47**

She's Disappearing (Cantarella) 27, **0.19**

"shoe box theaters" 242–243

shoulders, the 189–190, **5.11**; muscles 209

sight-size method (figure drawing) 321

silhouettes *see* outlines

silverpoint 298, **8.3**

Six Persimmons, The (Mu Ch'i) 134, **3.7**

Six Pillows (Dürer) **2.27**

size: and spatial effects 169

skeletons: animal 185, 190, 196; human 181, 182, 184–186, *see specific parts of the body*

skull, the 186–189, **5.8a–c**, **5.9**

Sliced Pepper (Patel) 130, **3.4**

slipped planes 176, 247, 328

Sloan, John 168

Smith, Shelton: *Closed umbrella* 73, **1.51**

smudges: avoiding 56, 321, 322; erasing 56

snake skeleton 185

Snelson, Kenneth 277

Sorcerer's Apprentice, The 222

space(s) 155–156, 242; cubing 328; extending 231, 233–241; and figure/ground interaction 35; fragmenting 328; lighting 145–147; negative 127; shaping 47–48, 233–234

spandrels 86–88, **1.71**

Spencerian exemplar (anon.) 310, **8.14**

spine, the 186, **5.7a,b**

spirals 74–75; equiangular **5.17**

split planes 126, 176, 247, 328

Spofford, C.: *Simulated newsprint drawing* 90, **1.74**

spook lighting 144

Spring Thaw (Mayhew) 55, **1.29**

Staircase, reversible (Schroeder) 166, **4.20**

Stanczak, Julian 90, 268, 282

Standing Female Nude (Picasso) 222, **5.57a,b**

Steinberg, Saul: *Hen* 290, **7.29**

Still Life Bach (Braque) **0.16**

still lifes: and Cubist abstraction 176; Gris 53, **1.23**; and illusion of place 255–256; Morandi 59, **1.36**; Patel 155–156, **4.10**

Stoops, Susan 278

stopped action 219, 221, 227

string, balls of 75, **1.57**

Structural Constellations (Albers) 251, **6.13**, **Plate 10**

Studio, The (Tsao) **8.16**

studios: basic needs 319–324

Study for Spring Light (Chaet) 53, **1.24**

style 331; emergence of 60–61

subject matter 24–25

"*Sudden Shower at Ohashi Bridge*" (Hiroshige) 166, **4.17**

Sul, Wonsun (Sunny): *Rib cage, spine, and pelvis* **5.10**

Sumi ink 314

Sunday in Monterey, A (Frasconi) 238, **6.3**

Sung, Posoon Park: *Two Women* **8.7**

superheroes 266

superimposition: definition 281

Surrealism 260–267, 268–269, 285, 331; and Symbolism 267–268

Swartz, Robert J.: *Perceiving, Sensing and Knowing* 272

Swimming Hole, The (Eakins) 222, 245

Swimming Turtle (Beerman) **8.17**

Swirnoff, Lois 90

Swivel Chair (Manzo) 290, **7.30**

Symbolism 267–268, 331

symbols, words as 270–271

symmetry 331; exercises 88–89

systemic art 274, 283

Tahitians (Gauguin) 211, **5.44**

tendons 202

Tenniel, Sir John: *Cheshire Cat's Smile* 262, **7.8**

texture 331; indicating 105, 107–108

themes 21; and subject matter 24, 25

therapy, art 21, 328

"*This Is Not a Pipe*" (Magritte) 272, **7.15**

Thought Which Sees, The (Magritte) **6.10**

Three Candles (Del-Prete) 251, **6.12**

Three Hands, Two with a Fork (van Gogh) 110, **2.23**

Three Studies of a Dancer (Degas) **5.52**

Three-Part Combinations of Four Directions in Three Colors (LeWitt) **Plate 4**

three-point perspective 163–164

thumbs *see* hands

Tiger (van Loen) 97, **2.5**

tilt-tables 320

time 242; Cubist techniques 246–249; extending 231, 242–243; fracturing 246

tints 331

tipped planes 176, 248, 328

Tji-wara Antelope Headdress and Dan Mask (Zawadi) 266, **7.12**

toes *see* feet

tonality: edgeless 59, 130–131; continuous 77–79; and gray scale 132–137; linear 76–77, 84–86, 102–105; *see also* alternate shading

tone 331

tools, drawings of 64, 71, **0.20**, **1.20**, **1.39**, **1.49**

Topping Tobacco (Gwathmey) 53–54, **1.25**, **1.26**

torso, human 189, 200, **5.10**, **5.26**; muscles 208–209

transformation 254–255

transitional edges *see* edges

Travels through Tuscany, II (Frasconi) **8.18**

Traylor, Bill: *Blue Goat* **Plate 6**

trees: *Olive Trees with the Alpilles in the Background* (van Gogh) 111, **2.24**; *Tree with Ivy in the Asylum Garden* (van Gogh) 105, **2.16**; *Trees #2* (Mondrian) 99, **2.11a**

triangular formats 240

triangulated compositions 151

tribal art 290

triptychs (triple-panel compositions) 234–236

Trout and Reflected Tree (Welliver) 55, **1.30**

Tsao, Vivian: *The Studio* **8.16**

turgor 64, 331

Twelve Flowers and Poems (Hsu Wei) 97, **2.6**

Twittering Machine (Klee) 251, **6.16**

"Two Nudes", Study for (Picasso) **5.5**

Two Reclining Nudes (Léger) 173, **4.26**

Two Women (Sung) **8.7**

two-handed symmetry 88–89

two-point perspective 160–163

Two-way landscape (Manzo) 36, **1.5**

umbrellas: closed 72–73, **1.51**; open 72, **1.50**

Untitled works: Bailey 90, 296, **8.1**; Christensen 95, **2.3**; Colinet 261, **7.5**; *and see below*

Untitled #30 (Diebenkorn) 170, **4.23**

Untitled (Paratrooper Boots) (Warhol) **7.27**

Utrillo and His Grandmother (Valadon) **5.4**

Valadon, Suzanne: *Maurice Utrillo and His Grandmother* **5.4**

value 331

van Gogh *see* Gogh, Vincent van

vanishing point 36

vanishing-point perspective 32, 36, 52, 157

Vasiliu, Anca: *Self Portrait* 144, **3.15**

vertical placement: and spatial effects 169

viewpoints: and attitude/emotion 119–120; changing 255–256; and perception 37; *see also* perspective

Villon, Jacques: *Interior* 117, **2.31**

violins 71, **1.47**

Vision of Thoreau, A (Frasconi) 97, **2.8**

visual fields 34–36

Voichysonk, Bernard: *Open umbrellas* 72, **1.50**

Warhol, Andy: *Untitled (Paratrooper Boots)* **7.27**

watercolor pencils 314

watercolors **1.14**, **1.27**, **4.33a**, **6.16**, **7.13**, **7.16**, **7.28**

Waterfall (Escher) 166, **4.19**

Weber, Nicholas Fox 274

Welliver, Neil: *Coat, hanging on a nail* **1.76**; *Study for "Immature Great Blue heron"* 54, **1.27**; *Study of pliers and scissors* 71, **0.20**, **1.49**; *Trout and Reflected Tree* 55, **1.30**

Wesselmann, Tom: *Monica Lying on a Blanket* **0.10**

window matts 324–326

Winogrand, Garry 293

Winter Apples (Dinnerstein) 134, **3.8**

Winters, Eleanor: *Gothic calligraphy* **2.4**

Woman in a Loge (Cassatt) **Plate 5**

woodblock printing paper 314

woodcuts 46–47, 97–98, 150, **0.4**, **0.11**, **1.13a–c**, **1.18**, **2.8**, **4.17**

words as symbols 270–271

Wordsworth, William: "Daffodils" 257

working environment 319–320

wrist, the 191–192

yarn, balls of 75, **1.57**

Yee, Evelyn S.: *St. Martin's Nature Reserve* 65, **1.40**

Young woman sleeping, her head resting on her right arm (Rembrandt) **1.37**

Zawadi, Kiambu: *Tji-wara Antelope Headdress and Dan Mask* 266, **7.12**

0 Through 9 (Johns) **7.14b**

Ziemann, Richard Claude: *Study of tools* 64, **1.39**